Social Roots

Social Roots

Lowcountry Foodways, Reconnecting the Landscape

EDITED WITH AN INTRODUCTION BY SARAH V. ROSS

The University of Georgia Press · *Athens*

A version of "Hoppin' John, the Core of Lowcountry Foodways" by John Martin Taylor has appeared in *Gastronomica* and on the author's blog, *HoppinJohns.net*.

Designed by Erin Kirk
Set in Minion Pro
Printed and bound by Friesens
The paper in this book meets the guidelines for permanence and durability of the Committee on Production Guidelines for Book Longevity of the Council on Library Resources.

Most University of Georgia Press titles are available from popular e-book vendors.

Printed in Canada

28 27 26 25 24 C 5 4 3 2 1

Library of Congress Cataloging-in-Publication Data

Names: Ross, Sarah V., editor.
Title: Social roots : Lowcountry foodways, reconnecting the landscape / edited with an introduction by Sarah V. Ross.
Description: Athens : The University of Georgia Press, 2024. | Includes bibliographical references and index.
Identifiers: LCCN 2023054318 | ISBN 9780820362489 (hardback)
Subjects: LCSH: Food habits—Georgia—Atlantic Coast. | Food habits—South Carolina—Atlantic Coast. | Human ecology—Georgia—Atlantic Coast. | Human ecology—South Carolina—Atlantic Coast. | Landscape ecology—Georgia—Atlantic Coast. | Landscape ecology—South Carolina—Atlantic Coast. | Cooking, American—Southern style.
Classification: LCC GT2853.U5 S64 2024 | DDC 306.4—dc23/eng/20231229
LC record available at https://lccn.loc.gov/2023054318

These chapters unfold through an intradisciplinary lens

inspired by Peggy Galis, who embodies unrestrained curiosity

to understand the glorious world which connects us all.

CONTENTS

ILLUSTRATIONS

TABLE

Social Roots

Introduction

SARAH V. ROSS, UGA Libraries, executive director for UGA Center for Research and Education at Wormsloe

I could tell you simply that America's Lowcountry is a magical place. Instead, I'll let chefs, farmers, oyster harvesters, artists, writers, historians, researchers, hunters, and fishers featured here in *Social Roots* speak. Regardless of livelihood or calling, each voice expresses a lived experience depicting diverse connections within this ecosystem. These stories bring to life myriad imperceptible threads weaving connections throughout the Lowcountry, from the St. Marys River on the Georgia-Florida border to the confluence of the Ashley and Cooper Rivers at Charleston, South Carolina. Ecological threads link maritime forests, freshwater rivers and wetlands, coastal marine systems, and extensive tidal salt marshes. In this place, powerful storm events with strong winds and heavy rains interact with ocean tides and currents, endlessly reshaping contours across the landscape as well as below the waterline. In this unique environment and with the skills and knowledge used by its inhabitants over time, we see processes, elements, eating habits, and culinary practices—also known as foodways—evolve.

Thousands of years ago, Native Americans relied on an abundance of oysters, shrimp, crabs, clams, and mussels that flourished in tidal creeks throughout the Lowcountry. Across time, these tidal creeks remained a critical source of food for a succession of cultures. If we look back far enough, we know our predecessors were hunters and gatherers who passed on the inherent connectivity of a food to a place. Even today, residents in the Lowcountry know that to eat the freshest, unadulterated, native foods in this area requires venturing physically into the

coastal ecosystems. We are lured into the soft marsh muds and murky waters of brackish creeks to harvest the briny creatures for a meal that will transform into our very flesh and blood. Such an endeavor means renewing relationships with our sustenance through experiential engagement with this unique place.

Every living thing exists within a complex web of ecological relationships. Only recently has it become possible for so many of us to be thoroughly disconnected from this reality. From breathing to eating, all living things are subject to biological constraints. In this book, we consider our fundamental food supply, which is deeply rooted in the structure and function of Lowcountry ecosystems and the ecological scaffolding from which our traditional Lowcountry foodways emerged. Historically, our foods descended from the modified landscapes we inherited, and they remain dependent on these terrestrial and aquatic ecosystems. Looking through time and across geography, this book interweaves fundamental ecological principles as it honors three cultures: Native American, European, and West African. Each was enmeshed within the coastal environment and all shared similar means of food procurement: hunting, foraging, planting, cultivating, and harvesting, along with traditions of cooking and preserving. These three interrelating cultures interacted for generations with the coastal environment and formed the basis for production and consumption of food in the Lowcountry.

In large part, Lowcountry foodways were shaped simultaneously by scarcity and fickle opportunity. Hunting, fishing, and wild harvesting depend on both skill and the dance of risk and luck. What one hauls home (or doesn't) depends on season, weather, migration patterns, and variations in prey abundance. As a fisher and bowhunter for many decades, I can confirm the ongoing challenges resulting in scant yields in spite of practice and best efforts. Even if conditions are favorable and your techniques are precisely performed, there are no guarantees of enough food in the stewpot. Harvesting the exact ingredients in correct amounts for an inflexible recipe is unrealistic. Roots of Lowcountry cooking are more akin to intricate free-form jazz or rock music riffs than a rigid musical score. Both musicians and chefs use improvisation to create a pleasing arrangement with musical notes or foodstuffs. Although specific ingredients commonly fluctuate, cooks transform the obtainable palette of coastal ingredients into the distinctive expression of Lowcountry foodways.

The environment that forged the roots of Lowcountry cookery was not the Eden promised to the English settlers in the promotional materials of the eighteenth century. While the environmental larder did indeed provide a wealth of nutritious fare from plants to animals that run, swim, and fly, there were very different challenges to acquire potential food items than we experience today. European colonists were distressed to encounter unfamiliar animals right at their front door such as wolves, cougars, venomous snakes, enormous alligators, strange fish, and peculiar birds. Dense forests were shrouded with mysterious plants. William Bartram described recurring encounters with wildlife in the Lowcountry environment: "The dreadful and formidable rattle-snake is yet too common, and a variety of other serpents abound. . . . The alligator, a species of crocodile, abounds in the rivers and swamps near the sea coast. . . . Bears, tygers, wolves, and wild cats are numerous enough." Of Native Americans, Bartram noted that "they wage eternal war with deer and bear, to protect food, clothing and other necessaries and conveniences."[1] What the newcomers found was a panoply of things to eat, sometimes as scary as tasty. Modern visitors and residents also have many of these edibles at their fingertips, but knowing how and when to forage, fish, or hunt is another matter.

Fishing is one of the most satisfying ways to engage with the local ecosystem; it can be a simple activity, a year-round pursuit for young and old alike in the Lowcountry. Freshwater rivers flowing across the coastal plain to the sea increase in salinity as they approach brackish tidal creeks meandering through salt marshes, and again when

the rivers connect with the ocean. This salinity gradient determines the type of fish you can catch. Commonly caught fish in freshwater lakes and rivers here include catfish, bass, bream, black crappie, and trout. Brackish tidal creeks and salt water support sea trout, red drum, flounder, sheepshead, mullet, and whiting. But how to proceed? First, throw a cast net for live bait. Let's assume fate smiles and you pull up some immature shrimp or small fish. So far, so good. In fresh, brackish, or salt water you can hook your bait and cast a line with a cane pole or rod and reel. Or you can pull a seine or toss a cast net. Head home with your stringer of fish, invite family and friends over, clean and chill your fish. Simple, right?

A mess of fish can be prepared in numerous ways. But what drives the process of how foodstuffs are prepared? What generates our options as we transform bits and pieces of an ecosystem into dinner? The relationship between the environment and the cultures of farmer and cook rules the menu. This inseparable triad connects, engenders, and ultimately determines what is available for dinner. The essence of Lowcountry cuisine is always based on the connection between the still-living ingredient in its environment, the harvester, hunter, or fisher, and the cook. Today we can enjoy savory results thanks to generations of coastal residents surviving unreliable harvests and honing skills to improve the odds.

What are other aspects of our culinary pursuits? Resources such as fuel type and abundance, the materials that make up cooking vessels, and inherited cultural techniques also affect cooking outcomes. An experienced cook in the Lowcountry can conjure a traditional dish while honoring seasonal yield and cultural fidelity. Although ingredients can vary from day to day, the resulting dish is distinctive as well as authentic. Which species, amount, and size of fish did you catch? What else edible is available the day you are cooking? In summer you may find a local version of a one-pot stew (or bog, pilau, chowder, or gumbo) that may include crab, shrimp, okra, tomatoes, peppers, onions, smoked meat or sausage, and plenty of local rice. Winter's chill offers collards, turnips, and mustard greens for a fish stew enhanced with oysters, dried peppers, smoked meat or sausage, and rice, of course. Serve with cornbread—always in season!

Notably, most of the ingredients in Lowcountry meals today are not native to the southeastern United States. It is surprising that what we consider traditional or conventional Lowcountry cuisine today comprises many ingredients and methods that are not endemic. In the example of our locally caught fish stew, fresh- and saltwater animals are the only native components. Other ingredients commonly found in Southern cooking are exotic flora and fauna from foreign countries. The Lowcountry benefited from a surprising sequence of global events that coalesced in the ports of Charleston and Savannah and transpired at an unprecedented pace. Inspired by Christopher Columbus, Spanish explorers sailed to the New World seeking gold and glory. In the mid-1500s on the Barrier Islands of what is now Georgia they established outposts as safe layover sites to reprovision for their journey to South America. Exploration of the New World advanced into an outpouring of immigrants from Old World countries to coastal areas of the New World, which set the stage for a collision course of multicultural foodways. Settlers sailed in clusters from Spain, Portugal, Great Britain, France, British West Indies, Germany, and Austria to Charleston and Savannah. As they left their countries behind, these people tightened their grip on their distinctive traditions and packed their bags with various and sundry components to recreate their familiar birthplace. Spanish explorers transported pigs, peaches, and figs. British settlers brought dozens of vegetable varieties and their beloved grains, such as wheat, barley, and oats. However, the Lowcountry environment presented greater constraints than they ever imagined. If they had possessed any awareness of the trials ahead, it is doubtful so many would have marshaled the courage to leave their homelands for a mysterious foreign shore. Salvation

for the Europeans came from the Native Americans who shared their knowledge of hunting and farming in the Lowcountry environment. As the number of European immigrants expanded, more land was needed. In the process of conquering more of the original landscape, Anglo-Europeans employed strategies that effectively eliminated long-established Native American tribes.

In the sixteenth century, Africans, transported against their will, arrived from countries across West Africa. Rice, field peas, okra, and sesame seeds arrived with them. Today, these African food plants remain essential components of the Lowcountry diet. Their importance is eclipsed only by the everlasting impact of traditional African cooking methods. African cooks indelibly integrated and thus transformed the assemblage of Old and New World foodstuffs into the distinct cookery traditions of the Lowcountry. In a remarkably short period, European and African immigrants bridged new connections with their historically dissimilar food cultures, all of it grounded in the plenitude that Native Americans before them had enjoyed.

In *Social Roots*, we explore the transformation of the Lowcountry environment into a connected patchwork of landscapes first shaped through an organized system of swidden (slash-and-burn) agriculture by Native Americans. As a community they cultivated corn, beans, and squash while managing areas for wild harvesting. As English colonists tried to replicate their customary European agricultural practices in the Lowcountry, they soon realized they could not transform forests into farms, feed themselves, and produce a product for export without forced labor. Enslaved West Africans cleared dense forests, managed agricultural fields, built and maintained rice plantations, and cooked for and served plantation owners. Each cultural group reshaped the landscape to most effectively reproduce their own long-standing, historical foodways. Bite by bite, landscapes were transformed into traditional dishes, now infused with multicultural techniques and components. But while foodways, including dietary preferences, directed significant alterations in the physical landscape it was environmental constraints that ultimately determined which plant and animal species farmers could hunt, raise, or cultivate.

As the executive director of the University of Georgia's Center for Research and Education at Wormsloe, I literally live every day immersed and engaged with Lowcountry foodways: through soil, marsh mud, blood, and bone. Here researchers in ecology, environmental engineering, geography, history, anthropology, landscape architecture, business, and agriculture work synergistically to advance our understanding of Lowcountry foodways. In this book, chapters written by experts in these fields outline how each area of study contributes to our broader understanding of the interplay between the physical environment, cultural traditions, and methods of food production. From the community cultivation of Native Americans to the individualized family-scale vegetable gardens of the English to the vast rice plantations constructed by the forced labor of enslaved Africans, food production provides a window through which different cultural norms interact and alter the environment in ways that still define and shape the landscape of the Coastal Plain and sea island marshes.

My interests in the broad scope of ecology and food history began in my teens, which inspired thirty-five years of teaching science and conducting research in terrestrial and marine ecosystems. Decades of organic vegetable farming, wild harvesting, and opportunities cooking professionally also cultivated in me an understanding of the connection between the production and consumption of food. Over time, these experiences coalesced into an investigation of the vulnerability of ecosystems when subjected to unwise agricultural practices and, conversely, how damaged ecosystems threaten traditional foodways.

Social Roots was inspired by the remarkable reference material in the De Renne Collection, a large archive of publications spanning many generations of life on the southeast coast. Six generations of owners of the Wormsloe estate

on the Isle of Hope in Savannah, Georgia, methodically acquired more than ten thousand manuscripts, maps, and prints to assemble this collection, which was transferred to the University of Georgia in 1938. The collection now resides in the UGA Hargrett Rare Book and Manuscript Collection in Richard B. Russell Special Collections Libraries. The fundamental purpose of the De Renne Collection is to document day-to-day activities at Wormsloe from the mid-1730s to the 1930s. This preeminent research collection with two centuries of observations, journal entries, and a wide range of estate management records (including weather conditions, descriptions of soils, harvest reports, and accounts of food history) provides the underlying structure and focus of this book. Although *Social Roots* embraces 180 miles of Atlantic coastal counties, Wormsloe—located midway along this corridor—is used as a focal point for ecosystem research and agroecology examples in various chapters. Remarkably, the original farm fields at Wormsloe have been in almost continuous vegetable and grain production since 1734. We continue the tradition on-site, annually growing more than 450 varieties of heirloom vegetables and grains, including landraces (locally adapted) heirloom rice.

In the American South, the lifeblood connecting a long and complicated human history is entangled with the agricultural past. This book cannot do justice to all areas of interest that contribute to a regional food system or the history and culture of multicultural foodways. We will, however, examine a series of environmental conditions and cultural foundations that have shaped Lowcountry foodways. Our hope is that this collection of essays will lead to discussions regarding the changing relationship between individuals and the landscape, with particular emphasis on agroecology and the dynamic evolution of all of our foodways.

For decades the late renowned cook, writer, NPR commentator, poet, actor, and celebrity Vertamae Smart-Grosvenor enthralled audiences with her knowledge, talents, and enthusiasm for life. She advocated for thoughtful purpose and for keen intention as we prepare, share, and enjoy food. In the 2011 introduction to her book *Vibration Cooking*, first published in 1970, she streamlined her perspective: "Now, forty years later, after the birth of my baby *Vibration Cooking*, we've changed, but some people still carry culinary baggage, carry their associations and sensitivities about food still too close." She enthusiastically closed with, "Appreciate and Enjoy! Cook!"[2] In this spirit we offer another generation of discussion, research, and culinary delight.

With deep gratitude to farmers and cooks in the Lowcountry, past and present, the nameless as well as the celebrated, we welcome you at our community table.

NOTES

1. William Bartram, *The Travels of William Bartram* (Athens: University of Georgia Press, 1998), chap. 4.

2. Vertamae Smart-Grosvenor, *Vibration Cooking: or, The Travel Notes of a Geechee Girl* (Athens: University of Georgia Press, 2011), xxxv.

PART I

Natural and Social Histories
of Coastal Counties in the
Lowcountry of Georgia and
Lower South Carolina

CHAPTER 1

A Slice of Ecosystem for Dinner

SARAH V. ROSS

Worldwide and throughout time, agriculture has been the backbone of all civilizations. Yet food production has wrought more damage to our terrestrial environments than any other human activity. A close look at the basic concepts of ecology in Lowcountry environments uncovers opportunities for sustainable farming and wild harvesting. Native Americans, Europeans, and Africans all brought seeds as well as their deeply rooted paradigms of a suitable diet to this coastal region. Lowcountry cuisine reflects a synthesis of these cultures, food products, farming practices, and cooking techniques, all of which depend on the historic multicultural stewardship of the landscape. The relationship triad of the environment, the farmer/harvester, and the cook evolved over ages, slowly shaping, adapting, amending, and improving systems for producing food and getting it to the table in fine form. Lowcountry foodways are the offspring of the fertile relationship between the environment and multicultural immigrants.

Writing between two cholera pandemics in the early 1800s, the legendary French culinary scholar Jean Anthelme Brillat-Savarin articulated a truth we urgently need to understand today: "The destiny of nations depends on how they feed themselves."[1]

This chapter explores the challenges English colonials faced with regard to survival in their new home along America's Lowcountry coast. Like all newcomers, they came with expectations and skills, but they had no way of knowing just what was in store for them. What appeared to be a verdant land rich with resources for food and commodity production turned out to be a much more foreign and difficult landscape than expected. This

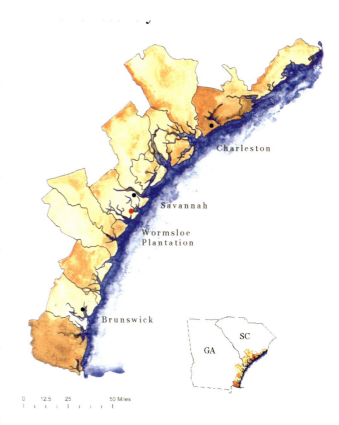

9

conundrum is not uncommon in human history: new people with old ways trying to fit into a new place. What they found was a place with different kinds of riches, affected by earlier arrivals from Europe and shaped by the Indigenous people who had enjoyed the area's bounty for thousands of years. While they did not have a concept of ecology as we know it today, they did experience firsthand a radically interrelated system of flora, fauna, and culture. Their lessons hold vital information for us today as we face significant and increasing threats to our systems of food production and distribution, as well as to the ecosystems we rely on for life itself. What follows explores the natural systems that shaped the early food production of the American colonials, with Wormsloe Estate on the Isle of Hope at Savannah as a model. 🐜

A Slice of Ecosystem Is Our Dinner

All living things are supported through endless exchanges within ecosystems. As we dine, we rarely consider the air, water, soil, or countless organisms, from algae to insects, that make our food possible. However, ecosystem constraints have always had us on a short leash. Our survival is seriously threatened if there is a shortage or degradation of any of these lifelines. We can live only a few minutes without oxygen, a few days without water, and a few weeks without food. We are absolutely dependent on our ecosystem—yet we often overlook how it keeps us alive.

Marine algae produce more than 70 percent of the oxygen in the atmosphere. Water cycles through ecosystems, evaporates or transpires into the atmosphere, falls as precipitation, and drains through rock and soil sediments into groundwater, lakes, streams, and the ocean. This is a ceaseless cycle cleansing the earth's finite water supply. Soil, too, supports the production of most of the food consumed by humans—as much as 95 percent of our supply—yet we frequently destroy soil through misguided agricultural practices.[2]

Throughout his forty-three years as a Harvard biologist, E. O. Wilson argued that a loss of insects and other invertebrates directly or indirectly threatens all life on earth. Insects are a crucial food source for many birds, fish, reptiles, and amphibians and some mammals. Entomologist Doug Tallamy's research concludes that without insect pollinators, 80 percent of all plants and 90 percent of all flowering plants would disappear. A loss of pollinators would eliminate not only chocolate and coffee but most of our vegetable and fruit crops. In short, humans need pollinators to survive.

While every living thing exists within a complex web of ecological relationships, only recently has it become possible for so many of us to be thoroughly disconnected from this reality. From breathing to eating, all living things are subjected to biological constraints. In this chapter, we consider the fundamental food supply in the Lowcountry, which is deeply rooted in the structure and function of its ecosystems. We investigate the ecological scaffolding from which our traditional Lowcountry foodways emerged. Our historic foods not only are descended from but remain dependent on the aquatic and terrestrial ecosystems that have existed for millions of years.

For the first time since *Homo sapiens* walked upright, we've become disconnected from knowing much about the foods we eat. Hunting, gathering, and farming were once daily reminders that survival depended on knowledge of opportunities within limits inherent in the biological, chemical, and physical components of the environment. By contrast, procuring food today can involve just a momentary swipe of computer code, certainly not entailing any understanding of the purchase. The infinite ways we participate in the environment have fundamentally changed from a relational engagement to a transactional arrangement. What does this modern shift reveal, and what does it portend for tomorrow?

Although agricultural activity began more than ten thousand years ago, only in the last century has the nation's

engagement with food production and the knowledge of farming, hunting, and foraging been relegated to such a small percentage of the population. In the early decades of the twenty-first century, approximately one percent of the U.S. population farmed full-time. While focus groups reveal most of the remaining population is attracted to and satisfied with the illusion depicted on packaging in grocery stores—the idealized family farm scene, happy chickens and cows, and perfect rows of weed-free vegetables—the reality of industrial agricultural production is purposely hidden from view. The marketing on packaged foodstuffs doesn't illustrate the reality of hundreds of square miles of monocrops; cows and pigs wading in manure periodically overflowing from confined feeding operations; or the pernicious effects of herbicides, insecticides, and fertilizers. The graphic designs rarely show evidence of the human labor involved as well. In sharp contrast, the first English colonists in Georgia did not have the luxury of not engaging in their own food production. Their survival, and the survival of their families, depended on the active participation of every man, woman, and child in food production. The agricultural knowledge and skills acquired and implemented by the early colonists can inform our decisions today about our next meal and how we feed our families.

We already know that sunlight, water, and soil are the foundation for the vast majority of food production on earth. Regionally, we take into consideration climate, particular soil profiles, nutrients, and the biodiversity of coexistent plants and animals to describe specific agricultural systems. In basic terms, we recognize that farmers sow seeds and cultivate the crops we eat and the crops fed to the animals we eat. Yet when we look more closely, we may wonder: Where does the actual food on our plates come from?

A colleague once posed this seemingly straightforward question to a class of elementary students when they visited a barnyard in Savannah, Georgia. First my colleague asked the children to identify the sources of bacon and milk, prompting such answers as "Look, there's the pig!"

and "Over there! A cow!" For some students it took a while to acclimate to being inside a fully functioning, fully alive, fully productive barnyard for the first time. One such student, who had been noticeably uneasy at first, had a sudden burst of confidence when my colleague asked the class where eggs come from. She energetically waved her hand and proclaimed, with certainty, "Room service."

I later had the privilege of discussing this encounter with the child's proud parents, and I learned that her father managed a distinguished hotel, where eggs were indeed delivered by room service. For individuals like this student, and for groups and society at large, the range and depth of our understanding are fashioned by many forces—family, schools, religious affiliations, cultural connections, and world affairs. What we pay attention to and absorb from this ongoing avalanche of information shapes our values, thinking, and behavior. Our brains are designed to filter, edit, and discard information we judge unusable while endlessly reordering our focus to address immediate concerns. We can simply look around and see how easy it is to be lulled into complacency through endless advertisements and public assurances that somewhere, somehow others will grow, prepare, and distribute food for our convenient consumption. With our minds struggling to sort and prioritize a daily assault of endless minutiae it is easy to lose our age-old engagement with food—from a seed's germination or an animal's birth, and eventually onto our plates—and the ecological infrastructure required to provide our sustenance.

Most of our food in America now is produced, shipped, stored, prepared, and delivered through a complex industrialized system. Very little of it gets to us without the labor of migrant populations. Thus, knowing where and how our foods are raised is more important than ever. How in the world can we track the convoluted steps from our plate back to the source? Consider ingredients in a Lowcountry shrimp boil: corn on the cob, new potatoes, sweet onions, dried red pepper, sausage, crab, and shrimp. Unless you

astutely procured your vegetables and sausage from a local farmer and caught the crab and shrimp in a nearby tidal creek, it would be difficult to track the ingredients backward through the unseen supply chain. This chain might include multiple continents. Although tracing where our food comes from is challenging today, it was a simple task for people who lived on and worked the land that produced their food, including the earliest coastal inhabitants.

Elements of Lowcountry Traditions

Coastal waterways have provided a consistent and reliable source of food for humans for thousands of years. Twice each day people in the Lowcountry of Georgia and South Carolina benefit from an exceptionally high tidal range, often eight feet or more. This massive movement of salty water through a maze of tidal creeks transports a bounty of fish, shrimp, and crab. As the tides ebb and flow, fishers and harvesters can return to the same area day after day and find a renewed supply. Salt marsh ecosystems are among the most biologically productive on earth.[3] Oysters in particular provided early coastal residents an unmatched, enduring, and dependable supply of protein. Although tribes routinely hunted terrestrial animals, oysters were easier to stalk and subdue than deer or other game. Piles of the discarded oyster shells, called middens, form a loose chain of shell mounds where salt water meets land along the Atlantic coast. These reveal the extent of oyster consumption by coastal tribes from the time of the earliest inhabitants. Predictable harvest of this abundant resource established oyster roasts as an enduring and important ritual in the American South. Harvested for thousands of years along our coast, fish and shellfish from fresh and salt water are the only native harvests we still routinely consider part of southern fare. (Dionne Hoskins-Brown describes tidal creek ecology in greater detail in chapter 16.)

Terrestrial wildlife offered Native Americans a range of game, including native woods bison, white-tailed deer, black bear, turkey, migratory birds, waterfowl, possum, squirrel, raccoon, turtle, and rabbit. (See chapter 17 for Drew Lanham's discussion of hunting in the Lowcountry.) According to anthropologist Kristen Gremillion, the author of *Ancestral Appetites*, Native Americans supplemented their wild game consumption with plants such as sunflower (*Helianthus annuus*), goosefoot (*Chenopodium berlandieri*), marsh elder (*Iva annua*), and a native species of squash (*Cucurbita pepo*).[4] About a thousand years ago, corn was transported to the Lowcountry from Meso America, along with additional varieties of squash, followed by beans. Over time, the cultivation of corn largely supplanted the earliest native food plants. Creeks and Cherokees maintained extensive farms and planted what is referred to as the three sisters—corn, beans, and squash—in an ecological and mutually beneficial arrangement.

Global Food Exchange

Where do the iconic elements of our southern diet come from, how did they get here, and how did they survive relocation to a continent with a dissimilar environment? Southerners today benefit from novel ingredients and new cooking techniques thanks to waves of immigrants who arrived in fits and starts over the last five hundred years, by chance or good fortune. Christopher Columbus never set foot on the mainland of North America, but he came close when he stopped at a couple of islands in the Caribbean. His journey across the Atlantic Ocean resulted in what historian Alfred W. Crosby Jr. refers to as the "Columbian Exchange"—which has proved to be the most massive intercontinental introduction of plants and animals ever known.[5] Columbus's ocean exploration inspired many subsequent transoceanic voyages from such countries as Spain, Portugal, France, and England. "From Asia came the pig," notes culinary writer Michael W. Twitty in his book *The Cooking Gene*, while "from Eurasia came the methods of curing and smoking its meat."[6] Swine landed in the New

World with the Spanish explorers more than five centuries ago. Domesticated poultry, also from Asia, followed on the same maritime trade routes. With remarkable speed, these expeditions transported many varieties of crops and livestock. Transportation to the "new" world, however, marked only the first of many challenges. Survival for both plants and animals in the new location required tolerance for a unique set of adversities such as low-nutrient soils, storm events with periodic flooding, incessant pest pressure, and long periods of high heat and humidity. Ultimately, environmental constraints would control which species could survive in the Lowcountry; those creatures and plants that did survive and adapt became the foundation of what we think of as southern coastal gastronomy today.

Regional Bounty

The exchange of cultural practices also played an important role in establishing the foundation for Lowcountry foodways. The early English colonists were fortunate that James Oglethorpe, appointed by its Trustees to lead the colony of Georgia, and Tomo-Chi-Chi, chief of the local Yamacraw tribe (a mix of Lower-Creeks and Yamasees), established a lasting friendship. This led to nonviolent ceding of tribal lands as well as the transfer of skills critical for hunting, gathering, and farming in the Lowcountry.

Native Americans provided a lifeline to Europeans with foundational crops originally from Meso- and South America. Corn was the primary crop cultivated by Creeks and Cherokees when the colonists arrived, and today it remains the major summer grain produced in Georgia and South Carolina. Though limited to warm-season cultivation, corn is especially suited for drying and long-term storage, providing food for humans and livestock throughout the year. Corn can also be transformed from harvest to cooking pot more easily than other grains. Kernels are shucked from the dried cobs and then ground into meal or soaked and boiled. Corn is more forgiving of being ground

than other grains and can be milled (or pounded) on a domestic scale. Without the need for massive, precisely honed millstones that are powered by waterwheels and thus limited to river locations, corn is a remarkably portable grain. Traveling with intrepid settlers into the frontier, corn provided critical calories to supplement hunted fare. Boiled and baked, ground corn has nourished Lowcountry inhabitants for a thousand years. Over time more crops with New World origins, including tomatoes, peppers, white and sweet potatoes, and peanuts, were introduced to the Lowcountry as well as to Europe, Africa, and Asia.[7]

Cultural Connections, Contributions, and Incongruities

Native Americans were the first inhabitants on the continent to practice swidden agriculture (also known as rotational planting, slash and burn, or fire-fallow cultivation). This activity shaped their early terrain and allowed them to cultivate native plants and later corn and beans. Fire was an important land management tool for Native Americans. Its intensity was affected by the amount of available flammable material, wind speed and direction, moisture, and season of the year. Woodlands, therefore, burned unevenly, creating a diverse environment. Fire could lightly singe one spot and incinerate an adjacent area, resulting in a range of patchy zones. (Today, prescribed burning is particularly important for maintaining the high biodiversity of the dominant forest type in the Coastal Plain, the longleaf pine forest community.) Fire reduced underbrush in the forest, thereby improving line of sight for bow and arrow shooting. Native Americans also used fire to drive game such as bison, deer, bears, rabbits, and squirrels into areas where they could be more easily slain. Nutrients were liberated and released into the soil as fire transformed plant material into ash. Furthermore, burning the landscape increased sunlight at ground level, which improved conditions for farming. In a landscape partially cleared

by burning, it was advantageous to plant seeds in clusters to avoid stumps, impenetrable root masses, and remnant trees (whose stumps can persist for a decade or more). Swidden agriculture was most productive in regions with vast tracts of unoccupied land and cultures adapted to migrate periodically. The Coastal Plain was an environment well suited to these practices. All of this worked well for Native Americans until Europeans arrived and interrupted their centuries of legacy agriculture in the Lowcountry.

For thousands of years European agricultural practices relied on plows pulled by draft animals to turn over the uppermost soil and create furrows for sowing seeds. Repeated plowing leveled and cleared British farm fields of remnant stumps and other natural debris that would impede plowing. Conditions in the New World, however, were dramatically different. Colonists disembarked into an environment dominated by centuries-old maritime oak and longleaf pine forests. They quickly discovered that their most technologically advanced farm tool was practically useless. Without the advantage of plows driven through fields as practiced in Britain, early colonists adopted farming techniques learned from local Native American tribes. Interestingly, digging sticks and hoes made from shells that had served Native Americans for centuries shaped agricultural practices similar to those in Africa. Farming practices as well as cooking techniques were exchanged between Native Americans and Europeans through beneficial alliances, forced captures, enslavement, and occasional marriage arrangements. The arrival of enslaved Africans added additional essential farming knowledge and skills in food preparation to this assemblage of cultural exchanges. As geographer Judith A. Carney observes, "The long-handled iron hoe, the fundamental implement of African agricultural systems, became important as well in plantation societies."[8]

The colonies of Carolina and Georgia shared similar challenges of wresting resources from the Lowcountry environment, but their rules for land allocation and labor practices were vastly different during the early years of the Georgia colony, and therefore they responded very differently to opportunities and constraints inherent in the environment. Carolina, from its founding in 1670, offered extensive landholdings to English and French gentry, and in short order they purchased multitudes of slaves. Rice was the most profitable crop in the colonies in the 1700s, and the profits were limited only by the number of enslaved laborers who cleared swamps and marshes to construct and maintain rice impoundments as well as cultivating and processing the rice. In contrast, the fledgling Georgia colony, founded on egalitarian ideologies, limited the size of land allocations to a fraction of the acres available in Carolina.

A conflicting approach to land use and tenure also arrived on the new continent with immigrants from the Old World. Land ownership in Britain was ruled by "tail-male" inheritance laws, which limited property bequest to male descendants. An opportunity to own land was a primary incentive for English immigration to the Lowcountry. To receive land, Georgia colonists agreed to join military efforts to defend the colony. Trustees of the Georgia colony scripted rules to force colonists to live and farm exclusively on the land assigned to them. However, land assigned to settlers in Georgia was based on a plan for military defense, not optimal food production. Land parcels were consistent in size but differed drastically in suitability for farming. Colonists confined to unproductive land frequently gave up and moved north to the Carolinas or back to their motherland. (Christopher Curtis thoroughly describes the British system of land ownership and how the rules controlled land tenure in the Lowcountry in chapter 8.) These historic policies continue to affect land ownership today, influencing tax structures that address inherited farms and large estates.

Much of the land in the Lowcountry is more suitable for raising livestock than for farming row crops. From their earliest days on the continent, Europeans transported livestock such as pigs, cows, sheep, and domesticated fowl to the Atlantic Seaboard. Labor shortages in the colonies

contributed to the rarity of fenced pastures, so livestock were allowed to range freely. Retrieving free-ranging animals was problematic, and theft of livestock was frequently recorded. While raising livestock was encouraged in the Savannah area as early as 1733, archaeologist William Kelso discovered deer bones to be the most abundant animal remnants deposited by the family of Noble and Sarah Jones at the Wormsloe homestead during the mid-1700s. Deer populations in the early eighteenth-century Lowcountry supported exports of tens of thousands of hides annually from ports in Charleston and Savannah to England. As Kelso reports, the wholesale slaughter of deer for leather also provided boundless venison for the dinner table. Although they frequently consumed venison, when given a choice, the colonists preferred to dine on their customary livestock and traditional British vegetables.[9]

English garden vegetables such as collards, cabbages, beets, onions, peas, and carrots, as well as exotic fruits including peaches, nectarines, grapes, oranges, and figs, were cultivated at the Wormsloe estate.[10] Herds of cattle, horses, sheep, and chickens increased at Wormsloe as forests were steadily cleared for additional grazing. These extensive agricultural endeavors required considerable effort to initiate and unrelenting labor to maintain. In the first two decades of the Georgia colony, labor was the limiting factor and principal challenge inhibiting anticipated land development. Noble Jones's land apportionment in the new colony was elevated from the standard fifty to a generous five hundred acres because he arrived with a wife, two children, and two indentured servants. The Joneses were fortunate to have the financial resources to pay all transportation fees for the voyage from England for their own family as well as the two servants. However, this large parcel of land required even more labor, as the Trustees placed obligations for horticultural production commiserate with acreage granted. The Trustees had assumed laborers from England would arrive in sufficient numbers to speedily transform the coastal environment into a cultivated landscape

producing ample food and products for export. However, their assumptions, based on high rates of unemployment in England, were overly optimistic. Labor shortages discouraged more than a few of the original colonists, who either abandoned the settlement altogether and returned to England or migrated north to South Carolina where, unlike in Georgia, labor in the form of slavery was legal at the time.

Multicultural Cookery Practices

Along with distinctive land and labor practices, a unique assemblage of foodstuffs from across the globe came together in the colonial era. Lowcountry foodways illustrate ongoing nature-and-culture negotiations in the fields, in the kitchen, and on the table. Rice, field peas, okra, sesame seeds, watermelon, and hibiscus arrived on ships transporting enslaved Africans to the Carolinas and Georgia. Well adapted to their environments in central west African countries, these plants thrived in the comparable climate and soils of the Lowcountry. In her book *In the Shadow of Slavery: Africa's Botanical Legacy in the Atlantic World*, Carney notes,

> The first generations of Middle Passage survivors collectively accomplished something extraordinary. They adopted the subsistence staples of the Amerindians and instigated the cultivation of familiar African foods. With this fusion of crop traditions, they confronted chronic hunger and diversified the often monotonous diets imposed by slave holders. In doing so, slaves Africanized the food systems of the plantation societies of the Americas. Treasured dietary preferences and culinary practices have traveled with migrants for millennia and this is especially important for the enslaved who struggled to recreate their cultural identity under dehumanized conditions in a foreign place.[11]

Tasked to cook with entirely new foodstuffs for affluent families, enslaved Africans introduced and integrated tastes from their homeland. Considering the role of enslaved men

and women, John Egerton, in *Southern Food: At Home, on the Road, in History*, reflects, "The kitchen was one of the few places where their imagination and skill could have free rein and full expression, and there they often excelled."[12]

Many food preparation practices routinely used by Native Americans, Europeans, and Africans demonstrate surprisingly analogous techniques, including stewing grains, animal protein, and vegetables in a single pot; roasting meats over fire (grilling) or baking in ashes, underground pits, or clay ovens; steaming a mixture of ingredients in leaves; and deep fat frying. Frying—among the fastest methods for preparing a meal—was quickly adopted throughout the South. Fat rendered from the ample number of feral and domesticated Spanish pigs was plentiful and widely available. As culinary historian and journalist Jessica B. Harris explains in her book *High On the Hog*, "The cooking of the slave yard inadvertently allowed the enslaved to maintain an African tradition of one-pot meals sopped with starches and stews of leafy greens seasoned with smoked or pickled ingredients."[13] Actually, serving stews of cooked meats or vegetables, or a combination, with or over a starch base is a tradition with global distribution.

These culturally overlapping procedures used to transform raw ingredients into traditional dishes contribute to but do not fully explain the trajectory of early southern cookery. What is distinctive about the southern diet is the unprecedented number and rapid availability of globally sourced ingredients prepared with newly intermingled cultural influences. "As with landforms and vegetation," geographer Carl Sauer explains in *Carl Sauer on Culture and Landscape*, "the cultural content of an area is an accretion and synthesis by different and non-recurrent historical events and processes of people, skills and institutions that are changing assemblages in accommodation and interdependence. Few human groups have lived in isolation, excluding persons and ideas from outside; the more they have done so the less have they progressed."[14]

As with migrants through the ages, newcomers to the Lowcountry endeavored to reproduce familiar tastes and beloved dishes from their homelands even when they were forced to modify or adapt to wholly new plant and animal foodstuffs, foreign cooking equipment, and dissimilar fuel sources. The interplay of old and new elements from multiple continents created a vibrant culinary kaleidoscope in the South. Lowcountry foodways emerged from the integration of several cultures, globally sourced ingredients, and distinctive cooking techniques with wide-ranging ideas of what constitutes dinner. Culinary influences from Native Americans, Europeans, and Africans advanced the art of stewing by combining locally harvested shrimp and game, tomatoes, peppers, and corn indigenous to South America, and European pork and onions with African okra, peas, and rice to produce dishes such as hoppin' John, limpin' Susan, pilau, gumbo, Frogmore, Brunswick stew, and Lowcountry boil. The flexibility of these recipes sanctioned resourceful meal preparation by allowing substitution of preferred ingredients for available ones. Farmers, fishers, and hunters realize there is no guarantee that skills and expertise can overcome misfortune or poorly calculated variations in nature. In these traditional southern recipes, as in stewpots around the globe, humans are legendarily opportunistic eaters. This early impact of fusion cooking resulted in a cosmopolitan interpretation that laid the groundwork for a new cuisine. Over time, these flavor profiles evolved and transformed modest ingredients into refined southern fare.

Indeed, Harris points out that "the culinary histories of the New World and African cooking as it is today are so intermingled that it is almost impossible to separate them."[15] The transcontinental exchange of foodstuffs between the Americas, Europe, and Africa can get complicated as we trace origins of plant and animal species, routes of dispersal, and dates of introduction. Peanuts, for example, originated in an area that is the modern-day intersection of Paraguay, Bolivia, and Brazil.[16] They were transported by Spanish

and Portuguese explorers to Europe and Africa and were incorporated into African cooking so long ago that they are routinely considered a traditional ingredient of West African recipes. Peanuts traveled back across the Atlantic Ocean with the slave trade, arriving in Georgia many decades after their culinary adoption in Africa.

Lowcountry culinary heritage was largely passed down orally and experientially through generations. Literacy was limited for many of the early settlers, and immigrants from non-English-speaking countries struggled with the new language. However, a few private journals documenting cookery practices and household management appeared in the English colonies. *A Colonial Plantation Cookbook, The Receipt Book of Harriott Pinckney Horry*, 1770, and *The Carolina Housewife*, published anonymously in 1847, were written by and for wives in affluent English households.[17] These receipt books, as they were known, were more representative of the fare relished by the wealthiest residents and do not reflect what the general population consumed.

Lower- and middle-class immigrants to America tried to maintain their familiar, though less sophisticated, English cookery in the midst of a different climate, strange flora and fauna, and often primitive living conditions. Without written recipes and with ingredients wildly fluctuating both in quantity and quality, tasting became more important than precise measuring. In the colonial South, the unpredictable availability of foodstuffs, the use of less desirable or unfamiliar parts of animals and plants, and the challenge of inconstant temperatures from cooking over fire challenged all cooks. These variables combined to create numerous seasonal variations and local solutions. Meal preparation required an intimate knowledge of ingredients in addition to culinary expertise. Recognizing this critical foundation for southern recipe development, Karen Hess writes in *The Carolina Rice Kitchen* that "the classic pilau is not so much a receipt as a culinary concept, one infinitely adaptable to featuring various ingredients."[18]

Sarah Jones, Wormsloe, Savannah, Georgia, 1739

Savannah in the late 1730s offers a unique window for exploring the ageless bond of nature and culture through the lens of foodways. Newly arriving colonists were committed to transforming coastal environments into European concepts of civilized landscapes. By narrowing the historical focus, we can concentrate on the development of Lowcountry foodways through the experiences of real people in a well-documented place. Through this window we can preview the progress of a still-evolving cultural food system inspired by waves of immigrants interacting with the coastal environment. Southern identity is more complicated than items on a menu, more complex than names of places or people, more convoluted than any list of past events. It is an enduring process where culture is tightly woven with regional ecosystems and international influences. These forces—culture, ecosystem, and external influences—coalesce to determine who eats what, where it comes from, and who provides food for whom.

The following interpretation of Sarah Jones is derived from numerous colonial documents woven together to represent the many challenges colonists endured in the early development of the colony.

> We boarded the fine ship Anne, and set sail November 1732, headed west across an endless ocean following the dying sun. Many onboard ship were of full of high hopes of a prosperous life ahead. We were promised what we could not have in England—our own land. We were assured a year of food and necessities to build a home. After two months at sea, we landed near the mouth of a large river and anchored at a high bluff to build a new life in a place we were told had only mild seasons and abundant fertile soils.

> Very soon we realized we had settled in a place where food plants don't flourish, livestock withers and disease routinely devastates our populace. We discovered obstinate

forests where we needed the protection of houses and fertile fields for crops, fierce summer heat, freezing-wet winters, rain storms, ferocious gnats, and mosquitoes which bite desperately, menacing alligators, devious wolves, and fearsome snakes. One dead, the other indentured stole our meager supply and ran off. Noble is working day and night with Oglethorpe. I am alone to feed the children. Each day brings no relief. Against all hope, we are forced to endless heavy labor or starve.

While these are not the exact words of Sarah Jones, the sentiment of hardship is well documented.[19] As one of the original inhabitants of the fledgling British colony, Sarah Jones lived under difficult circumstances and died with the consequences. Uprooted from a more predictable and sheltered life in urban England, she arrived with a deeply embedded belief system forged from her British upbringing. To improve their situation in life, she emigrated to the New World with her husband, Noble Jones, son, Noble Wimberly, and daughter, Mary. Sarah left England for what was promised to be an easier, more secure life with ample resources to raise a family. What she discovered was more problematic than she could have imagined, as her worldview, which was limited to a built English landscape, left her ill-equipped to consider herself within or as part of nature in the wild, especially in a wholly foreign environment. The colonists' preconceived visions of idealized agricultural prosperity were formed before they left England. They arrived ready to superimpose their ideology onto the new territory. Like other colonists, she labored to replicate an ancestral landscape, diet, and lifestyle with scant resources. Sarah's ensconced beliefs hindered her ability to adjust to the reality of her new environment.

Few English colonists arrived with adequate knowledge or actual experience of farming.[20] In the New World, they struggled with unfamiliar variables and constraints, including a radically different climate, poor soils, diseases new to their experience, odd flora and fauna, and other difficulties as they tried to replicate eating practices of their homeland. Agricultural practices developed through millennia of farming in Europe were only marginally successful in a wholly different environment. Relatively reliable crop yields in England resulted from centuries of adjustments to feudal-peasant land allocation, adequate manure for crops, intensely planted plots of vegetable varieties hand-selected for generations to thrive in specific locations, dependable distribution systems for harvests, and reliable trade relationships.

Agricultural practices from the old country were thwarted by environmental realities of their new homeland. Plows, for example, designed to create orderly, parallel rows for efficient sowing in long-established fields, were essentially useless in areas of abundant masses of interwoven palmettos and tree roots and sandy soil. Additionally, the common English garden hoe, relatively unchanged for centuries, was a uniquely efficient weeding tool when applied to regularly spaced rows planted in straight lines, but not in the less organized gardens dictated by the coastal flora. To make matters worse, the porous, low-nutrient soils and lack of adequate manure undermined the concept of permanent land occupation while farming in the same fields (albeit with periodic fallow years). Beloved varieties of vegetables and grains productive on European farms and common in kitchens of the ruling class and peasants alike were the result of millennia of seed selection for attributes such as yield, storage capacity, sweetness, and simplicity of harvesting in Anglo-European cultures, but not in America's Coastal Plain. (David Shields expands on the story of heirloom grains and vegetables in chapter 13.)

Environmental pressures from wildlife, weeds, disease, bugs, and adverse weather conditions can routinely diminish agricultural yields anytime. Indeed, any one of these pressures can eliminate entire crops. Colonists in the Coastal Plain fenced their garden plots to discourage damage from wildlife and roaming livestock and worked all year to control weeds by hand. The most consequential threat to farming, however, was low soil fertility, a

condition pervasive throughout the Lowcountry. Soil is truly the substructure of our food supply. While some foods today can be produced in manufactured space such as a greenhouse or high tunnel, there is no substitute for agricultural fields harboring natural, healthy soil ecosystems. Grains, the indispensable staple for human diets, and livestock require extensive acreage, which is not economically feasible in an indoor setting. Ecologically productive, sustainable soils are the bedrock supporting cuisines worldwide and the cultures they nourish. Corn, rice, and to a lesser extent wheat were cultivated in the Carolina and Georgia colonies and remain foundational components of our diet in cornbread, grits, rice dishes, and biscuits.

There is simply no replacement for healthy soils. Farming customs such as manuring, rotating crops, intercropping, fallowing, and composting have been practiced for thousands of years.[21] Even so, the appreciable labor required to implement these soil stewardship activities often motivated farmers to leave the degraded fields and migrate to unspoiled land. But this was an option only when there was accessible, unoccupied fertile land available. For centuries, English gentry who owned large holdings assigned tracts to peasant farmers, who had little choice but to labor to amend soil fertility, in part by confining livestock to fenced paddocks. This practice concentrated manure in a limited space and made the collection and field application of this soil amendment routine and manageable; the animal manure provided a rich source of nitrogen, a leading requirement for crop production. Farmers also incorporated nitrogen into farm fields by planting cover crops of legumes, such as beans, peas, and clover, in a planned rotation. Legumes, and the symbiotic bacteria associated with their roots, integrated and transformed atmospheric nitrogen into a form that could be assimilated by plants. Cover crops and field rotation with periodic fallow periods sustainably supported fertility in English farm fields for centuries, but what had worked in the homeland did not translate well in the new environment. The challenge of getting these familiar methods to work in the sandy soils of the coastal southeast in America proved daunting.

Amplifying soil nutrient deficiencies was a deficit of labor. While land appeared limitless in the frontier Lowcountry, the labor required to clear its forests and build fences was acutely limited. English pastures produced higher quality fodder for livestock at a manageable scale; the sparsely settled Coastal Plain offered access to more expansive terrains for grazing, and thus more human labor was needed. Throughout the Lowcountry, livestock were allowed to range freely across large expanses of land to forage adequate amounts of native grasses and herbaceous plants, making collection of the manure impractical. Limited availability of animal waste products was a shared and ongoing concern of the colonists in the Lowcountry. Coastal soils were, and still are, notoriously lacking in organic matter and therefore exhibited limited capacity to retain moisture and nutrients. The colonists experimented with locally available amendments such as marsh mud and dried marsh cordgrass stems (wrack), but the salt content proved too high. Insufficient levels of soil nutrients, particularly nitrogen, persisted in coastal farm fields. (Lawrence Morris and Julia Holly Campbell describe Wormsloe's soils in chapter 5.)

Noble and Sarah Jones may not have anticipated the vast amount of physical labor required to transform the coastal environments of old-growth forests and swamps into a landscape of farm fields, but they quickly learned firsthand about the perpetual labor required to keep those fields productive. Noble and Sarah paid attention to the fertility of their soil and understood the importance of maintaining this irreplaceable resource. Noble Jones was one of many coastal farmers who documented their purchases of guano (sea bird excreta) from Peru, which contained significant amounts of nitrogen, replacing the deficient nutrient in the agricultural fields at Wormsloe. A century later, Edmund Ruffin, a geological surveyor of South Carolina who is often referred to as the father of American soil science, recognized that abundant rainfall in the Lowcountry resulted

in the leaching of calcium from the soils, imposing acidity. He concluded that agricultural productivity in the Lowcountry was limited by two factors, noting that "only acidity and infertility held them back."[22] In 1832 Ruffin published his *Essay on Calcareous Manures*, which focused on the endless challenges of managing soil fertility in the Coastal Plain.[23] Ruffin's research became widely known and was implemented by farm owners across the South.

Of course, farmers deal with challenges in food production around the globe, not just in the Coastal Plain. Yet we often fail to notice when agricultural activities generate pervasive environmental problems. Agriculture has degraded more land worldwide than any other human activity, at a pace that accelerated following the invention of the plow. In the last century, a succession of technological advancements that first appeared to have enabled us to vanquish many agricultural challenges have simply exchanged the simple problems with more complex and lasting ones. For example, advances in agriculture that focus on replacing parts of a healthy ecosystem with chemicals or fossil fuel–based solutions is problematic.[24] Manuring is too labor intensive, so we substitute chemical fertilizers that degrade soil health. Plowing can also degrade soil health and increase rates of erosion; even so, we advanced from human to animal labor and ultimately to tractors that till and harvest under the direction of computers and satellites. While we completely rely on agriculture for all of our meals, we still don't know how to farm in the same place without significant inputs from outside sources. This is the fundamental challenge for agriculture. As Wes Jackson, cofounder of the nonprofit research organization the Land Institute, writes in his book *New Roots for Agriculture*, "Agriculture has been given every chance to prove itself as a viable experiment for continuously sustaining a large standing crop of humans. Its failure to do so is difficult to comprehend because since Jamestown, each decade, if not each year, we North Americans have harvested more and more food. In spite of all our scientific and technological cleverness of

recent decades, not one significant breakthrough has been advanced for a truly sustainable agriculture that is at once healthful and sufficiently compelling to be employed by a stable population, let alone an exploding one."[25] We need to learn how to farm as if our lives depend on it.

Historical Food Choices and Heirloom Seeds

The entire experiment of farming in the Lowcountry proved a formidable challenge, with radically different soil conditions that required new methods of farming and gardening and a large expanse of land that needed much more labor than expected. Therefore, early residents of the Coastal Plain began a rich and varied investigation in vegetable production for their own consumption.

One example is the cabbage. Most likely, cabbage originated in the eastern Mediterranean and Asia Minor, but the original wild plant has been transformed through seed selection and cultivation practices by countless generations of farmers across the globe. In his 2013 book *Soul Food: The Surprising Story of an American Cuisine*, Adrian Miller writes,

> Believe it or not, cooking greens with pork is old-school European cooking. We do know that the Romans, as early as 2,000 years ago, were making greens pretty soulfully, boiling them with a piece of pork. The Roman poet Ovid includes a story in his epic *Metamorphoses* (8 C.E.) about Baucis and Philemon that makes mention of greens. The poor peasant couple was visited by two traveling strangers and didn't think twice about inviting them in, heading out to the garden, stripping some collard greens, pulling down some smoked pork ("a chine of bacon") from the fireplace, and boiling it all in a pot of water until ready to eat.[26]

Cabbage was transported to the British Isles by the conquering Romans and cultivated by the Celts in Europe for at least three millennia. English farmers were instrumental in developing the appearance and traits we recognize in a head of cabbage. They selected traits for reliable and

prodigious production in English soils: tolerance for cold, wet conditions; resistance to regional pests and pathogens; and suitability for long storage. They preferred sweet, or at least less bitter, leaves and plants with leaves that formed a tight head.

Cabbage was one of the first food plants introduced to North America from Europe. Good storage capacity, shipping capability, and high vitamin C content were advantageous traits for fresh produce on ocean voyages before British sailors supplemented their diets with exotic limes. European explorer Jacques Cartier introduced cabbages to the New World when he sailed to Canada in 1541. Because it provided much longer storage and a more convenient form for shipping, British market growers preferred cabbage over the closely related, nonheading "coleworts" (today's collards). Europeans with a deep-rooted history of cabbage landed in Charleston (1670) and later Savannah (1733) with seeds to produce many varieties of *Brassica oleracea*. This species includes collards, cabbage, broccoli, cauliflower, Brussels sprouts, kohlrabi, and some varieties of kale. It turned out that collards were highly suited to thrive in the southern landscape; thus, they emerged as a beloved staple in Lowcountry cuisine from the start.

Simmering various ingredients together in one pot turned out to be a beneficial way to cook foodstuffs that were harvested in unpredictable volumes and at unpredictable times. This became an almost universal practice in the Lowcountry. A single pot also provided a vessel for the uneaten remains that could be kept warm or reheated, which for generations was one of the few options for the storage of cooked food. One-pot cooking with the inclusion of green leaves is historically ubiquitous in Native American, European, and African traditions (as well as in many other parts of the world). Native Americans would likely have selected from a variety of chenopods, such as white goosefoot (*Chenopodium album*).

Native culinary greens in West Africa include dozens of varieties such as amaranth. Enslaved Africans intent on upholding familiar foodways substituted collards and other locally available greens to best replicate traditional dishes of their homeland. Callaloo, for example, has connections to food traditions from many African cultures and is remarkably adaptable. Largely associated with Caribbean cooking, callaloo is a stew-like soup that features locally available greens, although the species of greens can differ historically and within the region. In the Lowcountry, collards are sometimes used as the greens in callaloo. Collards are hardy and easy to grow and are remarkably tolerant of both flooding and drought; they can grow in poor soils and, with the exception of caterpillars, are relatively resistant to most of the pests and pathogens that damage other vegetables. Collards thrive all winter in the Lowcountry when wild greens are scarce, and remarkably each plant can continue to produce edible greens for two or three years.

A Changing Climate

New challenges present themselves in the production of food, both in the Lowcountry and across the globe. In the short term, climate change in our time will result in overall, but uneven, worldwide warming trends, punctuated with periods of unusually cold temperatures.[27] Changes in the climate promote more frequent and intense extreme-weather events of all types. Global effects include rapid fluctuations in temperature and precipitation patterns that progressively increase threats to the global food supply. Increased variability and unpredictability are initial consequences of a changing climate—while industrial agriculture and the related distribution supply chains prosper with invariable and predictable conditions. Worldwide, climate change will significantly affect food availability and accessibility. Regions of the world unable to produce the nutritional needs to support the area's population—including the Lowcountry, which currently relies on global supply chains for most groceries—will suffer first and be hit the hardest. With food production and distribution

threatened by increasingly erratic and unstable conditions, we must support and increase the number of regional and community farms.

Another consequence of a changing climate is the worldwide loss of biodiversity. We are quickly losing our open-pollinated heirloom varieties of plants and traditional animal food sources, which are both nutritious and a vital part of our culture and history. While hybridized plants can be beneficial for large-scale production, these plants often lose some of their food value, and in the process, we lose the stories of our ancestors who farmed. We lose shared knowledge of traditional wisdom, dietary ties to religious practices, and our connection to the environment that supports us and all life around us. The biodiversity of wild and open-pollinated plants is critical to ensure that genetic resources are available to develop future needs for crop improvement and adaptation programs. The 2019 UNESCO food and agriculture biodiversity assessment recognized that humans have cultivated more than six thousand species of plants for food, yet only 9 percent of these species account for 66 percent of total crop production today. Seventy-five percent of the world's food is generated from only twelve plants and five animal species. The Food and Agriculture Organization (FAO) of the United Nations also estimates that 75 percent of crop diversity was lost between 1900 and 2000.[28]

A study highlighted in the FAO's *Second Report on the State of the World's Plant Genetic Resources for Food and Agriculture* predicts that as much as 22 percent of the wild relatives of important food crops of peanuts, potatoes, and beans will disappear by 2055 because of a changing climate.[29]

Food production is also becoming increasingly challenged by mounting threats from the loss of pollinators worldwide, as well as habitat destruction fueled by shifts in land use related to population growth and human migration. In a world of increasing changes through every part of our biosphere, traditional plant breeding and associated scientific research are essential to meet the ongoing challenges of producing food. Collecting and conserving open-pollinated seeds to safeguard plant genetic diversity for future needs are critical. With the demise of each variety of food plant, we lose our historically rich biodiversity. In *Heirloom Seeds and Their Keepers*, Virginia D. Nazarea documents the importance of gardeners and farmers cultivating heirloom seeds and how this practice safeguards the biodiversity of our food. She writes, "In the past, ritual, seasonality, and commensality in foodways and lifeways contained, but at the same time reinforced, variability, flux, and idiosyncrasy. To a certain extent, this seeming contradiction continues to fuel biodiversity conservation but more so at the margins of market-driven production systems."[30]

While few of us in America farm today, if we look back just a few generations, most of our ancestors were farmers or ranchers producing most or all of their food. But innovations in mechanical technology and the rapid development of inexpensive chemical fertilizers and pesticides fueled escalating economies of scale, resulting in a significant increase of acres for the average farm, accompanied by a decline in the number of farms. The current structure of our agricultural system incentivizes industrial-scale operations that dominate the production and distribution of agricultural commodities. In 1935, there were 6.8 million farms in the United States. By 2022, that number had decreased to two million.[31] Of the four million people counted in the first U.S. census, in 1790, 90 percent lived on farms.[32] By 1870, only half of all U.S. workers listed farming as their occupation—-a number that had dropped to 30 percent by 1940 and to less than 3 percent by 1981.[33] In 2023, the Economic Research Service of the U.S. Department of Agriculture identified a meager 1.3 percent of the employed labor force as farmworkers.[34]

What happens when the vast majority of us disengage from involvement in the most indispensable occupation on earth—the cultivation of food? Potentially we lose food

sovereignty, the fundamental ability to generate food for our families and communities. When we lose our local farms and family gardens, we sanction an industrialized food commodity system to control our access to food. We give up delicious varieties and textures in our foods as industrial agricultural production prioritizes cultivars exhibiting uniform size and shape, durability for long-haul shipping, and maturity timed for mechanical harvesting.

Sarah Jones's eighteenth-century priorities for plant selection would favor reliable productivity, lengthy harvesting periods, prolonged storage even in compromised conditions, and, certainly, traditionally cherished flavor and texture. The countless lessons Sarah Jones learned in her gardens at Wormsloe, from soil preparation to heritage seed selection, improved her ability to feed her family. Since the arrival of the early European colonists in the Lowcountry, numerous generations of farmers, through trial and error as well as collaborative research, have generated an unprecedented level of agricultural understanding. What remains unchanged is the critical question: If we are not part of the population who are farmers, to whom do we want to give control of supplying our daily food?

In summary, the Lowcountry's multiple cultures—Native Americans, Western Europeans, and Africans alike—supplied life-giving, culturally important seeds. A robust tradition of seed selection, saving, and sharing greatly increased rates of survival for all. This convergence of biodiversity from three continents increased the likelihood that enough adequately adaptable crops could be cultivated to sustain growing populations. Beyond sustenance, we know foods connect us to our histories, traditions, and culture. Expanding our understanding of Lowcountry foodways necessitates a wide range of voices. At Wormsloe today, we actively involve farmers, ranchers, seafood harvesters, and chefs. Their perspectives are highlighted throughout this work. These professionals embody specific areas of expertise in food production, procurement, and processing. Although individuals have gravitated toward honing

specialized skills for generations, we are now seeing a resurgence of coordinated, forward-thinking analysis that brings these experts together. Today, highly engaged food producers and chefs consult with one another to select varieties with specific taste profiles and consistently efficient production and delivery, as well as practices for sustainable, local harvests. Sarah Jones and other colonial home managers witnessed the benefit of merging these skills, saving and cultivating the finest seeds to produce the best food possible for her family.

Knowledge Is Power

Agricultural challenges have always kept pace with expansion in gardening and farming. Floods, droughts, powerful winds, hurricanes, and other severe storm events, snow and ice, insect assaults, and the spread of disease from pests (which can include birds, mammals, insects, and other invertebrates) are pervasive disrupters. Vulnerabilities from soil-borne organisms as well as fungal, bacterial, and viral diseases are ever present. Unpredictable and uncontrollable assaults on crops can ruin entire harvests. History has recorded countless food shortages across the globe. Agricultural conditions today favor open-pollinated varieties providing biodiversity that can best withstand numerous challenges in an ever-changing environment. Heirloom and newly developed cultivars of open-pollinated seeds need to be grown by as many people as possible and shared widely. Food security is more likely when food production is implemented at multiple levels—in our backyard, community, region, and nation, as well as globally—and using both artificial and natural methods.

If we relegate our food security solely to an industrial agricultural complex, we are at risk from accelerating disruptions in the complicated supply chain. An inadequate food supply from England was a life-and-death matter for the early colonists in the Lowcountry. Sarah Jones's efforts

to feed her family were heroic and demonstrate there is much we can learn about self-sufficiency and malleability from the early settlers. For generations before Europeans landed in the New World, Native Americans practiced wild harvesting, hunting, and farming methods refined through trial and error. They shared these life-saving skills with colonists in the Lowcountry. Enslaved Africans brought experience herding cattle and cultivating rice and a tradition of distinctive culinary techniques. In the following chapters we consider relationships between the environment, food production, and vital multicultural contributions.

Does it matter if we know where our eggs come from? Yes. Knowledge truly is power, and it is especially powerful to understand the relationship between healthy, evolving ecosystems and the source of our food. Knowledge elevates a reply to questions regarding complex food systems from "room service" to a response based on expertise and understanding. If we think of the Lowcountry and places such as Wormsloe where traditions have lived for hundreds of years and if we consider the rich diversity of this knowledge and the people who share it, Lowcountry foodways can serve as an enriching and life-saving body of knowledge—a callaloo of the human experience.

NOTES

1. Jean Anthelme Brillat-Savarin, *The Physiology of Taste* (New York: Vintage Books, 1949), 15.

2. Jo Handelsman, *A World without Soil* (New Haven: Yale University Press, 2021); Food and Agriculture Organization of the United Nations (FAO), *Healthy Soils Are the Basis for Healthy Food Production* (Rome, Italy: FAO, 2015).

3. Charles Seabrook, *The World of the Salt Marsh* (Athens: University of Georgia Press, 2012).

4. Kristen Gremillion, *Ancestral Appetites* (Tuscaloosa: University of Alabama Press, 1997).

5. Alfred W. Crosby Jr., *The Columbian Exchange* (Westport, Conn.: Greenwood Press, 2003).

6. Michael W. Twitty, *The Cooking Gene* (New York: Harper Collins, 2017).

7. Reay Tannahill, *Food in History* (New York: Three Rivers Press, 1988); Lizzie Collingham, *The Taste of Empire* (New York: Basic Books, 2017); James E. McWilliams, *A Revolution in Eating* (New York: Columbia University Press, 2005); Bruce Kraig, *A Rich and Fertile Land* (London: Reaktion, 2017).

8. Judith Carney, *Black Rice: The African Origins of Rice Cultivation* (Cambridge, Mass.: Harvard University Press, 2001), 117.

9. William M. Kelso, *Captain Jones's Wormslow: A Historical, Archaeological, and Architectural Study of an Eighteenth-Century Plantation Site near Savannah, Georgia* (Athens: University of Georgia Press, 1979).

10. Drew A. Swanson, *Remaking Wormsloe Plantation: The Environmental History of a Lowcountry Landscape* (Athens: University of Georgia Press, 2012).

11. Judith A. Carney and Richard Nicholas Rosomoff, *In the Shadow of Slavery: Africa's Botanical Legacy in the Atlantic World* (Berkeley: University of California Press, 2009), 2.

12. John Egerton, *Southern Food: At Home, on the Road, in History* (New York: Alfred A. Knopf, 1987), 15.

13. Jessica B. Harris, *High on the Hog* (New York: Bloomsbury, 2011), 100.

14. William Denevan, ed., *Carl Sauer on Culture and Landscape* (Baton Rouge: Louisiana State University Press, 2009), 303.

15. Jessica B. Harris, *Iron Pots and Wooden Spoons* (New York: Atheneum, 1989), xiii.

16. Andrew F. Smith, *Peanuts: The Illustrious History of the Goober Pea* (Urbana: University of Illinois Press, 2002).

17. Harriott Pinckney Horry, *A Colonial Plantation Cookbook: The Receipt Book of Harriott Pinckney Horry, 1770*, ed. Richard J. Hooker (Columbia: University of South Carolina Press, 1984); Sarah Rutledge, *The Carolina Housewife* (Columbia: University of South Carolina Press, 1979), a facsimile of the 1847 edition. Sarah Rutledge was not officially recognized as the author of this work until the twentieth century, when it became acceptable for a woman's name to appear in print in Charleston in a context other than notices of birth, marriage, or death.

18. Karen Hess, *The Carolina Rice Kitchen: The African Connection* (Columbia: University of South Carolina Press, 1992), 37.

19. Amalgamation of understanding derived from E. Merton Coulter, *Wormsloe: Two Centuries of a Georgia Family* (Athens: University of Georgia Press, 1955); Kenneth Coleman, *Colonial Georgia: A History* (New York: Scribner's Sons, 1976); Pat. Tailfer, with comments by

the Earl of Egmont, *A True and Historical Narrative of the Colony of Georgia* (Athens: University of Georgia Press, 1960); Anne Sinkler Whaley LeClercq, *An Antebellum Plantation Household* (Columbia: University of South Carolina Press, 1996); John T. Schlotterbeck, *Daily Life in the Colonial South* (Athens: University of Georgia Press, 2020); Betty Wood, *Women's Work, Men's Work* (Athens: University of Georgia Press, 1995); Harvey Jackson and Phinizy Spalding, *Forty Years of Diversity: Essays on Colonial Georgia* (Athens: University of Georgia Press, 1984); Walter J. Fraser Jr., *Savannah in the Old South* (Athens: University of Georgia Press, 2003); Sarah B. Gober Temple and Kenneth Coleman, *Georgia Journeys: Being an Account of the Lives of Georgia's Original Settlers and Many Other Early Settlers from the Founding of the Colony in 1732 until the Institution of Royal Government in 1754* (Athens: University of Georgia Press, 1961); synthesis of findings composed by Sarah V. Ross, 2020.

20. Temple and Coleman, *Georgia Journeys*.

21. David R. Montgomery, *Dirt: The Erosion of Civilizations* (Berkeley: University of California Press, 2008).

22. William Matthew, *Agriculture, Geology, and Society in Antebellum South Carolina: The Private Diary of Edmund Ruffin, 1843* (Athens: University of Georgia Press, 2012).

23. Edmund Ruffin, *Essay on Calcareous Manures* (Charleston, S.C., 1832).

24. Charles C. Mann, *The Wizard and the Prophet: Two Remarkable Scientists and Their Dueling Visions to Shape Tomorrow's World* (New York: Alfred A. Knopf, 2018).

25. Wes Jackson, *New Roots for Agriculture* (Lincoln: University of Nebraska Press, 1980), 3.

26. Adrian Miller, *Soul Food: The Surprising Story of an American Cuisine* (Chapel Hill: University of North Carolina Press, 2013), 147.

27. Intergovernmental Panel on Climate Change, *Climate Change 2021: The Physical Science Basis; Contribution of Working Group 1 to the Sixth Assessment Report of the Intergovernmental Panel on Climate Change* (Cambridge: Cambridge University Press, forthcoming).

28. J. Bélanger and D. Pilling, eds., *The State of the World's Biodiversity for Food and Agriculture* (Rome, Italy: FAO Commission on Genetic Resources for Food and Agriculture, 2019), https://www.fao.org/documents/card/en/c/ca3129en.

29. Food and Agriculture Organization of the United Nations Commission on Genetic Resources for Food and Agriculture, *Second Report on the State of the World's Plant Genetic Resources for Food and Agriculture* (Rome, Italy: FAO Commission on Genetic Resources for Food and Agriculture, 2010), 9.

30. Virginia D. Nazarea, *Heirloom Seeds and Their Keepers: Marginality and Memory in the Conservation of Biological Diversity* (Tucson: University of Arizona Press, 2005), 7.

31. "The Number of U.S. Farms Continues Slow Decline," U.S. Department of Agriculture Economic Research Service, last updated March 14, 2023, https://www.ers.usda.gov/data-products/chart-gallery/gallery/chart-detail/?chartId=58268#:~:text=In%20the%20most%20recent%20survey,million%20acres%20ten%20years%20earlier.

32. "History of Agricultural Statistics," United States Department of Agriculture National Agricultural Statistics Service, last modified May 4, 2018, https://www.nass.usda.gov/About_NASS/History_of_Ag_Statistics/index.php#farm.

33. See Patricia A. Daly, "Agricultural Employment: Has the Decline Ended?," *Monthly Labor Review* 104, no. 11 (November 1981), 11–17.

34. "How Many Jobs in America Are Related to Agriculture?," FAQs, U.S. Department of Agriculture Economic Research Service, last updated June 1, 2023, https://www.ers.usda.gov/faqs/#Q15.

The Weather and Climate of Wormsloe and Surrounding Lowcountry

PAM KNOX, director of the UGA Weather Network; **JOHN A. KNOX**, professor of geography at the University of Georgia; **EMILY PAULINE**, climate risk analyst at the Climate Service, Morrisville, North Carolina; **CHARLES SCARBOROUGH**, air quality data scientist at Sonoma Technology, Petaluma, California; and **HALEY STUCKEY**, meteorologist for the National Weather Service, Kentucky

In 1732, men and women were ingeniously enticed to leave England for a foreign shore on assurances of land and exaggerated promises of four seasons of "desireable" climate. These first English colonists anticipated and planned for a mild climate where they could cultivate crops such as olive oil, citrus, and wine grapes. When they disembarked in Savannah they found themselves in a region with recurring periods of cold well below freezing in the winter and prolonged summers with high humidity and temperatures well over 90°F. The weather proved too humid and hot for wine grapes and episodically too cold for citrus and olive trees. Insect pests and diseases thrived in the warm, humid region. Climate, in large part, dashed the expectations of how and what foods they could grow, which devastated their customary and cherished English diet. Weather-related crop failures severely limited their anticipated incomes. Weather continuously imposed day-to-day hardships as well as episodic and catastrophic storm events throughout the Lowcountry.

Still today, weather events heightened by a changing climate can reduce or eliminate crop yields, which increasingly threaten the stability of our food systems. This team of climatologists reviews the past and present climate of the coastal counties with a focus on Wormsloe in Savannah, Georgia. Historical accounts reveal a range of weather events in the early days of the Georgia colony. This chapter juxtaposes the historical context and range of temperature, precipitation, and weather types and discusses how those conditions are likely to change in the future. 🪶

Wormsloe Plantation was founded in 1735 by Noble Jones as an outpost against potential Spanish invaders along a water approach to Savannah, but from its early years it was also a working plantation.[1] As with any farm, the life and work of those who resided there were intimately tied to the weather and climate of the land. Weather controlled the daily activities of the residents and plantation workers, from the frosts that damaged crops in winter to the sultry days of summer before the sea breeze and associated thunderstorms brought cooler air to the plantation in late afternoon.[2] Climate controlled how residents built their houses and what crops they grew. Wormsloe's location—just eight miles from the Atlantic Ocean, across a vast swath of salt marshes bounded by a string of barrier islands—meant

FIGURE 2.1. Satellite view of Wormsloe Historic Site location from Google Maps.

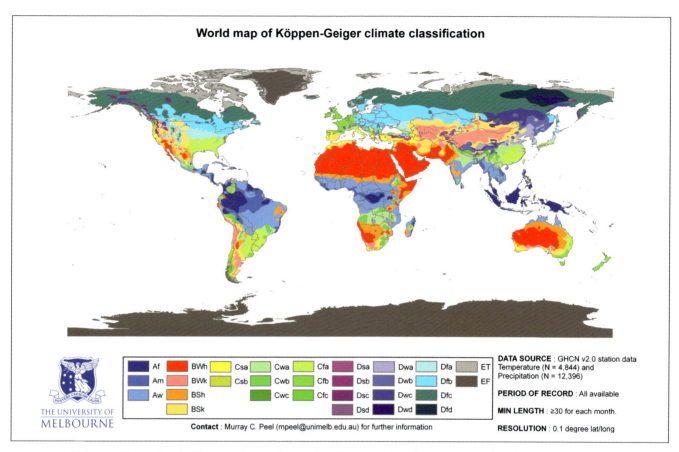

FIGURE 2.2. This map illustrating the Köppen-Geiger climate classification shows that Georgia is classified as Cfa (humid subtropical—hot), while the England the colonists left behind is considered Cfc (humid subtropical—cool). M. C. Peel, B. L. Finlayson, and T. A. McMahon, "Updated World Map of the Köppen-Geiger Climate Classification," *Hydrology and Earth System Sciences* 11 (2007), Wikimedia Commons, https://commons.wikimedia.org/w/index.php?curid=47086879.

that it was within reach of both dangerous Atlantic storms and strong cold winds that swept down in the winter from the interior of North America.

The early colonists of Wormsloe Plantation came from England, a climate that is considered humid subtropical—cool (Cfc) in the Köppen-Geiger climate classification system. The climate of Wormsloe, by comparison, is humid subtropical—hot (Cfa). The difference between these two climate subtypes is most pronounced in summer. But even in the winter, Wormsloe's position in the southeast corner of a large continent means that cold air masses can sweep in from the north and west—-a situation that has no parallel in England, which is located on a small island.[3] In their correspondence the colonists noted the warmer and more humid conditions, but they were also surprised that the weather could quickly become much colder. "Yet these

heats, violent as they are," Governor Henry Ellis wrote in one letter, "would be tolerable, but for the sudden changes that succeed them. On the 10th of December last the mercury was at 86; on the 11th it was so low as 38 of the same instrument. What havoc must this make with an European constitution?"[4]

Because of the warmer conditions, the early colonists assumed that crops such as citrus could thrive in the region, but they later discovered that the occasional freezing blasts from the northwest killed off many of the more tropical species, forcing them to reconsider what they could grow.[5]

In this chapter we describe the present climate at Wormsloe Plantation, look at the historical extremes of temperature, precipitation, and weather types there, place those observations in historical context, and briefly discuss how those conditions are likely to change in the future.

Present-Day Averages

Dearest Augusta: Summer has encompassed us. We awake only at intervals long enough to take necessary nourishment cooled to the right degree or to move our limbs languidly in tepid salt water. . . . Affectionately, Pauline.

—Undated letter

As a whole, Savannah has a very warm and humid climate. The summers are usually hot, with a large majority of the days when the average temperature reaches 90°F or higher occurring within these months. Winters could probably best be classified as mild. The average maximum temperature in the summer—June, July, and August—is approximately 91°F.[6] In winter—December, January, and February—the average maximum temperature is 62.4°F. Below-freezing days are much less common than hot afternoons. On average, there are twenty-four days a year when the temperature drops to 32°F or below, compared to an average of seventy-six days when it reaches 90°F or higher. Most of the freezing days are concentrated in the December through February period. If we look at the year as a whole, the average maximum temperature is 77.4°F and the average minimum temperature is 56.1°F, with an annual average temperature of 66.8°F. These averages are based on the 1981–2010 normal temperatures at the Savannah International Airport; as we will see later in the chapter, late twentieth- and early twenty-first-century averages are somewhat warmer than the conditions experienced by Wormsloe residents in previous centuries.[7]

Savannah has a fairly wet climate, and due to its geographic location and the fact that the temperatures are usually above freezing, most of the precipitation in Savannah predictably falls as rain. On average, Savannah picks up around forty-eight inches of precipitation a year. Summer is the wettest season, with nearly 40 percent of the annual total falling in June, July, and August. The driest season is winter, with an average precipitation total of only 9.43 inches. August is the single wettest month, with a total of 6.56 inches of rain on average. November is the driest month, at 2.37 inches on average. These average totals are also calculated from data collected at the Savannah airport in the years 1981–2010.[8]

With the average maximum temperature in the sixties during the winter, the Savannah area is much too mild to allow for much snowfall. Most years see no snow at all along the southeast Georgia coast. Savannah residents see just 0.2 inches of snow in an average December and 0.1 inches in February, for a grand total of 0.3 inches annually. However, the averages do not describe individual events.

Savannah's mild climate makes for a long growing season. The average number of days from the last spring frost at 32°F to the first fall frost at the same temperature is 259, although from one year to the next the span can range from 230 to 290 days. This long growing season allows for the cultivation of a great variety of crops, and double-cropping of combinations of different agricultural commodities can be done with little difficulty in the long seasons.

Extremes

TEMPERATURE

The extreme cold [in February 1899] did immense damage to crops and caused untold suffering. Traffic was seriously interrupted and many cattle perished. Reports from several hundred correspondents show that the peach crop was totally killed in many sections, and more or less damaged in all sections of the State.[9]

Historical records for the Wormsloe and Savannah area contain very few mentions of heat waves. In the summer of 1758, local resident and future colony governor Henry Ellis wrote that "in a thermometer hanging by me . . . the mercury stands at 102. Twice it has risen this summer to the same height, viz, on the 28th of June, and the 11th of July." He also noted that the temperature had reached 100°F degrees several times that summer, when the normal range of summertime high temperatures was between 84 and 90°F, leading him to conclude that "this is reckoned an extraordinary hot summer."[10] During the period from 1937 to 2012, the highest daily reported temperature was 105°F on June 24, 1944.[11]

Cold snaps presented a greater risk to area residents than heat waves, as many were farmers. Dr. William R. Waring, a prominent Savannah physician, wrote of a cold spring in 1836 that prevented the growth of important crops. He claimed that "our climate has become so much northern that . . . our vegetables [have] also. We can't of late raise orange trees, and even the fig has become precarious."[12] The *Thomasville Times-Enterprise* described another cold weather event that occurred on March 25, 1894, in which a cold rain fell all day and into the night. The result was "thin crusts of ice . . . formed on water in exposed places and fruit trees and vegetation of all kinds. . . . We fear they have all been ruined."[13] On February 18, 1899, the *Times-Enterprise* reported temperatures of 2°F and blizzard conditions that destroyed peach crops that had begun to grow.[14] In the twentieth century, the lowest daily temperature recorded was 3°F on January 12, 1985.[15]

SUMMER PRECIPITATION

> My Dear Miss Crisfield, Your note of September 23rd has just reached me, delayed in forwarding I imagine by the floods in Georgia, which left us marooned at Goshen with no Mail for several days.
>
> —Harriet A. J. Speer, October 4, 1929

During the first week of October 1929, the Savannah River flooded a large portion of Chatham County, closing many roads and damaging crops.[16] The *Springfield Herald* reported, "Crops in this section [have] suffered to some extent, with cotton suffering most. The farmers are busy salvaging what they can from the fields that was unpicked before the flood waters arrived."[17] This is one of many flood events that led to catastrophic results for farmers in the Savannah region. During the period from 1937 to 2012, the highest daily precipitation total in the Savannah area was 9.79 inches on October 19, 1944.[18]

Although the economy in the Wormsloe area was heavily based on agriculture, local historical records reveal a surprising lack of documentation of droughts. One of the few mentions is in a May 1881 letter between members of the De Renne family: "We have had a long drought and the dust is terrible but the weather is pleasant."[19]

Another drought occurred during the latter months of 1918 and continued into 1919. Thomasville's *Daily Times Enterprise* reported on January 23, 1919, that special prices on feed for livestock to "the drought ridden south" would be extended to March 1, implying that conditions in the region were too dry to produce any kind of plant and farmers were struggling financially.[20]

WINTER PRECIPITATION

> My dear Wymberley . . . We have had a heavy rainstorm, and it is a little cooler. Perhaps we shall have a taste of winter after all. —Mother.
>
> —February 3, 1880, letter

In Savannah, almost any occasion when there is some measurable frozen precipitation on the ground can be considered

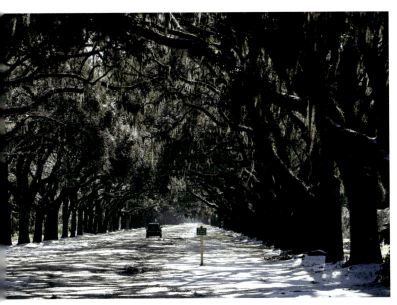

FIGURE 2.3. Entrance to Wormsloe on January 4, 2018. Photo by Joe Raedle / Getty Images.

an extreme winter event.[21] The climate doesn't support frequent bouts of wintry weather. Almost any amount of snow or ice can have a huge impact on the area, especially since emergency management services do not have as many resources or as much experience with such weather as places that see winter precipitation more often.

A major ice storm on January 25, 1922, left behind damage to plants and trees. "The severe sleet storm at Savannah on January 25 [1922] was very destructive," wrote one weather observer. "On that date the streets were covered with ice, and icicles were hanging from the eaves of buildings, from telegraph and telephone poles, wires, etc. The damage to trees and shrubs was greater than ever before experienced, and was a positive calamity to the city."[22]

Memorable snow events are a little more common, with at least ten recorded days with total accumulation of one inch or greater. Three of these events saw total snow accumulation above three inches: February 8, 1968 (3.6 inches);

February 10, 1973 (3.2 inches); and December 23, 1989 (also 3.2 inches). The highest annual snowfall total ever recorded in Savannah was 4.6 inches in 1989, with two days seeing totals above one inch.

HURRICANES

> The City of Savannah was swept last night by one of the most terrible storms it has ever known. The storm had been predicted for several days and started early yesterday afternoon. The climax was reached about 12 o'clock last night, having blown for eight hours. Hardly a house in the city has escaped damage. The wharves along the river front were inundated and Hutchinsons island was flooded. A number of warves floated away. It is thought that the storm attained a velocity of 80 miles per hour. . . . The rice planters will suffer more heavily perhaps than anyone else. The crop in the vicinity of Savannah is ruined.
>
> —*Waycross Herald*, September 2, 1893

As an eastern coastal city, Savannah is no stranger to extreme tropical weather. Hurricanes have passed close to the city many times in the past several centuries.[23] The extreme wind from these storms causes an immense amount of damage, but the major killer is the storm surge flooding. Official records did not start being kept until 1851; prior to that, one of the earlier recorded hurricanes to affect the area occurred in 1700 and is known as the Rising Sun Hurricane. This storm was responsible for the deaths of over one hundred people, produced considerable storm surge flooding, and damaged a number of ships—including the *Rising Sun*, which gave the storm its nickname.

Two powerful nineteenth-century hurricanes made landfall in the vicinity of Savannah. The Great Carolina Hurricane is estimated to have been a Category 3 storm on the modern Saffir-Simpson scale when it made landfall near Savannah on September 8, 1854. Winds of ninety miles per hour (mph) were recorded in the city, which, along with the storm surge, caused considerable damage. The hugely destructive Great Sea Islands Hurricane made landfall as a Category 3 storm south of Savannah on August 27, 1893. The storm hit around high tide, causing

FIGURE 2.4. Daily weather map of September 4, 1979, when Hurricane David was about to make landfall in Georgia. The concentric lines are isobars, connecting locations of equal sea-level pressure. NOAA Daily Weather Maps Weekly Series, September 3–9, 1979.

FIGURE 2.5. Fort Pulaski is flooded by storm surge after Hurricane Matthew in 2016. Curtis Compton / *Atlanta Journal-Constitution* via Associated Press.

a significant storm surge of about sixteen feet. The storm surge was responsible for most of the over two thousand fatalities associated with this storm, while the winds of around 115 mph were also damaging.

Since 1900, hurricane landfalls near Wormsloe have been much less frequent than earlier in the record. Hurricane David came onshore just south of the area in September 1979, and numerous other tropical storms have skirted the area, providing some winds, rising sea levels, and copious rain. Within recent memory, Hurricane Matthew made a significant impact along the coast in 2016. This storm, like many others, produced damaging storm surge flooding along the coast, so much so that it set a record at Fort Pulaski.

OTHER SEVERE WEATHER

Sometimes the thunder-gusts are attended with whirlwinds, which occasion great havoc; as may be seen in that woody country, Georgia; where in many places, tops of trees for a considerable distance have been twisted off.

—Anthony Stokes, "A Description of the Climate and Weather of Georgia from Observations Made during a Period Including the Years 1771–1781"

Thunderstorms are commonplace in coastal Georgia, given the warm, moist air that is often present and the accompanying triggers of sea breezes and frontal activity. According to World Meteorological Organization data for 1961–1990, Savannah is one of the top twenty cities for thunderstorms in the United States, with a little over sixty "thunderstorm days" per year.[24] The severe weather season in Savannah, according to a climatology map from

NOAA's Storm Prediction Center, generally begins in mid-March and ends by early September, with a peak in mid- to late June.[25] Lightning is the primary threat, because of not only the frequency of thunderstorms but also the many outdoor activities in coastal Georgia—such as farming, in Wormsloe's heyday, and boating, fishing, and recreation today. Tornadoes are very rare but not unheard of. A tornado on May 23, 2017, that was rated an EF2 on the Enhanced Fujita tornado intensity scale touched down just east of Wormsloe on Wilmington Island, hit the Fort Pulaski National Monument on Cockspur Island and caused $400,000 in damage, and then killed three people aboard a shrimping boat just northeast of Tybee Island.[26]

Historical Trends in Climate

> Our Climate is various and uncertain, to such an extraordinary Degree, that I fear not to affirm, there are no people on Earth, who, I think, can suffer greater extreames of Heat and Cold; it is happy for us that they are not of long duration.
>
> —Governor James Glen

Weather observations in Savannah and surrounding areas began informally shortly after the colony was established. The first individual known to keep a local weather diary was Johann Martin Bolzius, a minister to colonists from Salzburg, Austria, who migrated to the area in 1734.[27] Dr. Cadwallader Evans of Philadelphia used some of the earliest records from nearby Charleston to look for a relationship between yellow fever outbreaks and summer temperatures in the region.[28]

In the early 1800s, army surgeons at military installations in the area, such as Fort Jackson and Oglethorpe Barracks, also took observations several times a day, although few of those records survive. In the mid-1800s, records were kept by a number of private observers who reported to the Smithsonian Institute in Washington, D.C. Since 1895, the Weather Bureau (now known as the National Weather Service) has kept records for stations around the country;

these observations are archived at the National Centers for Environmental Information (NCEI).

Since 1895, the average temperature of Chatham County has risen and fallen both from year to year and over longer time periods. The year-to-year variability is due to changes in weather patterns across the United States that can also be linked to global variations in atmospheric and oceanic circulation, such as the El Niño–Southern Oscillation, that are known to affect the weather of the Southeast. The longer-term rises and falls of temperature are likely due to both long-term variations in global ocean circulation and the increase in carbon dioxide, a "greenhouse gas" that is warming temperatures globally. The rise in temperatures in Georgia has been slower than in the United States and over the earth as a whole, but it shows similar patterns, especially in the period from 1960 to the present. Nighttime

	The mean heat of June at 3 P.M.	The mean heat of July at 3 P.M.	Average of the two Months at 3 P.M.	REMARKS Note--Yellow fever years are set down with red ink—(Underlined)
1793	79.7	84.3	82.	Great Yellow fever here—4,000 died
1794	75.6	80.4	78.	No alarm in Philadelphia
1795	75.	82.4	78.6	No alarm here—fever in New York and Norfolk.
1796	76.5	81.5	79.	August was 80.3—No alarm here.
1797	79.	84.2	81.6	Yellow fever here—About 1,200 died
1798	77.	82.	79.5	August was 86.5. Very bad fever—about 3,500 died
1799	77.	84.	80.5	About 1,000 died
1800	75.	78.	76.5	No alarm here.
1801	76.	80.	78.	August was 77°—No alarm here.
1802	75.7	78.	76.3	August was 78°—A very little fever.
1803	76.9	81.8	79.3	Fever here but not bad.
1804	71.	78.	74.5	No alarm here.
1805	75.	83.	79.	August was 81° bad fever.
1806	78.1	78.7	78.4	August was 72.1°—No alarm here.
1807	71.6	77.9	74.7	No alarm here.
1808	75.5	78.8	77.1	No alarm here.
1809	73.7 say	75. say	74.3	

from 1st to 20th July 1809
Average at 3 P. M. is 74.

5. Chapin, *loc. cit.*, 481.

FIGURE 2.6. Transcription of an analysis of outbreaks of yellow fever compared with average summer afternoon temperatures. The Library Company of Philadelphia.

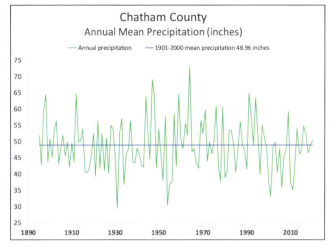

FIGURE 2.7. Annual average temperature for Chatham County, Georgia, from 1895 to 2017. Produced from the NOAA "Climate at a Glance" tool, https://www.ncdc.noaa.gov/cag/county /time-series/, by Pam Knox.

FIGURE 2.8. Annual total precipitation for Chatham County, Georgia, from 1895 to 2017. Produced from the NOAA "Climate at a Glance" tool, https://www.ncdc.noaa.gov/cag/county /time-series/, by Pam Knox.

temperatures are increasing faster than daytime ones, due in part to increases in humidity and urbanization, both of which keep temperatures warmer at night.

Annual precipitation for Chatham County displays a lot of variability from year to year but shows little long-term trend over the entire period of record. This is generally true of Georgia and the Southeast as a whole. Precipitation has decreased slightly from 1960 to the present, and this has contributed to more frequent droughts in Georgia in the last two decades as the temperature has warmed.

Tree-ring evidence allows us to look a little further back in time. Tree rings serve as a proxy for temperature and precipitation records by marking the patterns of annual tree growth, with wide rings representing good growing conditions and narrow rings representing poor growth due to drought or other stressors. The September Palmer Drought Severity Index (PDSI) derived from tree ring analysis near Wormsloe shows that drought in the area (negative values of the PDSI) was more common in the mid-1800s than for most of the twentieth century.[29]

Climate Change and Wormsloe

> In Savannah winter is so chequered, a warmth like an English summer, is all at once succeeded by a smart frost.
>
> —Anthony Stokes, "A Description of the Climate and Weather of Georgia from Observations Made during a Period Including the Years 1771–1781"

FUTURE CHANGES IN TEMPERATURE

An increase in temperature due to a warming climate is one of the most critical aspects of climate change science. Temperature shifts due to climate change do not occur uniformly over the globe. To understand the future climate of the Wormsloe Plantation, we must focus on projected climate change in Georgia and in the city of Savannah.

Temperatures are projected to increase over the next century in the southeastern United States. Since 1970, the average annual temperature has increased by about 2°F.[30] Temperatures in inland areas are projected to increase more than in coastal areas. One study under three different greenhouse gas "emission scenarios" showed that the mean (average) temperature in Savannah is projected to increase steadily throughout the twenty-first century. The increase in average temperature means there will be more days during summer months over 90°F, and more consecutive days over 90°F.[31] More high-temperature days will have serious consequences for public health, agriculture, infrastructure, and utilities. For example, one study projects that higher temperatures will cause heat stress for dairy cows and livestock and decrease their productivity. The same study shows that temperature increases in Savannah will be more pronounced during the summer months than in the winter, although the winter months will experience fewer consecutive freezing days (with temperatures less than or equal to 32°F).[32]

FUTURE CHANGES IN PRECIPITATION

Due to Savannah's location in the southeastern United States, predicting future precipitation patterns can be difficult. The climate in the Southeast is under the influence of large-scale atmospheric forces that vary annually. Nevertheless, climate models predict increases in the intensity of precipitation in the Southeast but show little to no increase in total annual precipitation.[33] In other words, the models predict that as the climate continues to warm, the Southeast will see more heavy downpours that account for a larger share of the total annual precipitation. A separate study using a higher-resolution model predicts that the trend in precipitation for the Southeast will apply to the city of Savannah as well. There is already observational evidence that precipitation in Georgia has become more intense; fewer and heavier precipitation events account for the total annual precipitation.[34] Projections indicate that

the trend of more heavy precipitation events in Savannah will continue into the twenty-first century.[35]

FUTURE CHANGES IN EXTREME WEATHER

Extreme weather events can be devastating to a coastal town such as Savannah. Many consecutive days of extremely warm temperatures will cause heat stress for Savannah's residents and utilities. More heavy precipitation events can overload existing infrastructure and lead to flooding. Drought is dependent on temperature and precipitation, among other factors, and summer droughts in Georgia are projected to worsen throughout the twenty-first century. As a consequence, the risk of wildfires is also projected to increase throughout the century.[36]

Evidence shows that since the early 1980s, there have been more Category 4 and 5 hurricanes in the Atlantic basin than in the previous century. Climate models predict that as the oceans continue to warm, there may be fewer tropical storms, but they will be more powerful. Storm surge is one of the strongest effects of tropical storms.[37] As the sea level near Savannah increases, the risk of storm surge and coastal flooding increases.

SEA-LEVEL RISE

Sea-level rise and ground subsidence threaten coastal communities, including Savannah and its surrounding area.[38] Sea-level rise will erode shorelines, increase the risk of flooding and catastrophic storm surge, and threaten ecosystems. According to the Environmental Protection Agency (EPA), global sea level has risen by about nine inches since 1880; sea level at Fort Pulaski, which is near Savannah, has risen by about seven inches since 1960.[39] Although Georgia is at a lower risk for sea-level rise than Florida and Louisiana, Savannah and other coastal cities in Georgia will have to adapt to rising sea levels.[40]

As the oceans continue to warm and sea level rises, Wormsloe Plantation will also be threatened. How much sea will rise depends on factors such as subsidence and offshore

currents.[41] Sea-level rise exacerbates present and future issues. Areas within Wormsloe that are prone to flooding will be at a greater risk as the sea level continues to rise.

IMPACTS ON AGRICULTURE

As the climate of Georgia and of the earth as a whole changes in response to increases in greenhouse gas emissions, agriculture is one of the major economic activities to be affected. Changes in both daytime and nighttime temperatures will affect crop and livestock production. Variability in the timing and intensity of rain will affect the water balance that the crops depend on. Changes in the frequency and strength of severe storms such as hurricanes will also cause huge impacts on local farm production as such storms can decimate whole crops and even entire farms.

Increasing temperatures cause several impacts on agriculture. Rising daytime maximum temperatures will lead to increased heat stress, which will hurt both outdoor workers and livestock. For example, if temperatures get too warm, cattle stop eating and then fail to gain weight. They also produce less milk, and their fertility decreases.[42] This is especially true when overnight temperatures remain warm, since there will be no cooling-off period for recovery. Recent studies show that minimum temperatures are rising much more quickly than maximum temperatures.[43] This appears to be due mainly to increases in humidity and cloud cover as evaporation from the ocean increases in a warmer world, although in some areas, urbanization may also be a factor.[44]

Changes in precipitation affect agriculture by disrupting the water cycle that controls crop growth. While the annual average precipitation in Georgia has not changed over the past one hundred years (as seen in figure 2.8), the rain is falling in different patterns. Rainfalls tend to be more intense and drop more water in a given time period, which can lead to flooding and more erosion in agricultural fields, reducing crop yields and stressing plants.[45] While individual storms produce more rain, there are longer dry spells between the storms, leading to increases in plant stress and drought, both of which decrease yields and, in the worst cases, destroy crops. Some models predict more precipitation in Georgia; even so, evaporation from water surfaces and evapotranspiration from plants are expected to cause a net decrease in available water.[46] Thus both droughts and floods are likely to increase in the future, leading to more hardship for farmers.

Increasing temperatures also lengthen the growing season. While coastal Georgia does not experience many frosts now, they will become even rarer over time. The last spring frost will occur earlier in the year, and the first frost of fall will come later, resulting in more frost-free days in the growing season.[47] This will allow farmers to grow crops that are suited to a warmer climate and may lead to the reestablishment of crops such as citrus that were pushed south out of the area by frosts in the twentieth century. Other crops such as olives and pomegranates have been introduced to Georgia to take advantage of warming conditions and a favorable market. Longer growing seasons will also mean more opportunities for double-cropping, where two different crops can be grown on one field in a single year. But the longer growing season also means that diseases and insect pests have a longer time period to attack the crops, reducing their yields. This could also affect human health since some of those pests, such as mosquitoes, can carry harmful diseases that can sicken coastal residents.

A fourth way that climate change can affect agriculture in Georgia is by changes to extreme weather. While there has not been any apparent increase in the number of tornadoes over time, scientists do not yet know whether warmer temperatures and changes to the global weather patterns that are related to those temperatures will make severe weather more likely. Recent research has shown, however, that hurricanes and tropical storms are likely to be affected. Warming sea surface temperatures are expected to increase the intensity of storms, and sudden strengthening could occur near the coast where the Gulf Stream flows

north just offshore. Hurricanes also appear to be slowing down as they approach land. This is leading to more flood events, such as those we have seen in the twenty-first century with Hurricanes Matthew and Florence. The volume of rainwater from these storms, which often falls over a wide area, causes huge disruptions in production, storage, and transportation of produce and livestock, potentially leading to huge losses by the agricultural industry. Even if the number of storms does not go up (a question that scientists are still studying, although some studies indicate that increases are occurring), the impacts of each one are likely to be larger and more costly to agriculture as well as to housing, transportation, and coastal infrastructure as the resulting high volume of rainwater drains into coastal estuaries and the ocean.[48]

Climate change is already affecting agriculture, the environment, and many other aspects of society in the lands surrounding Wormsloe. These effects are likely to get worse and cause more severe impacts in the future as warmer temperatures and a more extreme water cycle create climatological disruption in the region.

NOTES

1. Drew A. Swanson, "Wormsloe's Belly: The History of a Southern Plantation through Food," *Southern Cultures* 15, no. 4 (2009): 50–66. The epigraph for this section is from Robert Horne, *A Brief Description of the Province of Carolina on the Coasts of Floreda* [sic] (London, 1666), in *Historical Collections of South Carolina*, ed. B. R. Carroll (New York: Harper and Brothers, 1836), 2:13, as quoted in R. C. Aldredge, "Weather Observers and Observations at Charleston, South Carolina, 1670–1871" (master's thesis, College of Charleston, 1936), accessed online via National Centers for Environmental Information scans of microfilms.

2. Andrew David Crouch, "A Climatology of the Sea Breeze Front in the Coastal Carolinas and Georgia" (master's thesis, North Carolina State University, 2006), https://repository.lib.ncsu.edu/bitstream /handle/1840.16/217/etd.pdf?sequence=1&isAllowed=y.

3. Köppen Climate Classification, Hans Chen's website, January 11, 2023, http://hanschen.org/koppen/.

4. Governor Henry Ellis, July 1758 letter (published in *Savannah Morning News* in 1932), quoted in Gary K. Grice, *History of Weather Observations, Savannah, Georgia, 1734–1950* (report prepared for the Midwestern Regional Climate Center, National Climatic Data Center), 2005, 4, https://repository.library.noaa.gov/view/noaa/1225/noaa_1225_DS1.pdf?.

5. Swanson, "Wormsloe's Belly."

6. "Monthly Climate Totals (1981–2010)—SAVANNAH INT'L AIRPORT," accessed July 24, 2018, https://xmacis.rcc-acis.org/. The epigraph for this section is from Pauline to Augusta [De Renne], undated letter, 1925, George Wymberley Jones De Renne family papers, Hargrett Special Collections Library, ms 1064, box 22, folder 6.

7. Savannah Intl Ap, Georgia (097847), Period of Record Monthly Climate Summary, January 1, 1948, to June 10, 2016, Western Regional Climate Center, https://wrcc.dri.edu/cgi-bin/cliMAIN.pl?ga7847.

8. U.S. Climate Normals Quick Access, National Centers for Environmental Information, National Oceanic and Atmospheric Administration, https://www.ncei.noaa.gov/access/us-climate-normals /#dataset=normals-monthly&timeframe=81&location=GA&station =USW00003822.

9. Climatological Data for Georgia, February 1899.

10. Grice, *History of Weather Observations*.

11. Savannah Intl Ap, Georgia (097847), Western Regional Climate Center.

12. "Cold Snap," *Thomasville Times-Enterprise*, March 31, 1894, Georgia Historic Newspapers, https://gahistoricnewspapers.galileo.usg .edu/lccn/sn88054089/1894-03-31/ed-1/seq-1/#date1=03/31/1894 -text=&date2=03/31/1894#words=&searchType=advanced&sequence =0&index=3°ion=south&proxdistance=5&rows=12&ortext= &proxtest=&andtext=&page=1.

13. "The Cold Snap," *Thomasville Times-Enterprise*, March 31, 1894.

14. "Zero Weather," *Thomasville Times-Enterprise*, February 18, 1899, Georgia Historic Newspapers, https://gahistoricnewspapers.galileo .usg.edu/lccn/sn88054089/1899-02-18/ed-1/seq-1/#date1=02/18 /1899text=&date2=02/18/1899&words=&searchType=advanced &sequence=0&index=1&proxdistance=5&rows=12&ortext =&proxtext=&andtext=&page=3.

15. Savannah Intl Ap, Georgia (097847), Western Regional Climate Center.

16. Susan Exley, "The Meetings of Effingham's Two Rivers in the 1920s," *Effingham Herald*, October 28, 2010, http://www .effinghamherald.net/archives/12073/. The epigraph for this section is from the Wymberley Wormsloe De Renne papers, Hargrett Special Collections Library, ms 1788, box 10.

17. *Springfield Herald*, October 7, 1929.

18. Savannah Intl Ap, Georgia (097847), Western Regional Climate Center.

19. Letter to Wymberley, May 12, 1881, George Wymberley Jones De Renne family papers, Hargrett Special Collections Library, ms 1064, box 14, folder 10.

20. "Special Railroad Rates Have Been Extended," *Thomasville Daily Times Enterprise*, January 23, 1919, Georgia Historic Newspapers, https://gahistoricnewspapers.galileo.usg.edu/lccn/sn88054087/1919-01-23/ed-1/seq-1/#date1=01/23/1919-text=&date2=01/23/1919&words=&searchType=advanced&sequence=0&index=9*ion=south&proxdistance=5&rows=12&ortext=&proxtext=&andtext=&page=2.

21. The epigraph for this section is from George Wymberley Jones De Renne family papers, Hargrett Special Collections Library, ms 1064, box 14, folder 10.

22. Climatological Data for Georgia, January 1922.

23. U.S. Department of Commerce, and NOAA, "Tropical Cyclone History for Southeast South Carolina and Northern Portions of Southeast Georgia," National Weather Service, May 9, 2018, https://www.weather.gov/chs/Tchistory.

24. Brian Donegan, "The Most Lightning-Prone Cities in the U.S.," Weather Channel, July 1, 2016, https://weather.com/science/weather-explainers/news/cities-most-prone-to-lightning.

25. "Any Severe Probabilities: 22 April (1982–2011)," Storm Prediction Center, https://www.spc.noaa.gov/new/SVRclimo/climo.php?parm=anySvr.

26. Alan W. Black, John A. Knox, Jared A. Rackley, and Nicholas S. Grondin, "Tornado Debris from the 23 May 2017 'Tybee Tornado,'" *Bulletin of the American Meteorological Society* 100, no. 2 (2018), DOI:10.1175/BAMS-D-17-0176.1.

27. Gary K. Grice, *History of Weather Observations*. The epigraph for this section is quoted from Horne, *Brief Description of the Province*.

28. Aldredge, "Weather Observers and Observations."

29. K. C. Parker, C. Jensen, and A. J. Parker, "The Growth Response of Slash Pine (*Pinus elliottii*) to Climate in the Georgia Coastal Plain," *Dendrochronologia* 32, no. 2 (2014), 127–136. Additional tree ring chronologies going back to 400 CE can be found at the North American Drought Atlas at http://iridl.ldeo.columbia.edu/SOURCES/.LDEO/.TRL/.NADA2004/.pdsi-atlas.html.

30. "Climate Impacts in the Southeast," U.S. Environmental Protection Agency, https://19january2017snapshot.epa.gov/climate-impacts/climate-impacts-southeast_.html.

31. John Patrick O'Har and Michael Meyer, "Climate Change Risks and Adaptation Strategies in Chatham County/Savannah" (presentation for the Savannah Metropolitan Planning Commission, April 2, 2013), https://www.thempc.org/docs/lit/CoreMpo/Data/CCPresentationII.pdf.

32. "Climate Impacts in the Southeast."

33. Lynne Carter and James Jones, "Southeast and the Caribbean," *Climate Change Impacts in the United States*, National Climate Assessment, U.S. Global Change Research Program, https://nca2014.globalchange.gov/report/regions/southeast.

34. Climate Central, June 17, 2015, http://www.climatecentral.org/gallery/maps/summer-precipitation-trends1.

35. O'Har and Meyer, "Climate Change Risks."

36. Climate Central, http://statesatrisk.org/georgia/all.

37. Carter and Jones, "Southeast and the Caribbean."

38. Carter and Jones.

39. "Exhibit 3: Relative Sea Level Change along U.S. Coast, 1960–2020," Sea Level, U.S. Environmental Protection Agency, https://cfpub.epa.gov/roe/indicator.cfm?i=87#3.

40. Climate Central, http://statesatrisk.org/georgia/all.

41. "Climate Impacts in the Southeast."

42. Larry E. Chase, "Climate Change Impacts on Dairy Cattle," uploaded September 16, 2014, https://www.researchgate.net/profile/Larry-Chase/publication/253292665_Climate_Change_Impacts_on_Dairy_Cattle/links/54179b670cf2f48c74a40doc/Climate-Change-Impacts-on-Dairy-Cattle.pdf.

43. This can be demonstrated using the NOAA "Climate at a Glance" tool available at https://www.ncdc.noaa.gov/cag/county/time-series/.

44. Dian J. Gaffen and Rebecca J. Ross, "Climatology and Trends of U.S. Surface Humidity and Temperature," *Journal of Climate* 12, no. 3 (March 1999): 811–828, https://doi.org/10.1175/1520-0442(1999)012<0811:CATOUS>2.0.CO;2.

45. Kenneth E. Kunkel, David R. Easterling, Kelly Redmond, and Kenneth Hubbard, "Temporal Variations of Extreme Precipitation Events in the United States: 1895–2000," *Geophysical Research Letters* 30, no. 17 (September 2003), https://doi.org/10.1029/2003GL018052.

46. J. A. Alexandrov and G. Hoogenboom, "Vulnerability and Adaptation Assessments of Agricultural Crops under Climate Change in the Southeastern USA," *Theoretical and Applied Climatology* 67 (2000), 45–63.

47. Kenneth E. Kunkel, David R. Easterling, Kenneth Hubbard, and Kelly Redmond, "Temporal Variations in Frost-Free Season in the United States: 1895–2020," *Geophysical Research Letters* 31, no. 3 (February 2004), https://doi.org/10.1029/2003GL018624.

48. P. J. Klotzbach, S. G. Bowen, R. Pielke Jr., and M. Bell, "Continental U.S. Hurricane Landfall Frequency and Associated Damage: Observations and Future Risks," *Bulletin of the American Meteorological Society* 99, no. 7 (2018): 1359–1376, https://doi.org/10.1175/BAMS-D-17-0184.1.

Lowcountry Geography Shapes the Food We Grow

MARGUERITE MADDEN, director of UGA Center for Geospatial Research and professor of geography; and **TOMMY JORDAN**, associate director emeritus of UGA Center for Geospatial Research

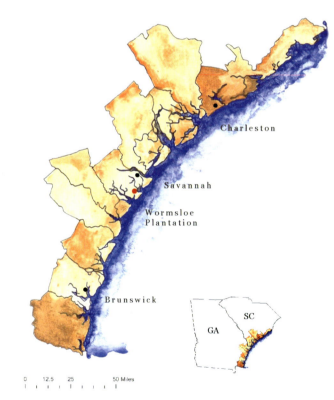

Food production presented the early colonists with a wide range of challenges. Here we consider the broadest view of the Lowcountry region through the study of geography. Geographers' investigations into multiple features of a region are layered to best describe the area and often reveal unsurpassed understandings of the landscape. Physical and cultural geographers collect data to create robust descriptions of how components interact to produce conditions for the food we cultivate, raise, hunt, fish, or wild harvest. Geographical attributes of the Lowcountry landscape are especially well suited for rice cultivation. Additionally, the Lowcountry's gently sloping coastal plain with freshwater rivers meeting the Atlantic Ocean forms an environment that generates an abundance of seafood.

Madden and Jordan use maps to explain how the physical geography of a landscape and the processes that shape the land change what we grow over time. These processes regulate and provide infrastructure for associated living systems that include humans and wildlife from freshwater rivers, saltwater marsh systems, and coastal forests. The authors follow the historical development of mapping tools from eighteenth-century surveyors to twenty-first-century three-dimensional digital images taken from drones. Examples of the geographical areas highlighted in this book provide illustrations of how geographers make maps today.

The Lowcountry of coastal South Carolina and Georgia is just as it sounds—low lying and flat. It is both a landscape and a culture, a geography and a cuisine. It is a southern state of mind with cooking traditions

steeped in the diversity of seafood pulled from the ocean, estuaries, rivers, and marshlands. Rice once grew in the flattest and wettest of Lowcountry fields, while rows of collard greens, okra, squash, and beans were tended in gardens on slightly higher ground. Wild game roamed the flatwoods and cypress forests following rivers that flowed with fresh water. These rivers moved eroded sediments from the upland Piedmont of the U.S. Southeast, through the Coastal Plain and into the Lowcountry before meeting the estuaries, tidal creeks, and coastal waters of the Atlantic Ocean.

The physical geography of a place includes the shape of the land and the distribution of features such as mountains and valleys, rivers, marshes, beaches, and coastlines. It involves the processes that create and change those features, as well as how the distribution of features in a landscape affects the people who live there.[1] The physical geography of the Lowcountry is shaped by its underlying geology, the type and depth of its soils, freshwater that flows through its rivers, and salt water that floods twice daily from the tides. The coastal climate is a driver of physical and biological processes that continuously shape the land and control the food we grow. Chapter 2 covered the climatic factors affecting the Lowcountry, and subsequent chapters will emphasize its geology and soils. This chapter focuses on the relationships between coastal foods and physical geography, along with historical and modern methods to map and visualize this "low and flat" terrain.

In their textbook *Exploring Physical Geography*, Stephen J. Reynolds and his coauthors list the following questions a geographer would ask when characterizing a landscape:

- Where is it?
- Why is it where it is?
- How did it get where it is?
- Why does it matter where it is?
- How does "where it is" influence where other things are, and why are they there?[2]

Geographers use maps to help answer these profound and fundamental spatial questions. They feel the need to draw, define, and describe a place before they can begin to understand it. Before the Lowcountry can be examined for ways the land shaped the food, the area must be mapped and measured. This chapter describes ways to do this, using sources ranging from early maps made by eighteenth-century surveyors to twenty-first-century, three-dimensional (3D) mapping from digital images taken by cameras on small drones. Armed with geographic data on land elevation and relief, maps of land use and land cover, records of historical land use legacies, and locations of rivers, roads, and cities, geographers can build databases that are stacks of layered information georeferenced to the same location on the earth's surface.

Computer programs called geographic information systems (GIS) pull all of the layers of information together and give geographers, planners, and coastal residents the

FIGURE 3.1. Layers of spatially registered data are input to geographic information system (GIS) software programs to make maps and ask spatial questions toward understanding the physical geography of a place.

superpower of spatial inquiry. No longer limited to asking questions of "what, how, and why," a GIS can show "what is where and why" in 3D space and time. For example, a GIS can be asked to show and measure the land area with just the right soils and hydrology to grow rice if dikes and water control structures were placed in the landscape. Maps can be created of creek banks receiving just the right tidal influence to support healthy oyster beds. Spatial analysis functions can identify the best habitat for wild hogs or turkeys. Modeling changes over time may divulge trends in coastal development that can be used for making predictions and plans for sustainable growth. This chapter describes some of the mapping technologies, visualization techniques, and computer analyses that can be used to study Lowcountry land, water, and food.

Maps of Lowcountry Physiographic Subdivisions and Ecoregions

The Lowcountry is generally accepted as a stretch of the U.S. Southeastern coast that is 322 kilometers (200 miles) long, beginning at a point slightly north of Georgetown, South Carolina, extending southward through Charleston, South Carolina, and Savannah, Georgia, and ending at Jacksonville, Florida. The width of the Lowcountry, however, is open to interpretation. How low is "low" and how flat is "flat"? In 1916, an American geologist, geographer, and teacher thought long and hard about the shape and form of land. Nevin M. Fenneman created a physiographic map of the United States that was adopted by the U.S. Geological Survey (USGS) and published in 1916 in the *Annals of the Association of American Geographers* (AAG), the journal of a professional society that still exists today.[3] Fenneman's "Physiographic Subdivision of the United States" shows a fairly reasonable boundary for the Lowcountry. Basing his map only on landforms and not on climate or vegetation, Fenneman distinguishes physiographic types classified by histories of the processes that created the landforms,

often due to differences in the nature or structure of the underlying geology. Within the Atlantic Plain Division and the Coastal Plain Province, coded no. 3, are six sections: Embayed (3a), Sea Island (3b), Floridian (3c), East Gulf Coastal Plain (3d), Mississippi Alluvial Plain (3e), and West Gulf Coastal Plain (3f). If we take a closer look at this map, Sea Island (3b) appears to best map the Lowcountry.

The U.S. Environmental Protection Agency (EPA) further refined the physiographic subdivisions of the United States as ecoregions that include not only landforms but also climatic factors. The EPA's ecoregion that equates most closely with the Lowcountry is the Sea Islands/Coastal Marsh (75j) Level 4 Ecoregion. This ecoregion consists of barrier islands, dunes, beaches, lagoons, estuaries, and tidal marshes with elevations ranging from sea level to 9.1 meters (30 feet), 127.0 to 132.1 centimeters (50 to 52 inches) of rain, 260 to 285 frost-free days per year, and temperatures ranging generally from 3.9 to 32.2°C (39 to 90°F). If we move inland about 10 kilometers (6.2 miles), the Sea Island Flatwoods (75f) Level 4 Ecoregion captures the southern mixed forest of the coastal flat plains, swamps, and slow-flowing rivers. Elevations here range about 1.5 to 6.1 meters (5 to 20 feet) in relief and extend from about 33.5 to 41.1 meters (110 to 135 feet) in elevation above sea level. Soils are sand, silt, and clay with 121.9 to 134.6 centimeters (48 to 53 inches) of rain annually, 240 to 260 frost-free days, and mean temperatures ranging from 3.3 to 16.7°C (38 to 62°F) in the winter and 21.1 to 33.3°C (70 to 92°F) in the summer. Figures 3.4a, 3.4b, and 3.4c display the EPA Level 4 ecoregions of Sea Islands/Coastal Marsh (75j) and Sea Island Flatwoods (75f) in pale shades of green for South Carolina, Georgia, and Florida.[4]

Outlines of physiographic subdivisions and ecoregions are fine, but what about the details of the rivers and tidal creeks, the coastlines and the form of the land? Erwin J. Raisz was an internationally renowned mapmaker (i.e., cartographer) who drew detailed landform maps by hand using pen, ink, and realistic symbols that look like the

FIGURE 3.2. "Physiographic Subdivision of the United States" by Nevin M. Fenneman, published in the *Annals of the Association of American Geographers* in 1916.

FIGURE 3.3. Enlargement of "Physiographic Subdivision of the United States" by Fenneman (1916), showing the Lowcountry generally defined by the 3b Section boundary of the Atlantic Plain and Coastal Plain physiographic boundaries.

a

b

FIGURE 3.4a, b, c. Level 4 ecoregions of South Carolina (a), Georgia (b), and Florida (c) approximately coinciding with the Lowcountry are Sea Island Flatwoods, labeled 75f and color coded medium pale green, and Sea Islands/Coastal Marsh, labeled 75j and color coded light pale green. Wikimedia Commons.

44

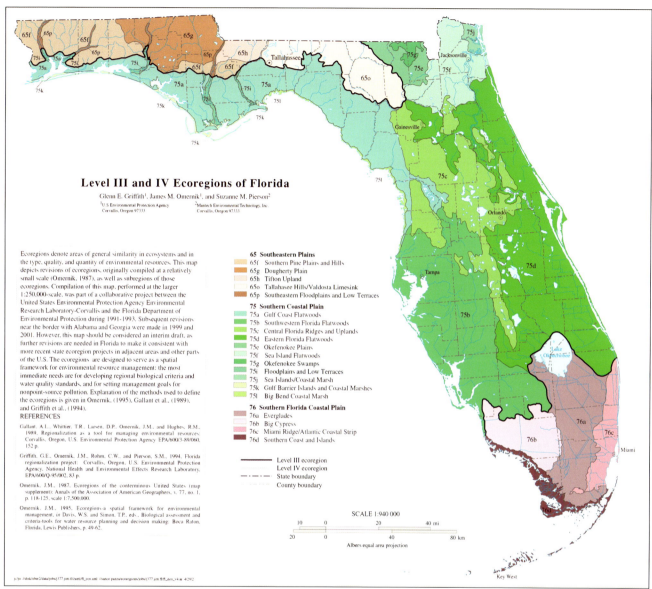

Level III and IV Ecoregions of Florida

Glenn E. Griffith[1], James M. Omernik[1], and Suzanne M. Pierson[2]

[1]U.S Environmental Protection Agency
Corvallis, Oregon 97333

[2]Mantech Environmental Technology, Inc.
Corvallis, Oregon 97333

Ecoregions denote areas of general similarity in ecosystems and in the type, quality, and quantity of environmental resources. This map depicts revisions of ecoregions, originally compiled at a relatively small scale (Omernik, 1987), as well as subregions of those ecoregions. Compilation of this map, performed at the larger 1:250,000-scale, was part of a collaborative project between the United States Environmental Protection Agency Environmental Research Laboratory-Corvallis and the Florida Department of Environmental Protection during 1991-1993. Subsequent revisions near the border with Alabama and Georgia were made in 1999 and 2001. However, this map should be considered an interim draft, as further revisions are needed in Florida to make it consistent with more recent state ecoregion projects in adjacent areas and other parts of the U.S. The ecoregions are designed to serve as a spatial framework for environmental resource management: the most immediate needs are for developing regional biological criteria and water quality standards, and for setting management goals for nonpoint-source pollution. Explanation of the methods used to define the ecoregions is given in Omernik, (1995), Gallant et al., (1989), and Griffith et al., (1994).

REFERENCES

Gallant, A.L., Whittier, T.R., Larsen, D.P., Omernik, J.M., and Hughes, R.M., 1989, Regionalization as a tool for managing environmental resources: Corvallis, Oregon, U.S. Environmental Protection Agency EPA/600/3-89/060, 152 p.

Griffith, G.E., Omernik, J.M., Rohm, C.W., and Pierson, S.M., 1994, Florida regionalization project: Corvallis, Oregon, U.S. Environmental Protection Agency, National Health and Environmental Effects Research Laboratory, EPA/600/Q-95/002, 83 p.

Omernik, J.M., 1987, Ecoregions of the conterminous United States (map supplement): Annals of the Association of American Geographers, v. 77, no. 1, p. 118-125, scale 1:7,500,000.

Omernik, J.M., 1995, Ecoregions-a spatial framework for environmental management, in Davis, W.S. and Simon, T.P., eds., Biological assessment and criteria-tools for water resource planning and decision making: Boca Raton, Florida, Lewis Publishers, p. 49-62.

65 Southeastern Plains

65f Southern Pine Plains and Hills
65g Dougherty Plain
65h Tifton Upland
65o Tallahasee Hills/Valdosta Limesink
65p Southeastern Floodplains and Low Terraces

75 Southern Coastal Plain

75a Gulf Coast Flatwoods
75b Southwestern Florida Flatwoods
75c Central Florida Ridges and Uplands
75d Eastern Florida Flatwoods
75e Okefenokee Plains
75f Sea Island Flatwoods
75g Okefenokee Swamps
75i Floodplains and Low Terraces
75j Sea Islands/Coastal Marsh
75k Gulf Barrier Islands and Coastal Marshes
75l Big Bend Coastal Marsh

76 Southern Florida Coastal Plain

76a Everglades
76b Big Cypress
76c Miami Ridge/Atlantic Coastal Strip
76d Southern Coast and Islands

——— Level III ecoregion
——— Level IV ecoregion
—·—·— State boundary
········· County boundary

SCALE 1:940 000

Albers equal area projection

c

45

landforms they are meant to represent.[5] In a 1931 publication, Raisz described his system of physiographic symbols for depicting relief as "appealing . . . immediately to the average man. It suggests actual country and enables him to see the land instead of reading an abstract location diagram. It works on the imagination."[6]

Basing his work on aerial photographs and observations in the field, Dr. Raisz produced over five thousand landform maps that are, in the words of a recent commentary, "beautiful renditions of the Earth's surface that are fascinating to ponder. These maps could never have been automatically generated by a computer software application but required the hand and sensibility of a human artist, convolved with the knowledge of a human geologist."[7] A subset of the Raisz landform map of the southeastern United States depicts a flat terrain dissected with rivers that flow from the Dahlonega Plateau, north of Atlanta, over the fall line at Columbus, Macon, and Augusta, and through

FIGURE 3.5. A subset of Erwin J. Raisz's 1931 landform relief map with focus on the area of the coastal Lowcountry. From Erwin J. Raisz, "The Physiographic Method of Representing Scenery on Maps," *Geographical Review* 21, no. 2 (1931).

the Louisville Plateau, Altamaha Upland, Upper Pine Belt, Lower Pine Belt, Low Terrace, and Phosphate Belt to the Atlantic Ocean. The details in just this small section can be further appreciated by viewing the broader context of the full map (https://ugapress.org/book/9780820362489/social-roots/).

Biogeography of the Lowcountry

Biogeographers study the interactions of the physical environment and the living organisms sustained by the available water, energy, and nutrients. They look at whole ecosystems from a broad perspective and constantly search for spatial and temporal patterns that will give clues about why plants and animals live where they do. The distribution and zonation of plant species in the Lowcountry, from the ocean to the uplands, tell a biogeographer which marshlands are most influenced by the tides, how saline the soil is, and how often and for how long the land is flooded. A plant may be succulent like a cactus in the hypersaline salt pan of a barrier island, or tall and needle-leaved like a pine tree, with protective woody bark, deep roots, and persistent needles, to survive in dry sandy soils of inland ridges that were once ancient shorelines. Native Americans, European settlers, and African slaves must have intimately understood the physical geography of the Lowcountry to know what food plants they could grow, livestock they could raise, wild game they could hunt, fish they could catch, and shellfish they could gather. By trial and error, experimentation, and shared experience, they grew the food they needed to feed themselves and others in the Lowcountry.

Taking a road trip through the Lowcountry of South Carolina and Georgia, Suzanne Bopp from *National Geographic* described it as having a "pungent, slightly salty smell." This smell comes from the area's pluff mud, the dark marsh mud exposed by the tide, and leaves a "lasting impression" on visitors.[8] Flooded twice daily by tides and periodically battered by salty waves and winds from

the Atlantic Ocean, the barrier islands of the Lowcountry are composed of sandy beaches, dunes, marshes, and maritime forests. Vegetation growing in the tidal marshes must be adapted to water and soil having a range of salinity levels, from brackish (less salty and dominated by black rush, *Juncus roemerianus*) and salty (predominantly covered by smooth cordgrass, *Spartina alterniflora*) to hypersaline (found in salt pans, home to a mix of salt-tolerant plants such as salt grass, *Distichlis spicata*, and glassworts, *Salicornia* species). In spite of the harsh environmental conditions, the marsh habitat provides a perfect nursery for fish, shellfish, crabs, and mammals gathered and caught as the main protein sources for Lowcountry meals. Author and historian Buddy Sullivan describes kitchen middens, or shell banks, found along the marsh edges as mounds consisting of "oyster shells with bits of pottery and the bones of animals mixed in," adding, "They were the refuse heaps left by the Indians." He notes the earliest Native Americans along the Georgia coast between the Savannah and St. Marys Rivers were the Muskogeans, whom the Spanish referred to as "Guale." Sullivan continues, "The Guale Indians chose the coastal islands and adjoining mainland as their home partly because of the abundance of food sources. The tidal streams and marshes provided a limitless supply of seafood; the Guale particularly relished shellfish, especially the oyster."[9]

When European explorers and then settlers arrived in the tidewater regions, they established missions and built forts for protection. As their populations increased, so did their need for agriculture. Sullivan notes in *Early Days on the Georgia Tidewaters* that early planters throughout the coastal region of the Georgia colony and lower Carolina relied on indigo, rice, naval stores, and provision crops.[10] He goes on to explain that the cultivation of rice was largely confined to the brackish inland marsh area, which offered a mix of fresh water flowing from upland streams and tidal influxes of salt water from the ocean. Located in the rich bottomlands of the freshwater rivers flowing into

a

b

FIGURE 3.6a, b. Grid patterns at Cathead Creek at Butler's Island Plantation.
Images courtesy of authors.

the Lowcountry and depositing sediment from the upland Piedmont, rice cultivation made use of tides for their cycles of flooding and draining the fields. The European planters benefited from the knowledge, skills, and experience of West African farmers who worked the coastal rice fields as slaves and understood that the interaction of salt and fresh water filtered through freshwater marshes would produce rice in abundance. An elaborate system of square fields, each 7.3 to 10.1 hectares (18 to 25 acres) in size, was dissected by a grid of drainage ditches dug by slaves to move water in and out of the fields. Separated by embankments that served as both walkways for the enslaved workers and levees to pool water on the fields, tide gates built at intervals along the levees controlled the flooding and draining of the fields.[11] Success of the irrigation system depended on regular ditching by the slaves to prevent the buildup of silt. "The grid-like layout of a rice plantation thus represented a complex system of hydraulics," Sullivan writes, "all predicated on the proper balance of a multiplicity of environmental factors, including landscape, soils, marshes, water, tides and not least, an assortment of weather conditions," and all predicated on the labor of enslaved men, women, and children.[12]

One of the largest rice plantations in the Lowcountry was Butler's Island in the Altamaha River delta (illustrated on this book's cover). Sullivan states that from 1819 to 1861, Butler's Island had up to 364.2 hectares (900 acres) per year in cultivation. Because the area was originally bottomland river swamp with cypress, gum, and maple trees, he points out, the "preparation of the island for rice planting required inordinate amounts of labor to expedite the difficult work of removing the timber, undergrowth and clearing stumps, followed by the building of embankments around and within the island, and the construction of heavy, wooden tide gates . . . for the management of the water flow."[13]

Even after the tide gates were constructed, conditions for enslaved laborers in the Lowcountry rice tracts did not necessarily improve. As Sullivan says, "Slaves had toiled in the wet, marshy rice fields under harsh, demanding conditions since the early 1700s in South Carolina, and after 1750, in Georgia."[14]

The grid pattern of rice fields of Butler's Island Plantation dating back to the early 1790s is visible in the landscape today. Images from drones flown in October 2020 by the authors clearly display the square rice fields, embankments, and impounded waters adjacent to Cathead Creek where rice was grown in probably the most productive rice plantation along the Georgia coast. Modern geographic technologies can capture both the coastal geography and landscape legacies that document Lowcountry agriculture and the lives of men, women, and children who worked the land.

NOTES

1. Stephen J. Reynolds, Robert V. Rohli, Julia K. Johnson, Peter R. Waylen, and Mark A. Francek, *Exploring Physical Geography*, 2nd ed. (New York: McGraw Hill Education, 2018).

2. Reynolds et al.

3. Nevin M. Fenneman, "Physiographic Subdivision of the United States," *Annals of the American Geographers* 3, no. 1 (January 1917): 17–22.

4. Glenn E. Griffith, James Omernick, and Jeffrey Comstock, "Ecoregions of South Carolina: Regional Descriptions," U.S. Environmental Protection Agency (2002), https://www.nrc.gov/docs /ML1127/ML112710639.pdf; Glenn E. Griffith, J. M. Omerick, J. A. Comstock, M. P. Schafale, W. H. McNab, D. R. Lenat, T. F. MacPherson, J. B. Glover, and V. B. Shelburne, "Ecoregions of North Carolina and South Carolina (Color Poster with Map, Descriptive Text, Summary Tables, and Photographs): Reston, Virginia," U.S. Geological Survey (map scale 1:1,500,000) (2002), https://www.epa.gov/eco-research /ecoregion-download-files-state-region-4#pane-38; G. E. Griffith, J. M. Omernick, J. A. Comstock, S. Lawrence, and T. Foster, "Ecoregions of Georgia: Corvallis, Oregon," U.S. Environmental Protection Agency (map scale 1:1,500,000) (2001), https://www.epa.gov/eco-research /ecoregion-download-files-state-region-4#pane-38; G. E. Griffith, J. M. Omernick, J. A. Comstock, S. Lawrence, G. Martin, A. Goddard, V. J. Hulcher, and T. Foster, "Ecoregions of Alabama and Georgia (Color Poster with Map, Descriptive Text, Summary tables, and

Photographs): Reston, Va.," U.S. Geological Survey, scale 1:1,700,000 (2002), ftp://newftp.epa.gov/EPADataCommons/ORD/Ecoregions /al/alga_front.pdf, ftp://newftp.epa.gov/EPADataCommons/ORD /Ecoregions/al/alga_back.pdf; G. E. Griffith, J. M. Omernik, J. A. Comstock, J. B. Glover, and V. B. Shelburne, "Ecoregions of South Carolina," U.S. Environmental Protection Agency, Corvallis, Ore. (map scale 1:1,500,000) (2002), ftp://newftp.epa.gov/EPADataCommons /ORD/Ecoregions/sc/sc_eco.pdf.

5. Erwin J. Raisz, "The Physiographic Method of Representing Scenery on Maps," *Geographical Review* 21, no. 2 (1931): 297–304; Erwin J. Raisz, *General Cartography* (New York: McGraw Hill, 1938).

6. Raisz, "Physiographic Method of Representing Scenery on Maps," 303.

7. Jon Blickwede, "Erwin Raisz and His Wonderful Landform Maps, from the Editor," *Houston Geological Society Bulletin* 58, no. 3 (November 2015): 7.

8. Suzanne Bopp, "Road Trip: Lowcountry, South Carolina, and Georgia" (Adapted from the *National Geographic Traveler*, September 14, 2010), https://www.nationalgeographic.com/travel/road-trips /low-country-south-carolina-georgia-road-trip/.

9. Buddy Sullivan, *Early Days on the Georgia Tidewater: The Story of McIntosh County and Sapelo* (Darian, Ga.: McIntosh County Board of Commissioners, 2001), 6.

10. Sullivan, 44.

11. Buddy Sullivan, *Early Days on the Georgia Tidewater: A New Revised Version* (self-pub., BookBaby, 2018), 227–228.

12. Buddy Sullivan, "Ecology as History in the Sapelo Island National Estuarine Research Reserve," *Occasional Papers of the Sapelo Island National Estuarine Research Reserve* 1 (2008), 2.

13. Sullivan, 2–3.

14. Sullivan, 5.

Lowcountry Geology

By a World of Marsh That Borders a World of Sea

DORINDA G. DALLMEYER, director emerita, Environmental Ethics Certificate Program, UGA

Following a consideration of climate and the broad scope of geography, this chapter focuses on geology, which reveals patterns of continental movement (explaining why we find sloth, camel, and mammoth bones in Lowcountry farm fields) and the transport of surface materials that formed the landscape we farm today. The study of barrier island formation in the Lowcountry, with its endless, ancient sand dunes, shows the historical landscape farmers struggled to flatten for crops. Geology allows us to travel through the millennia in just a few pages, from early formation of the Lowcountry to the massive forces that continue to shape the landscape—some incremental, others violent and transformative.

Dallmeyer considers geology of coastal counties as organized around four intersecting geologic themes: long-term processes, such as tectonic movements and sea-level change; coastal processes, such as tides and storms; sediment sources and deposition; and human activities affecting coastal geologic processes. Because Georgia's coastal geology is inextricably tied to the rest of the state, this chapter works forward from a regional perspective to examine the evolution of modern-day Wormsloe. Georgia is divided into four distinct physiographic provinces on the basis of surface geology. Wormsloe lies at the seaward edge of the Coastal Plain Province, a thick sequence of largely marine sedimentary rocks deposited beginning approximately one hundred million years ago and continuing today. 🦌

> *Steal off from yon far-drifting crowd*
> *And come and brood upon the marsh with me.*
> *—Sidney Lanier, "Individuality"*

As one looks across the marsh from the ruins of Wormsloe's old fortified house, it may seem like a timeless vista, disturbed only by the twice-daily rise and fall of the tides. You may ask, "Where's the geology here?" Certainly it's not as obvious as in the canyon lands of the West. But what if you could tunnel down far below the reach of fiddler-crab burrows, deep into the geologic past? There you would find evidence of great collisions, pieces of broken continents, and a mountain belt once as high as the Rockies pouring sediment into rivers to be carried to the sea. If geology is the skeleton underlying this landscape, Wormsloe rests on the bones of the Appalachians.

What was this vista like thousands or even millions of years ago? A basic tenet of geology is that processes we see in action today have occurred in the past and will do so in the future.

Relationship of Coastal Geology to the Rest of Georgia

Because Georgia's coastal geology is inextricably tied to that of the rest of the state, we use it as a starting point to work our way forward in the evolution of modern-day Wormsloe.[1] Close to the coast is a blanket of sedimentary rocks up to four thousand feet in thickness. These strata overlie much older crystalline metamorphic and igneous rocks exposed in the interior Piedmont and Blue Ridge provinces, which extend eastward at depth beneath the Coastal Plain. These so-called "basement" rocks represent the eroded roots of the Appalachian Mountains that were formed from collisions induced by plate tectonic movements.

When the Mountains Came Down to the Sea

Between 365 and 300 million years ago, an ancestral ocean closed, resulting in collisions between several major landmasses including Laurentia (chiefly North America and Greenland) and Gondwana (everything else). These collisions broke rock units, stacking huge tectonic slabs of coastal sediments, continental fragments, and volcanic island chains as they were pushed westward over Laurentian continental crust. Three hundred million years ago, when Laurentia and Gondwana finally united to form the supercontinent of Pangaea, portions of Georgia's Appalachians were uplifted to more than twenty-four thousand feet high.

FIGURE 4.1. This perspective block diagram illustrates geological relationships along the Georgia coast. Older Appalachian crystalline rocks extend from exposures in central and north Georgia southeastward beneath sedimentary rocks of the Coastal Plain. The oldest of these strata are approximately one hundred million years old. High-angle extensional faults that formed between 225 and 190 million years ago during rifting of the Pangaea supercontinent are marked in red. Adapted by R. D. Dallmeyer from R. S. Deitz, "Geosynclines, Mountains, and Continent-Building," *Scientific American* 226, no. 3 (1972): 35 (1972).

a

b

c

d

FIGURES 4.2a, b, c, and d. These images show continental reconstructions through time. Exposed continental areas are denoted in various shades of brown, and U.S. state boundaries are also marked. Ocean areas are shown in shades of blue, with shallower areas marked in lighter tones. (a) Three hundred sixty million years ago, the continental landmasses of Laurentia and Gondwana approached as an ancestral ocean closed as a result of plate tectonic movements. (b) Three hundred million years ago, Laurentia and Gondwana collided to form an extensive global area of continental crust named Pangaea. (c) Two hundred thirty million years ago, Pangaea began to rift apart, leading to the formation of numerous fault-bounded, intracontinental basins. (d) One hundred seventy million years ago, Pangaea finally ruptured, and the modern Atlantic Ocean began to form. Older continental failed rifts are buried beneath Coastal Plain sedimentary layers (see figure 4.1). Reconstructions from Ron Blakey, © 2013 Colorado Plateau Geosystems, Inc., http://deeptimemaps .com/north-american-key-time-slices -series/.

After the passage of approximately seventy-five million years, global tectonic forces changed, and Pangaea began to drift apart. However, it didn't tear along its original suture. Small basins bounded by faults began to widen and pull apart. Some continued to enlarge and, eventually, opened into today's Atlantic Ocean. Other basins failed to do so and remain buried under the Coastal Plain, out of sight but not out of mind. These inherent weaknesses in the crust continue to be the focus for earthquakes today. Deep beneath coastal South Carolina, one of these ancient faults produced the catastrophic 1886 Charleston earthquake.[2]

Following the breakup of Pangaea, for approximately the next one hundred million years, nearly all of what would become the state of Georgia lay well above sea level. Once the compression that brought Pangaea together ended, large-scale tectonic delamination and erosion reduced the height of the mountains. At this time, Georgia's landmass was located near the equator, where a combination of heat and high rainfall worked to chemically weather rocks exposed at the surface, thereby making them more easily eroded.[3]

Sea-Level Rise and Formation of First Barrier Islands

Eighty-five million years ago, global sea level rose dramatically and Georgia's ancestral rivers transported vast quantities of sand, silt, and clay to our Atlantic coast.[4] Where rivers met the sea, barrier islands began to form through the interactions of river and ocean, wind and tide. The same processes of barrier island formation we can observe today on nearby Tybee Island happened in the geologic past. As we will see, Wormsloe and the Isle of Hope sit atop an ancient barrier island.[5]

FIGURE 4.3. This continental reconstruction depicting land masses eighty-five million years ago uses the same color coding as in figures 4.2a–d. Note the very high stand of sea level relative to the area of the state of Georgia. Reconstruction from Ron Blakey, © 2013 Colorado Plateau Geosystems, Inc., http://deeptimemaps.com/north-american-key-time-slices-series/.

FIGURE 4.4. This satellite image shows a large, westward-facing embayment along the central section of the coast between North Carolina and Florida. This recess is called the Georgia Bight. The effects of waves and tides are focused within coastal areas along the embayment. The location of Wormsloe is marked with a red dot. NASA, https://eoimages. gsfc.nasa.gov/images/imagerecords/94000/94990/SouthEastUS. A2002048.1615.250m.jpg/.

FIGURE 4.5. Generalized map of the Georgia coast illustrating the relative distribution of salt marsh and barrier islands. Adapted from original map and data by the Nongame Section, Georgia Department of Natural Resources (2014).

Formation of Barrier Islands

Today, when the Savannah River's sediment load settles to the seafloor, tides, waves, and winds work to shape it. Geographically, our coast is located within the Georgia Bight, a major embayment along the eastern coast of the United States. Offshore lies a relatively wide and shallow continental shelf. These factors combine generally to diminish wave heights and to accentuate and focus tidal variations. As a result, the Georgia coast is dominated by tide-generated characteristics.[6]

Our coast experiences some of the highest tidal ranges south of Cape Cod. Wormsloe itself experiences as much as an eleven-foot rise and fall twice a day during full and new moons (i.e., "spring" tides). Large tidal ranges present a formidable plumbing challenge of cycling tens of millions of gallons of water twice each day from the marsh lagoon to the ocean and back again. To accommodate this massive flow, inlets cut Georgia's coast into short, stubby barrier islands, hallmarks of a tide-dominated coast.[7]

The Sand-Sharing System

Because the Georgia coast slopes gently seaward, large vertical changes in sea level are just as impressive on the beachfront as in the marsh. In addition to the tide, waves and wind shape barrier islands, particularly on the shorefront. Sand is moving all the time, at all scales, in what coastal geologists call the "sand-sharing" system. This complex interchange of sand between dunes, beaches, and offshore sandbars continually adjusts to the smallest nuances of waves, winds, and currents. During calm weather, offshore sandbars can advance on the shore and merge with it. Above the high-tide line where beach sand can dry, wind winnows and lifts the finer sand grains, blowing them landward where plants such as sea oats help to stabilize sand dunes.[8] With time these relatively ephemeral features can be buried and lithified into rock strata whose characteristic textures and types of sediment preserved in the rocks still reveal their origin as beach deposits.

In the geologic record, different rock types result from different sediment sources and depositional characteristics. In addition to nearshore deposits of river-borne sediment, Georgia's geologic record reveals the influence of a warm oceanic current that swept northeast from the Gulf of Mexico approximately thirty-two to forty-one million years ago.[9] In conditions similar to those found in today's

a

b

FIGURE 4.6a, b. These cross-sectional profiles illustrate the dynamics of the sand-sharing system along the Atlantic coasts of the Georgia barrier islands. (a) In stormy weather, wave turbulence erodes sand from the exposed shoreface, thereby making the beach narrower and steeper. The eroded sand is transported offshore and deposited in submerged sandbars. (b) In calm weather, with reduced wave energy, sand is transported landward from offshore, submerged bars. If calm weather is maintained, offshore bars can migrate up onto the shoreface and amalgamate with the beach, thereby making the beach wider and less steep. From "Jekyll Island: An Audio Tour of a Barrier Island," Georgia Sea Grant Program (2004); Charlotte Ingram, artist.

Bahamas, calcium carbonate remains of vast numbers of sea creatures that lived in these tropical environments formed limestones laid down offshore in a shallow, warm, tropical sea. Today these limestone beds are particularly important to the development of not only the Savannah region but also all of southeastern Georgia. Nearly eight hundred feet thick at the coast, the porous limestone and the water it holds within are known as the Floridan aquifer, the primary source for drinking water and industrial uses in Savannah and its neighboring communities.[10] As ocean conditions changed over time, these limestones were buried beneath sandstones and siltstones typical of river deposits. Later, new barrier islands were constructed atop them.[11]

The Importance of Sea-Level Changes

In addition to responding to changes in sediment supply, barrier islands react to global sea-level changes. When sea level rises, the islands—representing nothing more substantial than unconsolidated deposits of sand—roll over themselves like bulldozer treads, the sand pushed ever landward by waves and countless cataclysmic storms. When sea level stops rising, the islands stop moving, and marsh sediments may begin to accumulate in the island's lee. But when it comes to barrier islands, what goes up cannot come back down. If the climate swings back into another ice age and sea level begins to drop, islands become stranded along the ancient shoreline.

In Georgia, geologists have identified eleven paleo-barrier island/marsh complexes marking high stands of sea level across the Coastal Plain.[12] Just north of Hazlehurst, the highest rises 260 feet above present sea level with younger terraces descending like stairsteps to the coast 130 miles to the east. All of these terraces have been constructed in the last 2.6 million years, a relatively short period of time for such dramatic fluctuations in sea level. The cause? Global ice ages.

FIGURE 4.7. This shaded-relief, digital relief map of the Georgia coast illustrates a series of now inland, former barrier island complexes that were stranded during high stands of sea level associated with Pleistocene interglacial epochs. The location of Wormsloe is indicated with a red dot. United States Geological Survey, https://cecas.clemson.edu/geolk12/semaps/seregional/screen/sharelmap.jpg.

Geologists refer to the last 2.6 million years of Earth history as the Quaternary Period. It is divided into the Pleistocene Epoch (2.6 million years to 11,700 years ago) and the Holocene Epoch (11,700 years ago to the present).[13] Despite its distance from Earth's poles, the Georgia coast has been profoundly affected by global glaciations because, as seawater is sequestered into continental ice sheets, marked drops in sea level occur. Although sea level falls during glacial events, rivers continue to transport and deposit sediment along the coast, where it is shaped into nearshore barrier islands, just as we can observe today. During prior

warmer interglacial periods, the melting of continental glaciers, along with thermal expansion of seawater, resulted in global sea-level rise, often to heights above that maintained today. Thus, barrier islands along the Georgia coast slowly migrate westward across the shallow, gently sloping continental shelf toward the mainland.[14]

The effects of the rise and fall of sea level over the last 140,000 years is clearly recorded in the Savannah area. Because the climate was relatively warm 110,000 to 140,000 years ago, sea level stood nearly twenty-five feet higher than it does today. At this higher sea level, a barrier island complex of sands and marsh sediments called the Pamlico Terrace accreted to the mainland. The Pamlico Terrace is significant not only for coastal geology but also for its historic importance to the founding of Georgia. On February 12, 1733, General James Oglethorpe and a group of British colonists landed on a prominent rise alongside the Savannah River. Here at Yamacraw Bluff, which sits atop some of the highest and best-preserved portions of the Pamlico Terrace, they began the settlement of Georgia and founded the city of Savannah.

As Earth entered a global glacial period approximately 90,000 to 115,000 years ago, sea level dropped precipitously to be about four hundred vertical feet lower than it is today, leaving the older Pamlico barrier island complex stranded above sea level. At that time, the shoreline was located along the edge of the continental shelf, more than one hundred miles east of its present position. Camels, mastodons, and ground sloths roamed the exposed plain while ancestral rivers carried sand, silt, and mud to form a chain of barrier islands along the edge of the continental shelf.[15]

During a brief warming that occurred forty to eighty thousand years ago, sea level rose to approximately fifteen feet above its current height. Again, the barrier islands migrated toward the mainland. They formed the Princess Anne Terrace, which underlies Wormsloe, the Isle of Hope, and northwestern portions of Skidaway Island.[16] Had you

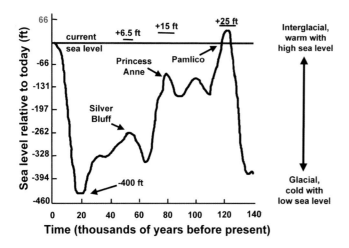

FIGURE 4.8. This graph illustrates the effects of Pleistocene-Holocene global glacial events on sea level. Coastal terraces in the vicinity of Wormsloe are labeled. Formation of the Holocene barrier islands coincided with current sea level. Adapted by R. D. Dallmeyer from age and relative sea-level data published in Frank J. Vento and Patty A. Stahlman, "Development of a Late Pleistocene-Holocene Genetic Stratigraphic Framework for St. Catherines Island: Archaeological Implications," in *Geoarchaeology of St. Catherines Island, Georgia*, ed. Gale A. Bishop, Harold B. Rollins, and David Hurst Thomas, Anthropological Papers of the American Museum of Natural History Anthropological Papers, no. 94 (New York: American Museum of Natural History, 2011), 99–112.

FIGURE 4.9. This map illustrates Pleistocene paleo-barrier island complexes exposed in the vicinity of Savannah. The location of Wormsloe is indicated with a red dot. Erin Susan Smith, "Assessment of Archaeological Deposits and Depositional History of Sediment Stratigraphic Units Using Grain Size Analyses, GPRZ, XRD, and Absolute Dating: Northern Skidaway Island, Georgia" (master's thesis, University of Georgia, 2013), 6, https://getd.libs.uga.edu/pdfs /smith_erin_s_201305_ms.pdf/.

been at Wormsloe then, you would have been standing not beside a quiet marsh but at the seashore of a barrier island, one looking very similar to Tybee Beach. As with the earlier terraces, the Princess Anne complex also would become stranded when temperatures fell at the onset of the next glacial phase.

Eventually, a warming period followed, but not as much ice melted this time. Consequently, rising seas and moving islands would not migrate far enough landward to obliterate the Isle of Hope sands. Instead a new rank of barrier islands formed along the length of the Georgia coast. Temperatures moderated long enough for this Silver Bluff

barrier complex to form and stabilize around forty thousand years ago. Standing approximately ten feet above current sea level, the Silver Bluff Terrace forms the core high ground for many of Georgia's barrier islands, from Tybee to Cumberland. Like the Pamlico Terrace, it also influenced Georgia's coastal history. Antebellum planters found that the rich soils formed on the weathered surfaces of the Silver Bluff Terrace and other paleo-barrier islands were ideal for growing Sea Island cotton, whose long, silky fibers made it a lucrative export crop.[17]

Twenty thousand years ago, Earth plunged into the most extensive glaciation of the Pleistocene Epoch. When this last ice age waned around 11,700 years ago, it marked the beginning of the Holocene period that we still live in today. At first, global sea level rose relatively rapidly as low-latitude continental glaciers began to melt. As the rising waters swept across the continental shelf, plants, animals, and native peoples occupying the zone of inundation had to migrate or drown.[18]

Holocene barrier islands that had formed at the edge of the continental shelf also began to shift west. About five thousand years ago, the rate of sea-level rise slowed and this new set of barrier islands amalgamated to the eastern shore of their Silver Bluff predecessors. Around the same time, marshes began to thrive in the protected waters behind island ramparts.

Wormsloe's Marshland

Because of the stabilizing effect of vegetation, the Holocene barrier islands have stayed put, more or less, over the last five thousand years. Draining large inland watersheds, Georgia's major coastal rivers—the Savannah, Ogeechee, and Altamaha—supplied vast quantities of sand, silt, and clay to their estuaries. Finer sediment settled in the lee of the islands, forming layered deposits as much as eighty feet thick. These relatively sheltered lagoons are dominated by the marsh grass *Spartina alterniflora*.[19]

Spartina salt marsh and tidal creeks surround Wormsloe on three sides. *Spartina* is well adapted to frequent inundation by salt water and outcompetes other plants to command a marsh vista that is lush green in summer and golden brown in the fall and winter; this is why the Georgia coast is often referred to as the "Golden Isles." But even *Spartina* cannot tolerate being immersed in seawater for more than six hours at a time. Where those conditions exist, it is replaced by bare mud flats and cut by tidal creeks supporting numerous oyster beds. As the marsh rises slightly higher in elevation, *Spartina* gives way to other intertidal plants such as black needlerush. Indeed, marsh plants are so attuned to changes in elevation that a simple topographic map can be generated by mapping the distribution of plant species. At the highest level of the marsh, reached only a few days each month by the highest of spring tides, salt crystallizes out as ponded seawater evaporates. Here, only the most salt-tolerant plants border the hard surface of these salt pans.

Regardless of the type of vegetation, the salt marsh and tidal creeks teem with life. Although most coastal residents once considered marshes nothing more than pestilential swamps, the marsh serves as a nursery for commercially important seafood species, including shrimp, crabs, and a wide variety of sport fish. Modern ecological research has shown that salt marshes are among the most biologically productive ecosystems in the world. A casual look at the marsh immediately suggests that the abundant *Spartina* must be a major contributor. Less obvious are the myriad species of microscopic algae living in the water and on the surface of the marsh mud that provide the foundation for the marsh food web. This complex web supports organisms ranging from some that are small enough to live between sand grains to large marine mammals such as dolphins and manatees. Migratory and resident birds swarm the tidal creeks and mudbanks searching for prey.[20]

Standing at the Wormsloe shoreline by the fortified house, you can observe the dynamics of the tide at work in the marsh. At low tide, fiddler crabs scuttle over the mud and oysters spit water from their shells. As the tide begins to rise, marsh periwinkle snails grazing on the mud begin to ascend spikes of *Spartina*, eager to be out of reach of hungry blue crabs. High tide brings the shuffling of marsh debris along the shore. And beneath your feet lie scattered oyster shells, remnants of feasts the early native peoples enjoyed as they, too, made the most of the bounty the marsh had to offer.[21]

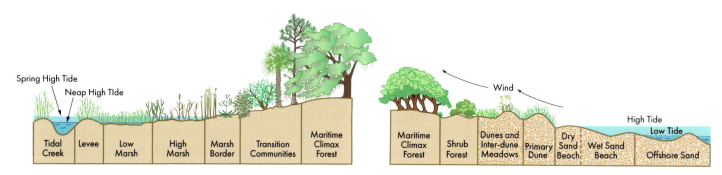

FIGURE 4.10. Cross-sectional profile illustrating the typical physiographic and vegetation zonation across Georgia coastal salt marshes. Spring tides occur during a full or new moon; the lower neap tides occur during a first- or third-quarter moon. From "Jekyll Island: An Audio Tour of a Barrier Island," Georgia Sea Grant Program (2004); Charlotte Ingram, artist.

Hurricanes

The early native peoples spent most of the year living on the mainland and only seasonally occupied the barrier islands. Through their observations over time, undoubtedly they understood that, while barrier islands and marsh provide a buffer to help attenuate the full impact of hurricanes and major storms, that protection is far from absolute. European colonists had fewer qualms about wringing a living from the barrier islands, but it came often at great cost. During the nineteenth century, nine hurricanes struck in the vicinity of Wormsloe.[22] In 1824 seawater submerged cotton and corn crops at Skidaway Island as well as destroying gardens and ornamental trees. In 1854 George W. Jones reported that a storm at Wormsloe left "a terrible path behind it of crops destroyed and property of every kind injured."[23] In late August 1881, a storm surge of at least twelve feet above high water swept the Tybee Beach "as smooth as a billiard table" and, just west of Wormsloe, flooded dwellings at Bethesda Orphanage up to the eaves. A series of major hurricanes punctuated the 1890s. In 1893, the Isle of Hope bridge washed away. In 1896, boats were driven ashore at the Isle of Hope, and many of Wormsloe's longleaf pines were topped or uprooted entirely. This disastrous string of hurricanes concluded in October 1898 with a storm that came ashore at a full moon during high tide, smashing wharves and capsizing ships.[24]

Although the twentieth century seemed calm in comparison, an August 1940 hurricane was strong enough to damage much of the forest cover, ornamental plants, and the garden walls. According to historian Drew Swanson, "The storm served as a reminder that for all the cultural and environmental changes that had taken place on Wormsloe, ecological processes continued to shape the Isle of Hope landscape, often in dramatic fashion."[25] In other words, people have sought to remake the landscape to suit their needs, often disregarding what the effect may be on ecological processes.

Human Impacts on the Landscape

So let us stand once more at the fortified house looking south over the marsh. Our twenty-first-century view differs markedly from the one Noble Jones had in 1736.[26] At that time, a major tidal creek, "Jones Narrows," connected with a strategic coastal route south to St. Augustine, the Spanish stronghold that posed a potential threat to the fledgling Georgia colony. Wormsloe and Jones Narrows were an ideal launch site for patrols by the British marines garrisoned there.[27] But the natural defensive advantages the site held would fall victim to human "improvements."

In the 1860s at the southern end of the Isle of Hope, Confederate forces built earthworks for an artillery battery and a combination of causeway and dam across the marsh for use as a potential escape route.[28] In 1910, dredging of the Intracoastal Waterway through Skidaway Narrows diverted and channelized water flow, further disrupting tidal circulation in the marsh. In 1972, the Diamond Causeway was built across the southern end of the Isle of Hope to provide road access to Skidaway Island. The causeway impaired tidal flushing even more, so that tidal creeks bordering Wormsloe silted in, narrowed, and, in some cases, disappeared entirely.[29]

On the other hand, fifty years ago many Georgians fought hard to preserve our coastal landscape. Only a few miles seaward of Wormsloe, the coastal marshlands faced a novel, existential threat, and all because of geology. During the 1960s, mining companies obtained options to buy mineral rights on Little Tybee and Cabbage Islands. Their goal was to strip away the marsh sediments and extract extensive phosphate deposits that could be turned into fertilizer. The crisis intensified in early 1968 when the Kerr-McGee Corporation applied for a license from the Georgia Mineral Leasing Commission to mine phosphate from thousands of acres of state-owned underwater land and to use barrier islands and marshland as dumping grounds for waste material.[30] The area of interest included

waters offshore of Wassaw, Ossabaw, and St. Catherines Islands, with mining proposed at depths of up to one hundred feet below the ocean surface.

Kerr-McGee's public relations campaign emphasized the putative economic benefits of the project but failed to sway the Georgia public. A unique coalition of coastal scientists, students, conservation organizations, garden clubs, historical societies, hunting and fishing groups, and newspapers rallied citizens statewide. The full-throated public outcry swayed the legislature and state agencies not only to deny the license but to move forward with comprehensive protection for Georgia's salt marsh: the Coastal Marshlands Protection Act of 1970, which was based solidly on ecological science. In 1979, the state adopted the Shore Protection Act to control human activities within the sand-sharing system. It, too, was based on sound ecological and geological principles.

Since that time, pressure has mounted to loosen restrictions on development in Georgia's coastal zone, regardless of scientific evidence. But once again geologic processes could have the last word. Coastal geologists and climatologists now project that global sea level may rise by as much as six feet by the year 2100, at a rate twice the speed Earth experienced at the end of the Pleistocene glaciations. At the end of the Pleistocene, the human presence at the coast was negligible. Now in the twenty-first century, coastal population density continues to increase, both from year-round residents and from visitors.

Already some coastal counties and individual communities are working on ways to adapt to changing circumstances and become more resilient. Given projected growth rates, however, by 2100 there may be 150,000 to 200,000 people at the Georgia coast whose homes, livelihoods, communities, history, and cultures will be at risk from rising sea level.[31]

As it nears its 300th anniversary, Wormsloe's stately live oaks and serene marsh vistas seem timeless and unchanging, a restful spot in a turbulent world. At the same time, as we stand "by a world of marsh that borders a world of sea," geology calls on us to remember how dynamic our Earth and our coasts have been and always will be.[32]

Epigraph

Georgia native Sidney Lanier (1842–1881) composed his four-part poem *Hymns of the Marshes* over several years shortly before his death.

The epigraph is excerpted from the first stanza of part 2, "Individuality," lines 4–5.[33] The most famous portion of the work, part 4, "The Marshes of Glynn," is based on his observations of the marsh at Brunswick, Glynn County, Georgia, from dawn to twilight. The poem, which combines descriptions of plants and animals of the marsh and the rhythms of the tidal cycle, is deeply grounded in the spiritual impact Lanier felt before the majesty of God's creation. The title of this chapter is an excerpt from its fourth stanza, where Lanier leaves the maritime oak forest and

> . . . with a step I stand
> On the firm-packed sand
> Free
> By a world of marsh that borders a world of sea.[34]

Memorized by generations of Georgia schoolchildren, "The Marshes of Glynn" remains a force for coastal conservation long after Lanier's death.

NOTES

1. Pamela J. Gore, "Geologic History of Georgia: Overview," *New Georgia Encyclopedia*, July 26, 2017, https://www.georgiaencyclopedia.org/articles/science-medicine/geologic-history-georgia-overview.

2. Although eighty miles away, Savannah experienced significant property damage from the quake. The brick wall of the 134-foot-high Tybee Light Station cracked about midway up, where it was six feet thick; its lens, weighing about a ton, was moved more than an inch to the northeast. Otto W. Nuttli, G. A. Bollinger, and Robert B. Herrmann, "The 1886 Charleston, South Carolina, Earthquake: A 1986

Perspective," U.S. Geological Survey, Circular 985 (Washington, D.C.: U.S. Government Printing Office, 1986), 27, https://pubs.er.usgs.gov/publication/cir985.

3. The removal of overlying mass by tectonic delamination, landslide, and erosion caused the crust to rebound, i.e., to rise upward, sometimes by astonishing amounts. Following the most intense period of Appalachian mountain building, Stone Mountain, the Georgia Piedmont's iconic granite monolith, solidified approximately 290 million years ago at a depth of approximately 7.5 miles below Earth's surface. It now looms nearly 1,700 feet above the landscape due to uplift and the relentless erosion of the less resistant rocks that surround it. R. D. Dallmeyer, "40Ar/ 39Ar Incremental-Release Ages of Hornblende and Biotite across the Georgia Inner Piedmont: Their Bearing on Late Paleozoic-Early Mesozoic Tectonothermal History," *American Journal of Science* 278, no. 2 (February 1978): 124–149, doi: 10.2475/ajs.278.2.124.

4. Along the ocean ridge system, magma erupts and cools to form new seafloor. During the Cretaceous period, the rate of seafloor spreading at the ocean ridge system increased dramatically. When seafloor moves away from the ridge at a faster rate, it travels a greater distance before it cools and contracts than in times of slower seafloor spreading. The "inflated" seafloor takes up more space in the ocean basin and displaces seawater. Thus sea level rises, just as water in a wading pool rises when you sit down in it. For more details, see M. Seton, C. Gaina, R. D. Müller, and C. Heine, "Mid-Cretaceous Seafloor Spreading Pulse: Fact or Fiction?," *Geology* 37, no. 8 (August 2009): 687–690, doi: 10.1130/G25624.A.1.

5. Paul F. Huddlestun, *A Revision of the Lithostratigraphic Units of the Coastal Plain of Georgia: The Miocene through Holocene*, Georgia Geological Survey, Bulletin 104 (Atlanta: Georgia Geological Survey, 1988), 144, figure 56, https://epd.georgia.gov/sites/epd.georgia.gov/files/related_files/site.../B-104.pdf.

6. This contrasts with the adjacent microtidal coasts of Florida and North Carolina that are dominated by wave-generated topographic characteristics. Microtidal barrier islands are elongate and lie in a long, narrow chain—for example, Cape Hatteras. Georgia's barrier islands are short and stubby and separated by numerous inlets. Paul S. Sutter, "The History of Conservation and the Conservation of History along the Georgia Coast," in *Coastal Nature, Coastal Culture: Environmental Histories of the Georgia Coast*, ed. Paul S. Sutter and Paul M. Pressly (Athens: University of Georgia Press, 2018), 12.

7. The volume of water exchanged in the twice-daily tidal cycle is staggering. Georgia's coastal marshes cover approximately 378,000 acres, one-third of all the salt marsh on the U.S. East Coast. Charles

Seabrook, "Tidal Marshes," *New Georgia Encyclopedia*, March 4, 2022, https://www.georgiaencyclopedia.org/articles/geography-environment/tidal-marshes. Assuming an average nine-foot vertical rise in the tide, 162 million cubic feet, or 1.2 trillion gallons of water, have to be moved into the marsh during each tidal cycle. That is enough water to fill 1.8 million Olympic-sized pools or 24 billion bathtubs. Of course, that volume of water has to flow seaward during the ebb tide. The Georgia coast experiences twice-daily tidal cycles, which means four times that volume is moving on average every day. R. David Dallmeyer, personal communication with the author.

8. Sea oats are not just beautiful. They also are protected by law in Georgia to preserve their function in controlling dune erosion. The Official Code of Georgia, Annotated, section 12-5-311 (2010), states, "It is unlawful for any person to cut, harvest, remove, or eradicate any of the grass commonly known as sea oats (*Uniola paniculata* L.) from any public land of this state or from any private land without the consent of the owner of such land or the persons having lawful possession thereof." A violator is guilty of a misdemeanor.

9. J. A. Miller, "Hydrogeologic Framework of the Floridan Aquifer System in Florida and in Parts of Georgia, South Carolina, and Alabama," U.S. Geological Survey Professional Paper 1403-B (Reston, Va.: U.S. Geological Survey, 1986), B10–B13, https://pubs.er.usgs.gov/publication/pp1403B.

10. William Boyd, "Water Is for Fighting Over: Papermaking and the Struggle over Groundwater in Coastal Georgia; 1930s–2000s," in Sutter and Pressly, *Coastal Nature, Coastal Culture*, 243–277.

11. "A Brief Geological History of Cockspur Island at Fort Pulaski National Monument, Chatham County, Georgia," U.S. Geological Survey, Fact Sheet 2018-3001 (Washington, D.C.: U.S. Department of the Interior, March 2018), 1–4, doi.org/10.3133/fs20183011.

12. Frank J. Vento and Patty A. Stahlman, "Development of a Late Pleistocene-Holocene Genetic Stratigraphic Framework for St. Catherines Island: Archaeological Implications," in *Geoarchaeology of St. Catherines Island Georgia*, ed. Gale A. Bishop, Harold B. Rollins, and David Hurst Thomas, Anthropological Papers of the American Museum of Natural History, no. 94 (New York: American Museum of Natural History, 2011), 103.

13. Analysis of ice cores from Greenland and Antarctica indicate that Earth was regularly affected by global glaciations during at least the last million years. Glacial events lasted for approximately ninety thousand years and were separated by approximately ten thousand years of warmer, interglacial periods. For more information about glacial-interglacial cycles, see the website for the National Centers for Environmental Information, National Oceanic and Atmospheric

Administration, https://www.ncdc.noaa.gov/abrupt-climate-change/Glacial-Interglacial%20Cycles.

14. This landward movement of barrier islands is termed "rollover" and can be envisioned as a sand conveyor belt. The primary mechanism for rollover is powerful storm waves that push beach and dune sediments inland, where they are deposited in "washover fans." With time, landward migrating barrier islands can override previous deposits of marsh mud. Marsh mud exposed on the Atlantic shoreface is clear evidence of barrier island migration.

15. Cores taken from the Georgia continental shelf suggest that during particularly cold periods, the landscape would have looked very different than it does today. In addition to having colder temperatures, the climate was much drier. Fossil pollen studies reveal that grasslands were much more dominant; a fern-dominated understory would have stood beneath cold-hardy pines that outnumbered hardwoods. Ervan G. Garrison, Wendy Weaver, Sherri L. Littman, Jessica Cook Hale, and Pradeep Srivastava, "Late Quaternary Paleoecology and Heinrich Events at Gray's Reef National Marine Sanctuary, South Atlantic Bight, Georgia," *Southeastern Geology* 48, no. 4 (February 2012): 165–184, https://scholar.google.com/scholar?q=Late+Quaternary+Paleoecology+and+Heinrich+Events+at+Gray%27s+Reef+National+Marine+Sanctuary,+South+Atlantic+Bight,+Georgia&hl=en&as_sdt=0&as_vis=1&oi=scholart.

16. Erin Susan Smith, "Assessment of Archaeological Deposits and Depositional History of Sediment Stratigraphic Units Using Grain Size Analyses, GPR, XRD, and Absolute Dating: Northern Skidaway Island, Georgia" (master's thesis, University of Georgia, 2013), 6, https://getd.libs.uga.edu/pdfs/smith_erin_s_201305_ms.pdf.

17. Following the American Revolution, the owners of Wormsloe turned away from a diversified crop base to focus on growing Sea Island cotton as their principal commodity. For a discussion of both the change in crops and the rise of slave labor to cultivate cotton, see Drew A. Swanson, *Remaking Wormsloe Plantation: The Environmental History of a Lowcountry Landscape* (Athens: University of Georgia Press, 2012), 54–94.

18. Archaeologists date the first arrival of humans in Georgia to 13,250 years ago. David G. Anderson, "Paleoindian Period: Overview," *New Georgia Encyclopedia*, http://www.georgiaencyclopedia.org/articles/history-archaeology/paleoindian-period-overview. Although groups of Indians lived in the coastal zone for millennia, these former occupation sites now lie underwater on the continental shelf and thus are very difficult for archaeologists to locate and study. In 2002, underwater archaeologists diving approximately twenty miles offshore of St. Catherines Island recovered a projectile point, an antler/bone tool, and two other stone artifacts estimated to be five thousand to eight thousand years old. J. Cook Hale, Christopher Cameron, Erin Smith, and Ervan Garrison, "SEM-EDS and XRD-WDS Characterization of Unconventional Prehistoric Artifacts from the Southeastern U.S. Continental Shelf, Gray's Reef National Marine Sanctuary, Georgia," paper 239–3, Geological Society of America annual meeting, November 7, 2012, https://gsa.confex.com/gsa/2012AM/webprogram/Paper209820.html.

19. Two recent books detail not only the ecological value of the coastal marshlands but also their enduring allure: Charles Seabrook, *The World of the Salt Marsh: Appreciating and Protecting the Tidal Marshes of the Southeast Atlantic Coast* (Athens: University of Georgia Press, 2013); and Evelyn B. Sherr, *Marsh Mud and Mummichogs: An Intimate Natural History of Coastal Georgia* (Athens: University of Georgia, 2015). A 1964 classic about the Georgia marsh ecosystem with a particular focus on Sapelo Island is Mildred Teal and John Teal, *Portrait of an Island* (Athens: University of Georgia Press, 1997).

20. Many species of shorebirds that spend time along the Georgia coast are international travelers. Some, like the red knot, migrate nine thousand miles in one direction from their wintering grounds on the southern tip of Argentina all the way to the Arctic Circle to nest. The Georgia coast provides critical stopover sites where a wide variety of shorebirds refuel from the rich food resources and rest before continuing their journey. Other birds winter over at the coast before returning thousands of miles to their summer nesting grounds. In recognition of the critical role Georgia plays in supporting migratory birds, the Western Hemisphere Shorebird Reserve Network (WHSRN) designated approximately eighty thousand acres of Georgia barrier islands and salt marsh as a "Landscape of Hemispheric Importance" in late 2017. Georgia is one of only three locations in the hemisphere designated at the "landscape" scale. Currently these acres encompass federally protected sites as well as municipal and private lands from Cumberland Island north to the Savannah River. See "Georgia Barrier Islands Named a Landscape of Hemispheric Importance," *Shoreline* (newsletter of the Stewards of the Georgia Coast), https://stewardsofgacoast.org/2017/11/10/georgia-barrier-islands-named-a-landscape-of-hemispheric-importance/. Although Wormsloe is not part of the designated landscape, nearby are WHSRN tracts in the Savannah Coastal Refuges Complex (which includes the Tybee and Wassaw National Wildlife Refuges), Fort Pulaski National Monument, and property owned by the city of Tybee. Recent research suggests that Wormsloe could support ninety-three species of songbirds, with an additional forty-eight species of wading birds, rails, and shorebirds in the adjacent

marshes. Nancy K. O'Hare, "Interim Wormsloe Fellow Report," December 31, 2012, 6, https://scholar.google.com/scholar?hl=en&as_sdt=0%2C11&q=wormsloe+migratory+birds&btnG=.

21. Wormsloe features a number of shell middens across the site, which provides some evidence of the way native people used the land and surrounding marshes prior to European contact. The tabby blocks composing the walls of the fortified house were made from the abundant shell material deposited in middens bordering the marsh. Swanson, *Remaking Wormsloe Plantation*, 23–25.

22. Walter J. Fraser Jr., *Lowcountry Hurricanes: Three Centuries of Storms at Sea and Ashore* (Athens: University of Georgia Press, 2006). That Fraser devotes 167 of 319 pages of his book to storms of the 1800s alone should leave no doubt that the nineteenth century was exceptionally hurricane ridden compared with the twentieth.

23. Swanson, *Remaking Wormsloe Plantation*, 129.

24. Fraser, *Lowcountry Hurricanes*, 91, 149, 170, 189.

25. Swanson, *Remaking Wormsloe Plantation*, 132.

26. For a reconstruction of the view south from the fortified house in the 1730s, see the website of landscape artist Philip Juras, https://www.philipjuras.com/artwork/2010072002jonesnarrows/. According to Juras, "In the eighteenth century a visitor to Wormsloe, the fortified home of Noble Jones, would have seen a view toward the south very similar to this one. In this view, recreated from historical maps and aerial photos, Long Island is on the left, the Isle of Hope is on the right, and Pigeon Island occupies the center of the opening. A tidal creek once flowed through this opening. It was known in the 18th century as Jones Narrows, and was the main inland water route between Savannah and points south. In more recent years, the highway to Skidaway Island was built across this space, forever changing the appearance of this historic view."

27. Swanson, *Remaking Wormsloe Plantation*, 24–25. Archaeologists and historical geographers continue to search for the patrol boats that the marines reportedly abandoned in the marsh after the cessation of hostilities with the Spanish.

28. Dan Rice, Susan Knudson, and Lisa Westberry, "Restoration of the Wormsloe Plantation Salt Marsh in Savannah, Georgia," *Proceedings of the 2005 Georgia Water Resources Conference* (April 25–27),

University of Georgia, ed. Kathryn J. Hatcher, http://hdl.handle.net/1853/47317.

29. Rice, Knudson, and Westberry.

30. Christopher J. Manganiello, "The Gold Standard: Sunbelt Environmentalism and Coastal Protection," in *Coastal Nature, Coastal Culture: Environmental Histories of the Georgia Coast*, ed. Paul S. Sutter and Paul M. Pressly (Athens: University of Georgia Press, 2018), 279–308.

31. Matthew E. Hauer, Jason M. Evans, and Deepak Mishra, "Millions Projected to Be at Risk from Sea-Level Rise in the Continental United States," *Nature Climate Change* 6 (March 14, 2016): 691–695, https://www.nature.com/articles/nclimate2961. For a thorough analysis of the social, economic, and ecological effects of projected sea-level rise on Chatham and two other coastal counties in Georgia, see Larry Keating and Dana Habeeb, *Tracking the Effects of Sea Level Rise in Georgia's Coastal Communities*, School of City and Regional Planning, Georgia Institute of Technology (Fall 2012), http://hdl.handle.net/1853/48711. Future sea-level rise will only exacerbate storm surge impacts from hurricanes. In October 2016, Chatham County bore the brunt of Hurricane Matthew. The bulk of the structural damage was caused not by high winds but by flooding due to record storm surge and excessive rainfall. The Fort Pulaski tide gauge recorded 7.7 feet above normal tide levels—the highest measured for Hurricane Matthew at any spot along the U.S. coast. Hunter Army Air Field, approximately five miles northwest of Wormsloe, measured 17.48 inches total rainfall. Stacy R. Stewart, *National Hurricane Center Tropical Cyclone Report: Hurricane Matthew (AL142016), 28 September–9 October 2016*, National Hurricane Center (April 7, 2017), 9, 11, 15, 17, https://www.nhc.noaa.gov/data/tcr/AL142016_Matthew.pdf. Total storm losses for the state of Georgia were estimated at $1 billion; only about half of that total was covered by insurance. AON Benfield, "Hurricane Matthew Event Recap Report," https://www.actuarialpost.co.uk/news/hurricane-matthew-event-recap-report-10994.htm.

32. Sidney Lanier, "The Marshes of Glynn," in *Hymns of the Marshes* (New York: Charles Scribner's Sons, 1908), 51.

33. Sidney Lanier, "Individuality," in *Hymns of the Marshes*, 29.

34. Lanier, "Marshes of Glynn," 51.

The Farmstead beneath Our Feet, Soils of Wormsloe

JULIA HOLLY CAMPBELL, public service assistant, Warnell School of Forestry and Natural Resources, UGA; and LAWRENCE A. MORRIS, professor emeritus, Warnell School of Forestry and Natural Resources

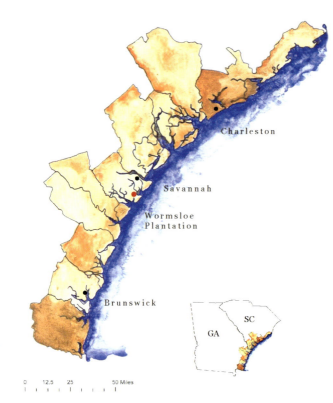

As a natural resource, soil deserves our highest level of respect. As we all know, our very lives are dependent on soil. Although we can grow vegetables hydroponically (even in spaceships!), humans rely on soils to produce the quantity and quality of food required to nourish our global population. Soils are shaped by the regional climate, precipitation, temperatures, physical geography, underlying geology, and time. Living communities within the soil profile as well of those supported on the surface interact with and contribute to the soil's characteristics. A leading challenge for colonists in Georgia and South Carolina was farming in poor-quality soils. They found the Lowcountry soils fast draining and seemingly incapable of holding moisture—a condition amplified by a deficiency of humus and very low fertility. Soil amendments, such as seabird guano, were so critical they were imported via sailing ships from as far away as Peru. Starvation in the early colonies was a periodic reality and unrelenting concern.[1]

Campbell and Morris address the soils of Wormsloe as they explain the physical and social history of the area to illustrate the vital importance of soils. In addition to its necessity for growing crops, soil provided the material for houses, roads, barricades during times of war, and household goods such as pottery and clay smoking pipes. An analysis of the soils of Wormsloe and the accompanying Isle of Hope community reveals the history and activities of its people.

Civilizations rise or fall based on the characteristics, quality, and care of their soils. As agronomist Daniel Hillel writes in *Out of Earth: Civilization and the Life of Soil*, "Perhaps our most precious and vital resource, both physical and spiritual, is the most common matter underfoot which is in fact the mother-lode of terrestrial life. . . . The successes and failures of past societies emphasize the crucial importance of the soil-water system in determining the long-term viability of all civilizations."[2]

Soil had a direct influence on the success of American life in coastal Georgia. Soil determined the type and quality of trees available for construction and the success of agricultural crops, thus influencing trade in important, early U.S. commodities. Soil was used to construct houses and roads, build barricades during wartime, and provide household goods such as pottery. Just as soil shaped the activities of Isle of Hope residents, those activities are recorded in the soil. In this chapter, we describe the soils that occur at Wormsloe and how they are intricately linked with Wormsloe's history.

Understanding and Describing Soils

Soils are more than finely ground rock. At a minute scale, they are a dynamic blend of variously sized minerals, water, gas, and organic matter—or once-living plant or animal matter in various stages of decomposition. Pick up a handful of soil. In your hand, you are holding time, as soils can be quite old. You are also holding an entire ecosystem, as a handful of soil contains millions of organisms.

On a larger scale, soils are shaped by five primary factors: variations in precipitation and temperature, or climate; the type of rock from which a soil is formed; the plant and animal communities that occur in an area; the location on a landscape; and the length of time over which a soil has developed.[3] Considering how diverse each of these factors is worldwide, one can hardly imagine all the unique combinations of soils they create!

The surface of the soil is the boundary between the ground and the atmosphere, where gases such as oxygen and carbon dioxide are exchanged and rain infiltrates. This surface layer conceals just how diverse the soil beneath it really is. All soils contain layers called soil horizons. Soil horizons are formed by natural processes, such as water transporting minerals and organic matter from the soil surface to deeper soil depths, the mixing of soil by organisms such as earthworms, and mineral changes that occur when soil is saturated in water for periods of time. Several soil horizons stacked on top of each other form a soil profile (figure 5.2). Each soil horizon has a name that corresponds to a certain set of characteristics. For example, the O horizon is the "litter" layer, made up of partially broken-down leaves, pine needles, and other organic matter on the soil surface. It contributes nutrients to the soil as the organic matter breaks down. The A horizon usually occurs near the surface, below the O horizon, and contains more organic matter than the E and B horizons, which are beneath it. The A horizon is typically the portion of soil used in agriculture. The E horizon is pale in color because water leaches minerals and organic matter through it, and the B horizon is a layer where minerals, such as clay, or organic molecules accumulate, being transported down in water from higher soil horizons. The E and B horizons, at least in Georgia soils, tend to be less fertile and thus less well suited for agriculture. Lastly, the C horizon is the deepest horizon and is the parent material from which these upper horizons develop. It may consist of partially broken-down rock, formed by weathering, or sand, silt, or clay materials deposited by wind or water. As you look at the different soil profiles found at Wormsloe and illustrated in figure 5.2, you can note the variation in soil horizons.

Sediments underlying Wormsloe and the Isle of Hope are from the Pleistocene epoch (ranging from 25,000 to 120,000 years old), deposited when the sea level was much higher than it is today. These deeper sediments are overlain with younger ones deposited in the last ten thousand

What Is in a Handful of Soil?

Pick up a handful of soil and you are holding thousands of individual organisms. From macroscopic earthworms, ants, and beetle larvae to mesoscopic mites, nematodes, and springtails to microscopic protozoa and bacteria, the soil is a living community with each individual in a life-and-death struggle to survive, grow, and reproduce. The diversity of soil organisms not only is essential for sustainable ecosystems but provides a wealth of possibilities for solving human problems. Streptomycin, the first antibiotic capable of curing tuberculosis, was isolated from the soil in 1943 by professor Selman Waksman, a soil microbiologist at Rutgers University. Other antibiotics isolated from soil by Professor Waksman's team at Rutgers include actinomycin, neomycin, and candicidin. Between 70 and 80 percent of the antibiotics currently used to fight disease were isolated from one group of soil microorganisms, the actinomycetes. The soil community has also provided us with the means to degrade oil spills in our oceans, break down toxic chemicals in our environment, and create stable organic matter that produces productive soils.

FIGURE 5.1. Top to bottom: macroscopic organisms: earthworms, beetle larvae, ants, millipedes, snails (photo by Melissa McMasters); mesoscopic organisms: springtails, mites, nematodes, pot worms (photo by Andy Murray); microscopic organisms: protozoa, bacteria, fungi, actinomycetes (photo by Alden Dirks).

years. Many Wormsloe soils have formed in sediments that are even younger and, in some cases, have been developing for less than one thousand years. Wormsloe soils were formed in ocean and marsh sediments. The way in which sediments were deposited and their age strongly influence the type of soil that formed. For example, soils formed in ocean deposits are composed primarily of sand, whereas those formed in marsh deposits contain more clay and silt. Some Wormsloe soils developed in former sand dunes, which occur on the seaward side of the peninsula, while others developed in low, wet areas found throughout Wormsloe.

Scientists organize categories of soil in a manner similar to plant and animal classification, called soil taxonomy. Within soil taxonomy, the name given to a certain type of soil is called a soil series. The soil series that occur at Wormsloe can be compared and contrasted to each other based on two defining characteristics: the type of soil horizon that occurs deeper in a soil profile and the drainage class, which refers to how well water drains through the soil. A spodic horizon (also referred to as a Bh horizon) occurs in a sandy soil profile and is defined as an accumulation of organic matter bound to iron and aluminum (noted by the letter "h"). Wormsloe soils with a Bh horizon appear reddish brown in color and, although their sandy profile would seem to indicate they would drain quickly, due to a sometimes high water table they are moderately to somewhat poorly drained. A Bh horizon can be seen in figure 5.2 in the Echaw and Ridgeland soil series. An argillic horizon (Bt horizon) contains clay ("t" indicates an increase in clay) and varies in color from gray to yellow to red at Wormsloe. Wormsloe soil series with a Bt horizon tend to occur in former marsh or drainage areas. Because Wormsloe's elevation is near sea level, these low-lying soils with Bt horizons are close to the water table and so are typically poorly to very poorly drained. A Bt horizon can

Echaw

O – leaf litter, bark & wood
A – dark brown sandy surface soil containing organic matter incorporated by soil animals
E1 – light yellowish-brown sand leached by organic acids

E2 – light grey to greyish brown sand leached by organic acids

Bh – accumulated organic matter, iron and aluminum, reddish brown color

Cg – grey sand with brownish mottles

Ridgeland

O – leaf litter, bark & wood
Ap – dark brown sandy surface soil containing organic matter, history of plowing
Bh – accumulated organic matter, iron and aluminum, reddish brown color, sandy

E – pale brown sand leached by organic acids

Bh1 – accumulated organic matter, reddish brown sand, slightly cemented and brittle

Bh2 – accumulated organic matter, dark reddish-brown sand, slightly cemented and brittle

Ellabelle

O – deep leaf litter

A – black loamy sand

Btg1 – grey sandy clay loam

Btg2 – grey sandy clay loam with brownish mottles

Bt – mottled yellowish brown & grey sandy clay loam

6 feet (200 cm)

FIGURE 5.2. Soil series at Wormsloe were developed in marine deposits, and most are sandy throughout a six-foot-deep profile. Soils containing a Bh horizon, with accumulated organic matter, aluminum, and iron (Bh), are the most common soil group at Wormsloe. Two soil series with Bh horizons that occur at Wormsloe include the moderately well drained Echaw and somewhat poorly drained Ridgeland series soils. Limited areas of soils such as the very poorly drained Ellabelle are formed in deposits that contain silt and clay and occur at the lowest elevations along drainages.

be seen in the Ellabelle soil series. A third type of soil series is common at Wormsloe, but these soils lack a B horizon and instead contain a C horizon immediately below the A horizon. These soils vary in color across the landscape but often have an organic, matter-rich A horizon followed by a yellowish-red, sandy C horizon. Where these soils were formed in sand, they are well drained. Where these soils occur in the interior forests, they are somewhat poorly drained. Examples of soils without a B horizon at Wormsloe are the Chipley and Foxworth soil series.

Soil series can be mapped across a landscape much as vegetation can. Soil mapping is used to plan ideal areas for agriculture, build a house, add a septic tank, and more. At Wormsloe, ten or more soil series occur, and these can be mapped to show their extent. Soils at the highest elevation—which occur along the center of the property—on the northern and middle portions of the property contain a Bh horizon and include soil series Echaw and Hurricane. At a similar elevation but on the southern end of the property, the soil series Mandarin occurs. Mandarin also contains a Bh horizon. Occurring at a slightly lower elevation and surrounding the central ridge of the property, two predominant soil series occur: Ridgeland and Chipley. The Ridgeland series contains two Bh horizons, one close to the surface and another at a deeper soil depth, whereas Chipley contains no B horizon. The Foxworth series tends to occur on old sand dunes along the eastern edge of the property. Soils developed in former marshes or drainage ways, containing clay, include the soil series Ellabelle and Rutledge.

FIGURE 5.3. Soil series that occur at Wormsloe are differentiated from one another based on the type and depth of the subsoil horizon and drainage. The relationships among common soils are illustrated in this diagram.

Soil Mapping

The National Resource Conservation Service (NRCS) has developed soil maps for 95 percent of the counties in the United States, and they are free to the public through the Web Soil Survey (https://websoilsurvey.sc.egov.usda.gov/App/HomePage.htm). These maps are developed by combining information on landforms, vegetation, and elevation with direct observation of the soil profile by a skilled professional. To directly observe the soil profile, soil scientists ordinarily use an auger to bore down into the soil from the surface and describe the type and depth of soil horizons. This information—along with data from samples collected and sent to the laboratory for determination of the particle size distribution, organic carbon, pH level, and concentrations of such elements as iron, aluminum, calcium, magnesium, and potassium—is used to classify the soil into its scientific name (soil series). Mapping is possible because similar soil profiles develop under similar conditions in repeating patterns on the landscape. For example, if a profile is observed on fine sediments near a stream in one portion of the landscape, it will also occur in similar conditions nearby.

The detail of soil maps or map scale differs depending on land use and the expected need for soil information. Most surveys are done at a map scale between 1:12,000 or 1:24,000, which means that one inch on the map represents twelve thousand to twenty-four thousand inches on land. At these scales, areas of dissimilar soils as small as two to three acres can be delineated. Areas of dissimilar soils smaller than this are included within larger map units. When a more detailed map is needed, a soil scientist will revisit the site, map at a much smaller scale, and make many more direct soil observations. Such was the case at Wormsloe, where over 150 soil profile descriptions were made and used to update NRCS soil maps.

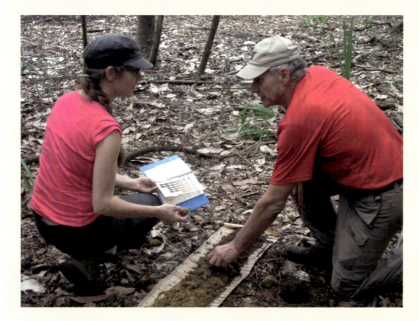

FIGURE 5.4. Soil scientists study the changes in soil horizons to identify the type and characteristics of a soil. Here, the authors have recreated the soil profile from a hole drilled into the soil. Note how the dark brown surface (top right) abruptly becomes yellowish brown, which is indicative of plowing at some point in the past. The yellowish brown color grades into gray colors deeper in the profile (lower left). This indicates that a water table often occurs in the soil at this depth. Image courtesy of authors.

FIGURE 5.5. The extent of soils at Wormsloe State Historic Site. The mapped series is the dominant soil found, but each of these soil series–based map units contains areas (inclusions) of other soils. Map by authors.

You will notice that different soil series occur in seemingly similar landscapes on the Wormsloe soil map. This is because soils are highly variable! Different soil series can be found just a few feet apart from each other. The type of vegetation, coupled with the rock (sand) found at Wormsloe and the area's climate, led to the development of soils with Bh horizons. Time plays another major role. For example, consider the Mandarin and Echaw soil series. On nearby St. Catherines Island, Mandarin soils occur on older Pleistocene-aged sediments, whereas Echaw soils are found on younger Holocene-aged sediments.[4]

Early Wormsloe residents appear to have understood inherent properties of the soil, at a time before science fully understood much of what we know about soils today. Maps of historic Wormsloe agriculture indicate that areas of the property containing the Chipley soil series were some of the first areas cultivated and, following the agricultural peak around the time of the Civil War, were some of the last agricultural areas to be abandoned. Most of the structures, including the home of Noble Jones (the tabby fort) and the family library, were located on areas containing the Foxworth or Echaw soil series that are located on the highest ground and thus are least likely to flood.

Land Use and Soil Change

The sandy sediments in which Wormsloe soils have developed contain few primary minerals, which are responsible for providing essential plant nutrients, and more clay-dominant soils are often too poorly drained to farm. As a result, Wormsloe soils tend to have low fertility and are very acidic, and most are somewhat poorly to poorly drained. None of these characteristics are ideal for agriculture. Moreover, sandy soils have a relatively low ability to store water after rainfall, which helps sustain crop growth between rainfall events. So, despite being near an abundance of water (the Atlantic Ocean), the soils of Wormsloe are prone to drought. By modern agricultural standards,

Color and Soil Horizons

🔥 The color of a soil is an important signal about its properties. Dark brown and blackish colors usually mean that a soil horizon contains a lot of organic matter. Most surface horizons are dark colored because of the organic matter incorporated into them from the activity of soil fauna such as beetles, ants, and earthworms. The colors below the surface are also important. Clean quartz sand, such as you would find at the beach, appears almost white. However, in most soils, sands are coated with compounds containing metals such as iron, aluminum, manganese, and, particularly, iron. In soils not saturated in water, these metals form oxide and hydroxide compounds that give soils their red, brown, and yellow colors. However, when soils are saturated, the soil microbes can use all of the oxygen in the soil. When this happens, some of these microbes will begin using these metal compounds, such as iron, to survive. This use changes the compounds and, in the case of iron, turns the substance from a red, brown, or yellow color to a gray or bluish gray hue. When these colors occur within the soil profile, it is an indication of saturated soil conditions and poor drainage.

Wormsloe soils are not well suited for row crop production, but row agriculture nevertheless occurred on-site in Wormsloe's history.[5]

Imagine the difficulty early farmers at Wormsloe had growing crops. First, they had to cut and remove the stumps of the many large pines and oaks that dominated the property. While the sandy soils were easy to plow, finding ways to irrigate and fertilize them would prove challenging. Most agricultural crops require fertile soils that are neither too acidic nor alkaline (pH of 6.0–7.0). Soils at Wormsloe have an average pH of 4.0, which is very acidic. Early farmers at Wormsloe would have constantly struggled to improve fertility and manage soil acidity. To address these challenges, oyster shells were crushed and spread on fields to raise the pH, and organic-rich muck was hauled from marshes to improve fertility. Animal manure provided a valuable source of nutrients, but having sufficient quantities to meet the demand for crop nutrients would have been challenging. Successfully producing commodities such as Sea Island cotton (which requires fertile soils with a pH between 5.8 and 8.0), which was grown at Wormsloe, required good soil. So, in 1857, Georgie W. Jones first arranged to import 10.5 tons of bird guano from the coast of Peru to apply to Wormsloe cotton fields.[6]

Human habitation on the Isle of Hope began thousands of years prior to European arrival. Native hunter-gatherer societies were common on the Georgia barrier islands three to five thousand years ago, or perhaps even earlier. While Native Americans did not practice agriculture, they hunted, fished, and lived year-round on the Isle of Hope. Remnants of their ocean harvest were left behind as shell refuse piles, known as shell middens. These middens, which can be up to nine feet high and hundreds of feet in diameter, are largely composed of oyster shells, but they also contain remains of other shellfish, plants, animals, and even pottery shards. Large rings may have been the result of intentional mounding activity, such as that associated with later Mississippian cultures. Small mounds were probably the household debris of peoples living in small villages with homes arranged in a circle. Where these middens are located, the soil properties and plant species that occur are altered. Oyster shells are mostly calcium carbonate—the primary constituent of agricultural lime, which is used to raise soil pH. As the shells in middens slowly weather and break down, they act as lime, increasing the soil pH from a level that might otherwise be as low as 4.0 to 7.0. Elevated levels of cation exchange capacity, calcium, phosphorus, and organic matter occur in midden-affected

Peruvian Guano and Wormsloe

Guano, the excrement from birds (and bats), is a valuable natural fertilizer that is still sold today. It is also a natural liming agent that was particularly beneficial as an amendment for the acid soils of Wormsloe. Where colonies of seabirds nest, large quantities of guano can collect. Such is the case on the Chincha Islands off the coast of Peru. Cormorants, pelicans, and boobies numbering in the millions have made the rocky volcanic islands their home for thousands of years. A combination of low rainfall and ample sunshine allows the guano to dry and to collect instead of washing away. In places, more than one hundred feet of guano coat the rocks on the islands. The publication of German scientist Justus von Liebig's Law of the Minimum in 1840 spurred worldwide interest in scientific agriculture and fertilization. By the middle of the 1800s, guano from Peru was fertilizing fields throughout Europe and North America. The miserable work of digging, hauling, and loading guano onto sailing ships was initially completed by convicts, army deserters, and slaves. Later, indentured workers from China were brought to Peru to complete these tasks.[1] It is estimated that 12.7 million tons of guano were exported from Peru between 1840 and 1880 with a value of $16.6 billion in 2018 dollars.[2] In 1857 George W. Jones ordered ten tons of guano to apply to fields of sea island cotton at Wormsloe.

1. W. M. Mathew, "A Primitive Export Sector: Guano Production in Mid-nineteenth-century Peru," *Journal of Latin American Studies* 9, no. 1 (May 1977): 35–57.

2. G. T. Cushman, "'The Most Valuable Birds in the World': International Conservation Science and the Revival of Peru's Guano Industry 1909–1965," *Environmental History* 10, no. 3 (July 2005): 477–509.

soils. Also, because oysters preferentially absorb manganese from ocean water, this micronutrient is transferred to the soils as the shells of the middens slowly weather, leading to increased concentrations of manganese in midden soils on Georgia's barrier islands.[7]

Other, subtler markers of native peoples can be found in the soils of Wormsloe. Native Americans used fire as a primary tool in shaping their environment. Fire was used to clear fields for agriculture, improve foraging for berries, improve hunting, and increase visibility and ease of travel. It also served as a weapon in tribal conflicts. Charcoal left behind by human- and naturally caused fire can be found deep within the soil of Wormsloe. One charcoal sample removed from sixteen inches below the surface was found through radiocarbon dating to be 810 years old and likely resulted from burning of the forest.[8]

The arrival of Europeans initiated a series of rapid changes to Wormsloe. Forests were cleared (and fire used again) and the land tilled and planted. Drainage ditches were excavated, water impoundments were created, and marsh mud, crushed oyster shells, and manure were spread upon the fields. Tools and pottery were made, used, broken, lost, and buried beneath new additions of household debris, waste, and soil. Each of these was a marker to its time.

No activity had more widespread impact than farming. Cultivation of rice and Sea Island cotton planted as commodities changed the nature of the surface soil, as did vegetable gardens, albeit with a more localized impact. In natural forests the surface of the soil is covered by a blanket of old twigs, pine needles, and leaves. Larger logs and branches from fallen trees are scattered across the surface. These support an entire ecosystem of soil flora and fauna. Pocket gophers, gopher tortoises, ants, fly and beetle larvae, worms, centipedes, and millipedes churn this organic layer into the soil. Along with soil microorganisms, they break it down and use it for the carbon structure of their bodies and the energy they need. In the process, they form a recognizable forest soil surface. Farming changes this, as tillage

FIGURE 5.6. A shell
midden at Wormsloe.
Source: Tommy Jordan.

destroys the surface organic layers and pushes them into the soil. Boundaries between soil horizons that reflected soil processes are replaced by the boundary created at the lower limit of the plow. At the same time, marsh muck, crushed shells, manure, and guano altered the chemistry of the soil. These changes can last decades to centuries after farming is abandoned and the land reverts to forest. Studies at Wormsloe illustrate this phenomenon. Consider the soil profiles of the Echaw and Ridgeland series shown in figure 5.2. The Echaw series was never farmed. Note how the lower boundary of the A horizon is wavy and irregular. In contrast, the Ridgeland series was farmed and abandoned. Although the forest floor has re-formed, the smooth, abrupt boundary between the A horizon and lower horizon is lingering evidence of plowing the soil surface.

Chemical changes resulting from farming also persist at Wormsloe. Although all the land has been used, some areas have never been farmed and have remained in forest cover since colonization. Animals were grazed among the trees and timber harvested in these areas, but they have not been plowed or fertilized as part of crop production. At the agricultural peak between 1865 and 1910, 55 percent of Wormsloe was cleared fields, and most (although not all) of the cleared area was used for crop production. These fields were abandoned over time: by 2010, less than 10 percent of Wormsloe contained open fields, and this portion consisted of lawn areas rather than fields of planted crops. These former agricultural areas returned to forest through the process of secondary succession and are largely indistinguishable from areas never farmed. One of the key differences in soils between these areas has to do with phosphorus. The sandy soils of Wormsloe have low concentrations of phosphorus, which is one of the essential nutrients for crop growth. Manure, shells, and guano applied to Wormsloe soils in the 1800s all contain high amounts of phosphorus, as do the inorganic fertilizers used in more

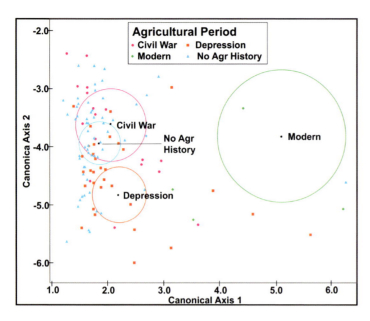

FIGURE 5.7. Soils beneath current forests that have previously been used for agriculture have different chemistry than forests that were never in agriculture. Only small differences occur between soils beneath never-farmed forests and forests in areas abandoned in the period following the Civil War. More recent abandonment results in greater differences. From J. H. Campbell and L. A. Morris, "A Soil Legacy of Land Use in the Lower Coastal Plain: A Case Study of Wormsloe State Historic Site," *Georgia Journal of Soil and Water Conservation* (2018).

modern times. Forested areas that were never farmed generally have lower soil phosphorus concentrations, averaging around fifty pounds per acre in the surface soil, than areas that are now forested but have some previous history of agricultural use, which average about 170 pounds per acre in the surface soil.

While agricultural use of Wormsloe soils resulted in a lasting increase in phosphorus concentrations, differences in other chemical constituents are not as apparent when forested areas are compared with areas that have some agricultural history. Especially with sandy soils, changes associated with agriculture tend to be lost after fields lie abandoned for a significant period of time. We sampled soil chemistry at 120 points on Wormsloe and analyzed how chemistry differed depending on the period of agricultural abandonment. Soil chemistry of forests that were never farmed are indistinguishable from agricultural fields abandoned after the Civil War, whereas agricultural fields abandoned by the time of the Great Depression—almost ninety years later—continue to have very different

soil chemistry from areas of the property that were never farmed.

Although the most widespread impact of early human activity on Wormsloe soils was agriculture, the most intensive impacts are near buildings where natural soil profiles have been replaced by anthropogenic soils—soils made by humans. The soil profile and chemistry reflect the activities of humans rather than natural soil processes. These soils, unlike those with naturally developed soil profiles, are highly variable on a small scale. Midden soils are one example of anthropogenic soil at Wormsloe. Soils of lands made by dredging on the southern tip of the Isle of Hope, near the site of the old tabby fort, near the old dairy, and near historic dwellings are more recent examples of anthropogenic soil. These anthropogenic soils can often be identified using noninvasive imaging of the soil by ground-penetrating radar, soil resistivity sensors, or electromagnetic induction. These techniques can detect changes in the soil that are not visible from the surface, such as buried debris.

Imaging the Soil beneath Our Feet

🦌 We used two noninvasive imaging techniques to investigate anthropogenic soils at Wormsloe, electromagnetic induction and electrical resistivity. In electromagnetic induction, changes in apparent electrical conductivity are measured by inducing an electromagnetic field that is then "read" by a sensor. In electrical resistivity, an array of probes is installed in the soil surface, a current established between probes, and the resistivity determined. Maps of the resistivity can be created from these sensor readings.

Electrical resistivity and electromagnetic induction were two noninvasive techniques used to investigate anthropogenic soils at Wormsloe. The grid used to place probes in the ground near the slave cabin is shown on the left. Coauthor Holly Campbell is shown running the electromagnetic induction (EMI) on the right.

Images of electrical resistivity at three depths from a disturbed soil near the slave cabin and forested site. Note the greater variability in resistivity at the cabin site resulting from soil mixing and addition of household wastes.

FIGURE 5.8. The grid used to place probes in the ground near the slave cabin. Image courtesy of authors.

FIGURE 5.9. Coauthor Holly Campbell is shown running the electromagnetic induction (EMI). Image courtesy of authors.

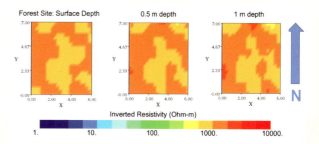

FIGURE 5.10, 5.11. Images of electrical resistivity at three depths from a disturbed soil near the slave cabin and forested site. Note the greater variability in resistivity at the cabin site resulting from soil mixing and addition of household wastes. From J. H. Campbell and L. A. Morris, "A Soil Legacy of Land Use in the Lower Coastal Plain: A Case Study of Wormsloe State Historic Site," *Georgia Journal of Soil and Water Conservation* (2018).

Additionally, anthropogenic soils often contain artifacts below the surface. The presence of artifacts also affects images of the soil. Examples of artifacts located by resistivity imaging near the old slave cabin at Wormsloe are shown in figures 5.12a and 5.12b.

a

b

FIGURE 5.12a, b. Artifacts found in soil samples collected near an old cabin. The top photo shows fragments of nineteenth-century pottery, animal bones, and oyster shells. The bottom photo shows nineteenth-century pottery and the stem of a tobacco pipe. From J. H. Campbell, L. A. Morris, and D. Markewitz, "Combining Electromagnetic Induction and Resistivity Imaging with Soil Sampling to Investigate Past Soil Disturbance at Wormsloe State Historic Site, Savannah, Ga.," *Soil Horizons* 56, no. 6 (November–December 2015), doi:10.2136/sh 15-07-0015.

Summary

The soils of Wormsloe, like soils of barrier islands elsewhere along Georgia's coast, are only marginally suited to agricultural production. Low fertility, high acidity, and poor water holding characteristics made them ill-suited to crop production. Yet Wormsloe succeeded where other farms failed—a tribute to the persistence of its owners and their ability to adapt to these soil limitations.

NOTES

1. G. T. Cushman, "'The Most Valuable Birds in the World': International Conservation Science and the Revival of Peru's Guano Industry 1909–1965," *Environmental History* 10 (2005): 477–509; W. M. Mathew, "A Primitive Export Sector: Guano Production in Mid-Nineteenth-Century Peru," *Journal of Latin American Studies* 9 (1977): 35–57.

2. D. J. Hillel, *Out of Earth—Civilization and the Life of the Soil* (New York: Free Press, 1991), 20.

3. J. H. Campbell, and L. A. Morris, "Land Use and Soil Legacy in the Lower Coastal Plain: A Case Study of Wormsloe State Historic Site, Georgia," *Journal of Soil and Water Conservation* 73, no. 4 (July 2018): 386–399, https://doi.org/10.2489/jswc.73.4.386.

4. E. J. Reitz, D. Linsley, G. A. Bishop, H. B. Rollins, and D. H. Thomas, "A Brief Natural History of St. Catherines Island," chap. 5 in *Native American Landscapes of St. Catherines Island, Georgia*, Anthropological Papers of the American Museum of Natural History, no. 88 (New York: American Museum of Natural History, 2008), 48–61.

5. G. B. Mahajan and L. Balachandran, "Sources of Antibiotics: Hot Springs," *Biochemical Pharmacology* 134 (2017): 35–41.

6. D. A. Swanson, *Remaking Wormsloe Plantation: The Environmental History of a Lowcountry Landscape* (Athens: University of Georgia Press, 2012).

7. V. Barbin, K. Ramseyer, and M. Elfman, "Biological Record of Added Manganese in Seawater: A New Efficient Tool to Mark In Vivo Growth Lines in the Oyster Species *Cassostrea gigas*," *International Journal of Earth Science* 97 (2008): 193–199; C. K. Smith and D. A. McGrath, "Alteration of Soil Chemistry through Shell Deposition on a Georgia (U.S.A.) Barrier Island," *Journal of Coastal Research* 27 (2011): 103–109.

8. J. H. Campbell, L. A. Morris, and D. Markewitz, "Combining Electromagnetic Induction and Resistivity Imaging with Soil Sampling to Investigate Past Soil Disturbance at Wormsloe State Historic Site, Savannah, Ga.," *Soil Horizons* 56, no. 6 (November–December 2015): 1–10, doi:10.2136/sh15-07-0015.

Insects

The Good, the Bad, and the Beautiful in Lowcountry Gardens

C. RONALD CARROLL, UGA professor emeritus, UGA Odum School of Ecology, and director emeritus, UGA River Basin Center

Insects are perhaps the most underappreciated and misunderstood element in our food system. They are dominant participants heavily influencing ecosystem functions worldwide. Here we consider the broad concept of ecology through the effects of insects in our food gardens and farm fields. The long, warm, moist growing season in the Lowcountry supports an abundance and diversity of insects, which exert significant control, both historically and currently, over crop productivity. In addition to the numerous beneficial insects in the Lowcountry, food crops are increasingly under assault from invasive (nonnative) insects that continue to arrive undetected in global imports. This chapter considers the ecological relationships of insects in farm fields and home gardens, and in the next chapter we take a close look at Lowcountry pollinators.

Carroll concentrates on the ecological relationships of cultivated food plants and insects. An agroecology field as well as a home vegetable garden encompasses the attributes of a complex ecosystem. They support herbivores, carnivores, omnivores, detritivores, and mutualists. Detritivores and burrowing insects such as ants help break down mineral and organic matter to improve nutrient uptake by plants. The sum of these complex interactions tells us that crop yield is a product of many ecological interactions and mutually beneficial relationships. Sustainable food production is more complicated than planting seeds, watering, applying fertilizer, and harvesting.

Survival of the human race is dependent on functioning ecosystems, and the accelerating loss of pollinators is an existential threat to terrestrial

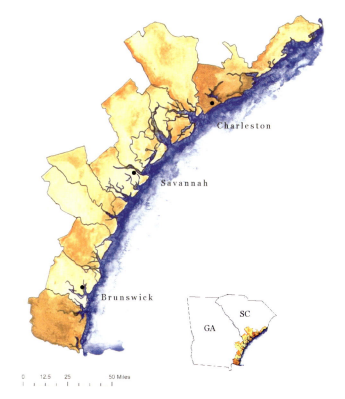

systems. Between 75 and 95 percent of all flowering plants on the earth rely on animals for pollination. More than 180,000 different plant species and more than 1,200 crops require pollinators. That means that one out of every three bites of food you eat is there because of pollinators. Growing food is one of the most critical services provided by the environment, yet industrial agriculture threatens pollinators worldwide, instigating a global pollination crisis. Insects dominate terrestrial life on earth and profoundly affect the quality of our lives, particularly our abundance of food. The importance of essential ecosystem services provided by insects cannot be overestimated. As the enduring maxim advises, insects actually rule the world and, so far, have let us share it with them. The Lowcountry's warm, moist conditions for much of the year produce favorable conditions for insects to thrive. As local farmers know well, this is an environment teeming with insect life. Growing food plants at any scale in the Lowcountry—from a backyard raised bed to a commercial truck farm—relies on irreplaceable insect pollinators. At the same time, growers struggle to manage troublesome or "bad" insects. But we underestimate or disregard destructive, as well as beneficial, insects at our peril. As one marketing slogan for bee merchandise puts it: "If we die, we're taking you with us."

Considerable expanses of monocrops, such as corn and soybeans, generate extensive and long-term harm to the environment. Monocultures require vast amounts of water for irrigation, eliminate biodiversity within and adjacent to agricultural fields, and require substantial amounts of biocides and synthetized fertilizers. These requirements result in a diminishing volume of water in aquifers and the buildup of biocides and other toxic chemicals in and around farmlands. Biocides threaten human health and lead to widespread destruction of pollinator species. Pollination by insects is and always has been required for the production of the majority of species cultivated for food, including fruit, nut, vegetable, and oil crops. Pollinators are also adversely affected by the warming climate, which is shifting the synchrony between flowering of crops and readiness of their insect pollinators.

Phenology is the study of cyclic and seasonal activities of plants and animals. Photoperiod, weather, and climate are the primary factors influencing phenologically instigated behaviors. Flowering plants and pollinators co-evolved to synchronize their activities benefiting plant reproduction and food resources necessary for pollinator survival and reproduction. A warming climate is disrupting the timing of flowering and the activity of pollinators. Temporal mismatches or asynchrony between flowering and pollinator activity threatens agriculture worldwide. Crops and livestock are routinely subjugated to the direct and indirect effects of weather and climate. Climate change fuels more destructive droughts, floods, wildfires, winds, storm events, tornadoes, and—especially noteworthy in the Lowcountry—hurricanes. In addition to the obvious problems caused by severe weather events, indirect effects from an average warming of only a couple of degrees include an increase in the abundance of agricultural insect pests, aggressive weeds, and lethal pathogens. Unlike the slow evolutionary variations through deep time, these changes are remarkable for the speed in which they advance.

The following chapter on "good" and "bad" insects in the Lowcountry explains the ecological role of the insects we encounter in our backyards and gardens. Insect pollination in the succeeding chapter emphasizes the most common insects in South Carolina and Georgia, the ones most likely to visit your yards, gardens, and farms. There are comprehensive lists for native Lowcountry plants that support pollinating insects and tips on landscaping with native plantings to create your own flourishing, pollinator sanctuary. 🐝

How Important Are Insects?

Insects are directly protectors, pollinators, and consumers of our food. Indirectly, they also greatly affect our agriculture and home gardens in a negative way by serving as vectors for plant diseases but play an even more important positive role by breaking down organic matter to

make nutrients available to plants. These varied roles are explored in this chapter. The focus is on plant-based agriculture, so the important role of livestock is not included. In this broad direct and indirect context, the economic value of insects to our food supply has been estimated to be approximately $57 billion in the United States.[1] This number does not include the value of pollinators, which for honeybees alone has been estimated at $15 billion annually.[2] In other words, insects play a critically important role in securing our food supply.

Although the topic is not covered in the body of this chapter, it is certainly worth mentioning that we eat insects, and they will likely form an increasing part of our diet in future decades. The human consumption of by-products of insect physiology—honey from bees, honeydew from scale insects and other homopterans, and certain "honeypot" ants—has a history that is thousands of years long.[3] Bees and honey production are well known, but it is worth noting the cultural value of these lesser-known honeydew producers. The Bible, the Torah, and the Koran all mention "manna from heaven." The sweet droplets of manna harvested on the ground are credited with helping the Israelites survive their long exodus from Egypt. One common explanation for the origin of manna is that it was the dried droplets of honeydew secreted from scale insects feeding on tamarisk trees along watercourses where the Israelites were likely to have had encampments. Indeed, manna is still harvested in arid parts of North Africa and the Middle East. The legacy of manna saving the Israelites is still celebrated today in the braided challah bread eaten on Jewish Shabbat.[4]

Globally, more than two thousand insect species, mostly the immature of beetles, moths, grasshoppers, and crickets, are consumed by more than two billion people. There are good reasons why insects will become increasingly important as human food. Insects are poikilotherm (cold-blooded); hence, more of their diet is converted to biomass and reproduction than is the case with birds and mammals, which must spend calories maintaining constant body temperatures. This high efficiency in food conversion, coupled with their short generation times, means that relatively large populations can be raised on relatively small amounts of food and in relatively small spaces. Furthermore, many insects can be reared on food that is not edible to us. Insects have a nutritional value similar to beef and often contain important micronutrients. Therefore, insects have the potential for making substantial contributions to our future food security.[5]

The Agricultural Field as a Distinct Ecosystem

An agricultural field and even a home vegetable garden have all the attributes of a complex ecosystem (or agroecosystem—the living and nonliving components of an agricultural area affected directly or secondarily by farming activity). They support herbivores, predators, mutualists, omnivores, and detritivores, as well as abiotic ecosystem functions. With facilitation from detritivores breaking down organic matter and burrowing insects such as ants, mineral and organic matter are mixed, thereby improving nutrient uptake by plants. The sum of these complex interactions tells us that crop yield is a product of many ecological interactions, not just seeds, tillage, fertilizer, and pesticides. In fact, the overuse of these common agricultural practices can disrupt normal ecosystem processes and possibly reduce crop yield. Excess tillage can result in loss of organic matter, which can negatively affect retention of plant nutrients and also result in vulnerability to soil compaction. Too much fertilizer can increase weed competition and disrupt bacterial symbionts with plant roots, and high nitrogen can injure root hairs. Even applying organic fertilizer is not without risk. In commercial pastures, poultry litter is commonly applied both as an organic fertilizer and as a means of disposal of poultry waste. Commercial poultry production is a rapidly growing agricultural industry in southern states, and poultry

litter is seen as a valuable byproduct. Southern soils tend to be nutrient poor, especially for phosphorus, and poultry litter is an excellent amendment. However, unless it is composted, excess poultry litter used as fertilizer can damage plant roots and may be contaminated with pathogens.[6]

Working with the Agroecosystem, Not against It

The value of an agroecosystem is its potential to produce a healthy, economically viable, and sustainable harvest. To realize that potential, we need to work with the agroecosystem to enhance its useful components and not work against it. Insects and other invertebrates can play an important role in the enhancement of useful agroecosystem functions but, of course, pest species can degrade their value. Poultry litter as fertilizer provides an interesting example of how insects can be used to improve the agroecosystem. Insects have been used to transform poultry litter into a safe fertilizer. Not only do soldier fly larvae (Stratiomyadae) reared in poultry litter decompose the material into high-quality fertilizer, but the fly larvae and pupae are themselves eagerly eaten by poultry.[7] The resulting high-quality fertilizer can not only be used on pastureland but can be safely sold to home gardeners for growing vegetables.

An especially egregious example of working against the useful functions of the agroecosystem occurs when pesticides are overused to control invertebrate pests, disease, and weeds. Pesticides kill beneficial as well as harmful species, thereby disrupting the agroecosystem. The effect is especially serious when broad-spectrum pesticides are applied over large areas. It has been known for many years that overuse of pesticides can result in a phenomenon known as the "pesticide treadmill." When pesticides kill off beneficial predators and parasites of pests, farmers will rely more on pesticides to protect their crop. Over time, pests evolve resistance to a pesticide and even more must be applied to achieve control. Unfortunately, beneficial species often show much less development of resistance to pesticides. As a result, more pesticides are applied in an attempt to control resistant pests and more beneficial species are harmed. Hence, we have the treadmill analogy. The large and growing number of pests that are resistant to one or more pesticides shows just how serious this problem has become. Some weeds, such as pigweed, are resistant to almost all herbicides, and some insect pests, such as green peach aphid, Colorado potato beetle, diamondback moth, corn earworm, and whiteflies, are resistant to virtually all insecticides. Several thousand insect pests are resistant to one or more insecticides, and the numbers keep growing. Of course, when pest outbreaks are severe and threaten economic returns, chemical control may be necessary. However, the prophylactic use of pesticides as insurance against possible future crop damage is problematic, because it leads to greater resistance at the same time that it kills beneficial plants and insects, and should generally be avoided.

Why Are Beneficial Species Especially Vulnerable to the Use of Pesticides?

There are several reasons why pesticides, especially broad-spectrum ones, are generally more harmful to beneficial species than to pest species. The most important reason is that beneficial predators and parasites are often more likely to encounter pesticides because they move in search of prey and hosts. This is also true of pollinators that fly from flower to flower. In contrast, herbivores often feed in less exposed places such as inside rolled leaves or stems or even just on the underside of a leaf, where exposure to predators, parasites, and pesticides is reduced. Another likely reason is that as herbivores, pest insects have over many thousands of generations evolved metabolic adaptations to the protective hostile chemistry of their hosts. A pesticide is just one more chemical defense to overcome. Pollinating insects, mainly bees and butterflies, are

especially vulnerable to pesticides—not only because of their great exposure but because the generally nontoxic nature of their food, pollen and nectar, means that they have likely lost the ability to overcome toxic chemicals.

What Are the Good, Bad, and Beautiful Insects?

"Good insects" are those that serve one of two primary functions: they kill "bad insects" (herbivores and disease vectors), or they improve crop yield and quality. Predatory insects (and spiders) and a special class of predators, known as parasitoids, are major sources of mortality to pest insects, especially caterpillars and aphids. A parasitoid is usually a wasp or tachinid fly that grows from an egg laid in a host insect. The developing parasitoid feeds on the host, eventually killing it. A parasitoid is a slow-acting predator. If you have a vegetable garden you may have seen the white cocoons of a braconid wasp parasitoid on tomato hornworms or the black mummified cocoons of an aphid wasp parasitoid among the living aphids. The most important parasitoids belong to the families Ichneumonidae and Braconidae, which mainly, but not exclusively, attack caterpillars, and the superfamily Chalcidoidea, which primarily attack insect eggs and small, soft-bodied insects, although a few are pests of agricultural seeds. There may be as many as 500,000 species of Chalcidoidea.[8]

The major predatory insects include the following families:

Coccinellidae (Coleoptera). Though some, such as the Mexican bean beetle, are important pests, the ladybird beetles are major predators as larvae and adults on aphids and mealy bugs.

Reduviidae (Heteroptera). These are sucking bugs that attack insects in many orders and families. They are indiscriminate predators, attacking both pests and nonpests. The large wheel bug is a familiar southern species.

(Odonata). Dragonflies and damselfly adults mostly attack flying insects. They can be important predators on day-flying Lepidoptera and Diptera.

Tachinidae (Diptera). The adults are important parasitoids and mainly attack caterpillars.

Although they are not insects, spiders need to be mentioned here because they are also important predators of insect pests—and in fact may be even more significant than insect predators.

Insects in the Southern Environment

Insects are ectotherms, meaning that they are "cold-blooded." Their metabolic rate is strongly affected by temperature, rising in warm temperatures and declining when their surroundings are cooler. Insects living in the warm, moist Coastal Plain of the South likely experience higher metabolic rates than their more northern cousins—although once species adapt to higher temperature regimes, their metabolic rate becomes less sensitive to rising temperatures. There are important implications for having an increased metabolic rate. Most obviously, food consumption must increase to offset losses through increased respiration. For predators, more prey must be consumed. If the prey are pests, this is a good thing. But for pest insects that may need to consume more plant tissue, it is a bad thing. The trade-offs between increased predation and increased herbivory will largely determine the net impact of pest and predator on agriculture. However, there are other considerations. Higher nighttime temperatures mean plants have greater respirational losses of photosynthate. During hot southern summers, plants may reach their upper thermal maximum by early afternoon and photosynthesis may shut off. So southern crop plants may make less photosynthate during the day and lose more from respiration during warm nights. And, of course, respirational losses also occur during the day. What all this means is that the

replacement costs of eaten tissue are greater for southern plants, and therefore the cost of herbivory is greater.

To Improve Agroecosystem Functions, What Are the Rational Responses to These Complex Interactions?

There are several ways to enhance agroecosystem functions to improve harvest yields. Rates of predation may be increased by augmenting the number of predators. For example, ladybird beetles can be released in cabbage fields to control aphids or Cotesia wasp parasitoids to control tomato hornworms in tomato, tobacco, or bell pepper fields. Predators or parasites should not be introduced into fields unless their natural history is known well enough to avoid unanticipated consequences. For example, lacewing larvae (of the Neuroptera family) are voracious predators that will attack beneficial ladybird eggs, larvae, and pupae. Pest insect populations are known to fluctuate widely and may not always be available as food for predators or parasitoids. To avoid local extinction of beneficial predators and parasitoids, it is important to provide alternate food during times when pest populations are low. Assuming you are not dealing with highly host-specific beneficials, one way to provide support is by maintaining borders of wild plants around the periphery of the crop field. Such borders will support diverse alternative prey and hosts, provide refugia for beneficials when the field is harvested, and become a source area for recolonization of the field in the following growing season. The use of fallow plants can also provide important food once the crop is harvested. For example, planting red clover or buckwheat during the fall following a season of cantaloupe will not only enrich the soil but will provide continued support for populations of bee pollinators, predators, and parasitoids that may then recolonize during subsequent crops.

Pollination rates may be increased by providing additional nest sites, such as mud walls for alfalfa bees, artificial stems for wild orchard bees, and bare soil patches for ground-nesting bees. Including more nectar-producing wild plants will provide energy to pollinators and parasitoid wasps. If enhancing pollination is a goal, one should focus on ways to increase wild bee and butterfly populations. Wild bees are especially important pollinators. Unlike honeybees, which pack pollen into specialized corbiculae that then become unavailable to plants, wild bees are often coated with branched hairs that trap pollen grains. This pollen is easily transported to new flowers for pollination.

Concluding Thoughts

This chapter has focused on the significance of pest and beneficial insects within agricultural fields and gardens. However, the most important insect in the agricultural economies of colonial plantations was the mosquito. Colonial plantations were highly labor intensive. Diseases such as yellow fever and malaria took a heavy toll among field workers. In fact, African slaves became the economic backbone of plantation agriculture largely because they were thought to be resistant to malaria. This was especially important on tidewater rice plantations, where standing and slow-moving water provided prime breeding areas for mosquitoes. (See chapter 14 for a discussion of tidewater rice production.)[9]

NOTES

1. J. E. Losey and M. Vaughan, "The Economic Value of Economic Services Provided by Insects," *BioScience* 56, no. 4 (2006): 311–323.

2. FDA, "Helping Agriculture's Helpful Honeybees," July 30, 2018, https://www.fda.gov/animal-veterinary/animal-health-literacy/helping-agricultures-helpful-honey-bees.

3. C. R. Carroll and D. H. Janzen, "Ecology of Foraging by Ants," *Annual Review of Ecology and Systematics* 4 (1973): 231–257.

4. J. Astaire, "The Evolution of Challah," Kosher.com, September 18, 2017, https://www.kosher.com/lifestyle/the-evolution-of-challah-200.

5. A. Van Huis, J. Van Ltterbeeck, H. Klunder, E. Mertens, A. Halloran, G. Muir, and P. Vantomme, *Edible Insects: Future Prospects for Food and Feed Security*, FAO Forestry Paper 171 (Rome, Italy: Food and Agriculture Organization of the United Nations, 2013).

6. M. Terzich, M. J. Pope, T. E. Cherry, and J. Hollinger, "Survey of Pathogens in Poultry Litter in the United States," *Journal of Applied Poultry Research* 9, no. 3 (2000): 287–291.

7. M. N. Moula, L. Scippo, C. Douny, G. Degand, E. Dewans, J. F. Cabaraux, J. LucHornick, R. C. Medigo, P. Leroy, F. Francis, and J. Dettilleux, "Performance of Local Poultry Breed Fed Black Soldier Fly Larvae Reared on Horse Manure," *Animal Nutrition* 4, no. 1 (2018): 73–78.

8. J. S. Noyes, *Catalogue of Chalcidoidea of the World* (Amsterdam: ETI, 1998), (CD-ROM).

9. For more information on the significance of malarial mosquitoes in colonial rice production, see H. R. Merrens and G. D. Terry, "Dying in Paradise: Malaria, Mortality, and the Perceptual Environment in Colonial South Carolina," *Journal of Southern History* 50, no. 4 (1984): 533–550; and Peter McCandless, *Slavery, Disease, and Suffering in the Southern Lowcountry* (New York: Cambridge University Press, 2011).

REFERENCES/RESOURCES

For additional information, here are four good reference sites for beneficial insects and spiders and pest insects and mites in southern gardens and crops.

"Beneficial Insects." University of Florida. IFAS Extension. https://edis .ifas.ufl.edu/topic_beneficial_insects.

Charbonneau, Jordan. "5 Predatory Insects Native to the Southeastern U.S." Southern Exposure Seed Exchange, July 15, 2020. https://www.southernexposure.com/blog/2020/07/5-predatory -insects-native-to-the-southeastern-u-s/.

Feaster, Felicia. "44 Common Garden Pests." HGTV. https://www.hgtv. com/outdoors/landscaping-and-hardscaping/16-common-garden -pests-pictures.

"Garden Pest Insects." University of Florida. IFAS Extension. https:// edis.ifas.ufl.edu/topic_garden_pest_insects.

CHAPTER 7

Insect Pollination in the South Carolina and Georgia Lowcountry

B. MERLE SHEPARD, professor emeritus of entomology, University of South Carolina; **EDWARD G. FARNWORTH**, adjunct professor of entomology, Clemson University's Coastal Research and Education Center; **DWIGHT WILLIAMS**, owner of Bottle Tree Gardening in Charleston, South Carolina; and **APRIL BISNER**, project manager, College of Charleston biology department

Insect pollination is a highly interactive, mutually beneficial process between plants and insects that has coevolved over millions of years. Plants are pollinated; insects get food, shelter, and chemicals, as well as courting areas in and around plants. Plants have evolved chemical and physical attractants that increase the probability that insects will find their flowers and will carry pollen to other like plants. These attractants include flower size, depth and width of the corolla, flower color, including nectar guides, ultraviolet visibility, scent, amount of nectar, and nectar composition.

Plant-pollinator networks have evolved a mutualistic relationship with wild pollinators visiting many plant species, as well as a given plant species visited by many different pollinators. In some cases, this has coevolved to the point where a single insect species may pollinate only a single plant species. These mutual dependencies provide support for both plants and insects in environmentally stressful periods, but given very harsh environmental stresses, the mutualistic associations could collapse.

Pollination—a service provided mostly by insects—is essential because of the ecological and human benefits it supports. Up to 80 percent of the world's crop species are dependent on pollination. In the United States, more than one hundred crops need or benefit from pollinators. Pollination contributes $24 billion annually to the U.S. economy, and honeybees contribute about $15 billion annually. Honeybee culture is critical for food production in the United States. Melon, orchard, and nut farmers rely

heavily on pollination from hived honeybees transported to their orchards and fields by commercial apiculturists.

Why the great current interest in pollinators? For the last few years the media have been replete with stories about the decline of honeybees and wild bees. Reports confirm that native pollinators are in serious decline, and food and fiber crop production is being negatively affected. Habitat loss, habitat fragmentation, farming monocultures, pesticides, parasites, and climate change have been identified as causes.

Pesticides, mainly neonicotinoids, a relatively new group, are now widely used in crop protection and show severe negative effects on insect pollinators. Climate change may be affecting pollination as well, because as plant flowering time changes with increased warming, their insect pollinators are likely to be to out of synchrony or not available at the right time to pollinate the blossoms. The decline of honeybees from colony collapse disorder and other factors has reduced the available number of bees and hives for commercial pollination services.

Clearly pollination and pollinators are critical to the natural and cultivated ecosystems. There is a growing need to protect, conserve, and enhance our native pollinators, particularly native bees.

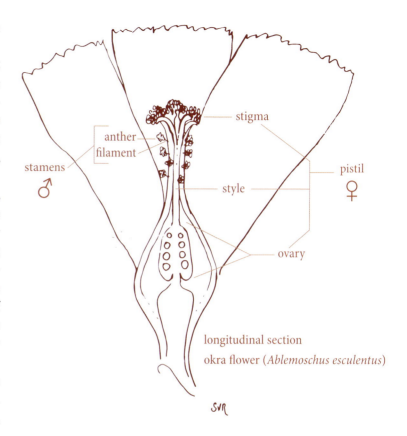

FIGURE 7.1. A diagram of a flower's anatomy. Drawing by Sarah V. Ross.

Pollination

Pollination is essential for the life of flowering plants. Pollen must move from the plant's male parts to the female parts for seeds to develop and for the plant to reproduce. Pollination may occur as self-pollination, the movement of pollen within a flower or between flowers of the same plant, or as cross-pollination, the movement of pollen among flowers of different plants. Most plants require cross-pollination to produce seeds, and insects are major vehicles for this pollen transfer.

A flower is made up of male and female structures. The male part is called a stamen and consists of a thin filament with a bulbous end, the anther. The anther produces pollen, which contains the male sex cells, gametes. The female part is collectively known as the pistil and is formed by one or more carpels. Each carpel has a sticky, feathery tip, the stigma; an ovary, containing the ovules, the female sex cells; and a stalk-like extension, the style, connecting the stigma and ovule. When a pollen grain reaches the stigma, it germinates and sends a microscopic tube down the style to the ovule. The male gametes are carried to the ovule through this tube, and fertilization occurs.

Flowering plants have evolved different strategies to disperse pollen. About half the flowering plants require pollen that comes from another plant, and close to 75 percent rely on animal pollinators, mainly insects, to transfer pollen. Insect pollinators and flowering plants have co-evolved, changed, and adapted together for mutual benefits. Plants have developed unique methods to attract pollinators, and pollinators have developed specialized structures and behavior to take advantage of the plants' rewards. Flowers have evolved physical and chemical means to attract pollinators, such as brilliantly colored petals, attractive designs and patches, and aromas. Insects, in return for carrying pollen to flowers, are rewarded with nectar, a sugar, and pollen, a protein food source.

Most plants need a diversity of pollinators to survive, and most pollinators require a diversity of flowers as food sources. Plants and their pollinators are constantly adapting to changes in climate, weather, diseases, predation, and so forth to continue this cobeneficial interaction, pollination and nourishment.

Hymenoptera: Bees, Wasps

The order Hymenoptera is the third largest group of insects, numbering over 195,000 described species worldwide, and includes bees, the most important pollinators, wasps, sawflies, and ants. These insects range from solitary species to those with highly developed social systems, such as the honeybee.

The most important pollinating species are bees, particularly honeybees, bumblebees, and carpenter bees. However, many smaller bee species provide essential pollinator services to wild and cultivated crops by directly collecting pollen, transmitting pollen on their bodies, and using "buzz pollination," which occurs when the bee grabs the flower and vibrates its wings, thereby releasing the pollen from the anthers. This activity is common in bumblebees and carpenter bees; honeybees do not buzz pollinate flowers.

FIGURE 7.2. A female southern carpenter bee. Courtesy of B. Merle Shepard.

FIGURE 7.3. A female eastern carpenter bee. Courtesy of B. Merle Shepard.

FIGURE 7.4. The American bumblebee. Courtesy of B. Merle Shepard.

FIGURE 7.5. The two-spotted bumblebee. Courtesy of B. Merle Shepard.

Solitary bees, bumblebees, carpenter bees, and honeybees are avid pollen and nectar collectors, with honeybees utilized commercially to pollinate agricultural crops. Most bees are ground nesters, but many nest in hollow stems and other secretive places. Braconid and ichneumonid wasps are almost exclusively parasitic on caterpillars and are important in biological control of pest species.

The magnitude of the positive impacts of hymenopterans is enormous. Relatively few hymenopterans are considered pests; the vast majority provide the planet with services that are immeasurably valuable.

Important Bee Families

APIDAE

This family contains about 5,700 species worldwide, including the larger and most commonly seen bees, such as the cuckoo, carpenter, bumble, digger, long-horned, and Western or European honeybee. Collectively, these bees are the most important pollinators of agricultural crops as well as of wildflowers, trees, and many cultivated fruit and nut trees. Most bees in this family are solitary, but many are social or eusocial where there is a division of labor, and some members are nonreproductive.

The European honeybee is a major pollinator of wild and cultivated plants. Honeybees and other pollinators support the production of eighty-seven of the world's major crops. Pollinator-dependent crops are five times more valuable than plants that do not rely on insect pollination. Commercial beekeeping adds $15 to $20 billion to agriculture each year. In North America, more than ninety-five kinds of fruits, such as apples, cranberries, and avocados, and trees, such as almonds, are pollinated by honeybees.

Unfortunately, numbers of honeybees continue to decline. Each winter since 2006, about 30 percent of honeybee colonies have been lost. Reasons for this decline include large-scale agricultural practices that lead to loss of habitat and plant biodiversity; pesticides used on farms,

FIGURE 7.6. The western honeybee. Courtesy of B. Merle Shepard.

gardens, and lawns and for mosquito control; diseases such as American foul brood caused by a rod-shaped bacterium (*Paenibacillus larvae*); *Nosema*, a protozoan parasite; the small hive beetle, *Aethina tumida*; and varroa mites.

Recent research has shown that one of the most widely used insecticides, neonicotinoids, is particularly damaging to honeybees, and no doubt to native bees. This group of chemicals dissolves in water, travels via surface water from agricultural areas and home lawns, and is taken up by plants long distances away from the source.

Another factor contributing to colony losses is invasion by the Africanized honeybee. When these bees invade normal honeybee hives, colonies become aggressive and must be destroyed.

ANDRENIDAE

Members of this large family of bees, with some three thousand species worldwide, are known as mining bees. They are small (0.8 inch; 2.0 centimeters) or even smaller, solitary, and brown or black. They are ground nesting, favoring

sandy soils along paths, dry roadbeds, and areas with sparse vegetation. Mining bees dig holes approximately two to three inches deep with about eight side chambers. A pollen ball is placed in each chamber in which an egg is laid and then the chamber sealed. Larvae develop and pupate inside the pollen ball. Some species are crepuscular and have enlarged ocelli. All bees in this family have short tongues.

MEGACHILIDAE

This is the second-largest family of bees after the Andrenidae. Most species within this family are solitary, with the pollen-carrying structure (scopa) located on the ventral surface of the abdomen rather than on the legs as in many other bee families. They also have hairs on their faces used to collect pollen from hard-to-reach areas of the flower. They are moderate-sized bees (0.24–0.71 inches; 6–18 millimeters). Megachilids are most commonly known as mason bees, which use clay to make nests, and leafcutter bees, although a few species use animal hair and fibers for nest building. Many species build their nest cells using soil or leaves. Some members of this family are cleptoparasites of other bees.

HALICTIDAE

Sixteen genera are found in the family. Several species are black, green, or gold metallic in color. Many species are social and have nests with queens and workers living together. Some are specialist feeders, while others feed on a wide range of flowering plants. For example, members of the genus *Lasioglossum* collect pollen and take nectar from over fifty plant species. Most species are ground nesters, with long mines of interconnecting tunnels that may be used year after year. Some members of this family are called sweat bees because they are attracted to the salt in human sweat.

Important Wasp Families

VESPIDAE

With approximately three hundred species in North America, Vespidae are a large and diverse group of wasps that contain some of the most commonly encountered species. They may be eusocial, social, or solitary. Most vespids take nectar from flowers and in the process move pollen from flower to flower. In addition, they are considered natural biological control agents because they prey on other insects, usually caterpillars, which they feed to their young. Although hornets and yellow jackets are in the Vespidae family, they are not usually seen taking nectar from flowers. Potter and mason wasps are vespids.

SPHECIDAE

Members of this family are called thread-waisted wasps because the abdomen has a long stalk (pedicel) that gives the wasps a "thread-waisted" look. Sphecids range in color from black, or white and black (sometimes tinged with metallic blue or green), to black and red, to yellow and black. Most are ground nesters, but others build mud nests on walls or other structures. A few nest in abandoned bee burrows or in hollow stems. Adults feed on nectar from flowers, on extrafloral nectaries, and on fluids from parasitized prey. Larvae feed on insects and spiders that have been stung and paralyzed by adults. Most are solitary, and a few use prey caught by other wasps (cleptoparasitism).

CRABRONIDAE

Wasps in this family are called square-headed wasps. They range in size from 0.02 to 0.78 of an inch (0.6–2.0 centimeters). Adults are commonly found on flowers. Some crabronid species nest in abandoned galleries in wood, hollow stems, or burrows in the ground. Larvae feed on prey paralyzed by the adults and brought back to the nest. For example, the mole cricket hunter, *Larra bicolor*, parasitizes a mole cricket outside the burrow, and then the cricket returns to its

burrow with the parasitoid egg attached. Some species are cleptoparasitic—their larvae consume prey items captured by other species of wasps. Crabronids take nectar from a wide range of flowers, pollinating flowers in the process.

SCOLIIDAE

Wasps in this family are hairy, robust, and very numerous in the southeastern United States, although only a few species are present. Adults take nectar from a wide variety of plants. Females dig into the soil, sting and paralyze ground-dwelling scarab grubs, and then lay an egg on the grub that will serve as food for the developing wasp larva.

THYNNIDAE

These wasps, sometimes called flower wasps, are solitary. Females sting and paralyze the larvae of beetles and lay an egg on the beetle larva, which serves as food for the developing wasp larva. Most thynnid wasps are small, but some may be three centimeters long. Besides moving pollen from flower to flower, they are considered biological control agents against some beetle species pests.

POMPILIDAE

Members of the family are called spider wasps. They range in size from 0.2 to 1.6 inches (0.5–4.0 centimeters) and most are dark colored with smoky or yellowish wings. The tibia of the rear legs has two prominent spines. Females paralyze a spider and take it back to their nest to lay an egg on it, while other species paralyze the spider, lay an egg on it, and leave the spider in its nest or web.

Diptera: Flies

The insect order Diptera consists of the true flies—insects with only one pair of wings attached to the second segment of the thorax. Approximately 25,000 species of flies have been described in North America and about 150,000 species described worldwide.

FIGURE 7.7. The common green bottle fly. Courtesy of B. Merle Shepard.

Flies are an extremely diverse group of insects and are of medical and biological significance. Blood-sucking species, such as mosquitoes, are vectors of debilitating and life-threatening diseases such as malaria, yellow fever, and dengue fever. Some flies are serious pests of fruit and cause extensive economic losses, whereas others are beneficial as pollinators and parasites of insect pests. Bee flies and hover flies are important pollinators and extract pollen and nectar from flowers.

Important Fly Families

SYRPHIDAE

This is a large and diverse group of flies with some eight hundred species in North America. Many species visit flowers to feed on nectar, thereby moving pollen between and among flowers. During the larval stage, many syrphids are predatory on other insects, particularly aphids. In addition to providing the valuable ecosystem service of

pollination, they are considered natural biological control agents. Syrphids are also called hoverflies because of their habit of hovering in one spot. The color patterns of many mimic those of bees and wasps, which gives them protection from predators.

BIBIONIDAE

The only member of this family frequently observed pollinating flowers in the Lowcountry is the lovebug or March fly, *Plecia nearctica*. Often large numbers of lovebugs are a nuisance because they are attracted to highways and wind up smashed on the front end and windshields of moving vehicles.

TACHINIDAE

This is a large and variable family where almost all of its members parasitize other insects. With over 1,300 species in North America, they are important natural enemies of several insect pests. The female typically lays one or more eggs on the outside of the host's body. Upon hatching, the larva bores into the host and develops on the host's tissue, eventually killing it. Although adults of many species do not feed, several species take nectar from flowers, thereby moving pollen from flower to flower.

BOMBYLIIDAE

Members of this family are commonly called bee flies. Many species resemble bees and wasps, and this mimicry may provide some protection from predators. Adults, which are important pollinators, generally feed on nectar and pollen. Larvae are predacious on or frequently parasitoids of the eggs and larvae of other insects. More than 4,500 species have been described, yet the natural history and pollination value of only a few species are known.

CONOPIDAE

This family is called thick-headed flies because of their broad head. Most species encountered in the Lowcountry are black and yellow, or black and white. These flies strongly resemble bees and wasps and have a large proboscis for taking nectar from flowers. Adult females aggressively intercept their hosts in flight and deposit eggs by forcibly jabbing them into their hosts. Developing larvae feed on the hosts' tissue, thereby killing the host. Adults take nectar from many flower species. About seventy species of Conopidae are found in North America.

Coleoptera: Beetles

The order Coleoptera is the largest group in the animal kingdom with 350,000 described species. Beetles are found in almost every habitat in terrestrial and freshwater environments. They range in size from 0.4 to 200 millimeters (0.02–7.9 inches). Beetles are usually black or dark brown, yet many, such as leaf beetles (chrysomelids), are quite colorful. Beetles are equipped with chewing mouthparts and exhibit a wide range of antennal forms. They may have a hard or soft integument (exoskeleton). The Coleoptera have complete metamorphosis—egg, larva, pupa, and adult growth stages.

Beetles occupy every imaginable feeding niche. Larvae feed on wood, leaves, twigs, detritus, dung, fungus, grains, flesh, earthworms, insects, and so on. They are pests of forest and ornamental trees. Many species from multiple families bore into living wood, sometimes devastating tree populations. Despite these destructive characteristics, beetles are major recyclers of nutrients and energy in ecosystems and provide food for numerous organisms in food webs. In the Lowcountry they are limited as pollinators, although they are found on open, cup-shaped flowers in the Magnolia family and are sometimes massed on clusters of small flowers.

Important Beetle Families

CERAMBYCIDAE

Members of this family are known as long-horned beetles because of their typically long antennae, which are often as long as or longer than the beetle's body. This is a large family, with more than twenty-six thousand described species. Some species are serious pests, and larvae often bore into trees or untreated lumber, causing extensive damage. Some species mimic ants, bees, and wasps, though most species are cryptically colored. Adults of many species visit flowers and are often referred to as flower long-horned beetles.

MELOIDAE

Called blister beetles, they secrete the chemical cantharidin, which may cause blisters on the skin. They are generally dull in color and often seen on foliage as well as flowers. However, some are brightly colored to warn predators that they are toxic. About 7,500 species have been described worldwide. The larvae of several species attack bee larvae and provisions, but some feed on grasshopper eggs. Adults sometimes feed on flowers and leaves, but many pollinate flowers.

MORDELLIDAE

Members of this beetle family are commonly referred to as tumbling flower beetles because of the erratic, falling movements they make to escape predators. Tumbling flower beetles are small, humpbacked, and wedge-shaped, broader in front and with a pointy abdomen. Hind legs are enlarged, and they kick and tumble when disturbed. These beetles are frequently found in flowers of many plant species.

SCARABAEIDAE

This family of beetles is diverse, with more than thirty thousand species worldwide. Often referred to as scarabs or scarab beetles, they are stout bodied, and many

FIGURE 7.8. The tumbling flower beetle. Courtesy of B. Merle Shepard.

are brightly colored. The front legs of several species are adapted for digging. Others have horns on their heads or pronotum, which are often used for fighting other males. The C-shaped larvae or grubs live underground or under debris. Many are scavengers, recycling dung or carrion. Several species take pollen and nectar from flowers.

Lepidoptera: Butterflies, Skippers, Moths

The insect order Lepidoptera consists of more than 150,000 species of butterflies, skippers, and moths. These are advanced insects with complete metamorphosis (four life stages: egg, larva or caterpillar, pupa or chrysalis, and adult). They have wings covered with scales.

Butterflies are active during the day and may be distinguished from skippers and moths by their hair-like antennae with rounded knobs on the ends. Skippers are typically smaller than butterflies, with pointed, slightly hooked knobs on the antennae. They are chunky compared to butterflies and have rapid, skipping flight. They are often

found gathering nectar from smaller flowers. Because of their size and speed, as well as the tendency for related species look alike, they can be difficult to identify.

Moths differ from butterflies and skippers in that most are nocturnal. They tend to have more somber colors than butterflies and hairier bodies suited for cooler nighttime temperatures. Moth species are about ten times more abundant than butterfly species and therefore are likely more important as pollinators.

Most Lepidopteran adults feed on nectar and are commonly found visiting flowers. Their slender tubular mouthpart (proboscis) is kept coiled under the head when not in use. Some have furry bodies that may carry pollen. However, except for a few species, they do not seek pollen as many bees do. Lepidopterans may be important in pollinating some plant groups.

FIGURE 7.9. The gulf fritillary butterfly. Courtesy of Keith McCullough.

Important Butterfly Families

PAPILIONIDAE

Members of the Papilionidae family are known as swallowtail butterflies and are the largest butterflies seen in the Lowcountry. Swallowtails have long proboscises and can get nectar from deeper flowers than most of their smaller relatives. The name "swallowtail" refers to the forked tails created by teardrop-shaped extensions on the hind wings. Swallowtails have six easily distinguished legs as compared to the Nymphalidae family, brush-footed butterflies or brushfoots, which have reduced front legs and appear to have only four legs. Spring swallowtails are often seen gathering nectar from the flowers of native and exotic azaleas.

PIERIDAE

Butterflies in this family are known as the whites and sulphurs and are mostly either white or yellow. Pierids are medium to small butterflies with six distinct legs. Some sulphurs may survive the winter as adults; others reinvade from farther south each year. The whites often are spring butterflies in the Lowcountry and overwinter as pupae.

LYCAENIDAE

The butterflies in this family are known as gossamer wings. They are generally small butterflies with common names such as hairstreaks, elfins, blues, coppers, and harvesters. They are often found on plants with clusters of small flowers. A few are common in the garden, but many are rather specialized feeders or have but one generation per year and are therefore not often seen. Hairstreaks are named for the hair-like extensions of the hind wings. The harvester, *Feniseca tarquinius*, is unique in our area in that its caterpillar preys on other small insects.

NYMPHALIDAE

This large and diverse group of butterflies includes many well-known species, such as the monarch. These butterflies

FIGURE 7.10a, b. The dorsal view (a) and ventral view (b) of the American lady butterfly. Courtesy of B. Merle Shepard.

share the reduction of the front pair of legs into furry vestiges held close to the body, which appear as four legs rather than the usual six of most insects. This characteristic gives them the common name of brush-footed butterflies. They are frequently seen taking nectar from flowers. These butterflies survive the winter as adults or larvae. Both monarchs and painted ladies have ranges that include several continents and are migratory species—a rare quality in the insect world. The monarch and the subtropical zebra heliconian are the longest lived adult butterflies in the South. Migrating monarchs may live for eight to nine months, whereas adults in other monarch generations live four to eight weeks, as do many other butterflies. Zebra heliconians feed on pollen as well as nectar and, since they benefit from the amino acids in the pollen, may live for several months.

HESPERIIDAE

Members of this family are collectively known as skippers because of their rapid, skipping flight. They differ from other butterflies in several ways. Skippers tend to be heavier bodied and have hooks at the end of the antennal knobs. They are avid nectar feeders and are as important for pollination as other nectar-feeding butterflies. Because of their generally small size and fast flight and because there are so many similar species, they can be difficult to identify.

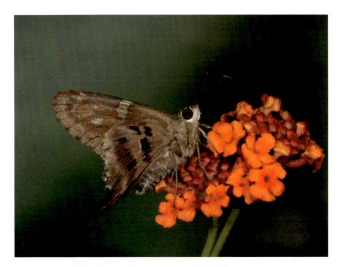

FIGURE 7.11. The long-tailed skipper butterfly. Courtesy of B. Merle Shepard.

FIGURE 7.12. The hummingbird clearwing moth. Courtesy of B. Merle Shepard.

Moths

Most of the insects we recognize as moths are in the lepidopteran suborder Heterocera, as opposed to butterflies, which are in the suborder Rhopalocera. Moth species are approximately ten times more numerous than butterfly species. Some moths and caterpillars have distinctive colors or patterns that make identification easy, but for many species, identification may be difficult, even for experts. There are a few guides to adult moths and caterpillars and some good websites to help identify moths. Some of these are listed in the references at the end of this chapter.

Pollinator Decline, Conservation, and Enhancement

The value of native pollinators is difficult to assess, but it is estimated that the Western or European honeybee, *Apis mellifera*, contributes $18 billion from pollination of domestic fruits, nuts, and vegetables annually. Of one hundred crops grown around the world, seventy-one rely on pollinators (mostly bees). Sadly, pollinator species are in serious decline, for several reasons. First, habitats have been lost due to land development and agriculture and the fact that urban areas typically have lawns and shrubs that are not conducive for pollinators. Second, habitat fragmentation may cause pollinators to travel farther to forage for food and therefore expend more energy on meeting their basic needs, leaving them with less energy to mate and reproduce. Also, agricultural areas lack sufficient plants with flowers that are rich in nutrition, such as pollen, nectar, oils, and resin, and that sustain domestic and native pollinators (and other beneficial insects and spiders). At the same time, diseases, including those caused by *Nosema*, negatively affect honeybees. Finally, pesticides are clearly a major cause of pollinator loss. Recent studies have shown that the widely used neonicotinoid pesticides have serious negative impacts on honeybees, native pollinators, and other beneficial species such as parasitoids and predators.

Enhancing pollinator habitat includes planting different plant species that flower from early spring to late fall (see table 7.1). Pollinators also require diverse nesting sites. Solitary ground-nesting bees, which make up 70 percent of North America's native bee species, require bare patches of ground that are well drained, untilled, and unmulched. Woody vegetation such as shrubs, piles of fallen branches, and plants with pithy stems provide habitat for wood-nesting bees, which make up 30 percent of North America's native bee species. Artificial nests can be made of mounted wooden nest blocks or bundles of hollow stems in areas that will not be disturbed. Hairy plants, pieces of leaves, and mud provide nesting material. Areas should be left undisturbed for hibernation and overwintering. The Xerces Society (Xerces.org) has much information about building and maintaining artificial nests. Water in a shallow dish or bath with rocks that serve as a perch can help during dry periods. Last, but just as important, is the imperative to reduce or eliminate altogether the use of chemical pesticides.

Table 7.1 provides a list of plants native to the South Carolina and Georgia Lowcountry that provide flowers for pollinators from spring to fall. The table also includes native plants on which we have observed pollinators at various times throughout the year. When considering habitat design, take an inventory of the plants that are already in your landscape. You may find that you already have some pollinator-friendly species! Take note of what time of the year these plants bloom and consider adding more to complement what is already present. Some helpful design tips for adding plants to your landscape include:

- Choose an area with good sun exposure for keeping pollinators warm and for navigational purposes.
- Clusters of plants are better than those from seed mixes, because they are easier for pollinators to spot.
- Choose plants with overlapping bloom times so that resources such as nectar and pollen are always available from early spring to early winter.
- Choose various types of flower shapes and colors to attract a diversity of pollinators.
- If planting more than one area, consider that patches that are closer together are a plus, as pollinators will not need to expend as much energy to collect resources. This is particularly important to consider in large agricultural areas where fields may be too large for some pollinators to cross. Planting rows of companion species will create habitat for pollinators at regular intervals.
- When selecting plants for your pollinator garden, be sure to ask your nursery or garden shop about whether the plants have been treated with any pesticides.

A Few Benefits of Native Plants

- Nonnative plant species may crowd out native ones that have evolved with native pollinators.
- Native plants are superior sources of nectar and pollen and provide superior nesting sites.
- Nonnative plants may cause pollinators to have to expend more energy to meet the same nutritional requirements.
- Plants adapted to native conditions require less care.

Recent studies in South Carolina to enhance pollination in watermelon by planting four species of flowering plants by the edge of watermelon fields showed that honeybees made up less than 30 percent of the bees that visited watermelon flowers. The added flowering species (*Cosmos sulphureus, Coreopsis tinctoria, Gaillardia pulchella*, and *Zinnia elegans*) increased the overall biodiversity of pollinators and caused an increase of at least one group of pollinators (*Lassioglossum* spp.) that visited watermelon flowers.[1]

TABLE 7.1

Suggested Common Native Pollinator Plants for the Lowcountry

Common Name	Scientific Name	Blooming Season
HERBACEOUS PLANTS		
butterfly weed	*Asclepias tuberosa*	June to August
swamp milkweed	*Asclepias incarnata*	June to August
aquatic milkweed	*Asclepias perennis*	June to September
partridge pea	*Chamaecrista fasciculata (Cassia fasciculata)*	June to September
wild ageratum	*Conoclinium coelestinum (Eupatorium coelestinum)*	July to October
lanceleaf coreopsis	*Coreopsis lanceolata*	April to June
rattlesnake master	*Eryngium yuccifolium*	June to September
joe-pye weed	*Eupatorium fistulosum*	July to September
narrowleaf sunflower	*Helianthus angustifolius*	July to frost
halberd-leaf marshmallow	*Hibiscus laevis*	August to September
crimson-eyed rose mallow	*Hibiscus moscheutos*	July to September
marsh blazing star	*Liatris spicata*	September to October
spotted beebalm	*Monarda punctata*	July to September
eastern prickly pear	*Opuntia humifusa*	June to July
eastern smooth penstemon	*Penstemon laevigatus*	April to June
silkgrass aster	*Pityopsis graminifolia*	August to October
black-eyed Susan	*Rudbeckia fulgida*	August to October
black-eyed Susan	*Rudbeckia hirta*	May to July
goldenrod spp.	*Solidago spp.*	August to October
silvery aster	*Symphyotrichum concolor (Aster concolor)*	September to October
Walter's aster	*Symphyotrichum walteri*	October to November
New York ironweed	*Vernonia noveboracensis*	July to October
golden Alexander	*Zizia aurea*	April to May
SHRUBS		
sweet shrub	*Calycanthus floridus*	April to July
New Jersey tea	*Ceanothus americanus*	May to July
spicebush	*Lindera benzoin*	March to April
highbush blueberry	*Vaccinium corymbosum*	February to May
Spanish bayonet	*Yucca filamentosa*	April to July
buttonbush	*Cephalanthus occidentalis*	June to August
summer sweet	*Clethra alnifolia*	September to October
Virginia sweet spire	*Itea virginica*	May to June
groundsel tree	*Baccharis halimifolia*	October to November

TREES		
red maple	*Acer rubrum*	January to February
eastern redbud	*Cercis Canadensis*	March to April
tulip poplar	*Liriodendron tulipifera*	April to June
southern magnolia	*Magnolia grandiflora*	May to June
sweet bay	*Magnolia virginiana*	May to June
wild plum	*Prunus* spp.	Late February to March
willow	*Salix spp.*	March to May
grancy greybeard, fringe tree	*Chionanthus virginicus*	July to September
VINES		
purple passionflower, maypop	*Passiflora incarnata*	May to July
Carolina jessamine	*Gelsemium sempervirens*	February to March

ACKNOWLEDGMENTS

Special thanks to Eleanor F. Shepard, who assisted with many aspects of the photography. We especially appreciate the assistance of Tony Mills, Chris Marsh, Rachel Walman, Kristen Mattson, Whitfield Marshall, Lisa Gavil, and Karl Ohlandt of the Lowcountry Institute/Spring Island Trust for helping us to sample pollinators on Spring Island and for logistical and administrative support. We extend our thanks to the taxonomists who provided us with correct scientific names of several species, especially to Peter Adler (several species), John Ascher (bees and wasps), Hadel H. Go (bees), Kelsey Byers (bees and hoverflies), Ken Wolgemuth (many species), Sam Droege (bees), and Terry Schiefer (long-horned beetles).

We thank the following for providing photos: Maria de Bruyn (hummingbird clearwing moth), Troy Bartlett (zebra heliconian butterfly), Charles and John Bryson, Kim King, and Irvin Pitts (Brazilian skipper), and Keith McCullough (gulf fritillary). We thank Priscilla Kanet for many edits on the manuscript. We appreciate the support from the Agricultural Society of South Carolina.

We appreciate the assistance of master gardeners Larry Carlson, Carol Acuff, and Joy Hume who provided names of plants they observed being visited by pollinators.

NOTE

1. M. M. Jenkins, "Planting Wildflowers to Enhance the Biodiversity of Bee Pollinators in Watermelon," (PhD diss., Clemson University, 2019).

REFERENCES/RESOURCES

Adamson, N. L., T. H. Roulston, R. D. Fell, and D. E. Mullen. "From April to August—Wild Bees Pollinating Crops through the Growing Season in Virginia, USA." *Environmental Entomology* 41 (2009): 813–821.

"Africanized Honey Bees." University of Florida IFAS Extension. Last modified May 8, 2023. https://sfyl.ifas.ufl.edu/natural-resources /africanized-honey-bees/.

Braman, K., B. Penisi, E. Benton, and K. Toal. *Selecting Trees and Shrubs as Resources for Pollinators*. University of Georgia Extension Bulletin 1483 (2017).

Buchmann, S. L., and G. P. Nabham. *The Forgotten Pollinators*. Washington, D.C.: Island Press, 1997.

Delaplane, K. *Bee Conservation in the Southeast*. University of Georgia Cooperative Extension Bulletin 1164 (2010).

Delaplane, K., P. A. Thomas, and W. J. McLaurin. *Bee Pollination of Georgia Crop Plants*. University of Georgia Cooperative Extension Bulletin 1106 (1994; revised 2010).

Grissell, E. E. *Bees, Wasps and Ants: The Indispensable Role of Hymenoptera in Gardens*. Portland, Oreg.: Timber Press, 2010.

Grissell, E. E. *Insects and Gardens: The Pursuit of Garden Ecology*. Portland, Oreg.: Timber Press, 2001.

Harris, B., K. Braman, B. Pennisi, and M. Putzke. *The Eco-Friendly Garden: Attracting Pollinators, Beneficial Insects, and Other Natural Predators*. University of Georgia Extension Bulletin 1456 (2016).

Hayes, R. F. *Pollinator Friendly Gardening*. New York: Queens Publishing Group, 2015.

Holm, H. *Pollinators of Native Plants: Attract, Observe and Identify Pollinators and Beneficial Insects with Native Plants*. Minnetonka, Minn.: Pollination Press, 2014.

Honey Bee Health Coalition. https://honeybeehealthcoalition.org.

Hopwood, J., A. Code, M. Vaughan, D. Biddinger, M. Shepherd, S. H. Black, E. Lee-Mäder, and C. Mazzacano. *How Neonicotinoids Can Kill Bees*. Portland, Ore.: Xerces Society for Invertebrate Conservation, 2016. https://www.xerces.org/publications /scientific-reports/how-neonicotinoids-can-kill-bees.

Jenkins, M. M. "Planting Wildflowers to Enhance the Biodiversity of Bee Pollinators in Watermelon." PhD diss., Clemson University, 2019.

Lee-Mader, E., J. Fowler, J. Vento, and J. Hopwood. *100 Plants to Feed the Bees*. North Adams, Mass.: Storey Publishing, 2016.

Lotts, Kelly, and Thomas Naberhaus, coordinators. Butterflies and Moths of North America, 2021. https://www.butterfliesandmoths .org.

Mader, E., M. Shepherd, M. Vaughn, S. C. Black, and G. LeBuhn. *Attracting Native Pollinators: Protecting North Americas Bees and Butterflies*. Adams, Mass.: Storey Publishing, 2011.

Natural Resource Conservation Service, U.S. Department of Agriculture. https://nrcs.usda.gov/.

Schlueter, M. A., and N. G. Stewart. "Native Bee (Hymenoptera: Apoidea) Abundance and Diversity in North Georgia Apple Orchards throughout the 2010 Growing Season (March–October)." *Southeastern Naturalist* 14 (2015): 721–739.

Shepard, B. M., and E. G. Farnworth. *Garden Insects: Beneficial Species and Potential Pests*. Charleston, S.C.: Lowcountry Biodiversity Foundation, 2014.

Shepard, B. M., E. G. Farnworth, and K. L. McCullough. *Insects and Spiders of Coastal South Carolina*. Charleston, S.C.: Lowcountry Biodiversity Foundation, 2017.

Shepherd, M., S. L. Buchmann, M. Vaughan, and S. H. Black. *Pollinator Conservation Handbook*. Portland, Ore.: Xerces Society for Invertebrate Conservation, 2003.

Tarpy, David. "Africanized Honey Bees: Prevention and Control." North Carolina State Extension, January 23, 2020. https://content.ces.ncsu .edu/africanized-honey-bees-prevention-and-control.

U.S. Fish and Wildlife Service. "Reducing Risk to Pollinators from Pest Control." 2013. https://www.fws.gov/media/reducing-risks- pollinators-insect-and-plant-pest-control-using-integrated-pest- management-0.

Vaughan, M., J. Hopwood, E. Lee-Mäder, M. Shepherd, C. Kremen, A. Stine, and S. H. Black. *Farming for Bees: Guidelines for Providing Native Bee Habitat on Farms*. Portland, Ore.: Xerces Society for Invertebrate Conservation, 2015. https://www.xerces.org /publications/guidelines/farming-for-bees.

Wilson, J. S., and O. M. Carril. *The Bees in Your Backyard: A Guide to North American Bees*. Princeton, N.J.: Princeton University Press, 2016.

Xerces Society for Invertebrate Conservation. "Pollinator Conservation Resources: Southeast Region." https://www.xerces.org/pollinator -resource-center/southeast.

PART II

Lowcountry Visual Arts Portfolio

Conceptual landscape: BETSY CAIN, painter, Savannah, Ga.
Digital landscape: DAVID KAMINSKY, photographer, Savannah, Ga.
Cultural landscape: MARK UZMANN, photographer, Savannah, Ga.
Representational landscape: PHILIP JURAS, painter, Athens, Ga.

In Betsy Cain's paintings, graphic lines express the raw beauty and transitory nature of *Spartina* marsh grass moving with the flow of water or breeze. She captures the feel of salt water mingling with fresh water in the eddying tidal flow through creeks and marshes. Cain evokes a sense of being the only human on earth frolicking in the brackish amber waters and observing firsthand momentary transformations in the landscape.

In his photographs, David Kaminsky stands on the outer edge of terra firma to capture a unique visual flow looking across salt water to distant horizons. An emphasis on color and light portrays images that fluctuate from morning to evening, from sky to sea and calm to storm. The repetition of line in his digital images conveys a commitment to fleeting time and spatial forms.

The geography of community is represented in the photographs of Mark Uzmann. They show current residents repeating activities that coastal populations have practiced for thousands of years. Wild harvesting, communal farming, and distribution of crops are time-honored traditions still performed in the Lowcountry. Uzmann's images capture residents in an interplay that is relational with the environment and also purely extractive or transactional. These images are visual representations of the wide-ranging, culturally based deliberations that rule human actions affecting land stewardship and ecosystem sustainability.

A strong narrative passage is evident in the paintings of Philip Juras. They describe traces of past agricultural endeavors as remnant scars on the landscape. We are drawn into these landscapes that have been dramatically altered by monocultural agriculture. We see landscapes modified by a succession of agricultural impacts over time, with particular human activities in each place. In the cover painting, mammoth earthworks wrought by forced labor built and maintained rice plantations in the coastal counties. Historic rice production was generally terminated in the area by 1900. Some of these forsaken plantations, repurposed as wildlife refuges, now provide exceptional wildlife habitats. This image captures the transitory beauty of the landscape transformed by time and long neglect into one that now provides critical wildlife habitat owing to recent restoration efforts.

Betsy Cain, *geechee squall #1.*

Betsy Cain. *under the canopy #6.*

Betsy Cain. *under the surface.*

David Kaminsky. *Ossabaw Pond.*

David Kaminsky. *Fog at Vernon View.*

David Kaminsky. *Egg Island*.

Mark Uzmann. *Boiler Repair*, 2016.

Mark Uzmann. *Close to It*, 2004.

Philip Juras. *Longleaf at Wormsloe.*

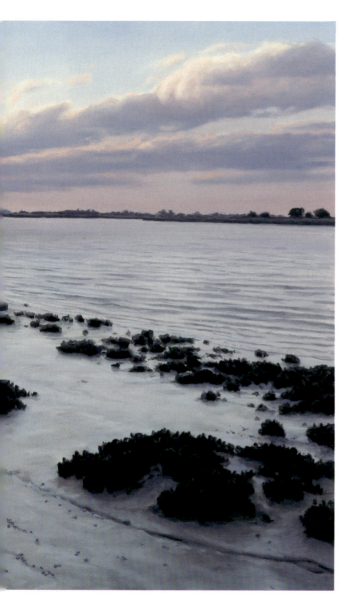

Philip Juras. *Oyster Banks of the Altamaha.*

Philip Juras. *Line of Fire in Remnant Dunes*.

Philip Juras. *Old Rice Field on Cathead Creek.*

PART III

Reconnecting Foodways

Fifty Acres of Pine Barren

Land Tenures and the Crisis of Food Production on the British Coastal Plain, 1733–1750

CHRISTOPHER M. CURTIS, associate provost for research, Georgia Southern University

Georgia's early settlers did not easily "take to the land," despite their self-perception as being naturally connected. This fissure continued despite a comprehensive settlement plan designed to encourage a lifelong commitment to arbitrarily assigned property. Clearing the land of trees and undergrowth; tilling and preparing the soil; planting, weeding, and harvesting the crops; and gleaning, plowing, and harrowing the fields proved to be arduous, with unrelenting responsibilities.

Curtis examines the influence of English common law based on traditions from medieval Europe as applied to the agricultural landscape in the colonies of Georgia and the Carolinas. Land rights woven within the foundation of political power shaped our agricultural history and left an enduring legacy that continues today. 🪶

The idea that cultivators are entitled to the food produced from land they possess and have tilled by their own labor stands as the cornerstone of our notions of individual self-sufficiency and independence. It crafts humanity's intrinsic biological need to labor for survival into an ideological narrative featuring self-reliance, improvement, and fulfillment through personal toil and skill. The self-sufficient, independent farmer epitomizes our aspirations to harness the natural environment and, through diligence and perseverance, shape it into an enlightened agricultural landscape of abundance. Man thus conquers nature: not only in the environment but his own as well. In reality, however, such practice has rarely been the case. Communal forms of agriculture have

dominated the historical practices of global agriculture and have proven to be a more resilient form of subsistence. Village agriculture, representing the belief that food production is a collective enterprise and responsibility, has been a ubiquitous practice across different climates, crops, cultures, and divisions of labor. Food production has been a shared responsibility because the stakes are too high to leave it to individual effort.[1]

During the seventeenth and eighteenth centuries, however, a narrative portraying the independent yeoman farmer as the embodiment of economic industry and civic virtue gained particular prominence, especially in England. Several factors contributed to its emergence at that time and place. It reflected a refined synthesis between two different considerations about how to measure the value of landholding in society. Foremost, it reiterated a long-standing discourse that connected land rights and, specifically, the ability to produce food with the foundations of political power. This political discourse became interwoven with an equally prominent religious narrative that considered improving the earth through agriculture as a direct manifestation of the stewardship and husbandry expected of good Christian souls. Both themes emphasized an inherently moral connection between humanity and nature that arose from laboring the soil, which was often juxtaposed against the relations of those employed in commerce. This portrayal of agriculture easily embedded itself in the new liberal political thought where it was contemplated as a product of individual enterprise in a state of nature and, thus, as a human activity that preceded the formation of government.[2]

Yet despite the liberal mythology of individual enterprise, the pursuit of agriculture has always been a political arrangement that has required the function of government to ensure. The yeoman ideal was made possible only by a matrix of corresponding assumptions about the nature of ownership, labor, and property relations, which enabled it to be actualized. Most significantly, it required a law of property that allowed individuals to make an independent claim on a piece of land and then entitled them to the fruits of that land as well. Those property laws themselves needed to be grounded on a larger belief system that recognized law as an appropriate, consistent, and authoritative form of social arbitration—what is generally referred to as the rule of law principle. Additionally, and specifically important in the context of early modern liberal political thought, individualistic agriculture demanded accessibility to a marketplace, where surplus foodstuffs could be easily exchanged for other necessities so as to provide an incentive to produce beyond subsistence and, simultaneously, constrain the selfish impulse and consider the labor as creating a perceived social benefit.[3]

These essential structures were present in the British world of the seventeenth and eighteenth centuries. Property rights were grounded in the English common law, which reflected, reinforced, and revised customary forms of social relations through the courts. Land rights in particular were articulated through a well-defined doctrine of tenures, which had originated from the feudal hierarchy of medieval Europe. Rights emanated from the land and defined status (an estate) to an individual attached to it. The highest form of estate—an estate for life—was known as a freehold and represented the quintessential status of English liberty. The cultural attributes of the yeoman ideal in England were thus expressed through the legal concept of the freehold and its specific terminology of status, rights, and liberties. As discussed elsewhere, the freehold concept underwent significant definitional changes during the period but it remained the principal designation of the independent cultivator in Anglophone societies.[4]

The attachment of the yeoman ideal with the freehold was abundantly evident in the proprietary colonies established in the Americas following the Restoration. Settlement projects in Pennsylvania and the Carolinas, on the Isthmus of Panama, and in Georgia boldly embraced this belief in the productive power of individual freeholders

to sustain themselves in distant lands. The letters and diaries of the settlers themselves attest to the strong cultural resonance of landholding and its association with self-reliance and political independence. But perhaps more revealing was the incorporation of the freehold model into the economic plans for these settlement projects. Although each of these colonies arose from multiple incentives to meet a different array of public and private interests, they all designed settlement plans to grant lands to individuals with the expectation that they would soon produce the food necessary to sustain themselves and, it was hoped, contribute to the Atlantic economy. Accordingly, the land allocation schemes in each of the colonial projects made significant provisions for freehold grants to attract settlers. Despite a historical familiarity with "starving times" and with more than a century's experience of the general difficulties in sustaining American settlements, these proprietors embraced the model of freehold cultivators to guide and develop their colonial enterprises. In so doing, they overlooked or rejected contemporary forms of collective agriculture that were models of economic success, most notably the plantation complex of the British West Indies.[5]

The failure of the freehold model on the Atlantic Coastal Plain and its replacement by the plantation system in the South Carolina and Georgia colonies are thus particularly noteworthy to consider within this context. The profound consequences of its failure for the economic and political development in the American South are familiar, but it also caused the British government to abandon the model in its future colonial projects during the eighteenth century. After Georgia, a preference for a forced labor system emerged throughout the new British colonies; whether in the form of enslaved Africans in the instances of East Florida, West Florida, and British Honduras, or in the form of convict labor in North America and New South Wales. In each of these colonies, forced labor was adopted to produce both the foodstuffs and the commercial products essential to the colonial endeavor. Additionally, in nonsettler colonies, as in Quebec, Bengal, and the Cape Colony, the British sought to assimilate native property distributions and subsistence practices into a colonial paradigm in lieu of implementing English agricultural practices.

The British colonial experiences along the southern coast thus afford interesting opportunities to examine the relations between land allocation policies and agricultural development, especially food production. The Lowcountry geography presented substantial challenges to agricultural development, let alone to the Norfolk four-course system familiar to English settlers. They found the elevated sandy dunes of the Pamlico shoreline complex to be interspersed by salt marshes and tidal estuaries, which experienced on average eight-foot tidal floods twice a day. The spring tides on the new and full moons were often higher. Broad, unregulated rivers flowing down from the Piedmont and Upper Coastal Plain carried their sediments into the salt marsh and surrounding lands. The rivers rarely conformed to their banks during the winter rains, however, and inundated the swamplands of the coastal forest well into the traditional planting season. Minimal frost enabled vegetation to thrive nearly year-round, keeping the land green and growing, especially with weeds and the vines. For a people familiar with only the orderly English landscape marked by metes and bounds, the moving and ever-changing lands of the coastal Lowcountry baffled and amazed them. And as with the Spanish missionaries who preceded them, the complex ecosystem resisted their efforts to convert it to agricultural lands.[6]

The initial settlement experience in Georgia provides the more significant insight. The South Carolina enterprise played out in a similar geography and ended in much the same fashion with the embrace of the plantation, but it was contested by sharply differing perspectives on property relations that make for a more protracted and complicated story. The Georgia plan, however, possessed a purity of design that was seldom found elsewhere. Georgia's Trustees embraced the model of the yeoman freeholder as

a means to reconcile their three distinct aims in establishing the colony: as a charitable haven and second chance for England's unfortunate; as a military buffer zone protecting South Carolina's rice plantations; and as a commercial adventure designed to make a unique contribution to Britain's merchant-capital economy. While the Georgia adventure shared many attributes of the other post-Restoration projects, it was, in many respects, the culmination of this particular imperial template grounded in the freehold model. Perhaps nowhere else was its design more detailed, its aims more explicit, its financial backing more stable, and its organization more committed to a uniform vision of independent farmers producing food and commercial products. And so perhaps nowhere else was its failure quite as spectacular.

The Georgia Adventure

The dismal history of the Georgia experiment under the Trustees has attracted the close consideration of several serious historians who have brought their finely tuned and sophisticated analyses to the subject. Their histories have painted generally similar portraits of a meticulously designed but struggling enterprise grounded on benevolent and antislavery principles, which was saved economically—but compromised morally—by the turn toward plantation agriculture and African slavery. The colony never approached self-sufficiency or developed commercial viability under the Trustees. That the eventual relaxing of the prohibition on slavery anticipated the assumption of Crown rule in 1752 has fostered a tragic interpretation of the trusteeship as a unique but ultimately failed enterprise whose forward-thinking ideas and aspirations were of a time that had yet to come.[7]

Intended foremost to establish military outposts to simultaneously protect against Spanish and Indigenous attacks from the south as well as to prevent slaves from escaping from the increasingly lucrative rice plantations of South Carolina, the Georgia settlement was grounded on specific attitudes toward work and social value, which manifested themselves in the philanthropic design to give the "worthy poor" a fresh start. The Trustees deemed "worthy" those who came from a particular status of the gentry, merchants, or tradesmen who were vulnerable to the vicissitudes of the market economy and found themselves without a livelihood because of these circumstances. Benjamin Martyn, the secretary for the Trustees, summarized the group's particular disdain for idleness and anxiety over unemployment, noting that the poor "must lie a dead weight on the public." Any wise government, according to Martyn, should follow the example of a beehive and "not suffer any drones in the state" but instead should situate the poor "in such places, where they might be easy themselves, and useful to the commonwealth." Beyond a pure expression of the value of labor, Martyn's orientation also reveals a shift in how the purposes of colonization were perceived during the course of a century. If, as Perry Miller famously asserted, the New England mission was an "errand into the wilderness" to purify the church so that it could eventually redeem a corrupt England, then one might think of the Georgia Trustees as looking through the lens from the other side of the telescope: Georgia would redeem England by sending its corrupted sons and daughters into the wilderness to purify themselves.[8]

The plan for settling Georgia was designed to achieve this benevolent purification and to cultivate those proper attitudes toward work and social responsibility. Settlers were organized into townships, which were laid out in wards based on the geometrically elegant vision of James Oglethorpe, the only Trustee to reside in the colony. The Oglethorpe plan provided each settler with a residential town lot situated in a rectangular pattern around a common square and fifty acres of land divided between five-acre garden lots, which were proximate to the ward, and forty-five acres outside of town in what was loosely conceived of as the "farm district." Settlers were expected to

clear and cultivate the land for food crops and plant mulberry trees for the development of a commercial silk industry. Larger grants of land were made available for those who provided for their own passage and could procure indentured servants to help cultivate the land. Oglethorpe's vision found its clearest expression in Savannah, where he laid out six wards, but it was generally replicated in the towns of Ebenezer, Darien, Frederica, and Augusta as well. With some foresight, the Trustees provided for a public store to supply foodstuffs while lands were being cleared and crops being grown, which was intended to serve as a temporary subsidy. They also established an experimental garden of their own and employed a gardener to investigate the horticultural potential of the region.[9]

Yet problems arose immediately. The land proved difficult to turn into the arable fields and pastoral landscape, especially without horses or plows. Thomas Causton, the public storekeeper for the colony, summarized the situation facing the settlers during the first few weeks of settlement. In a letter written to his wife he informed her that it was "impossible" to provide her with a "true Description of the Place" because "we are in a Wood." In the densely-vegetated ecology of the coastal forest, even a basic survey of the surrounding terrain proved difficult. Oglethorpe brought in slaves from South Carolina to clear out the trees for the Savannah settlement and on Hutchinson island, but the settlers were expected to clear their own lots through their own effort. The intricate design of garden lots and the farm district allocations failed to account for the type and quality of those lands and confined the choices available to those motivated to prepare the land. Hugh Anderson complained about "the irregular running out of Lotts of Savannah . . . without regard to the quality of the soil." He explained that many of the grants were made in lands that were "Pine-barren," and not improvable or they included lands that were swamps and "where the necessary drains surpasse the ability of the planter." Critical pamphlets mocked the Trustees for marketing the colony as a fertile

and bountiful province. *A True and Historical Narrative of the Colony of Georgia in America* opened by remarking that any knowledgeable "American reader" of the promotional literature must be surprised to learn "that such Number should have been so fooled and blindfolded, as to expect to live in this Part of America by Cultivation of Land's without Negroes, and much more without Titles to their Lands, and laid under a Load of Grievances and Restrictions." The pamphleteers contrasted their lands with those in other colonies and contended that no "persons in their Senses" would ever imagine that "a Family of White People" could be maintained by "Fifty Acres of Pine Barren."[10]

Various reasons have been emphasized to explain the inability of the settlers to sustain themselves independently of the public store. Oglethorpe proved to be a polarizing figure among the settlers, owing to his rigid adherence to the original concept throughout the first seven years of troubled settlement. His opposition to persistent demands for reforms from an organized group of "malcontents" established the political architecture of the new settlement. Malcontent petitions for slave labor and trade in West Indian rum, as well as for more practical and permissive land allocation policies, have provided the fodder for subsequent historians looking to explain the failure of the plan and its relatively rapid replacement by the plantation complex. In general, historians have followed the contours of the original political debate and generally assigned blame either to the incapacity of the settlers themselves or to the undermining influence of South Carolina planters eager to expand slavery and rice production into the Georgia coast.

Land tenure—the particular form of the Georgia settlers' relation to the land—has also been blamed for the failure of agricultural production. Certainly, complaints about the quality of the land, the land allocation and survey process, and the specifics of land tenure were ubiquitous in malcontent literature and rivaled petitions begging for slaves and for trade in rum. These criticisms of the Trustees' land tenure policy were especially revealing. Their policy of

granting lands in fee tail male—allowing land to descend to male family members only—and the limitations imposed on alienating land through mortgage or sale attracted particular derision from the colonists who clamored for the less restrictive tenure of fee simple. Their appeals have, on occasion, found their way into more contemporary historical interpretations written by scholars who have mistakenly equated fee simple title in the eighteenth century with the absolute ownership principles that only took root in the nineteenth century. Neither fee simple nor fee tail possessed any inherent limitations on agriculture—both were freeholds (estates for life)—and, indeed, as Oglethorpe and his party repeatedly made clear, the entail process in fee tail tenure better protected the land from absentee landholding and rampant land speculation than tenure in fee simple might have done. Settler petitions for landholdings in fee simple had nothing to do with increasing agricultural productivity in the colony; rather, they were appeals for more access to credit in the anticipation that colonists would be able to purchase slaves. The debate over land tenure thus attempted to cloak the issue of who would be responsible for food production.[11]

The Legal Foundations of the Georgia Colony

Georgia's Trustees and the settlers they sent forth shared an understanding about the nature and form of property rights as they were embedded in the English common law. They also understood that the common law was not a comprehensive or codified system of law but a body of principles that had developed from the medieval matrix of feudal social relations and continued to reflect the primacy of status, reciprocity, and custom. Accordingly, even as late as the eighteenth century, the common law did not conform to modern ideas of the law as prescriptive through force but instead served as a tool to negotiate property relations, which were themselves defined by shared and sometimes competing rights and privileges. A desire to find historical continuities can often obscure the significant differences in both the law and property rights as they existed at the time. Most notably, the contemporary notion of private property, where one person possesses absolute ownership and exclusive use over a specific piece of land, was antithetical to the common law understanding of the freehold in the early eighteenth century. Common law property rights were embedded in the land; individuals possessed only those rights that were based on their particular relation to a specific piece of land. Accordingly, different people could possess different rights to the same piece of land. This "bundle of rights and interests" framework enabled the common law to consider the rights to a piece of property across multiple statuses, uses, space, and time.[12]

These distinct webs of relations were articulated and directed by the forms of land tenure. Tenures had developed from the Germanic custom of military alliances between a warlord and his subalterns who had migrated into the former lands of the Roman Empire. These customary arrangements were known as feuds and symbolized the military alliances between a lord and his vassals. They were secured through grants of land. The land itself remained in the dominion of the lord, but vassals were entitled to possess the feud in return for a condition of service. Initially, this service was one of military allegiance and the expectation to fight with the lord. Over time, however, the conditions of service became more varied and, through the process of inheritance and the recognition of custom, the feuds became more permanent. Vassals were able to divide their land by issuing parcel grants, also on conditions of service, through a process called subinfeudation. The common law doctrine of tenures emerged from and was defined by this original system of reciprocity and rights. Accordingly, it was not the size or the value of the land but the conditions of service that defined the quality of tenure. Services were classified as either "free" or "base" depending on the nature of the specified task. Free services consisted of duties befitting nobility: military service,

providing counsel or household service for the lord, judging disputes, or paying a stipend. Base services, known as villenage, reflected the private labors required of "people of servile rank" and tended to demand agricultural and manual labors. Services were also defined by the length of time for which they were specified and, therefore, could be further classified as a certain or uncertain tenure. Certain services were prescribed for a set time, while uncertain services depended on contingency.

Such diversity allowed for a matrix of tenures to develop across a specific manor or estate. An estate might be said then to "belong" to a freeholder, but the rights of the freeholder were prescribed by the conditions of service and circumstances of the specific piece of land. The freeholder, for instance, might possess a right to transfer the land to someone else through sale or devise it to a son or daughter, but any tenants who worked the land might also be entitled to remain on the estate and work the same fields under the same conditions. Furthermore, tenants might retain an equity of redemption protecting them in their home. Both parties could claim legal rights to the land, but they did so from different relations to the estate—or status. The law provided for the exercise of property rights across time as well; a widow's dower right existed as a recognized legal right even before the death of her husband, as did future rights arising from the law of primogeniture or other inheritance rights too. And as all Jane Austen readers know well, even the intentions of a long-deceased landholder could be legally protected through an entail. Since all lands were ultimately vested in the dominion of the Crown, all estates were subject to forfeiture and escheat. Forfeiture could occur for a multitude of reasons, including the commission of high crimes and misdemeanors, treason or disloyalty, attainder (testifying on behalf of someone ultimately convicted in court), and failing to follow the conditions of the tenure. Land could also revert to a grantor through the practice of escheat if there was not an appropriate descendant or by simply allowing it to go to waste.

Landholding was complicated further by the presence of other ancient property rights, such as church property in advowsons and glebes and forms of title held through equity jurisprudence. Furthermore, in addition to prescribed legal rights, common law courts recognized as rights the customary practices of those who benefited from the land in a temporary or expedient fashion. Copyholds were one representation; but other common practices were protected as well. Neighboring tenants, for example, might possess the right to trespass (the right of way) and to move their livestock across an estate on their way to or from the market. Livestock could graze in open pastures. Tenants and the poor were permitted to collect firewood from the woods and to glean the remnants from a harvested field. In some areas, customary rights allowed for fishing and the construction of dams and weirs.[13]

By the early years of English colonization, the doctrine of tenures had been refined into more established and standard forms of estate. Base tenures had largely disappeared and tenancy took the form of a freehold, copyhold, or leasehold. Copyholds were customary grants and tenants held only at the will of the lord, while leaseholds were grants held for a specific length of time. The conditions of service had changed significantly as well. The medieval military service demanded of freeholders had been replaced by expectations of agricultural production and took the form known as socage tenure. Additionally, the annual payment of a quit-rent had increasingly been allowed to substitute for the diverse requirements of service. Quit-rents were not a tax on the estate but a recognition that the land continued to be held by obligation. The collection of quit-rents was recognized as a right entitled to the grantor, just as the original service had been.[14]

Common law land rights were thus an elaborate web of property relations and service obligations that allowed individuals to be in possession of a piece of land in the form of an estate, but the land itself retained association with the larger collective—whether it was a manor, a corporation,

a colony, or the Crown. This technical understanding of tenures, estates, and customary rights was underpinned further by a Christian worldview—albeit a diminishing one—that considered all earthly resources as part of a divine creation. For the freeborn Englishman, land was something that was to be held, not owned.

Both Georgia's Trustees and settlers embraced this historical interpretation of land tenure and property rights. Much of this structure, however, was coming under sustained assault from a diverse set of practices that are generally classified under the rubric of enclosure. Enclosure was not a consistent or coherent process but a reflection of the social trends toward rationalized commercial production through the individual ownership of the land. Economic rationalism and liberal political thought strained the tissues of collective association as land (or, more aptly, lands) came to be seen as a form of profitable resource when put under the responsibility of a skilled and attentive manager. Whig politicians of the eighteenth century facilitated enclosure by espousing a political agenda that sought a more consistent and uniform rule of law, an interpretation of property that fostered greater individual autonomy at the expense of common rights, and stiff criminal penalties for crimes against property. Taking advantage of a weakened established church, Whigs transfigured Christian ideas of husbandry into a secular, market-oriented perspective directed toward the acquisition of wealth through agricultural stewardship. Legislation, judicial rulings, and public improvement projects all wrought significant changes in property relations, especially as they pertained to land tenures and customary rights. By the middle of the nineteenth century, the majority of English farmers were producing for the market on lands that they leased from a landlord who possessed exclusive rights to the estate. A similar process of enclosure took place in the colonies and former colonies, although the restructuring of property relations was informed by the different forms of agricultural labor.[15]

The Land Tenure Question Reconsidered

The localized experience of the Georgia colony was part of this agricultural transformation. In the end, Georgia emerged as a veritable success story, producing rice, indigo, cotton, and timber for the Atlantic market and food for both the rural and urban populations. It did so, however, only after rejecting its original, elaborate design for freehold settlement and embracing instead the plantation model that had succeeded in the Caribbean and in South Carolina. The specifics of land tenure, and the subsequent debates over it, reveal much about the fate of the yeoman freeholder and the process of enclosure in the colonies.

Necessarily grounded in land acquisition and its conversion to commercial productivity, the Trustees sought to inhibit the more deleterious effects of this conversion by adopting a freehold model of settlement thought to be impervious to the forces of merchant capital. The land allocation policy reflected a conscious effort by the Trustees to inhibit the commercial attitudes increasingly attached to landholding while still supporting the overall economic aims of the colonial ideology. They believed that the natural virtue arising from cultivating the land would reconcile these tensions. Assigning the land in fee tail would keep the grants "in the family" and prevent them from becoming a source of speculation through sale and mortgage. Specifying that the entail would descend to male issue only (fee tail male) was primarily a means to ensure a militia, but it also required residence and thus encouraged cultivation. Yet the actions and experiences of the settlers revealed the true limitations of the design. Their reluctance to clear lands to make them arable, their preference to live off provisions from the public store or from South Carolina, and their desire to see land principally as a source of credit reflected an overt rejection of the yeoman ideal as imagined by the Trustees.

The original plan of land allocation was not a castle-in-the-air vision devised by the Trustees; rather, it conformed

to contemporary trends and practices in British imperial policies. The charter for the colony, while generally permissive, limited land grants to no more than five hundred acres per person, in accordance with a policy that had recently been established by the British Board of Trade. The board, in a 1731 report to the Privy Council, suggested that the practice of allotting vast manorial estates was inhibiting the orderly settlement of the colonies, serving as a detriment to sustained agricultural production, and contributing to general social dysfunction and rivalries. The board singled out the case of New York, but its members were likely considering the recent collapse of the proprietary adventure in the Carolinas as well. More notably, however, they were also keenly aware of the several recent "abortive frontier schemes" and were attempting to exercise more control over settlement patterns in North America. A decade earlier, the board had already expressed concern about the inherent communication and logistical problems of any settlements in the interior committed to agriculture. It preferred for settlements to be planted close to the coast, along the navigable estuaries so as to be accessible to commercial shipping, and for colonists to leave the interior for the establishment of trading outposts only.[16]

Beyond the prohibition on larger and manorial grants, the military mission of the Georgia adventure encouraged settlement using the frontier township model. Associated originally with William Penn's settlement policies in Pennsylvania, the practice of clustering families through freehold grant allocations into townships became increasingly commonplace during the eighteenth century. Governor Alexander Spotswood settled a group of German settlers on the Virginia frontier at Germanna in 1714, and similar practices were embraced to encourage the speedy settlement of Nova Scotia following the Treaty of Utrecht. Most notably, however, the Georgia plan bore the imprint of South Carolina governor Robert Johnson's plans to establish townships along the southern frontier.

Upon arrival in Charles Town in 1730, Johnson presented his plan to settle eleven townships along the major riverways from the Waccamaw in the north to the Altamaha in the south. Families would receive a town lot in addition to fifty acres and be provided with a monetary supplement for tools and provisions. The legislature agreed to incur the costs of the surveys and waived quitrents for the first decade of settlement. These South Carolina townships also prohibited slavery and expected their landholders to perform militia services.[17]

Oglethorpe supported Johnson's township plan, but overall the expansionist tendencies of the South Carolinians troubled him. Soon after arriving in Savannah, he expressed his anxiety to the Trustees about the potential consequences of a land rush by the Carolinians. In June 1733, he reported that he had received several solicitations and offers of gifts in exchange for "tracts of land from three thousand to twelve thousand acres." These requests were for lands on which those petitioning did not intend to reside. He urged the Trustees to repudiate these efforts. A few months later, he again voiced concern about the threat of absentee landholding and recommended stipulating that any of the five-hundred-acre grants be assigned in fee tail male as well. Grants awarded in fee simple were easy to lease and subdivide, and doing so often obscured who actually held the land by deed. He also proposed establishing the quitrent at a high rate—"ten shillings Sterling for every hundred acres"—although in following custom he intended for quitrents to be forgiven until ten years after the date of the patent.[18]

Oglethorpe and the Trustees articulated their mature vision of land allocation in the "Rules of 1735." The rules established a distinction between charity grants and grants to private settlers and set out specific conditions for both forms of grants. Settlers "sent on charity" were granted fifty acres per person (along the five- and forty-five-acre township plan), which were entailed to male children

only. Charity settlers were prohibited from alienating their grants through sale or lease and were required to cultivate the land within a specified time—normally ten years. Part of this cultivation included a provision to plant and maintain one hundred mulberry trees during that period. Per common law, the Trustees maintained the claim of reversion should any of these conditions be broken. The charity grant provisions clearly reflected the tensions incumbent in the Trustees' philanthropic design and their very real anxieties about the actual capacity of settlers who already had demonstrated themselves prone to economic failure.

The Trustees hedged their bets against the fortunes of the charity settlers by offering private grants as well. Grants that were awarded to settlers who arrived "at their own expense" had their own conditions but still reflected the Trustees' desire to maintain the integrity of the settlements. Grants up to five hundred acres per person could be taken up, but the grantee was required to migrate and take up residence on the estate within twelve months. These lands were also held in tail male, ostensibly for military purposes, but the provision elicited controversy. Private settlers were required to clear and cultivate one–fifth of their grant within ten years and three-fifths within twenty years. Many of these provisions were based on an expectation of what might reasonably be achieved with five-hundred-acre grants. The size of the private grants was limited, however, by a condition requiring that one indentured male servant must be provided for every fifty acres allotted. The servants were commanded to "abide, settle, and inhabit" the estate and were eligible for a grant of twenty acres when their indenture expired after three years. The racialized regulations banning people of African descent from the colony applied with particular force here, and freeholders were explicitly prohibited from hiring, keeping, lodging, boarding, or employing any Black person. As with the charity grants, there was a requirement to plant mulberry trees—one thousand for each one hundred acres—and the Trustees maintained the right of escheat.[19]

From the outset, the provision that land grants could descend to male issue only sparked controversy. Benjamin Martyn, in his sympathetic account of the first years of the colony, offered a detailed justification for Oglethorpe's persistent adherence to the tenure in the face of strong opposition. Emphasizing the original military mission of the colony, he noted that "each Lot of Land was considered as a military Fief" and that each inhabitant was considered both "as a Planter and as a Soldier." Accordingly, each of the freeholders was provided with arms and training for militia service as well as with tools for cultivation. Martyn also provided an argument for why tail male tenure was preferable to a general entail. He posited that every descent to a female heir would effectively remove one lot—and thus one soldier—from the garrison and, through this arithmetic, would "soon diminish . . . the strength of each Township." He concluded by noting that not only were female heirs unable to perform militia service but that they were also considered incapable of serving as jurors or engaging in the other civic duties of "watching and warding" required of freeholders. Accordingly, an increased burden would be placed on the men of each township, in direct proportion to the number of female property owners.[20]

Despite the elaborate justification, however, the conditions of the tenure do not appear to have ever been enforced. In October 1732, even before the first ship left England, four of the settlers demanded that the Trustees assure them that the English laws of dower—the widow's thirds—would be adhered to in the colony. They also required allowances to make wills of inheritance, which permitted their lands to descend to their female kin in the absence of a male descendant. These exceptions became the rule. Two years later, the Trustees again publicly amended the provision and made potential grantees aware that it would not be enforced. John Perceval, the first Earl of Egmont and the initial president of Trustees, was a staunch supporter of the tenure in tail male, but even he acknowledged that the council possessed the authority to allow for

female successors and argued that it "should never refuse" to do so as long as she agreed to marry a husband "who would settle there." Milton Ready, in the course of his comprehensive study of the colonial records, has identified "copious examples of land grants to daughters and widows." Still, despite all the evidence to the contrary, malcontent petitions and essays repeatedly blamed the tenure in tail male for the economic woes of the colony and tied it to their demands for lands in fee simple. It evidently made for good rhetoric if nothing else. As late as June 1740, William Stephens recorded a malcontent orator dismissing any public amendments to the rights of inheritance and promising to the crowd that, through his struggle, he would make tail male tenure appear to be "the basest Tenure in Christendom."[21]

The persistent inability of the settlers to produce sufficient food provoked a real crisis, however, during the winter of 1738–1739. Warning indicators had been apparent for some time as the colony struggled to grasp onto some form of prosperity. The poor harvests of 1736 and 1737 had already encouraged many to abandon the land and rely on casual employment as day laborers and the provisions from the public store for subsistence. Five years into the enterprise, only a little more than a thousand acres had been cleared and planted in the colony. Nearly a third of this acreage was associated with the military garrison at Frederica and had been cleared and cultivated not by individual freeholders but by the regimental soldiers. In Savannah, the largest population center, only 274 acres had been brought under cultivation. The township that had been designed to be the apogee of the yeoman ideal for the charity settlers had, by 1738, very few farmers. Complaints about the poor quality of the soil, especially lands that were regularly inundated by water or consisted of pine barren, were constant and often spoke directly to the futility of transplanting English agricultural practices there. Excessive delays in getting lands surveyed fostered uncertainty about titles to possession and provided additional excuses to defer

their cultivation. Conditions took a turn for the worse in January 1739, beginning a period that William Stephens referred to as the "fatal Times." By February, the public store was empty of meat and the flour and bread supply was nearly exhausted. Stephens blamed the situation on local merchants and creditors who had exacerbated matters by collecting debts in food provisions in lieu of money. Desperation became more palpable and, the following day, he reported on rumors of a conspiracy to kill the Trustees' steers to provide beef for the town.[22]

Even in areas where food production had shown more promise, ominous signs questioned the sustainability of the project. Scottish settlers at Darien, who had garnered praise from the Trustees for their industriousness in contrast to the charity settlers of Savannah, now reported on the "poverty of the soil" made apparent by the decreasing annual grain yields, even after their intensive labor to prepare the soil. They reported to Stephens that they no longer expected to raise crops from the land in the future and that they desired to turn their attention to livestock and timber instead. They appealed for their own public store in the town because they had no market to turn to "in case of dearth or want" and no means to access credit. They proposed that the store should "accept payment in sawn lumber, shingles, and pipe stoves" in exchange for provisions. Stephens confided in his journal that such reforms would "put an end to all Planting at once." At the Ebenezer settlement, the Salzburg immigrants had overcome several frustrating delays finding suitable lands and getting them surveyed and were now successfully cultivating 180 acres, enough to sustain the community; but they had done so by planting in a common field.[23]

The Trustees recognized the failing conditions in the colony. The abandonment of the agricultural project threatened an investment that already had exceeded eighty-two thousand pounds sterling contributed by Parliament and private parties. In 1737, the Trustees had dispatched William Stephens to the colony to serve as secretary and

report back directly to them. Concerned about the complaints about the land tenure and the incomplete surveys, the Trustees tasked Stephens with gathering information on the land allocation process. Savannah's freeholders responded by drafting a petition to the Trustees calling for the end of grants in entail, allowing for "lands in fee simple," and removing the prohibition on the importation of African slaves. The petitioners noted that even those who had improved and "planted their Land" had been unable "to raise sufficient Produce to maintain their Families in Bread-kind only." Their situation was dire and it was obvious they could not "subsist by their Land according to the present Establishment." They chided Oglethorpe— grounding their analysis on the basis of "Trial, Practice, and Experience" and not some theoretical "Scheme of Reasoning." Finding themselves in debt from the outlay to improve their lands and from buying provisions, medicines, and clothing for their families, they now found it necessary to abandon the land unless significant reforms were made. They proposed two principal reforms. First, they demanded "free title or fee simple" grants to their lands, which they believed would "induce great Numbers of new settlers to come amongst us," as well as "encourage those who remain here cheerfully to proceed in making further improvements." They asserted that the change in land tenure would enable them "to retrieve their sunk Fortune" and to make "Provisions for their Posterity." Second, the Savannah freeholders demanded African slaves, which they also believed would "occasion great Numbers of white People to come here" and would immediately remedy the economic failures of the colony.[24]

Oglethorpe immediately recognized the disingenuousness of the freeholders' petition for lands in fee simple. He informed the Trustees that this request could not be decoupled from the freeholders' demand for slaves. Indeed, any alteration of the tenure to fee simple was meaningless if African slavery was still to be prohibited. As their signatures made clear, these petitioners already

were freeholders; their tenure in fee tail was a life estate, in which they held in sole possession and maintained a right for it to descend to a male family member in perpetuity. The male issue provision to the entail was restrictive, but less so than primogeniture and deemed necessary for the military defense of the colony. The freeholders could still improve their land, and the fruits of these labors would be passed on to the benefit of their future generations. Fee simple title, on the other hand, would not bring any additional incentive to cultivate the land, nor would it erase the possibilities of forfeiture and escheat. If a fee-simple planter refused to cultivate mulberry trees, his land would revert to the Trustees as well. Fee simple, like fee tail, was a form of tenure—not private ownership.

The ability to alienate the land through transfer and sale represented the sole advantage that fee simple title held over lands that were entailed. The malcontent petitioners demanded this right of alienation as the only clear way to lift themselves out of the poverty of their condition. They sought to create a market in lands in Savannah, which, through their mortgage, rent, and sale, would provide them with the necessary capital to purchase slaves. Any bucolic images of the yeoman farmer evaporated in the heat and sandy soils of the Lowcountry: Georgia's freeholders preferred to be flesh-peddling merchants, not simple farmers. Already in possession of the land, they understood its onerous demands and the bleak prospects for an individual freeholder. Accordingly, they closed their petition to the Trustees by desperately pleading that it was enslaved laborers that they needed to raise "Provisions upon our Lands" and to thereby "render us capable to subsist ourselves."[25]

Oglethorpe organized a rival campaign to refute the grievances of the malcontent freeholders, which focused almost exclusively on the potential ills associated with introducing slaves into the colony. He received important support from the Ebenezer and Darien settlements in this regard, who opposed the introduction of slavery and refused to endorse the malcontent petition. They did,

however, share in the hopes of formally removing the bar against female inheritance. During the summer the Trustees took up the issues in their common council. After some discussion, they decided to remove the restriction of male descent only and to allow those freeholders who had no descendants the right to bequeath to named successors. The amendments weakened the conditions of the entail, but they still did not allow land sales. John Perceval, the Earl of Egmont, contended that the amended inheritance laws should be approved by the king, but the majority of the council believed it unnecessary and decided to make the change on the basis of their charter authority alone. Perceval's comments, however, subtly posed questions about the extension of the English common law to the colony and, correspondingly, about the legitimacy of land tenure there. On the question of slavery, the Trustees agreed with Oglethorpe and continued to believe that the agitation for it was the work of only a few merchants, so they recommended no changes to the law there.[26]

Malcontent complaints about land policy continued, but their focus shifted away from criticizing the tenure and was directed more toward the various conditions and restrictions attached to landholding. In 1741, Patrick Talifer, David Douglas, and Hugh Anderson published a comprehensive critique of Oglethorpe's administration under the title *A True and Historical Narrative of the Colony of Georgia in America*. All three men had abandoned the colony and moved to South Carolina during the previous year. Their commentary revealed the palpable anxiety of men who were afraid of not having control over their own economic fate. They lamented the possibility of forfeiture if they failed to plant a sufficient number of mulberry trees, or if they failed to pay a quitrent, which was not yet due. They complained about the possible escheat of their lands because they lacked a male descendant, even though the tenure in tail male had been abolished already. They decried all the "various restrictions, services, and conditions" that made cultivation "impossible for any human

Person to perform," only to then ask for an allowance to import slaves into the colony for its benefit. The paradox was revealing. Only through the ability to control the labor of others did they believe themselves able to provide for their basic economic needs. Throughout the redundant text, their ultimate desire to transform the colony from a structured agricultural settlement into a commercial entrepot based on the products of enslaved laborers served as the narrative theme and their solution for economic uncertainty. On behalf of the Trustees, Benjamin Martyn mustered a response, *An Impartial Enquiry into the State and Utility of the Province of Georgia*, which sought to address some of the men's concerns by offering a more halcyon perspective on the economic potential of the coastal ecology. Martyn was thorough and a bit more evenhanded in his presentation; nevertheless, the question remained as to whether the potential could be tapped without enslaved laborers.[27]

By 1741, then, two competing views about the economic future of the colony had fully developed and were focused on the question of slavery. At this time, Georgia was the only British colony to prohibit slavery, and that fact encouraged the proslavery faction to consider Oglethorpe's zealous commitment to the original design to be self-serving. His authority was diminished through changes to the local administration whereby the colony was divided into two districts, with administrative seats in Savannah and Frederica. Oglethorpe was appointed to govern the Frederica district, while William Stephens was appointed to preside over Savannah. Oglethorpe's gaze had already shifted southward with the outbreak of war against the Spanish during the summer of 1739. His victory at the battle of Bloody Marsh ended any real Spanish military threat, which had characterized the first decade of settlement and justified the land tenure in fee tail male. Correspondingly, the Stono Rebellion by slaves in South Carolina complicated the argument for expanding slavery but also led to the development of a legal code designed to regulate

master-slave relations through government force. Food scarcity remained an issue along the coastal settlements, at least through 1741, with corn being in short supply because of drought and caterpillar worms. The decision to close the deeply indebted public store opened new opportunities for merchants in Savannah and signaled a relaxation of economic control by the Trustees. By the middle of the decade, reports of enslaved laborers being employed despite the prohibition on slavery were considered common knowledge. Agriculturally, however, the colony still continued to depend on parliamentary subsidies and South Carolina merchants for food.[28]

The conclusion of the war with Spain, in 1748, also signaled the end of the Trustees' experiment in Georgia. Parliament suspended its annual allocation of funds to the Trustees and, the following year, withdrew the British regiment stationed at Frederica. With the military mission of the colony vacated, its economic viability became the sole concern. In January 1749, at the Trustees' behest, a council of notables assembled to discuss and devise a new economic model for the colony. They did not discuss the question of land tenure but instead addressed eight questions relating to the regulations considered necessary for the introduction of slavery into the colony. In the end, the council unanimously supported all eight provisions and endorsed removing the prohibition. By October, the Trustees had agreed to permit the importation of slaves, and the council had drafted regulations to govern the masters and the slaves. The regulations were implemented the following spring. So that new lands could be opened for the cultivation of rice and silk, all lands in Georgia were released of their entails and henceforth granted as fee simple freeholds with no restrictions on sale or alienation. During the next three years, nearly 40 percent of the land grants awarded were made to South Carolinians who sought out suitable lands for rice cultivation. The transition to a plantation economy was well underway by the time that royal government was established in 1752.[29]

Conclusions: The Consequences of Failure

The failure of Georgia's freeholders to clear and cultivate enough land to produce food for themselves encouraged an abandonment of the yeoman ideal as an economic model. Georgia's settlers did not "take to the land," despite a familiar ideology celebrating them as being naturally connected to it and despite a comprehensive settlement plan designed to encourage it. Clearing the land of trees and undergrowth; tilling and preparing the soil; planting, weeding, and harvesting the crops; gleaning, plowing, and harrowing the fields proved to be tasks too onerous for them. Trade and craft manufacturing seemed more natural to their inclinations. In fairness, most of them had not been farmers in the first place. Paul Pressly has calculated that "of the 827 persons sent by the trustees whose occupations are known, only 97 had occupations related to husbandry." But when given the opportunity, they disappointed those who believed that agriculture was the natural aptitude of the common man.[30]

By the 1750s they were being replaced by new men. The transition to a new mode of agricultural production represented an expressed preference for men with specific skills and technical expertise—men such as Henry Laurens, Jonathan Bryant, and Noble Jones, who had a new vision of agriculture as a rational and scientific enterprise. They observed the various properties of different soils, experimented with different plants and techniques, and recorded their results. They were far less concerned about political rights and status associated with freehold tenure than about the produce that could be extracted from it. Most significantly, however, they recognized that to subdue the natural environment, they had to be able to exercise command over other people, who could be brought into abject dependence and compelled to do the onerous work of clearing and cultivating, draining and improving. Agricultural modernity emerged on the Coastal Plain, as it did in England, as a collective process managed by the absolute authority of one individual.[31]

Georgia's embrace of African slavery and adoption of plantation agriculture thus reflected, as it had in South Carolina, a recognition that collectivized forced labor was a more viable economic model on the Atlantic Coastal Plain. The commercial success of the West Indian sugar plantations and the South Carolina rice plantations was increasingly obvious to all, but a significant lesson learned from Georgia was the necessity of collective farming and forced labor simply to produce the food necessary to sustain the colonial settlements. African slavery represented one source of this labor supply, but it was not the sole source. Convict transportation increased during the century as well. Convicts had been sent to the colonies since the seventeenth century, but the practice was formalized by the Transportation Act in 1718. The act was invoked to send approximately fifty thousand convicts to the Chesapeake colonies and then, following the American Revolution, on a more grand scale to New South Wales. Despite an abundance of lands, colonial food production was considered primarily a labor question.[32]

As the British Empire expanded during the eighteenth century, this lesson was carried with it. Following the French and Indian War, the acquisition of Florida opened new lands to the British along the Coastal Plain. The proposed land policy for the settlement of West Florida was representative of a new imperial attitude that encouraged the importation of slaves and plantation development. It diverged significantly from the Georgia plan. Heads of household were entitled to grants of one hundred acres as well as additional fifty-acre grants for each member of the household—to include slaves and indentured servants. Larger grants of up to one thousand acres were available for purchase with the consent of the governor. Unlike the proprietary scheme in Georgia, the British moved swiftly to establish government to facilitate the settlement of the colony. A governor was appointed and instructed to implement a three-step process to grant, survey, and record the land titles. Surveys were required to be completed within six months and were tasked with identifying arable and uncultivable areas within each grant. Cattle grazing was encouraged in areas of pine barren in lieu of planting. Quitrents were set at a halfpenny per acre and waived for the first two years of residence. Lessons from Georgia had been learned.[33]

Although the preference for the freehold as an economic model of colonial settlement waned, the cultural trope persisted. The failure of the Georgia freeholders could be attributed to climatic tropes about the geographic limits of the white work ethic and the necessity of African laborers in the tropical and subtropical regions. British settlers aggressively pushing beyond the western borders of the North American colonies embraced the archetype of the yeoman freeholder to cloak the illegality of their frontier settlements and justify their claims to the land. And following the revolution, a variation on Oglethorpe's design for an agricultural community of independent freeholders was revived by a young Virginia lawyer as part of his plan to settle the Ohio territory. Indeed, Thomas Jefferson situated the freehold as the cornerstone of his agrarian republic. Significantly, however, Jefferson's alodial reforms to the land law divorced the freehold's immemorial association with the doctrine of tenures. Instead, it considered the fee simple freehold as an exclusive right of ownership. Correspondingly, the rights of a freehold did not emanate from the land but were vested instead in the individual person. Jefferson's freeholders were thus deemed the absolute owners of their property—in both land and labor.

NOTES

1. Mark B. Tauger, *Agriculture in World History* (New York: Routledge, 2010); Giovanni Federico, *Feeding the World: An Economic History of Agriculture, 1800–2000* (Princeton, N.J.: Princeton University Press, 2009); Mark Overton, *Agricultural Revolution in England: The Transformation of the Agrarian Economy, 1500–1850* (Cambridge: Cambridge University Press, 1996); Marc Bloc, *French Rural History:*

An Essay on Its Basic Characteristics (Berkeley: University of California Press, 1966).

2. This paragraph inadequately summarizes a broad and sophisticated field of historical study, but some essential references to begin with are Laura Brace, *The Idea of Property in Seventeenth-Century England: Tithes and the Individual* (Manchester, England: Manchester University Press, 1998); J. G. A. Pocock, introduction to *The Commonwealth of Oceana and a System of Politics*, by James Harrington, ed. Pocock (Cambridge: Cambridge University Press, 1992); J. G. A. Pocock, "Authority and Property: The Question of Liberal Origins," republished in *Virtue, Commerce, and History* (Cambridge: Cambridge University Press, 1985); Joyce Appleby, *Liberalism and Republicanism in the Historical Imagination* (Cambridge, Mass.: Harvard University Press, 1992), especially her essay "The 'Agrarian Myth' in the Early Republic"; Christopher Hill, "The Norman Yoke" and "The Agrarian Legislation of the Revolution," in *Puritanism and Revolution: Studies in Interpretations of the English Revolution of the 17th Century* (New York: St. Martin's Press, 1997). The material conditions of English agriculture informing these narratives are discussed in Overton, *Agricultural Revolution in England,* and, famously, in *The Brenner Debate: Agrarian Class Structure and Economic Development in Pre-industrial Europe*, ed. T. H. Aston and C. H. E. Philpin (Cambridge: Cambridge University Press, 1985).

3. Commercial farming should not be conflated with capitalist agriculture. Commercial behavior and agrarian relations to the market changed significantly during the eighteenth and nineteenth centuries, but some historians remain overeager to classify any form of market exchange as capitalism. For important correctives to this tendency see James Henretta, "Families and Farms: *Mentalité* in Pre-industrial America," *William and Mary Quarterly* (1978): 3–32; Elizabeth Fox-Genovese and Eugene D. Genovese, "The Janus Face of Merchant Capital," in *Fruits of Merchant Capital: Slavery and Bourgeois Property in the Rise and Expansion of Capitalism* (New York: Oxford University Press, 1983).

4. See Christopher M. Curtis, *Jefferson's Freeholders and the Politics of Ownership in the Old Dominion* (Cambridge: Cambridge University Press, 2012); Chester E. Eisinger, "The Freehold Concept in Eighteenth-Century American Letters," *William and Mary Quarterly* 4 (1947): 42–59.

5. James T. Lemon, *The Best Poor Man's Country: A Geographical Study of Early Southeastern Pennsylvania* (Baltimore: Johns Hopkins University Press, 1972); Robert Weir, *Colonial South Carolina: A History* (Columbia: University of South Carolina Press, 1997); Peter A. Coclanis, *The Shadow of a Dream: Economic Life and Death in the South Carolina Low Country* (New York: Oxford University Press, 1991); S. Max Edelson, *Plantation Enterprise in Colonial South Carolina* (Cambridge, Mass.: Harvard University Press, 2006); A. Roger Ekirch, *Poor Carolina: Politics and Society in Colonial North Carolina, 1729–1776* (Chapel Hill: University of North Carolina Press, 1981); Paul M. Pressly, *On the Rim of the Caribbean: Colonial Georgia and the British Atlantic World* (Athens: University of Georgia Press, 2013); Alan Gallay, *The Formation of a Planter Elite: Jonathan Bryant and the Southern Colonial Frontier* (Athens: University of Georgia Press, 2007); Anthony Parent Jr., *Foul Means: The Formation of a Slave Society in Virginia, 1660–1740* (Chapel Hill: University of North Carolina Press, 2003); Richard S. Dunn, *Sugar and Slaves: The Rise of the Planter Class in the English West Indies, 1624–1713* (New York: W. W. Norton, 1972); Richard B. Sheridan, "Caribbean Plantation Society, 1689–1748," in *The Oxford History of the British Empire: The Eighteenth Century*, ed. P. J. Marshall (New York: Oxford University Press, 1998); Trevor Burnard, "The British Atlantic," in *Atlantic History: A Critical Appraisal*, ed. Jack P. Greene and Philip D. Morgan (New York: Oxford University Press, 2009).

6. Mart Stewart, *What Nature Suffers to Groe: Life, Labor, and Landscape on the Georgia Coast, 1680–1920* (Athens: University of Georgia Press, 1996); Charles Seabrook, *The World of the Salt Marsh: Appreciating and Protecting the Tidal Marshes of the Southeastern Atlantic Coast* (Athens: University of Georgia Press, 2012); F. Stearns MacNeil, "Pleistocene Shorelines in Florida and Georgia," Geological Survey Professional Paper 221-F (Washington, 1949). On pre-British agricultural patterns, see David Hurst Thomas, *Native American Landscapes of St. Catherines Island, Georgia*, Anthropological Papers of the American Museum of Natural History, no. 88 (New York: American Museum of Natural History, 2008), http://hdl.handle.net/2246/5955; David Hurst Thomas, "Deep History of the Georgia Coast: A View from St. Catherine's Island," in *Coastal Nature, Coastal Culture: Environmental Histories of the Georgia Coast*, ed. Paul S. Sutter and Paul M. Pressly (Athens: University of Georgia Press, 2018).

7. In addition to Pressly, Stewart, and Gallay see Kenneth Coleman, *Colonial Georgia: A History* (New York: Charles Scribner's Sons, 1976); Betty Wood, *Slavery in Colonial Georgia, 1730–1775* (Athens: University of Georgia Press, 1984); Phinizy Spalding and Harvey H. Jackson, eds., *Oglethorpe in Perspective: Georgia's Founder after Two Hundred Years* (Tuscaloosa: University of Alabama Press, 1989).

8. [Benjamin Martyn], *Reasons for Establishing the Colony of Georgia with Regard to Trade of Great Britain* (London: printed for W. Meadows, 1733). On the social attitudes toward work under the trustees see J. E. Crowley, *This Sheba, Self: The Conceptualization of Economic Life in Eighteenth-Century America* (Baltimore: Johns Hopkins University Press, 1974); Perry Miller, *Errand into the Wilderness* (Cambridge, Mass.: Harvard University Press, 1956).

9. Thomas D. Wilson, *The Oglethorpe Plan: Enlightenment Design in Savannah and Beyond* (Charlottesville: University of Virginia Press, 2012).

10. Letter from Thomas Causton, March 12, 1733, *Colonial Records of Georgia* (hereafter *CRG*, volume: page) 20: 16; letter from Hugh Anderson to Lord Egmont, August 28, 1739, *CRG* 5: 227; "A True and Historical Narrative of the Colony of Georgia in America," reprinted in *The Clamorous Malcontents: Criticisms & Defenses of the Colony of Georgia, 1741–1743*, introduction by Trevor R. Reese (Bronx, N.Y.: Beehive Press, 1973), 28. Benjamin Martyn defined pine barren as lands "so called from the Pines growing on it with scarce any other Sorts of Timber; and the Soil, being dry and sandy, will not produce Grain like the other Lands. However there is a Grass upon it, which feeds Abundance of Cattle. This being high Ground is found a healthy Situation, and the Houses are generally built upon it." Martyn offered this definition as part of a favorable categorization of Georgia's soils in his *An Impartial Enquiry into the State and Utility of the Province of Georgia* (1741) in *Clamorous Malcontents*, 131. For a more comprehensive analysis of the challenges see Stewart, *"What Nature Suffers to Groe,"* 53–86.

11. See Milton L. Ready, "Land Tenure in Trusteeship Georgia," *Agricultural History* 48 (1974): 353–368; Milton L. Ready, "An Economic History of Colonial Georgia, 1732–1754," PhD diss., University of Georgia, 1970. Ready's comprehensive understanding of Georgia's colonial records has made his scholarship deeply influential to other historians of Georgia, but it has also allowed for his mischaracterization of fee simple title to be perpetuated. The misperception precedes Ready—see Enoch Marvin Banks, *The Economics of Land Tenure in Georgia* (New York: Columbia University Press, 1905); James C. Bonner, *A History of Georgia Agriculture, 1732–1860* (Athens: University of Georgia Press, 1964).

12. For a lengthier discussion of land tenure see Curtis, *Jefferson's Freeholders;* A. W. B. Simpson, *A History of the Land Law*, 2nd ed. (Oxford: Clarendon Press, 1986). The "bundle of rights" explanation is most notably articulated in Robert Gordon, "Paradoxical Property," in John Brewer and Susan Staves, eds., *Early Modern Conceptions of Property* (New York: Routledge, 1995), 95–110.

13. E. P. Thompson, "The Grid of Inheritance," in *Making History: Writings on History and Culture* (New York: New Press, 1994); E. P. Thompson, "Custom, Law, and Common Right," in *Customs in Common: Studies in Traditional Popular Culture* (New York: New Press, 1993).

14. Marshall Harris, *Origin of the Land Tenure System in the United States* (Ames: Iowa State College Press, 1953); Beverly W. Bond Jr., *The Quit-Rent System in the American Colonies* (New Haven: Yale University Press, 1919).

15. E. P. Thompson, *Whigs and Hunters: The Origins of the Black Act*, especially 219–269 (Berkeley: University of California Press, 1975); Thompson, *Customs in Common*; Overton, *Agricultural Revolution in England*; Joyce Chaplin, *An Anxious Pursuit: Agricultural Modernity in the Lower South* (Chapel Hill: University of North Carolina Press, 1993); John C. Weaver, *The Great Land Rush and the Making of the Modern World, 1650–1900* (Montreal: McGill-Queen's University Press, 2003).

16. *Journal of the Commissioners for Trade and Plantations, Preserved in the Public Record Office*, vol. 6: *From January 1728/29 to December 1734* (London: Great Britain Board of Trade, 1928), 259; see also discussions of Nova Scotia, 176–178, 191; Ready, "Land Tenure in Trusteeship Georgia," 355; Henry Nash Smith, *Virgin Land: The American West as Symbol and Myth* (Cambridge, Mass.: Harvard University Press, 1978), 5.

17. Christopher Hendricks, *The Backcountry Towns of Colonial Virginia* (Knoxville: University of Tennessee Press, 2010). On the South Carolina township scheme see Weir, *Colonial South Carolina*, 111–112, 208; Walter Edgar, *South Carolina: A History* (Columbia: University of South Carolina Press, 1978), 52–55.

18. Wilson, *Oglethorpe Plan*, 90; Ready, "Land Tenure in Trusteeship Georgia," 355–356.

19. *CRG* 3: 373–378; Ready, "Land Tenure in Trusteeship Georgia," 354.

20. [Martyn], *An Account Shewing the Progress of the Colony of Georgia in America from Its Establishment* (1741) in *CRG*: 3: 373–378.

21. Ready, "Land Tenure in Trusteeship Georgia," 354–355; *Stephens' Journal, CRG* 4: 605.

22. On the seriousness of the food crisis and the sustainability of the project in general, see John Perceval, *The Journal of the Earl of Egmont: Abstract of the Trustees Proceedings for Establishing the Colony of Georgia, 1732–1738* (Athens: University of Georgia Press, 1962); *Stephens' Journal, CRG* 4: 272–273. Acreage totals taken from Ready, "Economic History of Colonial Georgia," 113, table "Acres Cleared and Planted in Georgia—1738." Pressly estimates the population at 1,735 settlers, mostly clustered in the townships of Savannah, Frederica, Augusta, Darien, and Ebenezer. Pressly, *On the Rim*, 19. Ready estimates the mortality rate to be around 30 percent during these early years.

23. *Stephens' Journal, CRG* 4: 239; Perceval, *Journal of the Earl of Egmont, 1732–1738*, 205–206, 235–236.

24. "Petition to the Honourable Trustees for Establishing the Colony of Georgia in America," December 9, 1738, in *Clamorous Malcontents*, 75–77.

25. *Clamorous Malcontents*, 75–75.

26. John Perceval, *Journal of the Earl of Egmont, 1739–1748*, in *CRG* 28: 167–171, 212–217.

27. Patrick Talifer, *A True and Historical Narrative of the Colony of Georgia in America, 1741*; Benjamin Martyn, *An Impartial Enquiry into the State and Utility of the Province of Georgia, 1741*. Both are republished in *The Clamorous Malcontents*.

28. Pressly, *On the Rim*, 23–26; Wood, *Slavery in Colonial Georgia*, 44–58, 74–87; Bonner, *History of Georgia Agriculture*.

29. The President, Assistants and Councilmen to Benjamin Martyn, January 10, 1749, and January 12, 1749, *CRG*: 25: 347–352; The President, Assistants and Councilmen to the Trustees, October 26, 1749, *CRG*: 25: 430–437. For commentary see Pressly, *On the Rim*, 29–49; Wood, *Slavery in Colonial Georgia*, 74–87.

30. Pressly, *On the Rim*, 235n51.

31. Joyce Chaplain, *An Anxious Pursuit: Agricultural Innovation and Modernity in the Lower South, 1730–1815* (Chapel Hill: University of North Carolina Press, 1993); Gallay, *Formation of a Planter Elite*, especially 94–99; Stewart, "*What Nature Suffers to Groe*"; Drew A. Swanson, *Remaking Wormsloe Plantation: The Environmental History of a Lowcountry Landscape* (Athens: University of Georgia Press, 2012).

32. A. Roger Ekirch, "Bound for America: A Profile of British Convicts Transported to the Colonies, 1718–1775," *William and Mary Quarterly* 42 (1985): 184–200.

33. Robin F. A. Fabel, *The Economy of British West Florida, 1763–1783* (Tuscaloosa: University of Alabama Press, 1988), 7–10.

Wormsloe's Belly

Understanding the History of a Southern Plantation through Food

DREW SWANSON, history professor, Wright State University, Dayton, Ohio

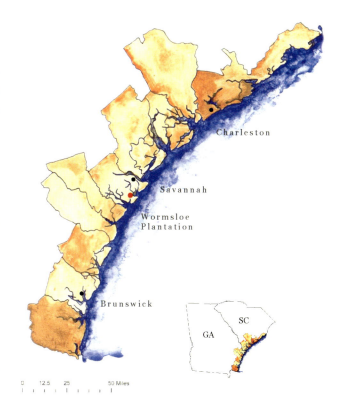

Using extensive documentation in the De Renne Collection and archaeological research onsite, Swanson describes two centuries of foodways at Wormsloe starting in the 1730s. Agricultural practices, food and beverage imports, celebration events with menus, and daily fare are revealed.

"Tell me what you eat, and I will tell you who you are." With this quotation, made famous by TV's *Iron Chef* and shelves full of cookbooks, the nineteenth-century epicure Jean Anthelme Brillat-Savarin stressed the centrality of food culture to life. As an environmental historian and amateur cook—"chef" would be too strong a label—I have always appreciated Brillat-Savarin's assessment of the essential nature of food. Up to this point, however, that appreciation did little to influence my own work. Recently, while working on a history of land use on Wormsloe, a Georgia plantation near Savannah, I noticed that my research continually uncovered fascinating evidence of food culture and its connection to the surrounding environment. Mesmerized by provision records, garden lists, recipe books, and the physical remains of meals long past, I began to imagine a history of the plantation from the belly up.[1]

But why is Wormsloe's story important? After all, it is just one plantation among the thousands of large and small landholdings that cover the southern landscape. The answer is twofold. First, Wormsloe has an astonishingly rich collection of records. From its initial settlement in the 1730s until the property changed hands during the Great Depression, plantation residents often jotted down recipes, receipts, estate inventories, and

other references to producing and consuming food, scraps that have been collected and preserved in the Hargrett Rare Book and Manuscript Collection at the University of Georgia. Second, southern food culture was and is so diverse that it begs for studies of particular places. A small-scale study of a place like Wormsloe allows the details to come out, details necessary for understanding the intimate relationships between people, landscape, and food that shape eating. Wormsloe cannot reveal *the* history of southern food and environment—no one place can—but it does provide a unique window into a piece of southern food culture, and it will, I hope, stimulate similar studies in other parts of the South. Wormsloe's story is, among other things, a classic southern food tale, an account of innovation and tradition, of constant struggles between forces of change and continuity. Based on these plantation records, this chapter is a snapshot of gardens, stoves, and plates, a brief attempt to understand the connections between people and place through one of the most essential ways humans interact with their environment—by eating it. So with apologies to Brillat-Savarin, I would suggest, "Tell me what you eat, and I will tell you where you live."

Founded in 1735 by Noble Jones as an outpost against potential Spanish invaders along a water approach to Savannah, Wormsloe was also a working plantation from its early years. Although much of the colonial food culture has been washed away by time, it is evident that the plantation's cuisine was from the very beginning a blend of local and foreign food. Soon after constructing a small fortified house out of tabby (sand, lime, and oyster shells packed together under pressure), Jones and the marines under his command cleared fourteen acres for corn and began ranging hogs and a hundred cattle they brought from South Carolina in the fenceless coastal woods. Not content with bacon and cornbread, Jones also began experimenting with a number of exotic fruits, attempting to grow subtropical crops on Wormsloe's sandy soil. Passing

through the area in 1765, famed naturalist John Bartram described Jones's unorthodox farming efforts:

> He hath & is makeing great improvements in fruites which [the plantation] is properly adapted for. His orange trees, pomegranates, figs, peaches, & nectarins grows and bears prodigiously. I saw one Apricot tree but it looked poorly, & one grape vine, ye fruit of which rotted Just before ripe, like as ours. Ye orange trees here is not hurt with ye frost while young, as in most parts of this countrey & allso at ye Colledge for a year or two, & his pomegranates is very large, 4 or 5 inches diameter, & very delitious.

Between the abundant local seafood, exotic neotropical fruits, corn, sides of free-ranging beef and pork, and purchased food items such as rice, sugar, and molasses, Wormsloe's colonial residents seem to have enjoyed a relatively diverse diet.[2]

Like many colonial southerners, Wormsloe's residents consumed as much alcohol as possible. With a location near the major port of the colony, Jones and his family and slaves seemed to have imbibed wine more than any other spirit. Probably fortified wines such as Madeira, sherry, and port, this alcohol was a product of the Atlantic trade and symbolic of Wormsloe's location on the edge of empire. The plantation's residents were such voracious drinkers that the remains of wine bottles were the most reliable way for archaeologist William Kelso to date colonial discoveries during his excavation of the old fort site in the 1960s. During roughly two months of digging in the fort, Kelso and his team discovered the remains of at least 177 discarded wine bottles, along with a number of other vessels that may have held alcohol. Considering the bottles that must have been refilled and reused, transported off-site, or dumped somewhere outside the archaeological grid in the fort, Wormsloe must have been a merry—or violent—place indeed.[3]

Although Jones and his family seemed to eat quite well, food and eating in a new land were tied to more than just

FIGURE 9.1. The ruins of the colonial tabby fort as they appeared to Wormsloe
Garden visitors, Bayard Wooten, 1934. Courtesy of Hargrett Rare Book and
Manuscript Library / University of Georgia Libraries.

experimentation and imagination; they were also a product of fear. With its hot, humid climate and myriad new food options, English colonists often feared that coastal Georgia endangered their health. What should a European eat and drink in a place so different from home? Could diet slow or forestall the diseases that ravaged the white body in a climate that approached tropical extremes? Noble Jones displayed some of these apprehensions in a 1754 letter. Writing to English ship captain David Murray, who was preparing to visit the coastal South for the first time, Jones outlined a number of dietary steps that might preserve health. He warned Murray against eating too much of English staples, advising moderate consumption of pork and only a pint of English beer each morning. He also cautioned against indulging in local food, telling the captain to abstain "intirely from all kind of Water Fowl, and eat Fish as Sparingly as possibly you can." In fact, Jones seemed to advise against keeping any sort of food inside the body too long, as he began his advice by ordering Murray to take three to five laxative pills on a regular basis. Unfortunately, no account survives to tell us how Jones's advice influenced Murray's stay on the Georgia coast.[4]

The British occupation of Savannah during the American Revolution meant hard times for Wormsloe and the Joneses, not least because the occupiers requisitioned most of the local "bullocks, hogs, sheep, poultry, &c." Following the war the plantation's livestock would recover, but for roughly five decades the records are relatively silent concerning the property's food culture. We can make some calculated guesses based on the surviving scraps of information. Wormsloe was alternately rented out or under the care of an overseer for much of this period, so Black and white diets were likely relatively basic. An 1810 agreement with John Rawls to oversee the plantation gives a brief window into the daily bread of white workers. In addition to an annual cash wage ($200), Wormsloe's owner George Jones promised to provide Rawls with "Corn & such other Bread kind as may be raised on the said plantation," as well

as "a wench named Flora to cook" for him. By the 1830s the Jones family was using Wormsloe on a more regular basis once again, and began documenting their lunches and dinners with greater frequency and detail.[5]

A pair of early to mid-nineteenth-century recipe books provide a glimpse of Wormsloe's kitchens, revealing a diverse repertoire. The plantation's cooks drew heavily from the surrounding waters, preparing among other recipes stewed turtle fins, fried turbot, shrimp pie, baked shad, rockfish, pickled oysters, baked crabs, potted herring, canvasback ducks, and soft-shell turtle soup. They turned to African cooking traditions with other dishes, fixing arrowroot puddings, custards, and griddle cakes, along with sweet potatoes and gumbo. The following recipe for terrapin stew is typical in its reliance on both fresh local game and European ingredients, prepared by an elaborate cooking method:

TERRAPIN—WHITE STEW

Cut off heads, and throw terrapins into cold water for about an hour to draw out blood. Then scald in boiling water to take off skin and nails. Boil slowly until thoroughly done so that legs may be pulled off. While boiling season with allspice, black pepper, thyme, salt & onion. Drain, open, and take out gall and intestines, keeping liver. Cut up fine, rejecting coarse white meat. Put in a stew pan with some of the liquor in which they have been boiled. Put in a tablespoonful of butter to each terrapin and season with salt & red pepper. Boil eggs—three to each terrapin fourteen minutes. Smash yolks thoroughly and stir in. Put in by degree a wineglass of cream to each terrapin, to which when stewed down and well incorporated, add a wine glass of Sherry to each terrapin. The eggs should be removed when the terrapin is opened, and only put into the stew one minute before dishing.[6]

Although some elements of food culture on the plantation remained constant, changes in plantation management created shifts in eating patterns. When George's son, George Wymberley Jones, moved his principal residence

to Wormsloe in 1854, he was determined to make the property over as a modern, efficient sea island cotton plantation. He sought improvements in labor efficiency by buying new tools and implementing paternalistic forms of slave management, from distributing gifts to inspecting slave cabins for cleanliness and organization. He also built a number of new farm structures, including a gin house, new slave cabins, a rice mill, various barns, and new stables. Jones also became one of the first planters in the region to use steam power on his plantation, purchasing an eight-horsepower engine to run a small saw mill and a new Fones McCarthy roller gin to separate cotton seeds from the fiber. Inspired by reading the works of agricultural reformers such as Virginia's Edmund Ruffin, Jones initiated these efforts in the hopes of increasing Wormsloe's sea island cotton production. In a period of four years, from 1856 to 1859, he raised the plantation's cotton production from just under 2,300 pounds to 10,155 pounds of clean lint.[7]

An instrumental part of Jones's modernization program involved increasing and diversifying Wormsloe's production of foodstuffs. The closer the plantation came to becoming a self-sufficient entity, the greater control Jones believed he would have over the production of wealth. To increase yield he imported improved strains of corn such as "Rhode Island yellow flint," "Wyandot," and "Maryland white"; experimented with making molasses from Chinese sugarcane; and planted peanuts in the sandier fields. He also bought purebred strains of various livestock, introducing Newport chickens and guineas; Devon, Alderney, and Newport cattle; and Merino sheep to the plantation. The Joneses seemed to increase and broaden their garden production during this period as well, planting southern staples and experimenting with exotic vegetables. Instrumental in helping these new crops and stock flourish was a program of building up the plantation's soil to produce larger crops and more fodder. Jones spent a substantial amount of money purchasing Peruvian guano and superphosphate of lime for Wormsloe's fields, and he had

his slaves spread boatloads of oyster shells over the property to lower the land's pH.[8]

As his program of modernization progressed, Jones reveled in Wormsloe's ability to feed his family and slaves. In an 1856 farm journal entry, he celebrated the success of his diversification programs. He noted with pleasure the food produced on the plantation during the month of November: "We have of eatables—the produce of this place—this month, the following: oysters, crabs, shrimp, fish (whiting), wild ducks, turkeys, chickens, eggs, milk, butter, English walnuts, hickory nuts, persimmons, pomegranates, hominy, sweet potatoes, Irish potatoes, [indecipherable], turnips, carrots, beets, cow peas, green peas, Lima beans, eggplant, tomatoes, okra, spinach, besides benne and arrowroot, and syrup from the chinese sugar cane—to say nothing of cabbage & pumpkins. We had also as fine a watermelon as I ever tasted on the 11th of this month."[9]

As during earlier periods, the diet of Wormsloe's residents reflected a meshing of African, North American, and European foods. The seafood, persimmons, hickory nuts, and ducks were wild products of the Georgia coast; pumpkins, potatoes, tomatoes, turkeys, and corn for the hominy were Native American staples; benne (sesame), arrowroot, okra, and eggplants were of African extraction; and the walnuts, dairy products, and many of the garden crops reflected the Joneses' English background. Filling in the interstices of the Joneses' diets were neotropical fruits and the Chinese sugarcane. What Jones celebrated as local independence was actually the product of an international food fusion—a triangular trade for the table.

While the plantation's white residents were eating their way around the globe, Wormsloe's slaves existed on a somewhat less diversified diet. Based on Jones's journal entries and purchases, his slaves seem to have subsisted largely on salt-cured bacon and some sort of starch accompaniment, usually rice, sweet potatoes, or cornmeal. He supplemented these basic rations regularly with molasses,

brown sugar, peanuts, and cowpeas. The sweet potatoes, peanuts, corn, and cowpeas came from Wormsloe's fields, while Jones purchased the other staples from Savannah merchants. In a gesture of paternalism, he also recorded giving out boxes of salted herring as "presents for the negroes" each holiday season.[10]

Of course slaves certainly augmented this basic diet with fresh vegetables from their house gardens and fish and game caught in the surrounding marshes and woodlands. Wild turkeys, raccoons, and opossums roamed between the live oaks and longleaf pines, and the local rivers and creeks were thick with oysters, crabs, waterfowl, and various fish. As one Lowcountry scholar has put it, most coastal masters probably expected their slaves "to be self-sufficient" when it came to supplementing their rations. This interaction with the surrounding environment—learning what portion of the woods harbored which game animals, how fish populations responded to the ebb and flow of tides and seasons, and where the ducks and geese liked to feed—connected slave diets firmly to their understanding and utilization of the surrounding landscape. The differences in white and Black diets also clearly outlined a fundamental disparity in the way Jones saw the relationship between the landscape and diet. Although Jones saw the diversity of his family's diet as evidence of the plantation's fertility, he believed the land's ability to provide the basics of his slaves' diet proved Wormsloe was a successful operation. A fat land from Jones's point of view was thus one that provided a bounty for masters and survival for slaves.[11]

Slave interactions with the Wormsloe environment serve as a valuable reminder that the story of African influences on Lowcountry food culture is not a simple tale of direct transference from the Old World to the New. After Georgia made slavery legal in 1749, food practices from Africa arrived in the Lowcountry via a cosmopolitan group of Black captives Ira Berlin labels "Atlantic creoles." This charter generation and their descendants came from worlds deeply influenced by the Atlantic trade and the edges of empire.

Atlantic creoles were often captured along the West African coast, where they had experience with European slavers and traders, and transported to the Caribbean, where they experienced work in sugar or cotton, before arriving in Georgia. Along the way, they picked up new crops and new forms of cooking, learning to blend the familiar and the foreign into something original. Rather than simple carriers of cultural fusion, Atlantic creoles produced new knowledge. A slave named Bilali on Sapelo Island, to the south of Wormsloe, was an example of the cultural diversity and influence of Atlantic creoles in the Lowcountry. Bilali was an educated Muslim captured along with his family on the West African coast in the mid-1700s. Slavers transported Bilali to the Bahamas, where he learned the cultivation of sea island cotton. Purchased by Thomas Spalding of Sapelo sometime in the late 1700s, Bilali brought his knowledge of cotton culture to Georgia, facilitating Spalding's experiments with the crop. Throughout his life, Bilali retained his ability to speak and read Arabic and clung to his Muslim faith, balancing daily prayers with overseeing cotton workers and eating special rice cakes on Islamic holy days. Neither simply "African" nor "creole," Bilali and his family were examples of a generation whose lives straddled the Atlantic littoral. Although Atlantic creoles were probably less influential in Georgia than in the Chesapeake or South Carolina because the region moved so rapidly from a society with slaves to a slave society, where the demands of planters and the importation of slaves from the African interior overwhelmed the charter generation, it would be an oversight to label the interactions between African and European cultures as direct transference.[12]

The Civil War ended the antebellum form of plantation culture on Wormsloe, and the Union occupation of nearby Tybee Island in late 1861 forced the Jones family to flee the coast for the relative safety of Augusta. When they returned to Savannah following the war, the family rented the plantation out to a succession of tenants, first to northern investors convinced that sea island cotton could

still turn a profit under free labor, next to cotton share-croppers, and finally to an assemblage of freedmen who rented small plots of land to grow subsistence crops. For the most part these were lean years on Wormsloe, and the property's residents made do with "the usual plantation fare." For sharecroppers and tenants the usual fare probably consisted of crops such as sweet potatoes, field peas, and corn and the produce of small kitchen gardens. By the early 1880s the Joneses—who legally changed their surname to De Renne in 1866—had profited from their nonagricultural investments and resumed closer care of their coastal plantation.[13]

More detailed records of Wormsloe's food culture resumed with the De Rennes' return to the plantation. In a postbellum South struggling to revive its economy, food nourished the body, but it could also clearly define status. Laying out an opulent spread asserted that the host was still a southern gentleman or lady (or at least aspired to that distinction). George W. De Renne (née Jones) used lavish meals to remind local citizens of his continued success and took great pleasure in describing how he fed his acquaintances. An 1878 picnic lunch, during an excursion to nearby Tybee Island, was an example of gustatory excess. During a pause in their journey, De Renne's party feasted on "boned turkey, roast chicken, sandwiches, rolls, crab salad and chicken salad, orange sherbet, strawberries, and strawberry ice cream, snowball pound cakes, 6 bottles champagne, 2 of sherry, 2 of whiskey; [and] lots of ice." Guests at Wormsloe were often treated to even more elaborate meals. At an 1880 lunch, De Renne served "Oysters on the shell, Boned turkey truffled, sandwiches, crab salad, ice cream and orange sherbet, cakes, strawberries, Oranges, apples, Prunes, Dried ginger, coffee, Burnt almond, sugared almonds, chocolate caramels: everything cold but coffee. Wines were sherry, and champagne." In a period when much of the South lay all but prostrate, it seems De Renne tried to prove the durability of his family's wealth through ostentatious displays of food.[14]

The De Rennes continued to swim in alcohol as well, though their tastes had grown more sophisticated since the cheap wine of colonial days and the rum and whiskey of the early nineteenth century. In an 1895 estate inventory, Wymberley De Renne recorded the spirits he and his father George had accumulated since the end of the war. It was a truly astounding list. Filling the racks, shelves, and corners of the plantation house cellar, George W. De Renne's collection included 460 bottles of Madeira and sherry, some dating as far back as 1730; twenty bottles of brandy, some of it seventy-five years old; and sixty bottles of whiskey and liqueurs. To this, Wymberley had added seventy bottles of liquor and fortified wine, 1,375 bottles of European wine, and fifty-two liters of thirty-year-old cognac. Carefully listed in a family journal label by label, often with prices paid and notes concerning provenance, these bottles were obviously family treasures. At the end of the nineteenth century the De Rennes' imbibing retained old connections to the greater Atlantic world.[15]

At first glance George W. Jones's voluminous descriptions of the food and spirits at antebellum Wormsloe and the De Rennes' elaborate feasts and overflowing cellar during the postwar period seem similar demonstrations of wealth and luxury. During both periods, Wormsloe's masters and their guests ate better than did most southerners, indeed better than did most Americans. In reality, these descriptions of food were expressions of two very different ways of understanding the value of land. Prior to the war Jones saw a full larder as the ultimate expression of a productive plantation—the land was a literal and figurative source of wealth. With the family's expanding investments in stocks, bonds, real estate, and railroads following the Civil War, their land on the coast became more a symbol of social standing than a direct source of wealth. Like a noble title, Wormsloe had become a patrimony. With this conceptual shift, it became less important that food and drink come from the local landscape; like the fields and forests surrounding the old mansion, food had become an

FIGURE 9.2. Wormsloe's grand dining room was the scene of elaborate meals following the Civil War.
Courtesy of Hargrett Rare Book and Manuscript Library / University of Georgia Libraries.

emblem of wealth rather than the producer of comfortable circumstances.

Recipes and notes from the early twentieth century reveal a growing disconnection between the Wormsloe landscape and the eating habits of the De Renne family. In an era when "specialists" and "professionals" came to dominate many facets of American life—from the regimentation of factory routines to new schools for subjects ranging from forestry to city management—food, too, fell under the guise of science. From the 1906 creation of the Food and Drug Administration's predecessor, the United States Department of Agriculture's Bureau of Chemistry, to John Harvey Kellogg's experimentation with vegetarianism and granulated breakfast cereals at his Battle Creek Sanitarium

in Michigan, nutritional experts increasingly defined foods by their component parts rather than by their ecological or cultural contexts. Vitamins, minerals, fats, carbohydrates, and proteins replaced provenance and tradition as the most important definers of food health and quality.[16]

Reflecting these changes, sometime in the early 1900s Wormsloe's mistress, Augusta De Renne, compiled a notebook recording her advocacy of this new nutritional advice. Augusta planned meal schedules that would increase calcium and protein in the family's diet. Her lunches and dinners featured healthy dishes ranging from green salads to vegetable sandwiches. In a typical passage, she wrote about the complicated concerns the new nutrition raised: "If foods reach our small intestines when a carbohydrate alkaline digestion is going on, the calcium in them forms a chemical combination which cannot be absorbed." Elaborating on her understanding of proper diet and nutrition, she summarized her dietary advice: "Briefly stated, my contention is that a combination of high protein and high starches effectively inhibits the *complete* absorption of all the nutritive factors of foods and places an unnecessary burden upon the entire digestive apparatus." In the back of the notebook, like a dietary roadmap, she had tucked a copy of a government pamphlet defining various vitamins and describing which foods contained them. Throughout her notes, Augusta treated eating as an activity centered on health and well-being rather than an exercise in pleasure and place. Oddly echoing Noble Jones's eighteenth-century fears that food was connected to health, Augusta had made a key distinction: she no longer included the importance of the local environment in the equation.[17]

Of course it would be easy to overemphasize this growing disconnection between landscape and diet. Although the De Rennes adopted an increasing number of industrial and national foodways during the early twentieth century, they did not completely abandon foods from the plantation and its environs. Augusta planted large vegetable gardens during the 1920s, where she raised family favorites such as a variety of bird's eye pepper her father-in-law Wymberley had loved so well. The family continued to enjoy some products of the surrounding wild environment as well. They gathered oysters during the cool months and hunted marsh hens in the autumn. From the 1890s through the late 1930s, a small commercial dairy on the property supplied butter, milk, and cream to the De Rennes as well as to Savannah groceries.[18]

The De Rennes also felt nostalgia for historic local foodways. In 1927, Augusta and her husband, Wymberley, opened Wormsloe's expansive flower gardens and azalea walks to the public as a tourist attraction. Reliving antebellum high society, the Savannah Junior League held high teas regularly in the garden, living out plantation fantasies while nibbling old-fashioned dishes. As part of the garden attractions, the De Rennes refurbished one of the plantation's slave cabins in 1929 and hired a local Black woman named Liza to play the part of "a nice old-fashioned mammy." As tourists strolled through the azaleas, roses, and camellias they could pause at Liza's cabin to enjoy Old South staples—coffee and hoecakes—served by the "bandanaed" mammy. Mammy figures such as Liza were popular tropes in the Jim Crow South and were often associated with food, from serving whites to selling pancake mix (think Aunt Jemima). The mammy was a comforting "image of racial and gendered yet asexual subservience" for the De Rennes and other southerners intent on remembering the food and service of the antebellum South.[19]

In 1938, debt forced Wymberley and Augusta to relinquish Wormsloe to Elfrida Barrow, Wymberley's sister, whose stronger finances ensured that the property would remain in the family. With Elfrida's control of Wormsloe, detailed records of food and eating on the property diminished. In a little over two hundred years, eating on Wormsloe had transitioned from a colonial exploration of dietary possibilities and fears to a modern food system, centered on science and purchased goods.[20]

FIGURE 9.3. A horticultural diagram of the walled formal garden at Wormsloe, Augusta De Renne, 1928. Courtesy of Hargrett Rare Book and Manuscript Library / University of Georgia Libraries.

WORMSLOE GARDEN,
1928 ADDITIONS,
by Augusta Floyd DeRenne.

Scale:- 2 inches 10 feet.

Legend:-
1. Sundial.
2. Fountain.
3. Statuettes.
4. Urns, Yucca.
5. Arbor Vitae.
6. Climbing Rose.
7. Azalea, Dwarf.
8. Row of Violets.
9. Heartsease.
10. Pansies.
11. Rock plants.
12. Columbine.
44. White Spider Lily.

13. Cacti.
14. Scotch Pinks.
15. Larkspur.
16. Iris.
17. Jonquils.
18. Verbena.
19. Forgetmenots.
20. Tuberoses.
21. Blue Sage.
22. Hollyhocks.
23. African Daisies.
24. Shasta Daisies.
25. Bougainvillea.
45. Montbrisa.

26. Dwarf Cedar.
27. Marigolds.
28. Strawberries.
29. Guernsey Lilies.
30. Rubeckia.
 Grandiflora.
31. Chrysanthemums.
32. Callendulas.
33. Gnomes & Jugs.
34. Hemero callis.
 Double Orange.
46. Nasturtiums.

35. Yellow Callas.
36. Hemerocallis.
 Yellow.
37. Water
 Hyacinths.
38. Eschscholtzia.
39. Ivy.
40. Cypress.
41. Grape Hyacinth.
42. Calliopsis.
43. Coreopsis.
47. Physostegias.

FIGURE 9.4. The 1928 additions to the formal garden, Augusta De Renne, 1928. Courtesy of Hargrett Rare Book and Manuscript Library / University of Georgia Libraries.

The notion that southern foodways are a product of cultural fusion is an old and durable idea, and for good reason. Southern food is obviously the product of African, European, and Native American cultures. Regional cooking is part of a "Creole culture . . . most evident in the kitchen," blending distinctive ingredients and preparation methods into a new and innovative cuisine.[21] Wormsloe tells this familiar story, but it also demonstrates that food and foodways can reflect even deeper connections between people, their desires, and the landscape. Foodways

have lessons to teach us about our past and present. Food culture has reflected fears of the surrounding environment; it has been an expression of independence; it has stood as an assertion of wealth; and it has also reflected a movement away from connecting local landscapes to consumption, privileging science over tradition. At its heart, Wormsloe's story demonstrates that food serves as a window into understanding the relationships between people and the environment by exploring how individuals both consumed and thought about the world that surrounded

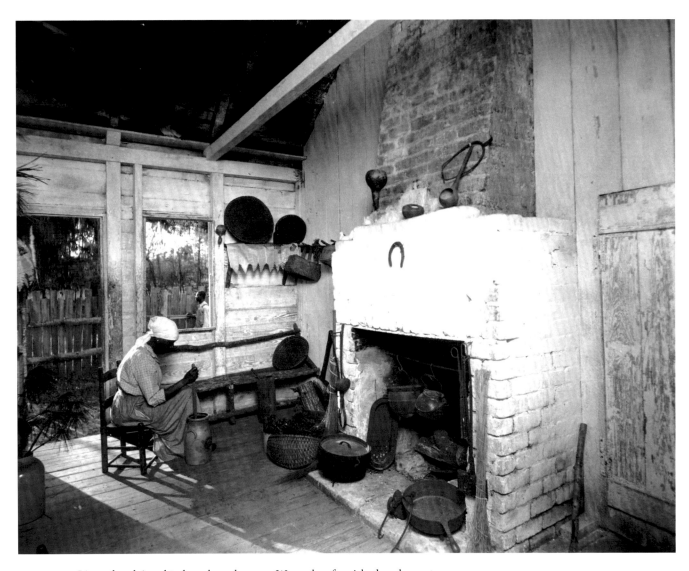

FIGURE 9.5. Liza, who claimed to have been born on Wormsloe, furnished park guests
with refreshments from a restored slave cabin, ca. 1930, Foltz Studio, Savannah, Georgia.
Courtesy of Hargrett Rare Book and Manuscript Library / University of Georgia Libraries.

them. Records of how people fed themselves may prove to be one of the most reliable expressions of their views of land available. People could not or did not always record what they thought about the surrounding environment, but they always ate.

Upon a little more reflection, perhaps we can say that Brillat-Savarin had it right all along. Food culture does explain much about the intrinsic power of environmental influence and place, but it also comes out of the dreams and desires tangled up in all landscapes. Maybe our gumbos and sweet potato soufflés are somehow reflections of ourselves as well as of the marshes and woods and fields where they originate, one part nature mixed with one part culture. Maybe food really can tell us both where we come from and who we are, or who we want to be. In the end, Wormsloe's story and Brillat-Savarin whisper much the same thing: paying attention to what people put in their stomachs can tell us much about what they believe in their hearts and heads, as well as how they act in their environment.

NOTES

1. Jean Anthelme Brillat-Savarin, *Physiologie du Goût* (Paris: Flammarion, 1982), 19, translation by the author.

2. Quote in John Bartram, "Diary of a Journey through the Carolinas, Georgia, and Florida, from July 1, 1765, to April 10, 1766," annotated by Francis Harper, *Transactions of the American Philosophical Society* 33 (December 1942): 30. Although punctuation has been modernized, the remaining grammatical conventions are Bartram's. For the best summary of Wormsloe's settlement, see E. Merton Coulter, *Wormsloe: Two Centuries of a Georgia Family* (Athens: University of Georgia Press, 1955), 16–38.

3. William M. Kelso, *Captain Jones's Wormslow: A Historical, Archaeological, and Architectural Study of an Eighteenth-Century Plantation Site near Savannah, Georgia*, 1st rev. ed. (Athens: University of Georgia Press, 2008), 95–96.

4. Noble Jones to David Murray, August 1754, Noble Jones Family Papers, mss. 1127 (1 vol.), Hargrett Rare Book and Manuscript Collection, University of Georgia Library, Athens, Georgia (hereafter cited as Hargrett). For the widespread nature of these fears in the early South, see Joyce E. Chaplin, "Climate and Southern Pessimism: The Natural History of an Idea, 1500–1800," in *The South as an American Problem*, ed. Larry Griffin and Don Doyle (Athens: University of Georgia Press, 1995); Mart A. Stewart, "'Let Us Begin with the Weather': Climate, Race and Cultural Distinctiveness in the American South," in *Nature and Society in Historical Context*, ed. Mikulas Teich, Roy Porter, and Bo Gustafsson (Cambridge: Cambridge University Press, 1997); Karen O. Kupperman, "Fear of Hot Climates in the Anglo-American Colonial Experience," *William and Mary Quarterly* 41 (April 1984): 213–240; Conevery Bolton Valencius, *The Health of the Country: How American Settlers Understood Themselves and Their Land* (New York: Basic Books, 2002).

5. The first quote can be found in "Advices from America, the East and West Indies, &c.," published in the *London Gazette*, 1779 (pamphlet), Craig Barrow Family Papers (hereafter cited as CBFP), box 25, folder 2, Hargrett; the second is in "Contract between George W. Jones and John Rawls," January 2, 1810, De Renne Family Papers (cited hereafter as DRFP), mss. 1064, box 29, folder 1, Hargrett.

6. Receipt Book, De Renne Family Receipts & Remedies (hereafter cited as DRFRR), mss. 1120, folder 11, and loose receipts in folders 2–9; Recipe Book, circa 1840, CBFP, mss. 3090, box 23, folder 9, all in Hargrett. The terrapin recipe is located in the former.

7. Account Book of G. W. J. De Renne, 1854–1861 entries, DRFP, mss. 1064, box 57, folder 1.

8. Agricultural Journal of George W. Jones, 1854–1860, DRFP, mss. 1064, box 12, folder 27.

9. Agricultural Journal of George W. Jones, November 30, 1856.

10. Agricultural Journal of George W. Jones, 1854–1860, compiled from entries throughout.

11. William S. McFeely, *Sapelo's People: A Long Walk into Freedom* (New York: W. W. Norton & Co., 1994), 101.

12. Ira Berlin, "From Creole to African: Atlantic Creoles and the Origins of African-American Society in Mainland North America," *William and Mary Quarterly* 53 (April 1996): 251–288; McFeely, *Sapelo's People*, 32–43. The distinction between societies with slaves and slave societies is Berlin's.

13. Contract between George W. Jones and Edward Nelson, January 10, 1864, DRFP, box 58, folder 12. For details of the various property rentals, see Account Book of G. W. J. De Renne, 1850s–1870s, DRFP, mss. 1064, box 57, folder 1.

14. Diary of George W. J. De Renne, 1876–1880, April 12, 1878, and March 20, 1880, DRFP, mss. 1064, box 13, folder 7.

15. Estate Inventory Book of Wymberley Jones De Renne, 1895, DRFP, mss. 1064, box 12, folder 26.

16. Gustavus A. Weber, *The Food, Drug, and Insecticide Administration: Its History, Activities and Organization* (Baltimore: Johns Hopkins University Press, 1928), 1–25; Philip J. Hilts, *Protecting America's Health: The FDA, Business, and One Hundred Years of Regulation* (New York: Knopf, 2003), 56–57; Richard W. Schwarz, *John Harvey Kellogg, M. D.* (Nashville: Southern Publishing Association, 1970), 37–45, 116–120.

17. Dietary Notebook, DRFRR, folder 12.

18. Gardening Journal of Augusta De Renne, 1927–1929, DRFP, mss. 1788, box 112, folder: gardening materials; *Isle of Hope Weekly*, September 1, 1936, p. 1, DRFP, mss. 2819, box 36, folder 13; A. W. Ziebold to Craig Barrow, November 12, 1929, CBFP, box 5, folder 16.

19. "Savannah's Show Places Be Opened to Tourists," *Savannah Press*, September 24, 1927; "Wormsloe Rich in Georgia History," *Macon Telegraph*, March 24, 1929; "Wormsloe Gardens," *Tourist Topics*, March 29, 1930; all clippings in DRFP, box 31; "Cabin of Woman's Birth Again Home," clipping in DRFP, box 39, folder 6. Quote in "Elizabeth's Letter," *Savannah Morning News*, March 2, 1929, clipping in DRFP, box 31, folder 3. For an analysis of Aunt Jemima and the mammy image, see Grace Elizabeth Hale, *Making Whiteness: The Culture of Segregation in the South, 1890–1940* (New York: Vintage Books, 1999), 151–153, 164–166, quote on 152.

20. William Harris Bragg, *De Renne: Three Generations of a Georgia Family* (Athens: University of Georgia Press, 1999), 336–352. Wymberley and Augusta's principal debt was, in fact, to Elfrida.

21. John Martin Taylor, "Lowcountry Foodways," in *The New Encyclopedia of Southern Culture*, vol. 7: *Foodways*, ed. John T. Edge. (Chapel Hill: University of North Carolina Press, 2007), 75.

CHAPTER 10

Braided Roots

ROGER PINCKNEY, author, farmer, hunter, and cook, Daufuskie Island, S.C.

Pinckney uses personal narrative from growing up on Daufuskie Island, South Carolina, as a starting point to illustrate the integration of foodways into life events. A coming-of-age story unfolds following Pinckney's decision to leave the Lowcountry for a farming opportunity and his ultimate return to the isolated coastal barrier island. 🪶

I ran off farming when I was twenty-four. It was flat Biblical, y'all: *Go ye to the field, Ephraim*. I was part of a larger social phenomenon, a generation fleeing the horror of Vietnam. I reckoned the south end of a northbound horse would do me good.

And it did.

This was way up in Minnesota, two hundred miles northwest of Minneapolis, if you can imagine such a place. God Bless America—rocks and rills, especially rocks, a wooden granary, a Sears and Roebuck chicken coop, a Norman Rockwell–perfect barn and a pioneer log cabin where you could throw a cat through the cracks in the walls. Decrepit machinery, much of it older than me, but still young enough to try to kill me on a regular basis.

The Simple Country Life? Right.

Eighty acres, then ninety, finally nearly three hundred, fields shaped like pork chops, not many of them flat.

I was too dumb to be deterred.

I came up a hunter and a fisherman on the South Carolina coast. I got my first boat before I got my first bicycle, no place for a motor, just

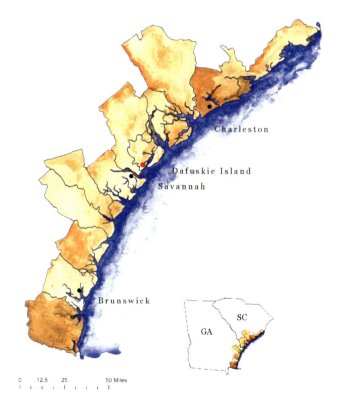

oars and oarlocks but no life jackets. And the tale of how a Lowcountry boy came to farm in Minnesota is too long and painful to relate here, as my prior agricultural experience was limited to throwing tomatoes car to car at high speeds all across St. Helena Island. We packed tomatoes for summer money, $1.25 an hour, and raided the cull dump after work. Participants got carried away one night and flung tomatoes high and wide beyond the foot of the Bay Street Bridge, the city limits in those days, a civil offense. The subpoenas shut down the packing shed during the peak of the season. The line boss was not amused.

But I digress.

Back to Minnesota and one pertinent question, and it could be asked about any small farm anywhere. What could I do well on three hundred acres that a man with two thousand could not do? Simple question with many answers but only three commonalities—symbiosis, sustainability, and biodiversity.

I would grow hay and small grains. The hay was alfalfa-bromegrass mix, a symbiotic relationship. Alfalfa is a frail seedling, needing the shade of brome to germinate and grow. But once established, it is a deep-rooted legume, adding tilth to the soil along with aerobic nitrogen, and the brome, thriving in a nitrogen-rich environment, grew tall as my head. The grains were millet and oats mostly, but sometimes barley, after Budweiser built a malting plant out toward Fargo and low-protein malting barley was fetching as much as good clean wheat. If the barley would not make good malt, it would still make good feed.

I ran the hay through livestock, harvested the manure to replenish my fields. I bought a dozen heifer calves, horned Herefords, an heirloom breed. Yes, they busted all the windows out of the barn, but they were hell on any coyote foolish enough to slip under the fence. I bred them to another heirloom breed, polled shorthorn bulls, an oxymoron as polled cattle have no horns.

There is a principle in livestock breeding, first-generation hybrid vigor. Those cows threw big liver-colored calves with a white spot around one eye. Really big calves, one hundred and twenty-plus at birth, and the cows needed help in labor. Many times I sat in the mud at a bovine rear end, reaching inside, affixing the calf with a length of baling twine, one foot on each hip, lending my back to each contraction, just like I lent it to the oars of my boyhood.

I kept the heifer calves, raised them up, put them into production. I made steers of the bulls, sold them each fall, a dollar, a dollar and a quarter per pound, walking weight, good money back then. And the knowledge gained was priceless when I was called on to deliver my own son by the light of a Coleman lantern, as a beaver dropped a popple tree across the highline. I cut the cord with my skinning knife and tied it off with a shoelace, not baling twine.

But that's a whole nother story.

The grains fed laying hens, two hundred or more at a time. Agribusiness has egg production down to a fine science. Each bird needs x number of square feet of floor space in total confinement. A pound of feed with x percent protein will produce x number of white eggs. A variety of chicken of the leghorn breed, usually denoted by a four-digit number, will start laying at x number of weeks and continue producing one white egg a day for x number of weeks before production tapers off to nonprofitability, at which point the poor worn-out bird becomes chicken noodle soup.

But white egg layers are notoriously volatile and subject to strange fits. They cannot tolerate heat, cold, or a change of rations. Thunder, a low-flying aircraft, or even a tomcat walking by an open door can provoke stampedes so severe they have been known to blow out barn walls. Surviving hens are so bruised they are unfit for human consumption, even as soup.

But down in Webster City, Iowa, about three hundred miles to the south, Murray McMurry Hatchery sold many heirloom breeds, day-old chicks that came to you via parcel post, RFD, rural free delivery.

Mail a chicken? Yep, they do it all the time, 100 percent live bird guarantee. I settled on Rhode Island Reds

and Barred Rocks, black and white stripes just like pillow ticking, big birds, quiet, easy-keeping brown egg layers. Straight run—pullets and cockerels. We knocked over the roosters at fourteen weeks for broilers, all but one. He kept watch over the hens, even attacking foxes who ventured too close, woke me faithfully each dawn but sometimes on full-moon midnights.

As most of the laying was just after first light, I'd turn them loose and let them run midmorning till dark. I also loaded them up with table and garden scraps. If the dog wouldn't eat it, the chickens would. Cabbage and broccoli trimmings made yolks the color of a sunrise and not a tick, grasshopper, or mouse survived their relentless foraging. If chickens weighed three hundred pounds each, they would dominate the earth.

I hung a sign: "Fresh Yard Eggs." Neighbors with milk cows brought fresh milk by the gallon to trade, tourists beat a path to my door, there was a fistfight in the yard over the day's last dozen, and the fruit jar on the kitchen table was stuffed with ones, fives, even tens. Hard to go wrong with chickens, especially these days with organic yard eggs fetching up to eight bucks a dozen.

But alas, I was no Wendell Berry, who farmed with horses and wrote about it. "Two roads diverged in a wood," the poet said, "and I, I took the one less traveled by." Robert Frost was a farmer too, a poor one by most accounts, and he celebrated the small farms of New England. But he could not write and farm at the same time, either.

I sold my machinery and fifty acres, gave the rest to my emerging ex-wife. Settled up and square, I headed south, back to where I really belonged.

The cool island with the funny name. Daufuskie Island, South Carolina, 29915—we get most of our mail most of the time. The last sea island before Georgia, three by five miles, six thousand acres, no yoga, no yogurt, no bridge, no problem.

I rented a house on the river, took up writing full time. Mostly magazine work, but books too, five right quick.

And brothers and sisters, I am here to testify, birthing a book is a whole lot harder than pulling a calf.

Daufuskie was once a Gullah island. The Gullah, descendants of West African slaves from the Gola region, got land with freedom, not forty acres and a mule, the lie they told us back in high school, but a *task* of ground, five, ten acres, what it took to feed a family. Some were gifted, some advanced on credit for work. Sweet potatoes and sweet corn, butter beans, black-eyed peas, little snips of rice in low ground, plums and scuppernongs for wine—all they had to buy was flour, salt, and sugar for their whiskey stills. *Scrap iron likker*, they called it.

For cash, they worked in the cotton fields, picked oysters for the Savannah market. But the boll weevil got the cotton and pollution from Savannah got the oysters and the Gullah drifted away, from two thousand in 1900 to just twenty in 2000. Their fields came up in pines, their fences fell, briar overtook their blackberries, shanties slowly sank into the earth, and their horses, their beloved Marsh Tacky horses, here since the days of the Spanish conquistadors, ran free and wild on beaches and marsh. Developers cast lustful eyes this way. The island was just too pretty to be all up in woods. Halfway between New York and Miami. Why not the Martha's Vineyard of the South?

Wonderful.

Thirty years and $300 million later, their golf courses are going back to woods, just like the Gullah fields. Some say marine transport did them in, fourteen miles dock to dock, a $4 million annual transportation budget. But others credit a Gullah voodoo curse, vengeful spirits annoyed at the desecration of Gullah land.

Whatever the reason, Daufuskie folks are picking up the pieces, and I am helping as I can. The curse apparently does not apply to individual initiative. The Gullah are coming back by twos and threes. There are a community farm, milking goats and cows, fruit trees, extensive vegetable plots, herbs, and of course laying hens, brown egg birds just like my Minnesota flocks. There are new vineyards

and a winery for the squeezings, a rum distillery that imports molasses (but fields of sugarcane are in the works—blue ribbon, an heirloom variety that grows here the best). Island girls are bringing back indigo production, for the first time since 1780, dyeing high-dollar fashion items for the tourist trade. There is an arts blacksmith, and the potter is keeping bees and growing olives and pressing out the oil. The Marsh Tacky horses were corralled and shipped away because there were deemed a threat to golf. But we have them back now, nine head, with a dot-org to support them.

And the south end of a northbound horse still does a man good.

"Land is the only thing in the world worth workin' for, worth fightin' for, worth dyin' for," old man O'Hara said to Katie Scarlett in *Gone with the Wind*, "because it's the only thing that lasts."

Indeed.

On the island's northwest side are eight hundred acres of climax maritime forest, the Webb Tract, named for a former owner back in the cotton glory days. There is nearly a mile on the water and marsh that the Halliburton corporation coveted in the days when energy companies were diversifying billions into real estate. It would be a perfect location for a marina for the Saudi princes' oceangoing yachts. But after paving roads and laying pipes, culverts, and wires, Halliburton became distracted by a couple of Middle Eastern wars and sold the tract to another company that sought investors to continue Halliburton's intent. But alas, investors were slow coming and their permits expired, once, twice, and each time were renewed without "visible works-progress," contrary to law. I joined a ragged and bleary band of locals, and we went after those permits in state and federal court. We lost every case, but they wore themselves out whipping us and after ten years offered up a compromise: no marina, no Saudi princes, hundreds of acres under conservation easement. And then they turned the property over to locals for deer hunting, the only stipulation being liability insurance lest anything go awry, three hundred bucks a year.

We have some monumental live oaks on Daufuskie, some surely six or seven hundred years old. But on the Webb Tract marsh front there is an ancient eastern cedar. It started life on the edge of freshwater meadow, and as the sea level rose and the meadow became a salt marsh, that cedar sent its roots sideways thirty feet in a great twisted braid, seeking fresh water from the bank. How old is that tree? Nobody knows for sure, but the roots have grown over and through Native American pottery that has been dated to 5000 BCE. I peg that tree as 3,500 years old, the oldest living thing on Daufuskie.

I take great comfort in the cedar and I visit it often, once the first frost knocks back the ticks and slows the snakes. A tree, not normally assumed to possess intelligence, did what it needed to adapt to a changing world. And the roots seem a metaphor for all my days, the unlikely twists and turns, also doing what I needed to do to survive in a changing world.

Braided roots.

Growing Up on Daufuskie Island

SALLIE ANN ROBINSON, cookbook author, Daufuskie Island, S.C.

Robinson discusses the Gullah foodways of her childhood in an interview with Southern food historian John Martin Taylor. They focus on Gullah rituals, food traditions, and practices through family stories of living on, and largely eating from, the coastal environment of Daufuskie Island located just north of the South Carolina–Georgia border. The family cultivated a garden with corn, beans, field peas, tomatoes, squash, collards, and okra. Meat, routinely harvested from the adjacent woods and their backyard chickens, was supplemented with finfish and shellfish harvested from the many tidal creeks. Robinson explains customary island methods to catch crabs and shrimp and expounds on how they are prepared in the Gullah tradition. She also discusses the expectations passed down for untold generations of her family that defined each member's role by age and gender in food procurement, processing, and cooking. 🦐

A Conversation with Sallie Ann Robinson (SAR) and John Martin Taylor (JMT)

Wormsloe Institute for Environmental History, February 24, 2019

JMT: We wanted to talk to you about crabbing and oystering. My mama would say to me, "Go get lunch"—off the boat. We didn't have any land; we came down to our boat anchored off Hilton Head on the weekends. If it were low tide, that meant go get oysters and clams. Occasionally we'd get the whelks—Mama didn't like to deal with them

. . . [or we might] empty the crab trap. . . . Could you tell us how that worked for you?

SAR: On Daufuskie we had a variety of food to eat, so we were never bored with any one of them, whether it was from the garden that we grew, the ocean, or the wilds—the woods. The oysters and the crab—oh, my goodness—we ate them on a regular basis, because they were a favorite. Shucking the oysters—you have to be very careful when you pick them because they do have razor-sharp shells. My mom . . . would go and gather—pick—numerous buckets (we called them bushel baskets) or croker sacks full of them and bring them to the house, and she would sit under a tree and she had these oyster knives . . . and she and Pop would shuck the oysters. Pop would like to shuck them from the back—the tail end. My mom would crack the mouths off and pry them open.

JMT: Was she born there? Because I've only seen people from the Chesapeake open them from the front.

SAR: Yes, she was born there. . . . She did both ways. . . . They would gather these oysters, bring them home. We'd sit under the tree and they would show us, *but* they knew that we had to be careful. What we mostly did was roast them. We would build a fire and roast them. . . . Mom and Pop also used to shuck oysters for folks who couldn't. There were folks there who didn't know how to open an oyster. . . . So we would sit under the tree and she would come and dump these croker sacks (which happen to be burlap bags) full and get these knives and shuck these oysters. Pints of oysters. Gallons, sometimes. And she would . . . shuck them not only for the house, for us to eat, but also for neighbors. She was pretty good at it. Her mom, her grandmom, they were all oyster shuckers on the island when there was an oyster factory there.

JMT: Did you stew them? Did you fry them?

SAR: We fried them, we roasted them, we—

JMT: Back to roasting. I am going to interrupt you again. Why don't you describe the oyster roast, how that works?

SAR: We did it on tin. We had a fire on the ground and built it with blocks or bricks so that the tin could sit on it. And then we would wash the oysters because they were muddy and then put them on the tin and cover them with the wet croker sack that we gathered them in.

JMT: Wet with creek water?

SAR: Yes. So we would wet them and throw them over [the oysters] so that this heat—once it came through the tin to the oysters, it would steam them. And steaming them, they would crack open. Now you can get them time they crack open . . .

JMT: Thank you! Time they crack open so they still have all the "liquor" . . .

SAR: So the liquid is still in it. I'm a person who likes them *roasted*. I like that burned flavor!

JMT: You like 'em like a piece of rubber band?!

SAR: Yes, I do! I do! . . . But . . . many times my mom would take us on the bank . . . and we would build a fire and roast the oysters and eat right at the edge of the creek where the oysters grew. They would go down there and shuck for hours but they kept us busy eating, so we won't bother them! [*laughter*] I *love* the reason!

JMT: Moving on . . . did you use a crab trap?

SAR: For the crabs we actually had drop lines. Before all the nets and crab traps came along, we had drop lines. We had chicken necks and chicken backs, and because we raised chickens, we always had these parts.

JMT: So you grew up with fresh chickens?

SAR: Oh, yes! Oh, yes! . . . So we had drop lines and a dip net. They would make these dip nets out of chicken wire and they would cut down a stick so long [*indicating about four or five feet*] and they would get this chicken wire and they would make a scoop—it would look like a scoop when they finished wrapping it around the loop they had on it. So we had a scoop net so when you caught a crab on a line, you had to ease it up and then you scoop 'em up.

JMT: I'm surprised you didn't have a crab trap. We were down there in the '60s, and we had one.

SAR: Crab traps came later.

JMT: Well, maybe my daddy made our first ones . . . but the reason I bring it up is that we got a lot of other things in the trap, like eels and flounder mostly . . . so did you have eel and flounder?

SAR: Yes, we did have, and my mom loved eel and we hated eel because I didn't like the snake-type thing about it.

JMT: Do you cook it?

SAR: No, I will not cook eel to this day! I don't like snakes and wiggly stuff.

JMT: But you fished for flounder?

SAR: We fished for flounder.

JMT: Did you throw a cast net when you were growing up?

SAR: I know how to throw a cast net. Yes, we did throw cast nets.

JMT: There was a guy on Daufuskie, as I remember, who made the nets.

SAR: My stepfather made nets. My stepfather, Thomas Stafford, made cast nets and shrimp and mullet nets. . . . Mullet nets are bigger loops.

JMT: And they have heavier weights. You throw it three times and you're exhausted. . . . But I found when the mullets come in the creeks at low tide, and you see 'em, and you throw it, and you get enough on one throw.

SAR: Well, the creek that we used to be in, it ran out to the river. When the tide was low, you could see the mullet following the water to the river. *But* my pop would have us stand in the shallow part and beat the water back to keep the fish in the hole. [*laughter*]

JMT: On Ladies Island I used to see them in the little impoundments . . . circling like menhaden.

SAR: You cannot catch one on a line! They will not bite a fishing line!

JMT: We found that either you had to cook 'em for breakfast that morning immediately or you had to smoke them. Did y'all smoke things?

SAR: No. We had what you call corn roe. Corn fish. They would take mullet—the big ones—get the roe out of them, and they would clean 'em, open 'em from the back. They spread open, salt 'em down, and they'd put 'em in a box overnight, couple of nights. In a wooden box. Full of salted fish. What we call corn fish.

JMT: That's so interesting. Oh, like corned beef! "Corned" is preserved.

SAR: Yes! Then after they'd been in the box, the next couple of days my mom would take wires and hang them out in the sun to dry.

JMT: Did you dry okra too? Did you dry shrimp heads?

SAR: No, we did not. We had such a plenty. We had fresh shrimp any time we wanted, so we didn't dry them.

JMT: I knew an older African American lady who grew up near Awendaw north of Charleston and she told me that they used to dry okra and shrimp heads, string them up and hang them under the tin roof to dry . . . and they would grind them later, but I had never heard of that before down around Hilton Head.

SAR: I was telling Sarah [Ross, of the Wormsloe Institute] how we used to dry peas. . . . We would pick green peas and put them on a tin and leave it out in the sun all day . . . We tossed them after a certain number of hours so they get done on both sides. And after they're dried after a couple of days in the evening we'd put them in a croker sack. Everything was about using the croker sack. This croker sack, which is a burlap bag, was one of the most important tools around.

JMT: What was your freshwater source? Did you have wells?

SAR: We had hand pumps.

JMT: So you had wells. There's no river on Daufuskie. Did you have frogs?

SAR: We had frogs.

JMT: Did you eat them?

SAR: No, we didn't eat them. Pop was a really different guy. Certain things he didn't like or do, and my mom wouldn't fix it or allow it in the house because it was always what the man wants in the house!

JMT: My dad was the same way. He wouldn't allow hot dogs or hamburgers in the house.

SAR: And creamy! Anything with milk cooked in it. And lettuce was rabbit food. We didn't grow lettuce. My mom did grow it, but we didn't have it. . . . [She grew it] because she liked to see how it looked. . . . She grew carrots. . . . My pop would go, "Whatcha doing? That's rabbit food. That can't fill your belly!" He was one of those that you had to get something that was served solid and would stick to your ribs! [*laughter*]

JMT: So we've done the crab and the oysters, let's go to the shrimp. So, you threw a net, but they didn't make you go get shrimp.

SAR: Pop taught me . . . We always went, even fishing/ crabbing, we always went as a family or community, we would all say, "We're goin' fishin' today," I mean half of the island who went fishin' . . . and some folks would go to the dock, remember the [county?] dock? We would be lined up along the bank, along the dock; everybody had their fishin' spot.

JMT: I saw y'all. I was the white boy on the sailboat wishin' I was over there with y'all. Y'all were always wavin'.

SAR: We would wave at everybody! Hey!

JMT: In those days, there really wasn't that much boat traffic.

SAR: But Daufuskie used to have over one thousand people living there back in the day. There were a lot of steamships. Mom told me the story. I was not supposed to be born on Daufuskie. I was supposed to be born in Savannah, like my other sisters. My mom went to her doctor. She used to work on Tybee. She said there used to be a hotel there called the Blue Moon . . . one of the first hotels on Tybee . . . but I cannot find anyone right now who knows that. She used to work there, and she said she was pregnant with me and she wanted to go home for a week before she had me, because after you had a baby back in the day you were not allowed outside for a month.

JMT: I hear that in the Lowcountry all the time. It's very West African. [My memory may be not quite right here, as it is actually very common in China, where I most recently lived.]

SAR: Yes, once they had a baby they were not allowed to put foot on the ground for a month. They had to stay in the house with the baby for one solid month.

JMT: And this is still true today.

SAR: Very true. You could not leave that baby.

JMT: That's good stuff.

SAR: [*Laughter*]

JMT: I mean, it's all good stuff, but when I hear things like that . . .

SAR: It's what I know that what was passed on to me. This is not somebody else tellin' me. . . . So my mom was a storyteller, my pop was a storyteller, and they really were teaching us . . . This was a message they were actually teaching us. It wasn't just the stories, 'cause they told stories all the time.

JMT: [*sarcastically*] I can't imagine! Really? You came from storytellers?

SAR: [*laughing*] My mom was something else! She would get a couple of nips, and, oh, my God! You had to come and sit and listen! It was like, "Come here! Sit down nyeah!" And you dared act like you not listenin'!

[Interrupted by guests arriving]

JMT: So let's get back to the shrimp.

SAR: We would go to the creeks. . . . Pop showed me and my sisters how to throw a cast net out actually in our backyard first. Because he said in order to teach you how to throw it, you had to do it on dry land, 'cause once it gets wet, it was extraheavy.

JMT: And back then they were made of cotton, not monofilament . . . and it was really heavy!

[Greeting Craig Barrow (CB) and Diana Barrow (DB), owners of Wormsloe]

DB: I gave John a book that this gal we have known for years wrote, called *Paradise*, and it's on the early years on Hilton Head.

JMT: It's the rich white.

CB: So, speaking of that, the rich white people on Hilton Head, I have something for you [*to Sallie Ann*] that I think is extremely valuable, extremely important . . . and I think she can be the custodian and take care of it, and I'm shifting it over.

DB: And I'm sure it will be in good hands.

JMT: Is it here? What is it?

CB: It's the symbol of the demise of a culture and an ecological environment on Hilton Head. This is the symbol. It's right here. This is so cool. . . . It's the Hilton Head Toll Bridge Stamp.

JMT: NO!!!

SAR: YES! YES! YES!

CB: It's only one of those in the world, and it's yours.

SAR: YES! YES! YES! I promise you I will take care! When I get my house built—I always have what you call my Sallie Ann Room—trust me! This is, like, the bomb!

CB: We all know this, but if you want to save the Gullah . . . This destroyed the culture. I remember this wonderful woman, Tara Taft, she had been there for years. . . . And they taxed her out of her house, and that was wrong.

[*inaudible, lots of mixed voices*] The Milbanks said, We are going to save these African American communities, and they put an easement on this whole area to protect it . . . [but] these poor people, a lot of them got pushed out.

SAR: Now remember, before the bridge got built, Charlie Simons was the transportation boat that used to take people back and forth. That's my son's great-grandfather. . . . And my family means more than you know. . . . I'm being honest with you.

CB: I knew it the moment I met you. And you need to have that.

JMT: That is the coolest gift I have ever seen in my life. I'll never forget when the bridge was built. My mother sat down and cried and said, "There goes paradise."

CB: My firm . . . built the bridge. . . . I've had this for fifty years, but when I met you, I said, you've got to have this.

[*Lots of laughter and mixed conversation and chopping vegetables*]

DB: Glad to see you!

SAR: Always a pleasure! You know, I have so much love for this place. I told Sarah, if this ain't part of Daufuskie like no place I've been . . . that reminds me, the water . . . and I said, "I gotta go home."

The Wild Garden

Making a Case for Agroecology in the Lowcountry

JANISSE RAY, author and naturalist, Baxley, Georgia

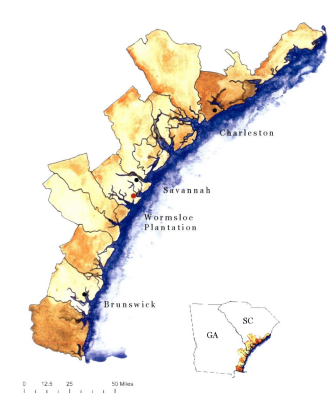

Ray uses the story of seeds to examine the agricultural history of the Low-country from its earliest inhabitants through current practices at Wormsloe. Each wave of immigrants brought seeds as well as traditional agricultural practices from their homeland to the Lowcountry. Integrating the many contributions of seed stocks from other continents, Ray traces how agriculture developed from small bands of hunter-gatherers to capitalist enterprises supplying global needs. She notes massive alteration in land use, including serial monocultures and exportation of natural resources, and how these activities comprehensively changed the Lowcountry landscape. 🦌

The Advent of Agrarianism

A history of civilization is a history of seeds. Thousands of years ago we earthlings, hunter-gatherers, began to use flowers to our advantage. We learned that some food starts as a flower and that some flowers cross-pollinate and that those crosses will produce variations in outcomes—positive and not. We also learned that we could change outcomes based on selection. We started to experiment with growing food rather than chasing it or wandering around looking for it, and thus we inaugurated plant domestication and our evolution to the agrarian cultures that bore us all. Seeds, and the development of varieties, for better and for worse, both allowed and encouraged our ancestors to settle down and become agricultural.

I say "for better and for worse" because the advent of agriculture, although it allowed humans to increase food security, was not without long-term injurious, even disastrous, results. An agricultural lifeway allowed humans to transport and to store goods, thus bringing to bear the concept of accumulation of wealth (one person had more than another), followed by the need to protect that wealth, class divisions, and finally capitalism.

Furthermore, now scientists are learning that the thousands of years we humans spent as rangers and foragers left an indelible mark on the human brain and body. Our bodies do best with cycles of feast and famine, as opposed to the constant satiation that agriculture affords. Our bodies need to move. Our bodies need sunshine. And grain, though portable and marvelously storable, may not be the best nutrition for humans. Brain sizes, for example, have decreased in the ten thousand years of recorded agriculture. This was documented by Dr. Marta Lahr at Cambridge University's Leverhulme Centre for Human Evolutionary Studies, who studied human fossil evidence remaining from a span of 200,000 years. In the past ten thousand years, human brain size has shrunk (from 1,500 cubic centimeters to 1,350).

Humans have also shrunk in stature, Lahr reported. And Amanda Mummert, researcher at Emory University in Atlanta, found that nineteen of twenty-one hunter-gatherer societies that switched to an agricultural lifestyle saw a correlating rise in disease.

Twelve thousand years of agriculture is a speck in the long scroll of human history. Since humans began to cultivate, we have been trying to adapt to this new world. The current paleo food movement is an attempt to retrieve some of the evolutionary and place-based fragments that we lost in the transition.

Hunter-gatherers are associated with wilderness and agriculturists with tamed (but not industrial) land. Likewise, hunting and gathering are associated with the body and agriculture with the mind. In my own preferences I move along this spectrum of human existence, dawdling between the far past, the recent past, and the immediate. We humans are all of these, we likely need all of them, and I have attempted to live in a balanced way with all three—a *field* at the edge of *woods* between trips to the *store*.

This borderland, this meeting ground, with all its tensions, interfaces, and boundaries, is an exciting, holistic place wherein we can know the full and vast reach of our intelligence.

The Coast of Georgia

When the Spanish, then the French, then the English arrived on the south Atlantic coast of the New World, hunter-gatherer cultures still existed in the wilds of what is now Lowcountry Georgia. They were oyster eaters, parakeet eaters, and fish eaters. They were wild plum eaters and arrowroot eaters. They had begun to cultivate. They were soon introduced to manufactured food. These peoples in southern Georgia's not-too-distant past were navigating the borderland between Paleolithic and agrarian and industrial.

The colonizers, who had long since been agriculturalists and were nascent industrialists, looked upon the continent of America with visions of full storerooms. As James Oglethorpe wrote in his "Founding Vision for Georgia" (1733), "In America there are fertile lands sufficient to subsist all the useless Poor in England, and distressed Protestants in Europe; yet Thousands starve for want of mere sustenance. . . . It is highly probable that when hereafter it shall be well-peopled and rightly cultivated, ENGLAND may be supplied from thence with raw Silk, Wine, Oil, Dyes, Drugs, and many other materials for manufacture."

The arrival of colonists, then, sparked a period of rapid and remarkable development in a gastronomy, one relevant to the Wormsloe of today, because food has to be figured out first.

The Amerindian Cuisine and Foods North America Contributed to the World

Russian seed scientist Nikolai Vavilov, who collected more than 200,000 seeds of plants in his too-short life, posited that there had been seven hotbeds of world plant domestication. These were China, South Asia, Southwest Asia (the Fertile Crescent), the Mediterranean, Ethiopia, the Andes, and greater Mexico. Certain foodstuffs are associated with having been developed in these centers. Some crops were developed in multiple centers, separately. Beans, for example, were domesticated first in the Andes of Peru about five thousand years ago and again in Mexico a couple thousand years later.

Native peoples in North and South America domesticated squash very early on. Seeds of one species (*Cucurbita moschata*) found in coastal Peru have been dated to 10,300 years ago. A species (*C. pepo*) found in Mexico was dated to ten thousand years ago.

Since Vavilov's time, eastern North America, New Guinea, and the Amazon have been added as three more centers of plant domestication. Pre-Columbian natives in Brazil's notoriously infertile Amazonia created rich, black soils up to two meters thick that we call *terra preta*, or black earth. From this region we got squash and beans but also peanuts, guava, and manioc.

Domesticates indigenous to New Guinea include bananas, taros, yams, and breadfruit, among others.

North America's contribution to the world table was a half dozen or so minor crops: sunflowers, pecans, blueberries, cranberries. (For the most part, as seed saver and author Will Bonsall once said to me, "Our crops, like us as people, are refugees. Our crops are immigrants.")

In his book *Travels*, plantsman and explorer William Bartram outlines how in the spring of 1774, between Augusta and Savannah, he encountered in a Native American settlement what he described as "ancient cultivated fields." They contained Chickasaw plum, beautyberry, mulberry, and hickory, "which informs us, that these trees were cultivated by the ancients, on account of their fruit, as being wholesome and nourishing food." Cultivation of native plants for the purpose of eating them is the process of plant domestication.

In addition to those being domesticated, numerous wild foods were consumed across eastern North America, supplementing Amerindian diets—foods such as American chestnut. From the Georgia coastal plains, for example, came Chickasaw plums, cattail roots, blackberries, chinquapins, acorns, hickory nuts, yaupon, and many more. Most of these plants did not become commercial wonders and are, for the most part, not eaten today. In fact, chemical agriculture and destruction of habitat are rapidly destroying native foodstuffs.

"One in fifteen wild, edible plant and animal species on this continent has diminished to the degree that it is now considered at risk," wrote native plant scholar Gary Nabhan in his book *Renewing America's Food Traditions*, which listed endangered food species across the continent.

When Noble Jones Arrived

Some of the crops that Noble Jones, first English owner of what is now Wormsloe, began to plant came from Europe, including rice. These foods would have flowed into Europe from China, Asia, and the Mediterranean. Others, such as corn, were Amerindian in origin. Some, such as grapes, were native. When Jones established Wormsloe as a Savannah outpost in 1735, he began to cultivate cotton, grains, berries, mulberries, vegetables, and grapes.

Within a few decades of the establishment of the first colony, agriculture was well established along the Georgia coast. A century later, using economic terms in an attempt to convince the South to withdraw from the Union, Dr. Joseph Jones addressed the Cotton Planters' Convention. According to Augusta's *Daily Chronicle & Sentinel*, Jones told the convention, "In 1763 the exports of Georgia

consisted of 75,000 bushels of rice, 9,533 lbs. of indigo, 1250 bushels of Indian corn, which together with deer and beaver skins, naval stores, provisions, timber &c, amounted to £27,021 Sterling."

In March 1774, William Bartram encountered south of St. Simons a well-set plantation. He describes in *Travels* the approach to the house and farm: "A cool area surrounded the low but convenient buildings, from whence, through the groves, was a spacious avenue into the island, terminated by a large savannah; each side of the avenue was lined with bee-hives, to the number of fifty or sixty." The planter invites Bartram to eat with him, and "presently was laid before us a plentiful repast of venison, &c., our drink being honey and water, strengthened by the addition of brandy."

This scene has always been one of my favorite in *Travels*, partly because it exists perfectly on that fulcrum between the wild and the cultivated, where a person could enjoy the best of both and not the worst of both—a pocket of cultivation in a vast wilderness, before our culture tips to industrialism.

The Agri-Culture of Wormsloe

Almost three hundred years ago—which seems such a long time to most Americans but is only a blip in the long span of time—agriculture in the Lowcountry was elevated among the landed gentry into a science. Treatises on agriculture were written, conferences held, newspapers studied. A successful plantsman was a hero indeed. During this era both the Lowcountry planter and the crofter, or homesteader, were engaged in an endeavor to better fill their storehouses. Grassroots experiments with crops were underway, crops were being introduced, varieties were being developed. Likewise, in the kitchens, a unique cuisine was being born.

The planting regimes, the harvest, the kinds of food, and the cuisine were determined and bent

- by the meteorologic specifics of the place, or the ecology of weather—specifically a temperate climate, with high humidity most of the year, abundant rainfall, long summers, and short winters;
- by the effects of the ocean; and
- by ecology itself, the native flora and fauna of the coastal plains. Within this matrix a planter or crofter had to eke out a food system.

Usually agriculture tries to avoid being bent by ecology. Indeed, most agriculture in the Lowcountry has been a continuous attempt to alter the matrix, by damming and flooding (especially for growing rice), by building fences against marauding buffalo and deer, by weeding, by fertilizing, and so forth. It has also been a continuous struggle to outsmart the ecology of place, by hand watering, by covering plants during frosts and freezes, by burning pots.

It was this primal tussle in which the early colonists were engaged. They needed to eke out vittles. They learned what they could from native people.

In Georgia, colonists from Great Britain were joined by Salzburgers from Austria (present-day Germany) and the Huguenots from France. But the synthesis was not over. With the (sad) introduction of kidnapped and enslaved Africans, a third rich culture began to influence the British traditions, and a strange and wonderful new culture would emerge. From this extraordinary place on the South Atlantic Bight, from the confluence of many remarkable civilizations, would come a melting-pot blending of tastes. It would include the barbecues of Africa, the cowpeas and corns traded upstream from Mexico, the pilaus of the Caribbean, the honey from Europe, the tomatoes developed around 700 CE by the indigenous Aztec people from Mexico. Southern food culture was wonderfully diverse.

In a November 1856 farm journal entry, George Wymberley Jones listed crops produced at Wormsloe that month: "We have of eatables—the produce of this place—this

month, the following: oysters, crabs, shrimp, fish (whiting), wild ducks, turkeys, chickens, eggs, milk, butter, English walnuts, hickory nuts, persimmons, pomegranates, hominy, sweet potatoes, Irish potatoes, [indecipherable], turnips, carrots, beets, cow peas, green peas, Lima beans, eggplant, tomatoes, okra, spinach, besides benne and arrowroot, and syrup from the chinese sugar cane—to say nothing of cabbage & pumpkins. We had also as fine a watermelon as I ever tasted on the 11th of this month."

During a rich three centuries of agricultural development along the Georgia coast, and at Wormsloe, an incredible agro-culture emerged, a polycultural synthesis—richly diverse, hybridized, energetic. It was improvisational, yes, in that corn produced more abundantly than oats, and so European porridges would become southern grits. But it was also an exciting fusion of many tastes.

It was also a manifestation of the place itself. There are "synergies that happen when a particular plant or animal adapts to a particular landscape, soil, climate, and food traditions," Gary Nabhan said. Traditional foods result from interactions between genetic stock and a particular area. These are place-based foods. This brings us to *terroir*, soil or ground, compatible with the French word *territoire*, territory. *Sentir le terroir* is to smack of the soil, as in the native tang of wine. Wormsloe developed its own terroir.

Industrial Agriculture

Around the middle of the twentieth century—an era we associate with the Second World War and the advent of technology, including the invention of fossil-fuel engines and chemical fertilizer—the nutritional landscape began to change. This period is called the Green Revolution—an ironic misnomer in light of today's connotations of the word "green." Suddenly methods of altering the ecological matrix and achieving greater returns (and thus, we assumed, greater wealth) were bigger, more effective, more affordable, and more available.

Mechanization, chemical fertilization, standardization, homogenization, transportation, and commercialization were catchwords of the new agriculture. Agricultural industrialization rode up to the farm gates, or the cattle gap, bringing with it a shift

- from the local to the global
- from the small to the large
- from the nutritious to the filling
- from topsoil measured in feet to topsoil measured in inches
- from living soil to dead soil
- from diverse to depauperate human microbiomes
- from the storied to the acultural
- from purity to toxification
- from independence to victimization
- from rural community to rural isolation

In addition to mechanization, industrial agriculture forced specialization—larger areas planted with a smaller number of varieties, as well as more acres planted in annuals and fewer in perennials. Its mania is monoculture, a few dependable, high-yielding varieties ripening at the same time. "In south Georgia," a farmer told me, "we're trying to major in corn and soybeans."

On the other hand, staying small and differentiated is the basis of diversity. Diversity, in fact, is an *impediment* to efficiency and productivity, as is small or human-scaled agriculture. Diversified small farmers who save their own seeds are not only of no use to a corporation, but a threat. Yet we know that diversity translates into possibility, stability, power, and hope.

The Green Revolution was followed by what Nabhan calls the Gene Revolution, leading to a precipitous decline in seed diversity—a diversity that was developed over decades, centuries, and even millennia and that was made up of open-pollinated seeds, which belong to the commons.

First came hybridization, plant breeding by corporations that can then own a patent on that "recipe" for a

particular variety. When farmers planted hybrids, bluntly put, they made more money. The bad news about hybrid seeds, however, is that although they often perform better, a farmer can't save them for another year's crop. The off-spring fail to "grow true"—to produce fruit similar to the ones from which they came. When gardeners plant seed saved from a hybrid, they don't get the same beefsteak tomato or supersweet corn but a hodgepodge of the ancestral strains used in breeding.

Another speeding bullet was coming to strike the very heart of a secure food supply. In the late 1990s came the introduction of genetically modified (GM) seeds. Based on the recombinant DNA research of the 1970s, GM seeds were first planted experimentally in the late 1980s and introduced to American markets in 1996. GM organisms are engineered through their DNA to take on new characteristics. Scientists may turn off active genes, turn on inactive genes, replace one gene with another, or splice in snippets of DNA from entirely different kingdoms of life. Organisms can be genetically engineered for pretty much anything.

Bt cotton, for example, contains a bacterium that is shuffled into the chromosome of cotton (there are also Bt corn and potato varieties). Bt, *Bacillus thuringiensis*, is a natural insecticide—a bacterium that produces a spore that proves toxic when ingested by insects. Once Bt is genetically encoded in the cotton, the cotton manufactures its own toxin to kill insect pests. Now we have a plant that produces not only cotton for our T-shirts and jeans but a bacterium to defy bollworms and perhaps other cotton pests.

In the last one hundred years, from 1900 to 2000, let's say, 94 percent of seed varieties available and considered a part of the human commons have been lost.

Three things result from varietal decline. First is the loss to our plates and palates. It's sad to miss, and not know we're missing, all those different kinds of apples, cabbages, corn, tomatoes, and so on.

Second is the loss of grassroots sovereignty over seeds and the ability of humans to control our food supply.

Third, a profusion of varieties did more than liven up the table and keep small farmers independent. Varietal decline threatens agrodiversity. We know this—the less biodiverse any system is, the greater the potential for its collapse. In shriveling the gene pool both through loss of varieties and through the human takeover of an evolutionary process, we strip our crops of the ability to adapt to change. Thus we put our entire food supply at risk.

When seed varieties vanish from the marketplace, they evaporate not only from collective memory but also from the evolutionary story of the earth. Seeds are more like Bengal tigers than they are like vinyl records, which can simply be remanufactured. Once gone, seeds cannot be resurrected.

The more food varieties we lose, the closer we slide to the edge of disaster. We are gazing already into the abyss. Maybe you haven't seen it yet, because maybe you were looking the other way. You were focused on grocery shelves stocked with an overwhelming selection of breakfast cereal.

A disappearing seed commons, combined with an exodus of people from the countryside to cities, meant our seeds, our seed saving, our agricultural skills, and our foodways were disappearing.

The same is true of a not-often-talked-about but profoundly vital knowledge, what I will call plant wisdom, which is inextricably tied to our place-based knowledge and thus is a part not only of our ecological literacy but of our understanding of human civilization.

A Vanishing Plant Wisdom

How many people still know that huckleberries have seeds, and they have glands at the base of their leaves—and that blueberries do not? How many still know that the pungency of wild peppers is related to altitude and that the higher the altitude, the greater the pungency? How many know that the scapes of wild onion, like garlic, are edible?

Or that a tobacco hornworm becomes a Carolina sphinx moth?

Mostly we do not even know what we have lost. Most of us don't know that a pumpkin vine, for example, puts out flowers most commonly in a specific order of male and female. Many of us don't know what the male flower looks like as compared to the female. In fact, some of us don't even know that a pumpkin begins as a flower. Or where a pumpkin comes from.

Part of the joy of this work is in discovery. Not long ago, as I was selling seed packets at the Statesboro Farmers Market, a couple in their second year of gardening, on a tiny scale, asked me about okra. "We grew some last year," they said. "We let it get big; then we couldn't eat it."

"Oh, no," I said. "Okra has to be picked young, when it's tender. The longer it grows, the tougher it gets, until it's inedible."

"We figured if we let it grow we'd have more of it."

"It's counterintuitive but true," I said. "You have to eat okra when it's young."

I recollected where I had learned the habits of okra. I had learned about it in any number of okra patches with which I had been associated as a kid, including that of Mr. Chavis, who lived in an empty building my dad owned and who grew a patch of okra to sell. Someone at some point told me how to harvest okra, at what size it could be cut. I also learned about okra in my mother's kitchen, as I watched her process the vegetable for stewing or frying and then helped her do it. If a paring knife did not easily enter the pod when pressed against it, the pod was too hard and must be thrown in the scraps pail for the hogs.

What other okra wisdom is there? It makes you itch when you pick it. You should wear long sleeves and gloves, unless you have grown Clemson Spineless. Okra is not harvested all at once, like a head of lettuce. Okra keeps producing. Keeping up with the harvest is difficult, since okra pours out pods. Every second or third day is the optimal harvesting time. You'll need a jackknife. Pick all pods that are ready. If you missed a pod during a previous harvest, cut it and throw it in the compost, unless you want to save it for seeds. If so, mark it with a string and leave it alone.

The job of a plant is to reproduce itself. When an okra plant throws some pods, and they are left to grow, and the seeds mature, that signals to the plant to stop producing. Its work is done. But if you keep taking the fruit, the plant must keep making more, in hopes of completing its work on earth. An abundance of okra is a product of plant stress.

I don't know everything there is to know about okra. Nobody does. The important thing is that I want to learn as much as I can.

But times are again changing, with more people getting educated about agroecology and the wonderful way food returns us to our places. As Drew Swanson wrote in "Wormsloe's Belly," food allowed "connections between people and place through one of the most essential ways humans interact with their environment—by eating it." I say that we are moving from the Cenozoic into the Ecozoic era, evolving from an industrial society into a sustainable one.

It strikes me that what we are doing at this point is reclaiming lost decades in the garden. "Gardening is managing our relationship with nature," said writer and naturalist John Tallmadge. Or as biologist Robin Kimmerer put it, "We're all reading from the same book—the land. The library of knowledge is in the land."

It seems that every day on my own small farm I am an archaeo-homesteader, uncovering lost wisdom, and not just about plants: how to render fat, how to prevent scours in bottle-fed calves, how to caponize roosters. At the same time, I recognize that a burgeoning science enlarges the body of agrarian knowledge, some of it in response to modern challenges. We want and need this information— where to find native earthworms to use in vermiculture so as not to spread invasive species, how to prune muscadines most effectively, how to control mites in beehives naturally. So I am a futuristic homesteader as well.

To plow forward without appreciating traditional wisdom is a mistake. Virginia Nazarea writes about "connecting people to places through 'rivers of time' so that the present becomes full of possibilities and the future not so daunting." Without the traditional wisdom, learned in traditional ways, it's hard to move forward.

Interspecies Cooperation

One area in which we are at risk of losing our wisdom is interspecies cooperation. Agribusiness, of course, favors monocropping, because that's what the machines can handle. But we are not machines, we are gardeners.

Traditionally, we humans have been great at multicropping. In India, a second crop, such as fava beans, would be planted among wheat at exactly the right time—the wheat could not be so tall as to shade out the bean, and the wheat could not be so short that the bean overwhelmed it. When the wheat was cut, the fava beans scrambled skyward.

In the southern United States, vining cowpeas would be grown on corn stalks. The pea had to be the right variety, planted at exactly the right time. If planted too early, the pea overpowered the corn. If planted too late, it was shaded out. This explains why so many heirloom cowpeas carry the name "cornfield bean." My hundred-year-old neighbor, Leta Mac Stripling, told me that her family planted velvet beans among their corn.

Companion planting also encourages symbioses. Tomatoes and basil planted together benefit each other, the tomatoes attracting pollinators to the basil, and the basil discouraging pests from the tomatoes. Strong-scented herbs such as mint and rosemary help deter the cabbage butterfly. Environmental author Bill McKibben reported from a trip he took to Cuba that, for some unknown reason, when green beans and cassava on the *organóponicos* are mixed in the same rows, yields improve 66 percent. Gardeners for centuries have been figuring out these things.

As Will Bonsall said to me, "Peasants were not stupid people."

I believe that we will relearn the ancient wisdom of the wild garden, and that we will become not only elders of the land but caretakers of it as well. If we get started learning from each other, learning from books, and (most imperative of all) learning from our own experiences on the land, we too will become wise.

The Human Microbiome

The human microbiome can be called the ecology of a person, a mediation between environment and physiology. Species within a person depend on the historical and ecological legacy of the place where the person lives. When we tally the losses due to industrial agriculture, or metabolic rift, we have to consider the loss of a diverse gut flora in modern Americans. This has been wrought by a disintegration of the relationship between ecology and agriculture and in turn affects that relationship. A compromised microbiome is associated with more illness, less intelligence, less tolerance of certain foods (thus bringing monocultures of its own), less resilience, less energy.

Soil is alive. One teaspoonful of healthy soil, I was told by Joel Salatin—iconic farmer in the good-food movement of the late twentieth century—contains sixty million bacteria, three to five miles of fungal hyphae, a few protozoa and nematodes, and maybe a tiny insect or two.

The human gut is like soil.

Current Influences

Because the movement of southern agrarian society has been toward insularity, and even white supremacy, the reality of its food history is surprising. Southern food culture is extraordinarily diverse, first a melding of the explorers and colonizers, then the deeply transformative and paradigm-shifting influx of African and Caribbean weight. This was

followed by waves of Scots and Irish, Jewish entrepreneurs and merchants, and, more recently, Vietnamese and Indian and Pakistani people. Currently Lowcountry cuisine is being shaped by the underground and increasingly visible influence of Mexican, Central American, and South American foodways: a Latin restaurant in every small, rural town; cactus pads, chayotes, and yucca available in the groceries.

The food becomes what the land will accept.

Of course since the mid-1700s, when provisions could be purchased, and especially since World War II, a land-based food culture can effectively be ignored by an increasingly urban demography.

So the food that happens at the margins becomes, essentially, the center of the culture—its defining reality—and in those margins today are not only displaced families from around the world and white families hanging on to field peas and lace cornbread but a new generation of small-scale, science-based, alternative farming, characterized by groups such as Georgia Organics and fueled by small farmers markets. These diversified backyard growers and small farmers are experimenting with crops such as sorrel (making the popular Caribbean beverage or pickling it), citrus, Japanese persimmons (orchards and a cookery springing up), Malabar (heat-tolerant) "spinach," and daikon radishes.

A rapidly changing climate and a soil matrix made depauperate by industrial agriculture have meant some traditional foodstuffs have become increasingly difficult to grow, affecting cuisine. For example, tomatoes bore bountiful harvests when I was a child, resulting in a popular dish served often—tomatoes over rice. But thrips carrying spotted wilt virus have made tomato growing without huge chemical interventions nigh impossible.

Field peas, once a staple, are now extremely difficult to grow because of southern blight, bacterial wilt, and other afflictions. Although summer squash and zucchini were not popular crops in the nineteenth century, by the twentieth century they were becoming increasingly important on the southern table. But the famed harvests of summer squash are a thing of the past, thanks to squash borers, fusarium wilt, and powdery mildew.

Food, in a nonindustrial world (a world where a folk- or people-based culture can develop), is dependent on the environment. The environment's response to climate destabilization and toxification of the matrix are changing southern food culture, and this is driven by the experimentation of young, educated, alternative farmers. For example, the cuisine will see greater emphasis on citrus. Recently a South Georgia friend baked an upside-down cake using sliced home-grown oranges. I see more emphasis on salt-cured lemons. More will be done with cherry tomatoes, which remain resistant to the decimating spotted wilt virus. Chayote will increasingly show up on Lowcountry menus. We are even now changing the landscape of southern cuisine.

Reconnecting to Wormsloe

Further conversations with farmer and author Joel Salatin reveal that he believes that agriculture needs to mimic the symbiosis found in nature. "What we want to do is use nature as the template," he said. "We actually build forgiveness into the landscape with the checks and balances of biodiversity. Chemical farmers don't do that. The only tool in their box is technology. There can't be a natural cure—it has to be a high-tech cure.

"The soil is the earth's stomach," he said. "In the soil, everything rots, rusts, and depreciates. The problem is that we treat soil like dirt and manure like waste." He named the biological activity of *soil* as the key to tilth. "That life supports healthy plants that support people's health," he said.

In gardens at Wormsloe, scholar Sarah Ross, director of the Wormsloe Institute for Environmental History,

is growing vintage and heirloom seeds. Her work is an effort at reconnecting with the place itself, part of the long history of the landscape nourishing the residents of Wormsloe, from Noble Jones and his family down to Craig and Diana Barrow and including resident slaves and other workers, nonresident slaves and other workers, and a long thread of guests.

In the heirloom gardens Ross is attempting to re-meld the synergies of the wild with the need for human nourishment or, in other words, to rebuild some of the culture lost in the last century and build a new culture for the twenty-first century. Her efforts are toward farming practices that accommodate wildlife, increase pollinators, encourage interspecies cooperation, and utilize agrodiversity. She necessarily responds to climate destabilization, increased toxicity, and increased pressure from disease.

In the kitchens at Wormsloe, this food will not only restore an old cuisine but inspire a new one that, like the genetic material, continues to evolve. This, in turn, will work to restore the greater microbiomes of human and place.

Much of the agricultural wisdom of Wormsloe was not recorded. Part of the current effort is to reclaim this knowledge and to walk forward into a plant wisdom that responds to today's environmental pressures, with a recognition that this plantation exists in a greater ecology that will forever leave its genetic mark on its seeds and flavor the food that it produces.

Agriculture and the Edible Landscape of Lowcountry Georgia

DAVID S. SHIELDS, Carolina Distinguished Professor, Department of English Language and Literature, University of South Carolina, Columbia

Shields assesses and organizes agricultural history of the area through the use of grains, vegetables, and livestock in Lowcountry plantations. Considering factors that shaped farming decisions and the functions of a Lowcountry plantation, Shields explores how these varied and changing purposes were expressed through the cultivation of livestock, trees, grains, vegetables, and wild resources. Since most of the plants grown on a plantation served multiple purposes, their versatility enabled them to endure significant changes in land productivity through long periods of time. Shields follows agricultural production at Wormsloe from a silk and cattle farm, to a cotton plantation, to a hunting preserve, to, finally, landscaped gardens open to the public.

What patterns of farming shaped the decisions that made Wormsloe a productive plantation over the eighteenth and nineteenth centuries? What functions did a Lowcountry plantation serve? How did the complex of purposes fit together in terms of the design of the plantation, and in terms of the livestock, trees, grains, vegetables, and wild resources found on Wormsloe from its founding to the twentieth century? To what extent were old patterns found wanting? What innovations took place in Wormsloe's woodlots, fields, gardens, and waterways over its lifetime?

Before turning to specifics of time and place we must recognize the unchanging features of planting along the southeast coast of North America. The following are enduring purposes of planting that would not be altered at Wormsloe by the failure of the original ambition to be a

silk plantation, the emancipation of the African American labor force, the 1800s turn from a diversified market product of goods to the monocropping of cotton as a cash crop, or the turn away from wild harvest to market purchase of food in the twentieth century. Here are the enduring functions that planting served:

1. A plantation needed to produce income; this was accomplished with cash crops or with staples grown in fields. In times of crisis the sale of slaves also produced revenue.
2. A plantation had to feed its inhabitants, the planters and the workers; this it did with provision crops, often grown in gardens as well as in fields.
3. A plantation had to feed livestock; this it did with fodder crops, hog and chicken trees, and root vegetables.
4. A plantation had to nourish the soil, by producing cover crops plowed in as green manure or soiling crops that promoted high-quality animal manure (the penning of ruminant animals to aggregate manure was an important development of the mid-nineteenth century).
5. A plantation had to grow medicinal plants to treat illness and injury; this it did with herbs and foraged wild plants.
6. A plantation had to supply fuel for heating and cooking; this it did with woodlots. Some plantations sought additional income or food from orchards, vineyards, and berry plantings.

Every one of these purposes for cultivation occurred despite the land's own penchant to succor a native array of plants and animals. Cultivation was a battle against "wild nature," and the tasks of clearing fields, weeding, repressing insect populations, and driving off feeding birds and marauding animals stole time and labor from those who worked at cultivation.

The value of something grown on a plantation was calculated in one of two ways: its vendibility in the market (indicated by rapidity of sale, high price, and capacity to generate good reputation for the provider) or its multiplicity of uses on the plantation (always conceived of in terms of employment of every part of the plant).

Wormsloe in its earliest incarnation pursued the phantom of silk wealth. Having prohibited slave labor in the colony, administrators sought a staple that could be raised on farmsteads employing family labor. Tobacco served this role in parts of the South, but by 1732 it had become overly plentiful in the transatlantic market. Silk had the virtue of its rarity, its lack of a need for gang hard labor, and its suitability to being worked by women. It had discommodities as well: the selection of English mulberries instead of Chinese white (the caterpillar's natural food) led to the stultification of its development. Vast quantities of leaves had to be harvested from the trees daily during cocooning season, and the dissolution and reeling of cocoons into silk thread required skill and machinery. As long as London paid bounties on cocoons or raw silk, and as long as the law mandated the planting of white mulberries, planters pursued the silk dream; but truth be told, the sole group to make money on silk culture in Georgia were the Salzburgers at Ebenezer. Even before the American Revolution, Noble Jones and the other major planters looked to other crops for cash—first upland rice, then cotton.

In the 1760s planters began realizing that their dreams of silk wealth were groundless and they began looking for other staple crops. The fortunes being made by South Carolina planters with rice set Georgians wondering how they might insinuate themselves into the market. Could they compete with plantings in the Carolina bays and Lowcountry marshes that were already up and running? Literate agriculturalists had known from the 1750s that upland rice—varieties that could be grown in dry land with no flooding—existed in many parts of Asia. Growing rice in water was expensive—in terms of both the creation of infrastructure and hours of human labor. If you could grow rice like a garden crop, a single family might have a ready supply for food and feed. A planter could produce

a cash crop at lower cost than competitors who paid to construct impoundments and dig water control ditches. Thomas Jefferson promoted upland rice assiduously. Jones was an early and successful adherent of the dry culture movement.

Two varieties of upland rice made their way to the Georgia Lowcountry in the eighteenth century—Cochin twelve-eek rice and West African red-bearded rice. Wormsloe received a shipment of the legendary Cochin rice long sought by Western horticulturists. The first Cochin seed to arrive in North America came through the efforts of a supercargo and plant collector for the East India Company at Canton, China, in the 1770s—John Bradby Blake.

Cochin upland rice was one of five landraces traditionally cultivated in the hills of Vietnam (called Cochin China in the 1700s); the others were tangi, bo-lo, lirnam-bang, li-randi, and le-muyo. The last of these is an early, short-season rice, ripening in four and one-half months, and was exclusively dry raised on the uplands. Nineteenth-century observers of rice cultivation in Cochin China observed that upland rice cultivation required more labor and care than aquatic growing. According to Edward Brown, a sailor who was held captive in the area for some months, "The land must be ploughed three or four times, and all the tuft and lumps well broken up by the harrow. During its growth, it must be weeded two or three times to save the crop from being choked. The seed is sown by hand in the month of May and is harvested in November. It is never reaped, in consequence of the grain not adhering to the ear, but is pulled up by the roots."[1] On December 28, 1771, the *South-Carolina and American General Gazette* of Charleston published information that Blake had conveyed to John Ellis of Gray's Inn in London regarding Cochin upland rice and tallow trees available for distribution in Carolina and the West Indies: "We have the pleasure to inform the public, that by the indefatigable industry of a very curious gentleman at Canton, a sufficient quantity for experiment of the upland rice from Cochin China, so long wished for, has

been sent by the Thames Indiaman to his friend in Gray's Inn, who will take proper care that it is distributed to such persons in our southern colonies as will make a fair trial of this most useful grain."

John Ellis held the office of royal agent for West Florida, an administrative post in London superintending the colony's development. He communicated the rice to several colonial planter botanists: his brother Henry Ellis in Jamaica, General Robert Melvill in Dominica, and Dr. Alexander Garden of South Carolina. A botanist himself, Ellis had published *Directions for Bringing over Seeds and Plants, from the East-Indies and Other Distant Countries in a State of Vegetation*, so whatever he communicated had a fair potential for being viable.[2] Nevertheless, of the parcel shipped to Alexander Garden, a sole grain was successfully cultivated and grew at his garden at Otranto in Goose Creek, South Carolina. The Ellis sample sent to Benjamin Franklin and then on to Jones did somewhat better. Upland rice became a fixture of local growing in the Georgia Lowcountry, as a provision crop for slaves and as a feed crop for fowl.

Indeed, upland rice and mulberries were ideal food for chickens and other yard birds, which were far less picky about what variety of mulberry—white, black, or native red—they wished to eat. Fowl runs in old mulberry groves were a fixture in the South until the second quarter of the twentieth century.

In integrative planting, cash and provision crops also operated as feed crops for livestock and fowl. One of the discommodities of cotton as a staple was its uselessness as feed. Experiments in feeding cottonseed to cattle and hogs and pressing cottonseed oil proved fruitless until David Wesson refined the stink out of cottonseed in the 1880s. Cattle absolutely refused to eat cottonseed cake (the vegetable residue after the oil had been pressed from the seed), and pigs, though they would eat it, preferred to root around than to consume seedcake from a trough. When Wesson Oil (refined cottonseed oil) became commercial, the cotton plant became part of the food system—and in this capacity

I will discuss it later. Meantime, let us consider in greater depth how planters fed farm animals.

In theory, the easiest way to feed animals is to let them forage on the native growth of the land. Yet there are problems with this strategy: free ranging puts fowls at too great a risk for predation from owls, eagles, hawks, foxes, and wild dogs. Furthermore, allowing fowl to roost in the wild deprives the homestead of eggs. So fowls were penned and mulberry trees often grown as shade over the roosting shed. Their foraging was restricted to yards and gardens. A portion of the grain crops—corn, rice, or winter barley—grown on the plantation or farm would be fed to fowls. In the nineteenth century, when planters began realizing the potential of the African diaspora oil seed benne (landrace sesame), grown in the huck patches of enslaved Africans, it too was added to the feed for fowls.

Not only did grain crops and benne provide feed to livestock and fowls; they drew in wild fowl, deer, and other wild animals that could be harvested for meat. Rice birds and ducks led the list of desirable wild foods, and hunting them proved a diversion and also a source of protein for Lowcountry residents.

When we examine the grains and row crops planted at Wormsloe and other farmsteads of the pre-1800 Lowcountry, we see that the classic grains of Britain—oats, rye, barley, and wheat—while cultivated, were decidedly secondary to rice and maize. This is because a century of planting experience by English settlers in Virginia and South Carolina had shown that the landrace English wheats (white lammas and yellow lammas), the Scottish bere barley, the Old English black oats, and the North European white rye languished over the summer and suffered insect infestation. Comparatively, rice and maize thrived. The autumn planting of winter wheat, rye, oats, and barley did not begin systematically in the South until the end of the eighteenth century and depended on the discovery or development of a set of grain varieties—white May wheat, purple straw wheat, red May wheat, all developed in Virginia;

seashore black seed rye (early nineteenth-century South Carolina); six-row winter barley (later Tennessee winter barley, planted in the 1810s); and white potato oat (end of the eighteenth century) and winter gray turf oat (late eighteenth-century Virginia). The one exception to this history was the development of timilia durum wheat by the Salzburgers of Ebenezer, Georgia. This famous landrace hard wheat from Sicily enabled the mills and bakery at Ebenezer to produce the best bread in the colonial South. It would also become the pasta wheat that produced the first southern macaroni—manufactured by Angelo Santi of Charleston and Savannah in the 1790–1810 period.

Along the coast, black seed rye, because it grew well in sandy soils, had very sturdy straw, and grew tall enough to serve as a windbreak for more delicate crops, became a standard winter crop. It remains in cultivation in Florida and South Carolina. It would become the most popular feed for cattle. Turf oats and the post-1840s red Mexican rust-proof oats enjoyed similar favor, becoming the standard horse feed in the Lowcountry.

One reason that a panoply of Old World grains was not extensively cultivated in the Lowcountry was that cows, pigs, goats, and sheep were loosed to forage on the landscape and not for the most part fed on grain. Grazing on wild plants proved easy for pigs and goats, less so for sheep and cattle. Pigs were brought to the Southeast of the North American continent by the Spanish in the sixteenth century. The iberico black pig turned feral on the sea islands, and several strains developed—the Ossabaw pig on the islands and the Guinea hog on the mainland. The former, shaped by the limited resources of Ossabaw Island, evolved into a slow-growing and efficient, fat-producing animal.

George Jones was appointed cattle inspector for the colony of Georgia but differed from many of his fellow husbandmen by establishing a dairy at Wormsloe. A dairy requires that cows be regularly milked, and that happens only when their movements are constrained by fence, ditch, or hedge. While many, if not most, of his contemporaries let

cattle roam in the longleaf pine woods of the Lowcountry (ancestors of the Florida cracker cattle and the Georgia pineywoods cattle), Jones restricted movement and benefited from their manure, milk, and labor. Judging from the experience of modern wranglers of cracker cattle, we can conclude that collecting cows for milking is difficult, the quality of the milk is resinous, and the quantity scant. Cracker cattle are not optimal dairy animals. They are ambulatory meat.

If one did not let one's cattle range—if one cherished milk, cheese, butter, cream, and clabber—one had to supply feed. Rice would not do. Maize would. Three landraces of maize had been cultivated by the native peoples of the Georgia Lowcountry: sea island white flint corn, Guinea flint corn, and a flour corn that has not survived. Settlers took these varieties over. The white flint was tall growing, not prolific, but excellent as a meal and grits corn. The Guinea flint was short cobbed, short statured, orange kerneled, and prolific. It too was of high culinary quality. We know little about that flour corn, but it may have been related to the surviving Carswell white variety, a settler-improved Creek landrace from late eighteenth-century Georgia. While these landraces had decided virtues and pronounced culinary quality, they suffered from disadvantages—the white flint would lodge during violent storms because it grew so tall; the Guinea flint bore multiple cobs only when spaced widely, undercutting the acre productivity of the variety. For this reason George W. Jones in the 1850s sought out the most discussed maize varieties in the agriculture journals: "Rhode Island Yellow Flint," "Wyandot," and "Maryland White." Neither the first nor the last provided a clear advantage over the local varieties, but the Wyandot corn had the potential to be a commodity corn. There is no evidence, however, that Jones sought to have corn serve as a cash crop; it was a provision and feed crop.

But there had to be other matters as well. Seventeenth-century livestock management in the West Indies had shown that cattle developed a zest for cured sweet potatoes as late winter feed. Sweet potato greens could provide silage in summer. But the great resource for fodder proved to be the cowpea, a legume that arrived with enslaved Africans and would prove to be one of the important agronomic crops of the South—a protein source for humans, feed for livestock, and a nitrogen builder and green manure for the soil. Several landraces transited from Africa to the Lowcountry: the sea island red pea, the white lady/rice/conch pea, the black crowder pea, the whippoorwill pea, and the black-eyed pea were all grown extensively in Georgia and South Carolina. Rebranded as "southern peas" or "field peas," they remain a staple of southern fields and tables.

A native analogue of the cowpea was the sieva bean, or butter bean, a small lima bean that took several forms—speckled red and greenish white being the dominant colors, bean leafed and willow leafed being the two foliage forms. Originating in Central America over a millennium ago, these beans migrated via trade routes to the native peoples of the Southeast. The Sewee people of the northern coast of South Carolina conveyed the pea to settlers in the 1680s, and it became a favorite foodstuff in the first quarter of the eighteenth century. The name "sieva" (pronounced sivvy) derives from "Sewee." It functioned agronomically exactly like a cowpea, building soil, supplying fodder, and feeding humans. George W. Jones mentions planting lima beans at Wormsloe; he most likely planted what Georgians now call butter beans and South Carolinians call sievas.

Another legume that would serve a similar function was the peanut, brought to the Lowcountry at the end of the seventeenth century from West Africa, after first transiting the Atlantic from South America to West Africa in the sixteenth century. Like cowpeas and native beans, the peanut was cooked for human consumption, boiled, parched, or roasted, but it differed in one respect: edible oil was pressed from the uncooked nuts. The peanut plants were dried down and rendered into "peanut hay" for fodder. The original variety planted in the Lowcountry was the

Carolina African runner peanut, a small, sweet kind with superb oil quality. It would be supplanted in the twentieth century by the Virginia, Spanish, and Valencia peanuts.

Cowpeas, butter beans, and peanuts became rotation crops in the 1840s, planted after corn, cotton, or sweet potatoes. Some experimental farmers cocropped peas with corn.

While cowpeas pleased cows, pigs, and goats, they did not please sheep. The English agronomist Arthur Young, through extensive experiments, determined that the turnip was the ideal sheep feed in the absence of grass. George Washington counted himself a disciple of Young, and other thoughtful practitioners of sheep husbandry made the turnip ubiquitous when flocks grazed. Merino sheep became something of a cult animal among planters at the turn of the nineteenth century, although it would not be until the 1850s that they appeared in Wormsloe, as a feature of George W. Jones's renovation of the plantation. Throughout the region, several varieties became standard cultigens: the purple top, the early Dutch, the Norfolk, and the white globe. The first and last of these became enduring favorites in the Lowcountry. Their flavor—minty and mustardy with sharp and sweet notes—made them among the more versatile of the root vegetables. The majority of the crop was planted in late summer for early winter or late autumn harvest. Another, lesser crop went in late winter for early summer harvest. Frost-nipped roots were considered the most flavorsome, with the taste becoming more sweetly mild than sharp. In the South in the latter part of the nineteenth century, two types of salad turnips grown for greens especially emerged: the seven top (which lacked a bulbous root) and the Georgia winter turnip (crawford, southern pride), which generated much foliage and a root known for texture more than flavor. "Turnip salat" vied with curly mustard and white cabbage collards as the favorite green of the region.

One relative of the turnip—the yellow flat-topped Swedish turnip or rutabaga—became greatly popular in certain parts of Georgia. One of the resonant statistics of the 1840s was J. W. Brewster's harvest result from an acre of land cultivated in successive years by corn and rutabaga. The soil generated fifty bushels of corn (approximately four hundreds feeds for livestock) versus one thousand bushels of rutabaga (or 5,500 feeds at ten pounds per animal).[3] The result was simple enough for even dull farmers to grasp. If feeding livestock was your concern, the rutabaga was your plant. Only the mangel-wurzel (German cattle beet) rivaled the rutabaga for yield. And the rutabaga had one advantage over the mangel-wurzel—it tasted good to humans. The rutabaga also had certain advantages in cultivation: its growing season was shorter than the other roots; it could be manured by plowing in a clover field after the clover hay had been cut (most other roots required a major application of animal dung); it remained vital in the heat of midsummer; and it harvested more easily than mangel-wurzel. Its disadvantages lay in its poor productivity in clay soils (which was not an issue in the Lowcountry), its susceptibility to the insect pests that afflicted turnips, particularly the turnip fly, and its occasional toughness. One matter that could not be decided until rather late in the nineteenth century was whether the rutabaga was more or less nutritious than the other roots, and agricultural journals were filled with studies claiming different, sometimes greatly contradictory, findings.

When used as cattle feed, the tops proved as palatable as the roots. Farmers chopped the roots with a spade, intermixed them with hay or silage, and fed the mixture to cattle, hogs, and sheep during the winter. Horses preferred them steamed rather than raw.[4]

George W. Jones grew three other root vegetables at Wormsloe—the carrot, the beet, and the Irish potato. All were widely grown by his neighbors, as well. The carrot was a garden crop invariably grown wherever one maintained horses. In the colonial period and early republic the long orange carrot, a Dutch invention and England's standard root in the late eighteenth century, grew universally

in American fields. Some American horticulturists believed the carrot to be the most nutritious of all vegetables: "One bushel of carrots will yield more nourishment than two bushels of oats, or potatoes, and it is a remarkable fact, that horses will frequently leave oats to feed on carrots," wrote John Prince.[5] Cropping beets was a distinctive American habit of the nineteenth century. English farmers had little use for them. In the United States farmers discovered that the leaves could be stripped for cattle feed every fifteen days. "Oxen, cows and sheep devour them greedily, and fatten readily upon them. All domestic poultry eat them readily, when chopped fine and mixed with grain."[6] The roots roasted or boiled could be sumptuous.

Roots required curing—aging after extraction to instigate chemical transformation of the vegetable starches. Certain roots gained a reputation for being able to winter over in the ground, saving storage space. The black Spanish (red Spanish), the pumpkin yam, and the West Indian white sweet potato earned high regard for their keeping qualities and their culinary versatility. These red, yellow, and white varieties were ancestral to the array of sweet potatoes found today. Most turnips and rutabagas could also linger in the soil over winter.

If one ventured into the winter cellars of the Georgia Lowcountry in the eighteenth and nineteenth centuries, one would find pumpkins and apples as well as roots. The pumpkins of the Lowcountry were the ribbed moschata varieties (the Seminole pumpkin and the Dutch fork pumpkin are surviving examples of these varieties). Pumpkins were loved by hogs, tolerated by cattle, and devoured by chickens. Native cultigens, they grew profusely and tolerated drought, disease, and insects. Pumpkins accrued value because they overwintered, offering unspoiled nourishment until April. In contrast, their relatives, the summer squashes—the yellow crookneck and the cymling or pattypan squashes—because of insect incursion and advanced spoilage were reckoned less durable sources of food, though welcome summer provender.

The garden vegetables cabbages, kale, and collards were at times attempted as row crops. Because kale and collards drew up salt from the soil, they were valuable in coastal areas, where saltwater incursion from storms and freak tides mineralized fields. Scotch kale had been the preference among eighteenth-century rice planters as a desalinator, but when it was discovered that seed from certain popular European heading cabbages, when planted in the Lowcountry, would not head and instead formed loose-leafed coleworts, farmers turned a liability into an advantage. "Coleworts" as a word morphed into "collards," and by 1850 collards in quantity grew in the region. This did not forestall the interest of local growers and cooks in heading cabbages. They simply imported seed from London or from the North for the favored York, Savoy, drumhead, red Dutch, sugarloaf, and green glazed varieties. The last variety, because of its glossy hard foliage, thwarted the damage of the flea beetle or "fly" that feasted on other kinds of cabbage and so gained a following along the coast.

Many standard European garden vegetables did not tend to be grown on the Georgia coast until the advent of truck farming in the 1880s, or even later: asparagus, artichokes, broccoli, brussels sprouts, cauliflower, celery, fennel, parsnips, and rhubarb. The one European vegetable deemed essential for the spring table from the colonial era onward was the garden pea. Very few of the varieties thrived in the hot humid spring of the Lowcountry: the tall sugar, the marrowfat, the Prussian blue, and the early frame were the most advertised by seedsmen in the region's newspapers. But a garden pea suited to the region did not exist until the breeding of the wando in the middle of the twentieth century. Spinach retained its high esteem throughout the period, though when it came to cooked greens, spinach was prepared by itself, while collards, mustard, turnip greens, and sweet potato greens went into the greens pot with a hog jowl for pot likker.

When one looks at Wormsloe's records, what strikes a reader is the extent to which the garden at the plantation

was not a re-creation of a European kitchen garden. Indeed, only the pharmacological dimension of the garden, the herb beds, hewed closely to a European prototype. The food plantings were culturally syncretic with African diaspora vegetables (guinea squash/eggplant, okra, cowpeas, peanuts, and benne), Native American foods (pumpkins, sweet potatoes, tomatoes, squash, Jerusalem artichokes, lima beans, and maize), and a few European standards (spinach, cucumbers, peas, lettuce, onions, and Irish potatoes—originally from South America, but coming to Georgia by way of Europe).

Mary L. Edgeworth's *The Southern Gardener and Receipt Book* discusses the standard items grown by market gardeners supplying the towns and cities of Georgia and South Carolina from 1840 to the Civil War.[7] There we see the conservatism of the herb garden spelled out, with her listings of balm, basil, borage, burnet, chamomile, caraway, chervil, coriander, dock, hops, hyssop, lavender, mint, marjoram, parsley, pennyroyal, rampion, rosemary, rue, samphire, summer savory, skirret, tansy, and wormwood. Once can grasp how much Native American and African American ethno-pharmacology was passed over in the standard thinking of planters and market gardeners when one looks into the contemporary *Resources of Southern Fields and Forests* by Dr. Frederick Porcher. A physician's examination of the native and introduced plants of the region intended for use by Civil War medical staff in the absence of pharmacist-prepared drugs, this book reveals worlds of knowledge about the applications to which a multitude of growing things were made.

Much has been written and said about the African diaspora vegetables that became so central to Lowcountry cookery. Okra, a member of the botanical family to which cotton belongs, had the same taxing effect on soil that its relative did, so it had to be planted in different soil year after year or inserted into a rotation of crops. Numbers of landrace okra strains have survived along the coastal South. Originally identified by color (green, white, and red) and configuration (barrel, finger, horn), the coastal okras tended to have spines and proved irritating to pick. Consequently seed selection over the decades tended to favor smoothness rather than hairiness. When the Clemson spineless okra was introduced in 1939, it was universally embraced and now dominates Georgia gardens. The eggplant, or guinea squash, grew readily in the Lowcountry. Two varieties traversed the Atlantic with the enslaved Africans, the ancestor of the long purple black eggplants now represented by the Florida high bush and the black beauty, and the red eggplant (*Solanum aethiopicum*), whose compact fruit resembles a tomato. This latter plant, because it was more bitter than the purple eggplant, remained an item of the "hidden gardens," never appearing for sale in the markets of North America. Its scarcity ultimately caused its demise in North America, with the seed of the last known line destroyed in the arson-caused fire of a seed house in Louisiana eleven years ago. The red eggplant, however, thrives in Brazil, where it has become, in its fried form, a popular street food, "gilo."

In a November 1856 letter, George W. Jones mentions his most experimental food crops: "arrowroot, and syrup from the Chinese sugar cane."[8] The U.S. Patent and Trademark Office had only just started distributing seed for sorghum (Chinese sugarcane), and former governor James Henry Hammond's experiments at Redcliffe Plantation in South Carolina with fifteen varieties of sorghum imported from natal South Africa had just begun. The cold tolerance of sorghum made it an attractive alternative to sugarcane, which was notoriously vulnerable to cold snaps and freak freezes. Even the vaunted purple ribbon sugarcane, the hardy variety grown on Sapelo Island since the 1820s, suffered periodic failures from Savannah northward. Sorghum was so resilient it could be grown in southern Michigan. Yet the only persons who embraced sorghum in the 1850s were agricultural experimentalists like George W. Jones. It took the Civil War and the cutting off of sugar supplies to the Union that prompted the widescale embrace of

sorghum—particularly the amber and honey drip varieties. The fall of Natchez in 1863 turned Confederate farmers into sorghum growers. Wormsloe grew some of the first in the United States, the Chinese sorgho strain. During Reconstruction the African white and the amber became favorite local varieties, the former for meal and forage, the latter for syrup.

Two developments drove a mid-nineteenth-century interest in arrowroot. The fined grained starches of arrowroot made a digestible and refined emulsion when liquid was added. Indeed, it was the one starch that could be used to thicken fruit juices to create orange or lemon sauce without dulling the color of the juices. After the introduction of cookstoves in the 1840s, with a temperature control that permitted the creation of low-temperature sauces such as orange sauce, a premium was placed on ingredients that enabled the most finely textured, brightly flavored sauces. Arrowroot filled the bill. The fine-grain digestible starch convinced physicians that it was an ideal food for invalids. Arrowroot puddings, arrowroot biscuits, and arrowroot breads came into being to feed the sickly. A number of planters in Georgia experimented with arrowroot in the mid-nineteenth century, mostly on the sea islands. Wormsloe was the northernmost site of this experiment.

The twentieth-century repurposing of Wormsloe as a hunting and entertainment center meant the suspension of cotton planting. But because sorghum, corn, benne, and upland rice are favorite foods for ducks, they remained in cultivation at Wormsloe and throughout the Lowcountry on plantations that left off agricultural production. Since most of the plants grown on a plantation from the first served multiple purposes, their versatility enabled them to endure after the general use of the plantation lands altered, whether from a silk and cattle farm to a cotton plantation, or from a cotton plantation to a hunting preserve and entertainment center.

NOTES

1. Edward Brown, *Cochin-China and My Experience of It: A Seaman's Narrative of His Adventures and Sufferings during a Captivity among Chinese Pirates on the Coast of Cochin-China* (London: Charleston Westerton, 1861), 211.

2. John Ellis, *Directions for Bringing over Seeds and Plants, from the East-Indies and other Distant Countries in a State of Vegetation* (London: L. Davis, 1770).

3. "Ruta Baga," *American Farmer* (1849): 419.

4. Thomas Green Fessenden, *The Complete Farmer and Rural Economist* (Boston: Lilly, Wait, & Co., 1834), 267.

5. John Prince, "The Culture of Carrots," *American Farmer* 4, no. 1 (April 5, 1822): 6.

6. Thomas G. Fessenden, *The New American Gardener Containing Practical Directions on the Culture of Fruits and Vegetables* (Boston: Otis, Broaders & Company, 1842), 46.

7. Mary L. Edgeworth, *The Southern Gardener and Receipt Book* (Savannah, Ga., 1859).

8. Farm Journal of George W. Jones, November 30, 1856, De Renne Family Papers (ms. 1064), box 12, folder 27, Hargrett Rare Book and Manuscript Library, University of Georgia, Athens.

"Nature Points Out Where to Begin His Labours"

Georgia Rice Agriculture and the Environment

HAYDEN R. SMITH, history professor, College of Charleston

Geography, topography, surface hydrology, tree types, and soil profiles all contribute to the understanding of the environmental attributes required for successful rice cultivation. While agricultural endeavors in the Lowcountry were confronted by nutrient-poor soils, periodic flooding and drought, and a flat landscape that could be difficult to adequately drain for row crops, these were the very conditions in which rice thrives. Fertility flowed into the rice fields with the controlled flooding of impounded or fresh river water; and likewise, water could be drained as needed. These landscape features combined to create ideal growing conditions for rice. But unlocking the advantages of this commodity crop required significant amounts of labor and access to markets. Rice cultivation drove the importation of slaves from Africa, and rice exports departed from ports in Charleston and Savannah onward to markets throughout the British colonies in America as well as Western Europe.

Smith studies the physical and cultural history of the area through the evolution of rice as it was grown and consumed in the Lowcountry. Rice, Georgia's first cash crop and successful cultivation in the mid-eighteenth century, provided an economic foundation for the fledgling colony. 🦐

The Georgia Lowcountry defines the subtleness, yet importance, of elevation. Variations in soil characteristics, plant life, and water hydrology are represented in elevation changes of a few feet, if not inches.

Human occupation and land use are also important representations of subtle elevation changes. An example of the dramatic impact

that geography had upon the Lowcountry is represented in how people—free and enslaved—approached growing a central cash crop in colonial and antebellum Georgia. Decisions about which tracts to clear, the size of fields, and irrigation strategies relied on the microenvironments that existed throughout the Lower Coastal Plain.

Rice was Georgia's first cash crop, and successful cultivation in the mid-eighteenth century provided an economic foundation for the colony. With the 1750 repeal of the Georgia slavery ban, colonists scrambled to claim land and begin figuring out which landscapes were conducive for rice cultivation, while simultaneously ordering enslaved Africans to perform the excruciating task of transforming the countryside. The Lower Coastal Plain provided an ideal environment for inland rice cultivation, for the Atlantic Ocean's rise and fall during the Pleistocene Epoch had created fingers of small streams and creeks that spanned out over relatively level land and also merged into larger rivers flowing into the nearby ocean. Water's movement through these areas shaped the land to form knolls, ridges, and troughs, which became critical features for rice plantations and the people who lived on them. Islands of "high pine land" lying within and around the small-stream floodplains enabled landowners to establish living structures and grazing fields on terra firma, while streams flowing around the elevated landform provided the water source and floodplain needed for inland rice cultivation.

The flow of water through wetlands fed the dense vegetation that added to the apparent "inexhaustible fertility" of the Georgia Lowcountry. Colonial naturalist Mark Catesby noted that inland swamps were "impregnated by the washings from the higher lands, in a series of years are become vastly rich, and deep of soyl consisting of a sandy loam of a dark brown colour." The late eighteenth-century naturalist William Bartram described the Lowcountry with similar amazement. He observed wooded avenues "opening to extensive savannas and far distinct Rice plantations, [which] agreeably [employ] the imagination and

[captivate] the senses by their magnificence and grandeur." One rice planter described inland swamps as having a "better foundation and soil than any other lands" and as being "by nature more durable" for cultivation, because rainfall running downstream results in "fine supplies of decayed vegetable, which are deposited while the waters are passing over said lands."[1]

Inland Rice Construction

Reservoir irrigation strategies appeared initially, as the process required relatively less labor compared to the tidal infrastructure. Georgia planters relied on cultivation methods initially developed in West Africa and depended on African and African American labor to develop the land. The basic inland rice field consisted of two earthen dams. Enslaved people quarried clay from nearby deposits, which provided a watertight core, while they built up the embankment with available fill from adjoining drainage trenches. The dam on higher elevation contained stream- or spring-fed water to form a reservoir that would provide a water supply to the lower rice fields. Once cultivators released water from the reservoir, a second dam retained this resource to nourish rice fields. Located between these two earthen structures was a series of smaller embankments and ditches to hold and drain water effectively during the cultivation process.[2]

Water control for inland rice cultivation required not only precise construction of earthen embankments but also an understanding of the topography. Inland cultivators had to choose where reservoirs and fields would exist in relation to watercourses and terrain. To retain water in the reservoir and rice fields, the soil required a substantial clay foundation to prevent impounded water from seeping out. The subtle elevation change, in some cases just three or four feet from sandy highlands to alluvial swamps, allowed different types of vegetation to take root, depending on the ground permeability. This provided cultivators

some insight into soil composition. For example, longleaf pine and oak communities grew in well-drained sandy soil, while cypress and tupelo gum communities grew in less permeable soil. To aspiring rice cultivators, who did not have access to the insights of soil science until the mid-nineteenth century, the distribution of trees and other plants directed them toward appropriate inland sites. Colonial historian Alexander Hewatt observed that "nature points out to [the planter] where to begin his labours; for the soil, however various, is everywhere easily distinguished, by the different kinds of trees which grow upon it." The importance of water management explains why inland rice cultivators required, according to geographer Judith Carney, "careful observance of topography and water flow" to properly retain and release water.[3]

Topography determined the natural boundaries of the reservoir and fields. Higher land enclosed plots and retained water. Elevation change from knolls to bottomlands helped enclose the reservoir and fields, eliminating the need for more embankments. Because of the planter's reliance on geographical features to surround flooded fields, the layout of these plantations was very fluid, overlapping branches of tidal tributaries and sprawling through low-lying inland wetlands.

The process of carving rice fields out of the colonial inland forests took an untold amount of lives and labor. Using axes and saws, enslaved people removed dense woodlands, consisting of trees such as bald cypress (*Taxodium distichum*), tupelo gum (*Nyssa aquatica*), and sweet gum (*Liquidambar styraciflua)*. Laborers cleared the colonial rice fields first by slashing and burning trees, then by hoeing the weed roots to prevent recurring growth of competing vegetation. Once vegetation was removed in South Carolina inland tracts, slaves had to level potential fields to prepare for rice planting and water drainage. After fields were developed to drain standing water, slaves constructed precise quarter ditches that removed floodwaters more effectively. Geometrically shaped fields eventually replaced

the fluid landscape, redefining the nonhuman landforms of streams, banks, and knolls.[4]

Rice cultivators used gates, or "trunks," to control water flow from reservoirs onto the rice fields. Originally made from hollowed-out trees, trunks were traditional African devices used to regulate water flow through a conduit by plugging the end of *Borassus* palms. Slaves substituted cypress for this device. Field engineers placed trunks in sloughs, or stream channels, so water efficiently ran out of the holding pond from the embankment's lowest point. Sloughs were an important natural feature for draining the wetlands, for they served as a "gutter," or a depression in the subtle elevation change. After these floodwaters nourished the soil and rice crop and killed competing weeds, slaves drained the fields through trunks located at the second embankment. The water released from these fields flowed downhill toward nearby tidal rivers.[5]

The simplicity of inland rice field design led to water management problems, as the only option for flood control was the single downward direction of water flow. Unlike tidal rice, which used the river's natural rise and fall to move water in and out of fields, inland rice depended on a reservoir to provide nourishment. Ironically, by wishing to withhold controlled amounts of water, planters actually created a precarious situation when abnormal rainfall occurred. Freshets and droughts directly affected the reservoir. Freshets occurred when storms or hurricanes provided more rain than the soil could absorb and streams could channel, causing, in the words of Catesby, "rapid torrents" that were "sudden and violent" as they flowed downhill.[6] This rush of water would flood the reservoir, causing an overflow that would breach the dam. Droughts presented another problem for inland rice planters. Reservoirs that did not receive enough water would eventually dry up, preventing rice from receiving nutrients and creating competition with weeds.[7]

The antebellum period saw the dominance of a second type of rice plantation. Tidal cultivation, although closer

to inland fields, relied on different topographic and hydrologic settings. Tidal cultivation used hydrology governed by the tidal cycle of the ocean, with a falling tide, or ebb, and a rising tide, or flow, to capture the energy of freshwater rivers for irrigating or draining the rice fields. Permanent embankments and surrounding interior ditches kept high water out of fields and floodwater in and allowed proper draining of fields. As with inland fields, rice trunks controlled water flowing in and out of the embankments, yet these wooden devices were modified to allow a multidirectional flow of water. To achieve this, planters designed gates to cover both ends of the trunk. When fields needed flooding, slaves would open the exterior gate closest to the river, while the interior gate pivoted on a hinge for water to flow naturally into fields from the force of the tide. Once the tide changed direction, slaves closed both gates to prevent impounded water from leaving the fields. After the desired time elapsed for irrigating the fields, slaves raised the interior gate to allow water to flow out of the pivoted exterior gate, preventing resurgent tidal waters from flowing into the fields. Tidal rice fields were subdivided into smaller plots to efficiently control water flow. By building levees on a grid system, planters could direct water flow more precisely. These embankments were called quarter divisions because they were originally a quarter of an acre. Planters connected these divisions to a network of canals, ditches, and drains to properly irrigate the crop.[8]

Although tidal rice cultivation was used in the colonial period, the irrigation practice rapidly expanded after the revolution. Planters had to reinvest capital to repair their rice fields after the war, so many chose to focus on the new tidal technology. Because of the dramatic shift from inland to tidal cultivation, there was an agricultural movement from inland swamps to freshwater marshes. This location adjacent to tidal rivers provided more effective transportation and incorporation of tidal-powered threshing mills and processing capabilities with higher output.

Water salinity challenged planters to choose which rivers would successfully produce rice. Rivers with a small watershed or with water located near the ocean produced brackish water, a mixture of salt and fresh water. This water quality killed rice crops growing along the shore. Rivers such as the Sapelo, with no fresh water from the Piedmont and the mountains, could not generate enough force to push the ocean's encroaching waters near the coast. Therefore plantations situated near the mouth of these rivers could not successfully grow rice by tidal culture, as opposed to plantations located next to rivers with larger watersheds and more powerful flow, such as the Savannah and the Altamaha.

Specific tidal rivers possess a layer of fresh water over a layer of salt water in the tidal zone. This feature produces a wedge effect as the lighter fresh water flows downriver over the denser, heavier salt water pushed upriver by tidal forces. As salt water moved upriver, a wedge effect pushed the freshwater levels higher and allowed planters to capture this water in embanked rice fields. Rivers with larger watersheds efficiently formed this phenomenon from the voluminous water flow, originating in the Southern Appalachians and Georgia Piedmont, to force through their watersheds and deep channels, allowing this wedge to occur.

Like water hydrology, floodplains were a critical element for successfully growing rice within tidal estuaries. This land bordering the tidal rivers had to be low enough for water to cover the area during high tide. Sediment carried from higher elevations settled on the floodplains after every tidal cycle, developing fertile riverbanks. The rich soils constantly saturated with fresh deposits or decomposition and tidal waters provided ideal conditions for surrounding vegetation, which some contemporaries compared to the Nile's alluvium. Before tidal rice took hold in the Lowcountry, Catesby observed that "the richest soil in the country lies on the banks of those larger rivers that have their sources in the mountains, from whence in a series of

time has been accumulated by inundations such a depth of prolifick matter, that the vast burden of mighty trees it bears, and all other productions, demonstrates it to be the deepest and most fertile of any in the country."[9]

Nineteenth-century writer and politician William Gilmore Simms noted that these river wetlands "abound in cypress, with oak, hickory, poplar, ash, chestnut, cedar, beech, sycamore, laurel, and cotton tree." Virginia planter Edmund Ruffin also described the diversity among trees and explained that the undergrowth consisted of vines, cane, and "water grasses." He observed that the landscape was "always saturated with water, is rendered firm only by its close and deep mat of roots of every description, and but for this would be a quagmire in its natural state, and the more so in proportion of the excess of decomposed vegetable matter, will be the subsequent sinking of the land, after draining and cultivation." These conditions faced planters when they decided what landform would best suit a potential tidal rice plantation, yet the forest density placed an untold amount of hardship on the people forced to clear these environments with axe and saw.[10]

Planters were concerned about water draining off the floodplains during the outgoing tide, for any land that did not efficiently allow this to happen would contribute to poor rice fields. Small creeks, or sloughs, running through these floodplains like capillaries stemming from arteries funneled retreating waters to larger rivers during the outgoing tide. During the draining cycle, water would flow down the floodplain, depositing any sediment it carried through the sloughs toward the tidal rivers. A rapid flow of draining water from the slightly higher elevations prevented any potential alluvium from clogging these sloughs, keeping the passageway open for the next tidal cycle. More important for future rice dikes, this motion built up land near the sloughs, providing a supportive riverbank. The river's hydraulic depositing of sediment would become a crucial feature in the mechanics of tidal rice cultivation, for this natural occurrence alleviated the need to provide

fertilizer to the rice fields. Planters scouting out potential rice fields noticed how efficiently these sloughs drained water. Future canals and trunks would serve a similar purpose. Floodplains that did not have substantial creeks indicated that the land did not accommodate proper tidal draining.

Tidal Rice Construction

People had to work with these natural conditions to produce an efficient "hydraulic machine." By surveying potential land and using available agricultural knowledge, planters had to make speculative decisions concerning rice field locations and labor management. Planters sought to control the natural forces by directing the tidal flow through drainage canals to flood the entire field, yet the environment dictated where planters could and could not construct these features. Floodplain elevation determined how much land planters could devote to improving rice fields. Land had to be low enough to receive water during a rising tide, yet high enough to efficiently drain receding water during the "flow." Sloughs in these floodplains were sought out for trunk placements. The geometrically shaped fields covered the original topography of the drainage basin, so the original streams and sloughs that flowed through the undeveloped floodplain were eventually modified to receive and extract tidal floodwaters.[11]

As with inland cultivation, each plantation followed a different pattern for developing rice fields depending on the immediate environment. Describing how planters followed general patterns for establishing rice plantations, Mart Stewart emphasizes that "the local environments shaped the elevation on plantations on each river." He states that each microenvironment produced a different rice culture that forced the planter to adapt, or fail, in his economic venture. Factors of land, surveying, and knowledge formulated into the agricultural equation changed slightly from plantation to plantation. Planters had to

adapt their cultivating practices to the natural terrain, yet similarities are found among tidal rice planters in clearing swampland, establishing rice fields, and growing rice.[12]

After planters observed which land had sloughs that drained water during the falling tide, they forced enslaved African Americans to build secure levees high enough to prevent water from rising over the embankment crest and also thick enough to withstand the powerful force applied to the earthen structure on a daily basis. Water seepage and consistency through the embankment were major problems for enslaved African Americans to confront. Earth dug near the river's edge served as the preliminary levee that separated future rice fields from the river; it also protected slaves against the high river flow. Each end of this dike had to be on high ground to prevent any water from making its way into the floodplain. A permanent embankment placed on top of the original had to be at least five feet high, to keep out spring freshets with a fifteen-foot base to withstand the tremendous pressure that tidal rivers naturally placed on the structure and to substitute for the natural floodplains that would absorb this energy. Planters had to build these embankments on firm ground, such as clay, for unstable sand would cause the dike to breach from the tidal pressure.[13]

Once this task was completed, slaves then had to clear out the intended area of rice fields. This process varied depending on the type of vegetation growing near the tidal river. Small vegetation, such as thin trees and bushes, was cut and placed into central piles. Larger trees were "lopped," leaving massive trunks lying in the future rice field. Once vegetation was cut and the soil dried from the lack of tidal flow, slaves set fire to the future fields from the "windward" side of the floodplains. This use of fire had two purposes: it efficiently removed all growth, and it created a layer of ash that would later serve as fertilizer for the first rice crop. Depending on the season, slaves had to endure stifling hot weather or cold, damp conditions. Some planters ordered slaves to construct embankments and clear tidal land beginning in July, yet not to set fires until January. Winter became the optimum time for slaves to clear fields, for they could easily burn dead vegetation and avoid insects and reptiles.

Larger tidal rice fields were subdivided into smaller plots to efficiently control water flow. By building levees on a grid system within the major tidal embankments, planters could direct water flow more precisely than in a larger field. Eventually planters connected smaller rice fields to a network of canals that drained specific quadrants into the river. The canals fed into large channels that removed water from these smaller sections and also established boundaries of rice fields from neighboring plantations.[14]

Tidal Rice Cycle

The overlapping rice cycle lasted twelve to fourteen months and began soon after the previous crop was harvested. Slaves hoed trenches and removed any unwanted growth, plus debris, beginning in the late fall and winter months. They also cleared out ditches that had alluvium buildup to ensure efficient drainage once flooding stages occurred. Fire was an important tool to clear any unwanted growth before planting began. Slaves also made repairs to dikes and trunks damaged by natural erosion, freshets, and burrowing animals or reptiles. The lack of flooding in the fields allowed more time for planters to focus on these repairs and better conditions for enslaved field hands to work.[15]

After slaves completed major dike repairs and dug rows, Carney argues, women performed cultivating techniques that earlier generations brought over from Western Africa. This gender division led women to carefully observe soil fertility, drainage conditions, and cultivation stages. In Africa, women are responsible for sowing seeds in trenches they previously hoed. Cultivators planted seeds either by hoe, covering the seed fully with the soil, or by "open planting," which required seeds to be covered in clay or cow dung and placed in open trenches to prevent floating.

Although the former stage was practiced more frequently in Lowcountry plantations, open trench planting protected the rice seed from birds, insects, and parasites; yet the procedure of wrapping seeds with soil or dung took more time and labor.[16]

Rice cultivation took place in the beginning of March, while the second half of the month was devoted to planting provisional crops on higher ground. Soon after slaves seeded the fields, the first flooding "sprout flow," as the name suggests, allowed the seeds to germinate. The first flooding of the rice fields signified the beginning of the growing season, which enabled cultivators to remove loose debris floating on the water surface. By using water as a tool, slaves brought African culture to Lowcountry rice plantations. Sprout flow also served as a support for tender rice stalks to grow. After four to fourteen days, depending on when the seeds "pipped" or started to rise, the fields were drained and slaves were assigned to keep ricebirds from feeding off the grain as they migrated through the Lowcountry in late April and May. The second flooding occurred after the rice plants reached one inch in height. This stage, known as the "point flow," also protected the crop from ricebirds, killed competing grasses, and replenished moisture to the alluvium soil. The river water covered these fields for three to seven days, depending on the strength of the rice stalks or until the plants were three to four inches high.

After draining the point flow, field workers used four hoeing periods, each separated by two weeks to eighteen days during the summer, to remove weeds and clean canals. This period lasted until the plants were six to eight inches high and the stagnant water destroyed the weeds. The second, and most involved, stage of flooding happened soon after this draining period. The "long" or "stretch" flow required the trunk tender's precision for managing the height of water, which began with flooding above the entire crop and then gradually lowering to show the tips of the rice plants. This stage also supplied more moisture to

plants, especially if a drought occurred during the season, and allowed weeds to completely die off. Enslaved people were, once again, assigned to remove any floating debris that would hinder rice growth when the water was let out. This period lasted ten to twenty days.[17]

Enslaved cultivators conducted a third hoeing after the "deep flow" took place. Fields were drained and left to dry until the plants "jointed," signaling time for an additional hoeing to remove weeds and aerate soil. This time period lasted two to three weeks, depending on the amount of rain and maturity of the rice plants. The fourth and final flood stage, "lay-by-flow," in late August and early September covered the plants once again. Tide waters were constantly raised for rice to come to a "head" as the growing crop penetrated the water surface. This period lasted until harvest in early September or into October.[18] The rice fields lined tidal riverbanks with such density that, according to one planter, "during the summer months, the Rice crops waved over fields of thousands of acres in extent, and upon a surface so level and unbroken, that in casting one's eye up and down the river, there was not for miles, an intervening object to obstruct the sight."[19]

Conclusion

Rice cultivation resulted in the first significant plantation development in Georgia. Productive cultivation led to massive coastal development and increasing demand for a supporting infrastructure. The successful rice economy also led to increasing demands for labor that fueled the transatlantic slave trade and African diaspora in Georgia. Rice plantations, in turn, provided an economic foundation in the Lowcountry. Savannah became a central trading destination, and the accumulation of capital helped induce the colony's economic expansion, which was seen in society, religion, and government. Rice fields became a landscape where people, influenced by the dramatic cultural, political, and economic currents occurring throughout

the Atlantic world, constructed distinctive identities that still exist today. Through the conduit of rice, European, African, Caribbean, and Native American customs played out in plantation labor, architecture, foodways, language, and religion.

NOTES

1. *DeBow's Review*, vol. 5 (New Orleans: DeBow's Review, 1854), 528; H. Roy Merrins, ed., *The Colonial South Carolina Scene: Contemporary Views, 1697–1774*, tricentennial ed., no. 7 (Columbia: University of South Carolina Press, 1977), 92; Francis Harper, ed., *The Travels of William Bartram: Naturalist's Edition* (Athens: University of Georgia Press, 1998), 196; "Observations on the Winter Flowing of Rice Lands, in Reply to Mr. Munnerlyn's Answers to Queries, &c. by a Rice Planter," *Southern Agriculturist, and Register of Rural Affairs* 12 (December 1, 1828): 531.

2. Hayden R. Smith, "Reserving Water: Environmental and Technological Relationships with Colonial South Carolina Inland Rice Plantations," in Francesca Bray, Peter A. Coclanis, Edda L. Fields-Black, and Dagmar Schafer, eds., *Rice: Global Networks and New Histories* (New York: Cambridge University Press, 2015), 191–200.

3. Alexander Hewatt, *A Historical Account of the Rise and Progress of the Colonies of South Carolina and Georgia* (London: Alexander Donaldson, 1779), 305; Judith A. Carney, "Landscapes of Technology Transfer: Rice Cultivation and African Continuities," *Technology & Culture* 37, no. 1 (January 1996): 16.

4. Judith A. Carney, *Black Rice: The African Origins of Rice Cultivation in the Americas* (Cambridge: Harvard University Press, 2001), 86; Daniel C. Littlefield, *Rice and Slaves: Ethnicity and the Slave Trade in Colonial South Carolina* (Baton Rouge: Louisiana State University Press, 1981), 89.

5. Smith, "Reserving Water," 199.

6. Catesby, quoted in Merrins, *Colonial South Carolina Scene*, 96.

7. Paul M. Presssly, *On the Rim of the Caribbean: Colonial Georgia and the British Atlantic World* (Athens: University of Georgia Press, 2013), 139.

8. Mart A. Stewart, *What Nature Suffers to Groe: Life, Labor, and Landscape on the Georgia Coast, 1680–1920* (Athens: University of Georgia Press, 1996), 99–104.

9. Catesby, quoted in Merrins, *Colonial South Carolina Scene*, 94.

10. William Gilmore Simms, *The Geography of South Carolina: Being a Companion to the History of the State* (Charleston: Babcock & Co., 1843), 80–81; William A. Mathew, ed., *Agriculture, Geology, and Society in Antebellum South Carolina* (Athens: University of Georgia Press, 1992), 416.

11. Stewart, *What Nature Suffers to Groe*, 98–99.

12. Stewart, 114.

13. Mart A. Stewart, "Rice, Water, and Power: Landscapes of Domination and Resistance in the Lowcountry, 1780–1880," *Environmental History Review* 15, no. 3 (Fall 1991): 50.

14. David Doar, *Rice and Rice Planting in the South Carolina Lowcountry* (Charleston, S.C.: Charleston Museum, 1936; reprint, 1970), 8–10.

15. Philip D. Morgan, *Slave Counterpoint: Black Culture in the Eighteenth-Century Chesapeake & Lowcountry* (Chapel Hill: University of North Carolina Press, 1998), 149; Doar, *Rice and Rice Planting*, 29.

16. Carney, *Black Rice*, 107–110.

17. Stewart, *What Nature Suffers to Groe*, 102–111.

18. Stewart, 102–111.

19. G. S. S., "Sketches of the South Santee," in Eugene L. Schwaab, ed., *Travels of the Old South: Selected from Periodicals of the Times*, vol 1. (Lexington: University Press of Kentucky, 1973), 4.

Hoppin' John, the Core of Lowcountry Foodways

Cultural-Agricultural Foodways Integration

JOHN MARTIN TAYLOR, Southern food historian, writer, artist, cooking instructor, and chef

Taylor analyzes the integration of cultural and agricultural foodways through the lens of historical influences culminating with the story of hoppin' John—perhaps the single most important Lowcountry dish. He integrates centuries of recipes featuring this iconic dish, ranging from the earliest cookbook authors in colonial America to traditions celebrated today. Field peas and rice have nourished societies from Africa to Asia for thousands of years. Highlighting influences from West Africa, Europe, and the Americas, Taylor brings to life the cultural practices of the growers, producers, and cooks who contributed to the evolution of what has become known as hoppin' John. 🌾

I have eaten creole cooking all my life. The first written recipe that I know of for hoppin' John, the "national" dish of the Lowcountry, appeared in *The Carolina Housewife* in 1847. Writing anonymously, as was the custom for Charleston women prior to the Nineteenth Amendment, Sarah Rutledge was the "Lady of Charleston" who penned this early American cookbook that established Lowcountry cooking as a creole cookery separate from the other cuisines emerging throughout the South. She was the daughter of Edward Rutledge, a signer of the Declaration of Independence, and niece of Arthur Middleton, another signer. Her version, calling for bacon, "red peas," and rice, is a Charleston "PER lŏ" as we say—a pilau or pilaf, a sort of bean and rice jambalaya. Miss Rutledge suggested adding, "*if liked*, a sprig of green mint" (italics mine).[1] The Lowcountry classic, served on New Year's Day for good luck, is a very

dry version of the dish, but it is served with greens (for financial success throughout the year) and their juices, as well as a side dish of more cowpeas and pot likker. Most folks today use black-eyed peas, which are one of many types of cowpeas.[2]

There have been many conjectures about the name "hoppin' John." My dear friend and colleague, the late, great culinary historian Karen Hess, was convinced, and attempted to prove through assiduous research, that the name comes from the old Persian *bahatta kachang*, meaning cooked rice and beans, from Hindi and Malay origins.[3] Her sources are historical, etymological, and sociological.[4] It makes sense, but I'm not convinced, though it's certainly more compelling than the folk etymologies surrounding the dish—-for example, that it was hawked on the streets of Charleston by a disabled man known as hoppin' John; that the name is a corruption of *pois à pigeon* (pigeon peas), another legume brought to the New World from Africa; or that children were required to hop around the table before the dish was served. Historians call these apocryphal tales "fakelore" because they are based on neither fact nor historical record; Karen added that "most of the proposed origins are demeaning to African-Americans."[5]

The dish certainly came from West Africa, whence came both cowpeas and the enslaved who were great growers and cookers of rice. Wherever rice is grown in the world, you find dishes of rice and legumes, whose synergy is legendary. The white men who owned the vast rice plantations in early Carolina, on which the fortunes of Charleston were built, probably knew little about rice prior to their arrival in the New World, where they found themselves the owners of not only land but humans as well. It is to the ancestors of today's African Americans that I raise my glass on New Year's, with our meal of hoppin' John, collards, sweet potatoes, and roast pork. For it is they, from the West African Rice Coast, who knew the systems of wetland rice cultivation, cleared the land, built the embankments, cultivated the floodplains, sowed the seeds, maintained the weeding,

harvested the crop, hoed the stubble, burned the remains, threshed the sheaves, winnowed with baskets of their own making, and milled with mortars and pestles of their own making, Finally, it was they who cooked the rice.[6] As I have written many times before, neither the French nor the English who owned the rice plantations in Carolina knew much of anything about rice cookery; I dare say they still don't.

Hess speculated in her seminal work, *The Carolina Rice Kitchen: The African Connection*, that there is a Provençal connection to the pilaus of Carolina. In Charleston you might hear "*pĭ LŌ*" or "*PER lō*" or "*per LOO*" or several other pronunciations of the word, but I always say "PER lō," no matter how it's spelled. Hess wrote, "Pilau is the most characteristic dish of the Carolina rice kitchen. . . . Word and dish come from Persia. . . . The classic pilau is not so much a receipt as a culinary concept." Twenty pages later, as she traces the pilau following Islam, through Turkey and Spain, to Paris as early as 1300, and to Provençal cookbooks of the nineteenth century, she hypothesized that "the pilau was brought to Carolina by Huguenots fleeing persecution." Hess asked me to read the manuscript twice before publication, and twice I protested. But she countered in the book, "It has been objected that most Huguenots in Carolina did not come from Provence, or even the Midi. Considering that some of the most important strongholds were in the Midi, particularly in the Cévennes, adjacent to Provence, it seems reasonable to suppose that there must at least have been a few. Nor does the objection take into account *the compelling presence of rice in South Carolina*." Her supposition that since the rest of the French and English settlers would have known nothing about rice cookery, but "even a single family from Provence could very nearly have introduced such a concept into the new rice lands," diminishes the strength of the major thesis of her work, which she calls the "skill of the African-American cooks who had long known rice cookery, almost surely including certain versions of pilau."[7]

Culinary history is fascinating, but these days I'm far more interested in both the "big picture" and the cultural aspects of food. Hoppin' John is, simply, a bean and rice pilau which has traveled from the Lowcountry plantations to wherever both Black and white southerners have settled. The dish may have originated in West Africa, but this delicious, nutritious favorite of the hapless Africans must have quickly moved from slave cabin to the "Big House," and on to the tables of merchants and freedmen, former Europeans, Jews, Christians, cooks, and eaters both rich and poor who left the Lowcountry and settled across America, taking a love of hoppin' John with them.

Before Ms. Rutledge provided us with a recipe, Caroline Howard Gilman wrote in her *Recollections of a Southern Matron* in 1838:

Lo! there stood before papa a pig on his four feet, with a lemon between his teeth, and a string of sausages round his neck. His grin was horrible.

Before me, though at the head of many delicacies provided by papa, was an immense field of hopping John; a good dish, to be sure, but no more presentable to strangers at the South than baked beans and pork in New-England. I had not self-possession to joke about the unsightly dish, nor courage to offer it. I glanced at papa.

"What is that mountain before you, my daughter?" said papa, looking comically over his pig.[8]

Caroline Howard was a proper Bostonian who married Samuel Gilman, a Harvard graduate who became the minister of the Archdale Unitarian Church in Charleston in 1819, a position he kept for nearly forty years. She was neither southern nor the mistress of the plantation she purported to be in her recollections. She published under her own name, which was unheard of for a woman in Carolina society (until the passage of the Nineteenth Amendment, a Charleston lady's name appeared in print only upon birth, marriage, and death). She *did* own house slaves, and most historians agree that her observations of daily life are poignant and relevant, however fictional. Her scene of hoppin'

John's appearance at the table (which she felt necessary to footnote and explain as "bacon and rice") is perhaps the *first* of many to follow in southern writing.[9]

In 1946, Carson McCullers wrote in *The Member of the Wedding*:

They stopped off for a few minutes to get on with the dinner. F. Jasmine sat with her elbows on the table and her bare heels hooked on the rungs of the chair. She and Bernice sat opposite each other, and John Henry faced the window. Now hopping John was F. Jasmine's very favorite food. She had always wanted them to wave a plate of rice and peas before her nose when she was in her coffin, to make sure there was no mistake, for if a breath of life was left in her, she would sit up and eat, but if she smelled the hopping-John and did not stir, then they could just nail down the coffin and be certain she was truly dead. Now Bernice had chosen for her death-test a piece of fried fresh-water trout, and for John Henry it was divinity fudge. But though Jasmine loved the hopping-John the very best, the others also liked it well enough, and all three of them enjoyed the dinner that day: the ham knuckle, the hopping-John, cornbread, hot baked sweet potatoes, and the buttermilk.[10]

The Member of the Wedding is fiction, but it is said to be the most autobiographical of McCullers's works and the character Frankie, who is the F. Jasmine of the cited passage, is *the one* of all of her many "who seemed to her family and friends most like the author herself," according to the author's sister, Margarita Smith.[11] Set in a small southern town in the 1940s, the book is a brilliant window into adolescence, but it truly illuminates the culture as well. Just before hoppin' John makes its appearance, we read:

"Don't call me Frankie!" she said. "I don't wish to have to remind you any more."

It was the time of the early afternoon when in the old days a sweet band would be playing. Now with the radio turned off, the kitchen was solemn and silent and there were sounds from far away. A colored voice called from the sidewalk, calling the names of vegetables in a dark, slurred

tone, a long, unwinding hollering in which there were no words. Somewhere, near in the neighborhood, there was the sound of a hammer, and each stroke left a round echo.[12]

McCullers could simultaneously draw broad strokes and pinpoints of light. Hoppin' John was part of her world.

It was also part of Tennessee Williams's. Southern food and drink are often major characters in his plays, and in *Cat on a Hot Tin Roof*, Big Mama knows how to satisfy Big Daddy:

BIG MAMA: Did you all notice the food he ate at that table? Did you all notice the supper he put away? Why, he ate like a hawss! . . . Why, that man—ate a huge piece of cawn-bread with molasses on it! Helped himself twice to hoppin' John.

MARGARET: Big Daddy loves hoppin' john.—We had a real country dinner.

BIG MAMA: Yais, he simply adores it! An' candied yams? That man put away enough food at that table to stuff a field-hand!

GOOPER: I hope he don't have to pay for it later on . . .

BIG MAMA: . . . Why should Big Daddy suffer for satisfying a normal appetite?[13]

Much has been written about the Lowcountry rice plantation and the knowledge system that came with the enslaved from West Africa.[14] Until my gentleman planter friend Dick Schulze reintroduced Carolina Gold to the Lowcountry in the 1980s, there had been virtually no rice grown in the area in sixty years.[15] The Civil War had taken away the slave labor; the grain had been introduced into Arkansas, Louisiana, and Texas, where the new machinery, which was too heavy for the soft Lowcountry soil, made competition impossible for the Lowcountry rice planters, whose aging plantations were battered by a series of storms, freshets, and silting caused by upriver cotton farming.[16]

Interestingly, though, people still ate rice at nearly every meal. And many sandlappers, as residents of the Lowcountry are apt to call themselves, continue to do so. When Fritz Hollings was elected governor of South Carolina in 1958, he learned that its largely rural population was suffering from malnutrition, even though they were eating the same foods they had eaten since the end of the Civil War. He funded a study of the diets of the malnourished and found that all of the rice being eaten in the state was also imported. Stripped of its nutrients in the milling process, it was filling bellies but not sustaining life. He rushed a bill through the state legislature requiring that all rice sold in the state be fortified with the vitamins and minerals stripped off in the milling process; further, directions must instruct the cook *not* to wash the rice before cooking, which would rinse away those restored nutrients. The law is still on the books.[17]

I grew up eating hoppin' John in the land of cowpeas—those "red peas" Sarah Rutledge called for in that earliest of written recipes for the dish. Many food writers seem to think that boiled peanuts and grits are the defining foods of the South, but I sell stone-ground, whole-grain, heirloom corn grits to folks in every state, and many of my customers are chefs in restaurants. Very few of them are, in fact, southerners. And the Lee Bros. have popularized boiled peanuts in New York City, though I do think that the popularity of edamame (the boiled green soybeans of sushi bars, similar in texture and flavor) has also helped boiled peanuts' visibility. Everyone has heard of black-eyed peas, perhaps the best known of the cowpeas, but no one would call them "red." There are dozens of varieties of cowpeas, including an heirloom *California* black-eyed. But few Americans outside the Deep South grow or eat the myriad other varieties of *Vigna unguiculata*. The nomenclature, both scientific and common, can be maddening. Even the botanists can't agree on the pronunciations, and subspecies continue to be isolated. All peas and beans, including *Vigna* (cowpeas), *Pisum* (green peas), *Glycine* (soybeans), *Cajanus* (pigeon peas), and *Phaseolus* (common beans such as lima beans, black beans, navy beans, and green beans), belong

to the legume family, *Fabaceae*, which means fava-like. In other words, they resemble Old World beans. There are both subtle and dramatic culinary differences among the peas and beans. New Orleans red beans and rice, for example, does not taste like hoppin' John, but unripe cowpeas in the pod can be eaten like unripe common green beans. At the turn of the last century, *Sturtevant's Edible Plants of the World* classified cowpeas with pigeon peas, but today cowpeas are recognized as a separate genus.[18] They are neither peas (as in green peas) nor beans (as in green beans or favas), but you may hear them called both. If you hear southerners talking about shelling peas, they mean cowpeas, which are also known as crowders, field peas, and, tellingly, southern peas. Crowders are so called, some say, because the beans are crammed together in the pod, squaring off the shoulders of the peas, but William Woys Weaver, the food historian and master gardener, has written that as poor whites began to eat them in the eighteenth century, they began to call "them crowder peas, from the Scotch-Irish word crowdy, a porridge."[19] Tom Fitzmorris, New Orleans's venerable restaurant sleuth, says the name comes from the practice of planting them in cotton fields "where they would crowd (and fertilize) the rows."[20]

Yet another shelling bean of the South is the butter bean, or sieva bean. But those lima types are, well, an entirely different bag of beans, as are yard-long beans, which resemble green beans, but which are a subspecies of *Vigna unguiculata*, which may have originated in Africa, but have been in Asia for thousands of years, and are not directly related to the New World beans.[21] Because of the confusion, I urge food writers to use scientific nomenclature, and not worry about how it's pronounced.

Cowpeas are as varied as grapes or apples, and southerners tend to crave the type that was grown in their neck of the woods. I'm partial to cream peas and some of the lesser-known black-eyed types, such as whip-poor-wills, but, in truth, I love them all.

Thomas Jefferson wrote in 1798 that the cowpea "is very productive, excellent food for man and beast." He praised the plants' ability to improve the "tilth and fertility" of the soil, and he sowed them in the South Orchard at Monticello between 1806 and 1810.[22] Perhaps the cowpea's reputation as both fodder and soil enhancer has kept it off tables, because the season is *not* too long for many American climates. Indeed, Weaver grows several varieties in his awe-inspiring garden in Devon, Pennsylvania. Mine matured as quickly as my tomatoes and squash, and before my corn and melons, in my Washington, D.C., community garden. And that's how it should be. Native Americans knew all about the companion planting that we are *all* learning about now that gardening has become one of the country's most popular pastimes. "The Three Sisters" are the trinity of corn, beans, and squash planted together. The corn provides a pole for the beans to climb; the beans restore the nitrogen that corn demands back into the soil; the squash rambles on the ground, providing shade to lock in moisture and to block out the sun's rays on which weeds thrive. Further, the prickly stems of the squash plants deter insects.[23]

Jesus quoted the Torah when he said that man does not live by bread alone, imploring his flock to cultivate spiritual health as well. I choose to believe that the ancient texts were based on far more practical homilies—that is, grains do not provide us with all we need to live. Neither wheat nor corn nor rice can sustain life. They lack certain amino acids to form complete proteins. When grains are combined with pulses, however, complete proteins become accessible to humans. The enslaved West Africans who arrived in Carolina had for centuries grown cowpeas and pigeon peas to complement their rice, as well as root vegetables, greens, and other grains such as millet and sorghum, most of which quickly became established in the New World or were replaced with similar plants. Many of the enslaved were also excellent herdsmen and understood free-ranging cattle long before and much better than their European masters. As Judith Carney explained in *Black Rice*, in the vast wetlands of the Inland Niger Delta, following rice

harvests, cattle entered the fields to graze on the stubble, "their manure fertilizing the soil. This seasonal rotation between rice cultivation and pastoralism embraces a clever land-use strategy that satisfies both cereal and protein . . . needs while improving crop yields through the addition of animal manure. Rice farmers [farther] south . . . in the absence of cattle . . . rely upon other techniques to maintain soil fertility, such as rotating fields with nitrogen-fixing legumes and intercropping plants that add crucial nutrients to the soil."[24] In *In the Shadow of Slavery: Africa's Botanical Legacy in the Atlantic World* (2009), Dr. Carney and Richard Rosomoff pointed out that "the practice of leaving cattle to graze on the plants' [leavings] . . . is likely responsible for the plant's alternative names in English (cowpea), Portuguese (*ervilha de vaca*) and Spanish (*chícaro de vaca*)."[25]

It's too bad that succeeding generations of southerners didn't pay more attention to the successful and sophisticated Native American and African farming techniques. Monoculture, as we know, has continued to destroy even the smallest farms of the South, which have gone from one ill-fated crop such as cotton to another, such as the Christmas trees that replaced heirloom corn and bean patches throughout Appalachia and now are dying from root rot and acid rain.[26] Single varieties of newly developed legumes may have increased yields and specific disease resistance, but they are vulnerable to other pathogens.

In the Lowcountry, the taste has never died for the cowpeas and rice and sorghum and greens and sesame seeds that came to Carolina with the slave trade from West Africa early on, though most of the original varieties were long ago abandoned. By 1708, there was a Black majority in South Carolina. When I was growing up, some say, there were three hundred varieties of cowpeas being grown on traditional, small truck farms throughout the Lowcountry. In the forty years that followed, however, most had all but disappeared until the interest in heirloom plants took off a few years ago. Now, through the efforts of dedicated farmers; seed savers; universities; nonprofit organizations such as Monticello, the Carolina Gold Rice Foundation, and Southern Exposure Seed Exchange; and scholars such as Will Weaver and Steven Facciola, I can type the name of many heirloom cowpea varieties into my browser and probably find someone with seeds to sell.[27]

In Washington, I've grown Mississippi Silvers, razorbacks, purple hulls, and clay cowpeas—a rare old favorite of Confederate soldiers who both added them to their rations and planted them alongside battlefield stations.[28] One of the great beauties of growing them is that you can eat them fresh (I simply boil a piece of smoked ham hock or neck bones in water until it's seasoned, then add the peas and cook on a low boil for about half an hour) or save the dried beans for winter use, though let me advise you to freeze them first to kill any critters. There's nothing more disheartening than opening your precious stash of whip-poor-wills on New Year's Day to find them riddled with bugs. Sometimes I can harvest both green and dried cowpeas on the same day from the same plants. Cowpeas will grow right up to frost, then you simply leave the plants in the ground to provide nutrients for next year's corn.

Cowpeas are favored all over the world now. And wherever you find them, you are likely to also find rice. And wherever you find rice, you're likely to find some form of rice and beans. In a Facebook exchange, I followed the discussion of several well-known southern cookbook authors about what they thought was southern and what wasn't. "I draw the line at Saigon hoppin' John," wrote one. "I don't care how many Vietnamese live down south now." I couldn't resist butting in and telling her that we've known for several years that cowpeas got to Asia several thousand years before they got to America.[29] In Vietnam, rice and black-eyed peas are cooked just like hoppin' John, though the street vendors who sell it often have a stalk of lemongrass garnishing it in lieu of Miss Rutledge's mint.[30]

It's no wonder that the black-eyed type became the defining cowpea of the dish as it spread across the country in

what I call the southern diaspora. Mature at sixty-five to seventy days, it doesn't require the eighty-five to ninety or more days that many of the other, more delicate lady peas, cream peas, and white acres do. The common names are as confusing as the scientific nomenclature, and, as with barbecue and jambalaya, the way you like your hoppin' John probably has more to do with where you grew up than with actual taste. Hoppin' John has managed to keep its name, but even the same varieties of cowpeas seem to change names as you cross county lines. You can grow them anywhere you have full sun and warm, well-drained soil. Their ability to grow in poor soil is legendary, but they remain a mostly southern vegetable. Like many African plants, they are extremely versatile, though few people today use these old foodways: the green seeds can be roasted like peanuts, the leaves may be used as a potherb, and, in hard times, you can dark roast the seeds as a coffee substitute.[31]

Weaver claims that their "close association with African Americans and the New England perception of the peas as a fodder crop for slaves" kept them out of not only nonsouthern gardens but also books. But not out of the literature, so to speak, for Thomas Jefferson described raising a black-eyed pea he referred to as French, though many varieties are now thought to have come to America via the Caribbean or Brazil rather than directly from Africa. That would certainly make sense in Carolina, which was granted to some Barbadian planters who restored Charles II to the throne. Nevertheless, Weaver writes, "cowpeas are not generally considered among the vegetables fit for the kitchen garden. . . . Because cowpeas require considerable space, they have always been treated as field crops. On the other hand, they are no more troublesome in this respect than sweet potatoes, and the bush varieties can be raised like bush beans. If there is a drawback, it is only that cowpeas cannot be grown in much of the country due to their need for a long, warm growing season. For this reason their culture is most closely associated with the South."[32]

In 1879, Marion Cabell Tyree edited the remarkable

Housekeeping in Old Virginia: Containing Contributions from Two Hundred and Fifty of Virginia's Noted Housewives, Distinguished for Their Skill in the Culinary Art and Other Branches of Domestic Economy. In it there appears, attributed to Mozis Addums, a "Resipee for Cukin Kon-Feel Pees," complete with condescending eye dialect, which is the spelling device used by writers to disparage a speaking character's nonstandard pronunciation and grammar.[33] Such spellings can be effective in fiction, but they mostly serve to make the writer appear superior by making the speaker seem uncouth and illiterate.[34] There was no Moses Adams. It was one of several pseudonyms for the blowhard racist George William Bagby, author of *The Old Virginia Gentleman*, in which I read the most disturbingly bigoted diatribes I've ever encountered in culinary literature. Field peas were so dear to Bagby's heart, however, that he argued that Virginians were the greatest people on earth simply because they lived where "cornfield peas" grew. In spite of his hysterical, racist ranting, Bagby does demonstrate one truism: in the South, the white man came to love the Black man's food.[35]

Two more recipes appear in Tyree's book. One, for "Cornfield or Black Eye Peas," submitted by a Mrs. S. T. (who happens to be Tyree herself), reads, "Shell early in the morning, throw into water till an hour before dinner, then put into boiling water, covering close while cooking. Add a little salt, just before taking from the fire. Drain and serve with a large spoonful fresh butter, or put in a pan with a slice of fat meat, and simmer a few minutes. Dried peas must be soaked overnight, and cooked twice as long as fresh."[36]

Mrs. Tyree's advice to salt only just before serving shows what Black South Carolinians would call "an old hand," referring to the wisdom of experience that makes good cooks.[37] Salt toughens peas and beans, so it's prudent to avoid salting them while they cook.

Mary Randolph's *The Virginia House-Wife* of 1824 had long before waxed poetic about field peas: "There are many varieties of these peas," she wrote, "the smaller kind are the

most delicate.—Have them young and newly gathered, shell and boil them tender, pour them in a colander to drain; put some lard in a frying-pan, when it boils, mash the peas and fry them in a cake of a light brown; put it in the dish with the crust uppermost, garnish with thin bits of fried bacon."[38] So much for California chef Jeremiah Tower's laughable claim to have invented the bean cake in the 1980s![39]

Many cookbook authors would add their own tips through the years. Lettice Bryan advised in *The Kentucky Housewife* in 1839 to harvest the peas "when full grown, and the pods just beginning to turn yellow; then they have their full flavor, and are perfectly tender, and may be shelled without difficulty."[40]

But in just as many southern cookbooks, recipes for vegetables and fish are conspicuous in their absence. I am convinced that the cooks assumed that you would know the most important thing about both: don't overcook them. Prior to the twentieth century, when rice *is* mentioned, it's mostly in Carolina and Georgia cookbooks, or the recipes clearly have a Carolina provenance.

I like to think that Miss Rutledge, like many Charlestonians after her, published her version of hoppin' John as an attempt to get the old slave recipes down on paper before those days were over. Surely hoppin' John had long been a favorite on the master's table by the time her recipe appeared. We culinary historians generally agree that written recipes lag many years behind common usage.[41] Rutledge and the Virginian Randolph were both from aristocratic families. When Randolph wrote about rice, she was writing about Carolina rice cookery. But she didn't mention hoppin' John, and it's rarely mentioned outside the rice-growing Lowcountry until much later.

Immediately after the Civil War, *Mrs. Hill's Southern Practical Cookery and Receipt Book* appeared in Atlanta. Fish and vegetables are finally given their due. For asparagus, she warns: "Take them up as soon as done; too much cooking injures the color and flavor." "Vegetables intended for dinner," she writes, "should be gathered early in the morning. A few only can be kept twelve hours without detriment. . . . They lose their good appearance and flavor if cooked too long." Her devilled crabs are made with "fresh olive oil"; frogs' legs are broiled or fried, "their meat is beautifully white; the taste delicious."[42]

She also included her version of "Hopping John: Pick out the defective ones from a quart of dried peas; soak them several hours in tepid water; boil them with a chicken or piece of pickled pork until the peas are thoroughly done. In a separate stew-pan boil half as much rice dry; take the peas from the meat, mix them with the rice, fry a few minutes until dry. Season with salt and pepper."[43]

After the Civil War, however, much of the South was emasculated and poor. Many formerly wealthy landowners struggled on small plots of land, just like the African Americans. Coincidentally, industrialization and the modern railway system brought cheap canned and dried foods to areas where everyone had once eaten fresh, local produce. It was mostly *after* the war that simpler foods began to be embraced by the former gentry, when overcooked canned vegetables became the norm, when the South came to be defined as hog meat and hoecake.

In summary, this is what we know: field peas and rice came to Carolina from West Africa, along with Africans who knew how to cook both, and together. The dish spread throughout the South. Favored varieties of the peas were saved. New varieties appeared through selective breeding. Dishes of rice and beans are served throughout rice-growing lands as a sort of good-luck dish, associated with the harvest of both grain and pulse. In the antebellum Lowcountry rice fields, the new year marked the ancient celebration of days becoming longer and the one time when field hands could take a break from the backbreaking work of rice cultivation.[44] As descendants of those enslaved moved inland, and southerners, both Black and white, spread throughout the land, the dish, and custom, traveled with them. If ever there were a single defining dish

of the Lowcountry, it is hoppin' John, which has come to characterize the southern table as well.

NOTES

A version of this chapter has appeared in *Gastronomica* and on the author's blog, *HoppinJohns.net*.

1. [Sarah Rutledge], *The Carolina Housewife, or House and Home: By A Lady of Charleston* (Charleston, 1847), in facsimile, with introduction by Anna Wells Rutledge (Columbia: University of South Carolina Press, 1979), 83.

2. Stephen Facciola, *Cornucopia II: A Source Book of Edible Plants* (Vista, Calif.: Kampong Publications, 1998), 113, 350–351.

3. John Martin Taylor, "Karen and Me," *Gastronomica* 7, no. 4 (Fall 2007).

4. Karen Hess, *The Carolina Rice Kitchen: The African Connection; Featuring in Facsimile: Carolina Rice Cook Book* (Columbia: University of South Carolina Press, 1992), 97–100.

5. Hess, 98.

6. See Hess. Also Judith A. Carney, *Black Rice: The African Origins of Rice Cultivation in the Americas* (Cambridge, Mass.: Harvard University Press, 2001).

7. Hess, *Carolina Rice Kitchen*, 36–64.

8. Caroline Howard Gilman, *Recollections of a Southern Matron* (New York: Harper & Brothers, 1838), 142.

9. David Haberly, "Caroline Howard Gilman," Dictionary of Unitarian and Universalist Biography, March 11, 2002, http://www25.uua.org/uuhs/duub/articles/carolinegilman.html.

10. Carson McCullers, *The Member of the Wedding* (1946; reprint, New York: Houghton Mifflin Company, 2004), 81.

11. "The Member of the Wedding by Carson McCullers—Discussion Questions," Scribd, https://www.scribd.com/document/240279917/The-Member-of-the-Wedding-by-Carson-McCullers-Discussion-Questions#.

12. McCullers, *Member of the Wedding*, 77.

13. Tennessee Williams, *Cat on a Hot Tin Roof* (New York: New Directions, 1975), 136–137.

14. See, especially, Carney, *Black Rice*.

15. John Martin Taylor, "Carolina Gold: A Rare Harvest," *New York Times*, December 28, 1988. See also Richard Schulze, *Carolina Gold Rice: The Ebb and Flow History of a Lowcountry Cash Crop* (Charleston: History Press, 2005).

16. John Martin Taylor, *Hoppin' John's Lowcountry Cooking: Recipes and Ruminations from Charleston and the Carolina Coastal Plain* (New York: Bantam Books, 1992), 13.

17. John Martin Taylor, "Lowcountry Gold Rush," *Oxford American* 49 (Spring 2005).

18. U. P. Hedrick, ed., *Sturtevant's Edible Plants of the World* (New York: Dover Publications, 1972), 597. One of the best of the modern horticultural dictionaries is *Hortus Third* by the staff of the L. H. Bailey Hortorium at Cornell University (New York: Macmillan General Reference, 1976).

19. See, for example, Elizabeth Schneider, *Vegetables from Amaranth to Zucchini: The Essential Reference* (New York: William Morrow, 2001), 62; William Woys Weaver, *Heirloom Vegetable Gardening: A Master Gardener's Guide to Planting, Growing, Seed Saving, and Cultural History* (New York: Henry Holt and Company, 1997), 151.

20. New Orleans Menu, http://www.nomenu.com/subscriber/MD051210.html.

21. Schneider, *Vegetables from Amaranth to Zucchini*, 718.

22. Quoted in *Thomas Jefferson's Garden Book*, ed Edwin Morris Betts (Charlottesville, Va.: Thomas Jefferson Memorial Foundation, 1999), 262.

23. Native American companion planting methods are well documented. For practical instructions, see Sally Jean Cunningham, *Great Garden Companions* (Emmaus, Pa.: Rodale Press, 1998).

24. Carney, *Black Rice*, 47.

25. Judith A. Carney and Richard Nicholas Rosomoff, *In the Shadow of Slavery: Africa's Botanical Legacy in the Atlantic World* (Berkeley: University of California Press, 2009), 149.

26. From conversations with Cecilia Holland, my miller, who lives near Blairsville, Georgia, 2003–2005. Also see various articles at Appalachian Voices, www.appalachianvoices.org, e.g., April 2001. Also see "White Pine Root Disease Caused by *Verticicladiella procera*," Bugwood Wiki, http://www.forestpests.org/southern/whitepineroot.html.

27. Dr. Merle Shepard at the Clemson Coastal Research and Education Center near Charleston is a font of information about the heirloom plants of the Lowcountry. He is a board member of the Carolina Gold Rice Foundation, whose mission is "advancing the sustainable restoration and preservation of Carolina Gold Rice and other grains; raising awareness of the importance of historic ricelands and heirloom agriculture; encouraging, supporting, and promoting education and research activities focused on heirloom grains, and serving as a resource for the authentic documentation of heirloom grain culture and heritage." See Carolina Gold Rice Foundation, http://www.thecarolinagoldricefoundation.org; "Thomas Jefferson Center for Historic Plants," Jefferson Monticello, http://www.monticello

.org/chp/index.html; Southern Exposure Seed Exchange, http://www
.southernexposure.com/index.html; Weaver, *Heirloom Vegetable
Gardening*; and Facciola, *Cornucopia II*.

28. See Melody Rose, "Cowpeas Please! The History and Importance
of the Cowpea Plant," Dave's Garden, December 31, 2010, http://
davesgarden.com/guides/articles/view/86/.

29. Carney and Rosomoff, *In the Shadow of Slavery*, 33.

30. Hess, *Carolina Rice Kitchen*, xv, and in conversation and
correspondence, with accompanying photograph taken of the dish in
Saigon, 1990.

31. See Carney, *In the Shadow*, 149; Facciola, *Cornucopia II*, 113.

32. Weaver, *Heirloom Vegetable Gardening*, 150–151.

33. Marion Cabell Tyree, ed., *Housekeeping in Old Virginia:
Containing Contributions from Two Hundred and Fifty of Virginia's
Noted Housewives, Distinguished for Their Skill in the Culinary Art and
Other Branches of Domestic Economy* (Louisville, Ky.: John P. Morton
and Company, 1879), 253–254.

34. Wikipedia has an excellent entry on eye dialect at http://
en.wikipedia.org/wiki/Eye_dialect.

35. George William Bagby, "The Old Virginia Gentleman," a lecture
quoted in *The Old Virginia Gentleman and Other Sketches*, ed. Thomas
Nelson Page (New York: Charles Scribner's Sons, 1910).

36. Tyree, *Housekeeping in Old Virginia*, 254.

37. Many old expressions such as this one are common in Charleston
and the surrounding Lowcountry. They are often based on Gullah, the
creole language of descendants of enslaved Africans in the area, or on
the original West African idioms.

38. Mary Randolph, *The Virginia House-Wife: A Facsimile of the First
Edition, 1824, Along with Additional Material from the Editions of 1825
and 1828, Thus Presenting a Complete Text, with Historical Notes and
Commentaries by Karen Hess* (Columbia: University of South Carolina
Press, 1984), 135–136.

39. Jeremiah Tower, *New American Classics* (New York: Harper &
Row, 1987).

40. Lettice Bryan, *The Kentucky Housewife* (Columbia: University of
South Carolina Press, 1991), 211–212.

41. See Hess in Randolph, *Virginia House-Wife*, xv.

42. Annabella P. Hill, *Mrs. Hill's Southern Practical Cookery and
Receipt Book: A Facsimile with a Biographical Sketch and History Notes
by Damon L. Fowler* (Columbia: University of South Carolina Press,
1995), 179.

43. Hill, *Mrs. Hill's Southern Practical Cookery*, 196.

44. See, in particular, Charles Joyner, *Down By the Riverside: A South
Carolina Slave Community* (Urbana: University of Illinois Press, 1984),
101–102.

Protein from Marsh Mud

Oysters, Shrimp, and Crab

DIONNE HOSKINS-BROWN, NOAA fisheries biologist and professor of marine and environmental sciences, Savannah State University

Raw, roasted, or featured as the principal ingredient in a one-pot meal, oysters, shrimp, crab, and finfish harvested from Lowcountry tidal creeks have been prized continuously from the earliest humans on the coast to our menus today. Remarkably, these highly valued sources of protein subsist for part or all of their lives by consuming decomposing debris and tiny invertebrates in the brackish waters of the tidal creeks. Almost all the foods we consider characteristic of southern cooking were transported to the region along with a series of human migrants from other parts of the world. Oysters, shrimp, crab, and finfish are among the few ingredients that are truly native to the region.

Hoskins-Brown explains the ecology of tidal creeks and nearshore waters of the Lowcountry through the history of harvesting shellfish. For thousands of years, shellfish were an important source of protein for Native Americans in the Lowcountry. We see evidence of this culinary mainstay in the shell middens that remain along the saltwater edge of marsh and barrier islands. Africans and African Americans, before and after the Civil War, relied on shellfish to supplement their diets and income. These entrepreneurial watermen and women applied traditional African net-weaving and fishing skills to establish long-standing businesses, all the while linking Old and New World customs and cultural habits. 🏃

Every day, the movement of the tide resumes a communication with the marsh that began just a few hours before. Mudflats slowly slide under tea-tan water, and coastal creeks appear to swell their banks. They look deceptively smooth and stable, but creek banks and mudflats can reveal long swaths of marsh mud when the tides recede. Marsh mud, also called pluff (or plough) mud, is a dark pudding of silts and clays that accumulate as the diurnal tides bring nutrients into Georgia's salt marshes. It traps marsh pedestrians and releases the pungent smell of sulfur when disturbed. As far as there is tidal influence, the flow of water brings dissolved nutrients from nearshore waters into the estuary and feeds marsh plants such as the smooth cordgrass *Sporobolus alterniflorus* (formerly *Spartina alterniflora*). Ever dominant because of its high tolerance of high salinities, *Sporobolus* thrives under the long growing season we enjoy on our coast. Incoming tides bring dissolved nutrients that feed its roots. Decaying material from senescing marsh plants moves through the marsh vertically with each tide, falling to the sediment surface where bacteria and fungi colonize each fragment and break it down into smaller particles of detritus.[1] Larger particulates degrade into smaller ones and become colonized by microbes—then they move horizontally through the marsh landscape. Ebbing tides move particulate organic material out, feeding multiple levels of estuarine invertebrates and finfish that also move in and out with the tide.[2] The conversion of marsh grass to this decomposing material, detritus, contributes to the export of organic material from the salt marsh.

It is the movement of organic matter throughout the estuary that makes it the perfect nursery grounds for shellfish. Richly colonized particles coated with microbes are sifted out of the overlying water by the mucus-lined gills of filter-feeding oysters. The coincidental ingestion of microscopic planktonic algae makes food gathering just that much more rewarding. This process of consuming whatever gets entrained in the gills makes oysters a risky delicacy if collected from the wrong location—they are whatever they filter, and that could include *Escherichia coli* (*E. coli* are bacteria that can contaminate our food products) or petroleum-laden particles.

Not bound by a sedentary lifestyle, shrimp and crabs expertly take advantage of the marsh boundaries by season. After successful reproduction offshore, juvenile shrimp move into the estuary on the flood tides and take shelter in the upper areas of the creeks. There they feed on detritus and small invertebrates. As they grow into subadults, they migrate to deeper parts of the estuary. They become omnivorous and use all the marsh provides: polychaete worms, bits of plant material, algae, snails, and more. As adults, they make their way to ocean waters where spawning occurs and resets the cycle.

Blue crabs follow a similar cycle. Sexually mature females move out of the estuary to more saline waters, and reluctant adult males move only when they find estuarine areas too cold. The juvenile crabs move in on the tides just like the shrimp, using the marshes for refuge and food. Anyone who has ever prepared a Lowcountry boil knows the blue crab to be a fearless predator that will clamp down on anything that it perceives as a threat. Or as a meal.

Early Provisioning from the Marsh (prehistory to late 1800s)

NATIVE AMERICANS

Evidence of oyster harvesting, as well as of other types of finfish and shellfish from Georgia tidal creeks, can be observed early in the historical record. The presence and contents of shell middens on Georgia's barrier islands point to the importance of oysters in the Native American diet. Oysters are more abundant in shell sites than the other invertebrates consumed (crustaceans and mollusks). Zooarchaeological records documenting the use of animals in the mid-Holocene (ca. 3000 BCE) show that Native Americans hunted and fished the wetlands of St. Catherine's Island.[3] They

used complex instruments such as seines and weirs, sometimes working in groups.[4] During the Early Archaic Period (8000–6000 BCE), fish and shellfish were among the food items that drove movement of small groups of foragers. Some camps were used for just one season, while others—namely, shell fishing camps—were used for multiple seasons.[5] One such occupied fishing camp was located on the north end of Little Saint Simon's Island.[6] Lidar revealed at least nine shell middens on Pumpkin Island, just west of Sapelo Island, which has its own well-studied shell ring.[7] Hard clams and oysters were excavated from sites on Pumpkin Island, and isotopic analysis indicated that shell fishing occurred throughout all seasons. Carbon isotope data (which identify the type and quantity of carbon) support that the Guale were collecting shellfish across a range of salinities and that they traveled as far as twenty-one kilometers to exploit favorable shellfish grounds.[8]

Early observations of Native American towns in the eighteenth century report many were located on the banks of rivers where land was fertile and could support agriculture.[9] The Cherokee, Creek, and Chickasaw lived along the Savannah River and were trading deerskins with English merchants from Charleston by 1690, prior to Georgia's establishment as a colony.[10]

COLONISTS

Historians of early Georgia credit Native Americans with introducing the British colonists to oysters and clams.[11] By no coincidence did General James Oglethorpe choose Yamacraw Bluff, a high midden in the western portion of the modern city of Savannah, as the site for "New Georgia."[12] After he landed in Charleston, S.C., on January 13, 1733, he moved south until reaching a location along the Savannah River occupied by Yamacraw Indians on February 12. The location was eighteen miles from the mouth of the river and was no doubt attractive because of the large midden that bordered the enclave of roughly two

hundred. While the general and the other emigrants immediately began clearing timber, building shelter, and preparing land for crops, they were assisted by the Yamacraw chief Tomochichi. Most emblematic of the diplomacy that could be offered by native peoples, Tomochichi was an indispensable ally for General Oglethorpe and the colonists. The Yamacraw helped provide stabilizing food sources to the colony, introducing them to shellfish in addition to the abundant hunting game they found: turkeys, geese, and other fowl.[13] Fishing was also productive because coastal streams were filled with shad, flounder, and trout.[14]

When Henry Parker purchased five hundred acres from Noble Jones in 1735, he was moving away from a home at the corner of Bryan and Drayton Streets in Savannah to live on a verdant tract of maritime forests and marshlands now known as Isle of Hope. There Parker and his family built a home that overlooked the river to the south and saw waters full of fish, shrimp aplenty, and mucky banks carpeted with oysters.[15]

Feeling the American colonies moving adrift of the goals of the Crown, British forces turned their attention to the south when northern campaigns to regain control failed. The ports of Savannah and Charleston were targets for acquisition, yet even this part of the history of the colony carries the common thread of the salt marsh in providing valuable protein. In 1779, when British troops defeated rebel forces led by Major Joseph Lane at Fort Morris in Sunbury, the victory brought General Augustine Prevost to the command of all British forces at Savannah, a post he assumed after his unit made a difficult march through South Georgia from East Florida. With no horses or provisions, the British trod through the marshes and barely subsisted on oysters.[16]

THE PLANTER CLASS AND THE ENSLAVED

The planter class adopted seafood as a primary protein, and oysters made regular appearances on the tables of the affluent. A traveler moving through the area just before the

Civil War noted "that oyster boats and fishing craft along the Savannah River were filled with a diversity of items" and that "the inhabitants of Savannah, rich or poor, free or slave, consumed large quantities of oysters. For breakfast, for dinner, and for supper, oysters, in one form or another or short to be supplied to all above the poorest classes of the population; and here there are few who can be called as absolutely poor as their compeers in Europe. The result is, according to the calculation of a notable and inhabitant that Savannah consumes in a year of sufficient quantity of oysters to leave shells enough for the construction of one mile of road."[17]

The enslaved, whose rations were mandated by a Savannah ordinance, supplemented their diets with fishing in the same manner that other coastal communities did, mainly because meat was not provided in abundance by most owners.[18] This practice developed with the permission of their owners because it relieved them of part of their obligation. As much as one-half of the meat consumed by slaves may have come from foraging, including fishing. Consequently, "slave economies" developed as early as 1755, when Savannah's City Public Market opened and bonds people were allowed to sell fish, oysters, shrimp, and "everything else that comes out of the water," providing they had a ticket from their owner.[19] Entrepreneurial fishing, hunting, and farming were common and centered around goods that the slaves could produce on their own time after work quotas were satisfied. Market-based enterprises run wholly by enslaved Africans grew and had regular clientele.

Descendants of enslaved Africans on the Georgia coast (formerly known as Geechee) and the South Carolina coast (formerly known as Gullah) literally were isolated, since some barrier islands did not have bridges connecting them to the mainland. Some still do not. "Gullah Geechee" is a combined term that is now being used to refer to the heritage and customs of modern African Americans whose cultural emergence occurred when their ancestors sought ways to communicate across diverse ethnic groups in intense isolation.[20] The Gullah Geechee were brought to the Lowcountry from the "Rice Coast" and "Grain Coast" of West Africa because of their ability to cultivate rice.[21] With them they also brought competencies in net making and fishing that, over time, contributed to the emergence of a fishing class from the enslaved that partially explains the strong connection between seafood and Gullah Geechee culture.

Post–Civil War Shellfish Fisheries (late 1800s to mid-1900s)

Economically and politically bruised from the Civil War, Georgia joined its neighboring states in the process of Reconstruction. In an effort to ensure that coastal populations had enough food, the federal government assessed fish stocks in the coastal states, including Georgia. They measured fish diversity, abundance, and cultured species that could be grown and used to seed the headwaters of the rivers to promote popular fisheries. The U.S. Fish Commission deposited 1.8 million shad near Albany, Macon, and Crawfordsville from the hatcheries it operated.[22] Although social and economic systems were tender and fragile, the fisheries were booming. Shellfish were abundant, and accounts of the markets in Charleston and Savannah describe many types of fish and multiple peddlers.

After the Civil War, slaves were virtually penniless when freed, though some in the Southeast received land or the use of land. The fishing, crabbing, and shrimping skills that developed in the slave economy fostered self-employment for African Americans during Reconstruction and contributed heavily to sustaining families with little other means of support, particularly after the economic collapse of the South. Along with agricultural pursuits, they engaged in oystering and fishing for food and for profit.[23]

Charleston had a robust market in which seafood of many kinds were available. Savannah echoed the variety of Charleston but was no match. The success of the Charleston

market was primarily due to the business acumen of a bi-racial entrepreneur named Charles C. Leslie.[24] Leslie was born in Chandler, South Carolina, and was known to have been a gunrunner for the Confederacy. However, after the war, he set up shop in the city market as a seafood vendor. What made Leslie different from other vendors was his deep knowledge of all the creeks and waters surrounding the Charleston area. He was a guide for other fishermen because he was so highly literate of the species occurring in Lowcountry waters and because he augmented his local knowledge by reading scientific literature. Leslie utilized connections in Norfolk, Virginia, and built relationships with marine scientists of the day, including professor Robert Baird, director of the United States Fish Commission, the precursor to the National Marine Fisheries Service of the National Oceanic and Atmospheric Administration (NOAA). Leslie also was the go-to person for Dr. David Jordan when he visited the region for survey work he was performing for the museum at Indiana University and the United States National Museum.[25] Leslie cultivated a demand for sea products in Charleston by exposing the community to species they were not accustomed to eating. By procuring fish caught by the "Mosquito Fleet," he fed the tastes of the poor, who wanted porgy, scup, and adult drum, as well as of the rich, who bought blackfish. Moreover, he helped develop a taste for pompano, jacks, red snappers, bastard snappers, squirrelfish, and hake. With advice from Professor Baird, he also established a soft-shell blue crab nursery on the Cooper River in Mount Pleasant.[26] Such activity surely had a regional effect on Savannah tastes, given the proximity of the two cities.

Purveyors of fine seafood in Savannah were easy to locate because city ordinance relegated sellers to the city market or to a commercial address. Those looking for any kind of consumable goods needed only procure a copy of *Sholes' Directory of the City of Savannah*. In it they could find a list of vendors who plied all types of wares, including seafood. The directory listed vendors alphabetically by their product, indicated the vendor's race, and provided the vendor's business address. Fishing and fish selling were an equal opportunity enterprise in which Black and white vendors rented stalls and serviced clients in Savannah's market. If a business was located in Savannah's City Market at West St. Julian Street, the guide included the stall number. Others may have been found on Bay or Broughton Streets.

The number of purveyors advertising in Arnold Sholes's directories gives us a glimpse of the productivity of the fisheries and the demand for their products. For example, the 1880 directory listed eight "Negro" and nine white seafood vendors.[27] All were listed as selling in the market except for the D'Savarese brothers, who were located at 3 Jefferson Street, and G. A. Hudson, whose business was at 171 Bay Street. Sullivan and Son were at 150 Bryant Street. In 1882, the directory listed fish dealers separately from those selling oysters, fish, and game. Four fish dealers of color were in that year's directory: W. Brisbane, F. J. Byrd, H. Grant, and S. Hines.[28] The other white fish dealers included the D'Savarese family, who reappeared in the 1884 directory, as well as M. Connerelle, J. B. Fields, G. A. Hudson, and L. P. Maggioni and Company.[29] At the Savannah Market in 1888, the price for drum fish, bass, snapper, grouper, and other large-scale fish that sold individually was five cents apiece.[30] Shad were three cents, and a string of fish was not less than one cent but not more than two. Shellfish brought the true premium rates. Twenty-five cents could purchase a basket of shrimp or prawns or a pail of open oysters. Oysters and clams were five cents per bushel, with each draft over thirty pounds selling for ten cents, and under thirty pounds for five cents. By 1896, L. P. Maggioni and Company had moved to 178 Bryan Street, and later the business amassed quite an oyster operation in Thunderbolt.[31]

The commercial market grew to meet the consumer demand. Oyster meat harvesting increased from three hundred thousand pounds in 1880 to eight million pounds in 1908.[32] Canneries popped up along the coast, from Brunswick and

Darien to Cedar Point and Thunderbolt.[33] Oystering and all the tasks involved became a family enterprise, as can be seen in an 1899 photo of children shucking oysters in Savannah (figure 16.1). As thriving seafood companies established themselves along the coast in the early twentieth century, they created work that was seized by African Americans and white women. In Thunderbolt and Pin Point, mothers and daughters worked at plants in succession or side by side.[34] Because people with different racial backgrounds worked side by side in Thunderbolt's many seafood processing plants, some historians described the seafood industry as a uniting force between the white and Black citizens in the town.[35] Even Savannah State University found its way into the history of fishing technology in Thunderbolt's growth. L. P. Maggioni turned to the former Georgia State Industrial College for the expertise of a blacksmith on the faculty when the New York manufacturer of their oyster grabs discontinued production.[36] Following the pattern of industry growth in Thunderbolt, Augustus Oemler (1867–1927) started his first oyster packing plant on Wilmington Island, then established another plant on St. Catherine's Island to market his Mermaid brand packed shrimp.

Although commercial shrimping occurred in Alabama and Louisiana as early as the late 1700s, Georgia's shrimping industry began to grow in the late 1800s.[37] Gullah Geechee descendants of John Anderson recall that his factory on Pin Point Road—Ben Bond and John Anderson Seafood—was in existence as early as 1900 and note that it preceded the A. S. Varn and Sons factory, which was not established until 1926.[38] Demand notwithstanding, shore fisheries in South Carolina and Georgia were still very limited as late as 1923 and largely confined to Savannah and Charleston, where the markets and demand were located.[39] With no refrigeration, sea products would not be transported very far. Shrimp was the largest fishery, followed by menhaden, shad, and oysters.[40]

Thunderbolt, Georgia, played a unique role in expanding the national popularity of shrimp. In 1948, Henry F.

FIGURE 16.1. African Americans shucking oysters in Savannah. Billington and Weed family photographs, Georgia Historical Society, MS 1573-01-02-07.

Ambos and William Mullis pioneered the preparation of breaded, fantail shrimp out of their company, Trade Winds, one of many factories operating on the Wilmington River riverfront.[41] As a result of this advancement, "Pan-Redi" Georgia shrimp was marketed across the country and added to the volume of oysters and picked crab that was moving out of coastal canneries like those described in Melissa Fay Greene's *Praying for Sheetrock.*[42]

The enjoyment of oysters was egalitarian across stature; those who enjoyed the delicacy pursued it as a communal fete with their family and peers. Providing such an outdoor feast was also a grand gesture of hospitality. Businesses offered oyster roasts for their employees and families. Roasts

were large gatherings where people assembled in a surprising degree of finery compared to today's standard. Such attention to proper attire can be seen in a colorized postcard depicting citizens eating oysters at Savannah Beach in 1912. Large hats tilted downward conceal the faces of women shucking oysters. The men appear the same, donning full jackets and vests. Only the cook, who attends the fire next to a large wheelbarrow of oysters, can be seen in shirtsleeves. In a 1919 photograph from Sapelo Island, depicting men and women shucking oysters, two men appear seated while two women in full hats, full-length skirts, and jackets lean forward to open oysters (figure 16.3). All are watched over by an African American man in a shirt and vest. In the background appear to be some tabby ruins. This group appears slightly more casual than the group in the postcard from Savannah. The men's hats are light colored and misshapen, with the brims folded up. The women's attire also appears to be daily wear, and their hats are more casual than those in the Savannah photo.

What is certain is that the oyster roast became to be considered an essential Georgia seafood experience. In 1927, U.S. president Calvin Coolidge visited the Georgia coast. As with any executive visit, great pains were taken to present an authentic and superior Georgia experience. After flying into Sea Island, President Coolidge was met by financier Howard Coffin, who hosted the presidential party at his mansion on Sapelo. Hunting and beach walking notwithstanding, the visit was not complete without an oyster roast on the mainland at Cabin Bluff, an area now known as Woodbine, Georgia. In a photo, a group of approximately seven well-dressed African American men stand in the background as Coolidge's entourage, mostly white men, watched the president eat oysters by lamplight.

Over the first half of the twentieth century, oysters were very abundant and very popular. In fact, one can find repeated newspaper advertisements of oyster roasts being offered by churches, especially African American churches, as fundraisers.[43] They occurred with the frequency of

FIGURE 16.2. A postcard depicting an oyster roast on Savannah Beach, 1912. Historic Postcard Collection, RG 48-2-5, Georgia Archives. Courtesy of Gary Doster.

FIGURE 16.3. Daytime oyster meal on Sapelo Island in 1919. Vanishing Georgia, Georgia Archives, University System of Georgia, SAP128.

FIGURE 16.4. President Calvin Coolidge enjoying an oyster roast during his 1927 visit to the coast. Vanishing Georgia, Georgia Archives, University System of Georgia, CAM237.

pancake breakfasts, spaghetti dinners, or brisket barbecues that we see in the present day. They were particularly popular shortly after the turn of the century. Oyster roasts also were rewards for employee service, as illustrated by the Citizens and Southern (C&S) Bank oyster roast (see figure 16.5). As recently as 2018, the Knights of Columbus were maintaining their tradition of an annual oyster roast in Brunswick, Georgia. The ritual of shoveling oysters, tending the fire, and having folks shuck and eat wheelbarrow after wheelbarrow of oysters has been maintained for eighty-six years.[44] The Georgia Conservancy hosts its annual oyster roast each year as one of the premier coastal advocacy fundraisers. Seeing that no one has tired of this type of event, the Georgia Sea Grant College, an educational program funded by the National Oceanic and Atmospheric Administration at the University of Georgia, started its tradition in 2017.

The Lowcountry boil has had a decidedly more informal tone than the oyster roast. While Richard Gay of Frogmore, South Carolina, is often given credit for the delicious emulsion of seafood leftovers as a solution for feeding a unit of Army National Guard soldiers, its origins far precede the

1960s moniker "Frogmore stew." The messy concoction has no "pristine" recipe, but most agree that it is not a "boil" without shrimp and/or crab, smoked sausage, corn on the cob, potatoes, and Chesapeake Bay–style seasoning. Its origins are no doubt shaped by the confluence of needs that planters, colonists, and the enslaved had for a one-pot meal of abundant saltmarsh protein. This creolization is characteristic of Gullah Geechee culture—the incorporation of seasonings (and, in some places, rice) is distinctly African, while the introduction of sausage has been suggested as a European contribution.[45]

Boils are casual affairs in which a large pot of seasoned water is prepared outside (preferably) and consumed at a leisurely pace. Especially in the African American community, family reunions, football homecomings, and birthdays commonly culminate in a pot of crabs (which

FIGURE 16.5. At the 1952 Citizens and Southern Bank oyster roast, well-heeled bankers consume the tasty bivalves as they network during the Georgia bank's heyday. Robert L. Heriot Collection, 1908–1986, Georgia Historical Society, MS 1371-2359.

is often used interchangeably and is understood to mean crab boil or Lowcountry boil). The author has experienced Lowcountry boils in which even boiled eggs, chicken feet, or other chicken parts have been tossed into a highly seasoned pot to absorb the flavor and extend the meal.

Changing Fisheries, Enduring Palate: Modern Trends in Shellfish Demand

By the time the U.S. Bureau of Fisheries began recording annual commercial fishery landings in 1950, Georgia was well on its way to overexploiting its oyster, shrimp, and crab fisheries. In fact, the oyster fishery had already crashed from a combined wallop of overfishing and degrading water quality. Our appetite for the multiple uses of oysters was voracious. Whether we were satiating our palate, building Lowcountry "palaces" of tabby, fortifying roads, or using shells as fill, Georgians fully exploited the fishery. The need to rebuild the fishery met several responses—one of the earliest was to build an oyster fishery at the Shellfish Laboratory at the University of Georgia Marine Extension facility on Skidaway Island.[46] Subsequent efforts to restore natural reefs with natural shell were part of several projects, including the creation of the first Georgia "Living Shorelines" sites on Sapelo Island in 2006.[47] While the oyster stocks were rebuilding and benefiting from oyster reef restoration projects, there was some promise in developing "singles," unclustered single oysters that are preferred by niche buyers such as restaurants. Justin Manley started the first such operation in Georgia, SpatKing, in 2011 after earning his master's degree in marine sciences from Savannah State University. Manley's expertise in shellfish aquaculture developed during graduate work at the UGA Marine Extension Shellfish Laboratory under Tom Bliss. These academic techniques turned into a pioneering business model adopted in 2015 by Earnest L. McIntosh Sr., a third-generation fisherman in Harris Neck, whose father operated the McIntosh Crab Plant until the 1990s.[48]

Ask any career crabber, and they are likely to tell you that they believe their best crabbing years are behind them. Georgia's annual crab landings hit a peak of 15.7 million pounds (worth $516,755) in 1960—a level that has not been seen since.[49] In just thirteen years, Georgia experienced a dive in total blue crab landings (down to 3.6 million pounds, worth $298,153). The state would recover in 1981 (thirteen million pounds) but crashed further through the 1990s and early 2000s, as drought and disease decimated blue crab stocks. Although the parasite *Hematodinium perezi* was not a new phenomenon in shellfish, its effect on the Georgia blue crab fishery was not surmised until after the drought and scientists at the Skidaway Institute of Oceanography (SkIO) began to make the connection between salinity and the number of infected crabs across Georgia's estuaries.[50]

Populations of shrimp—ever the more profitable fishery—fared only slightly better, missing the extreme vacillations of the 1970s and 1980s observed in crabs but still dropping from just over 11 million pounds (worth $3,177,422) in 1950 to ranges of 8.4 to 10 million between 1960 and 1980. Some commercial fishermen recovered from the disastrous drop to 4.9 million in 1981, but the wavering increase to 11.3 million in 1995 is the highest the fishery has seen since then. In the 1970s some fishermen joined together to form the Georgia Shrimpers Association, a professional organization intended to help fishermen advocate for the industry and against overregulation.[51] In 2004, the group developed a marketing strategy to combat an influx of cheaper imported shrimp. The popular "Wild Georgia Shrimp" campaign featured a distinctive blue-and-white logo that was emblazoned on billboards and menus across the state in an effort to encourage Georgians to choose local shrimp. A small minority of fishermen took an adaptive approach to changes in the fishery and migrated to emerging opportunities, such as a jellyball fishery.[52] Those who remained in the industry managed to endure the reduction in landings to 5.98 million pounds in 2016, suffering setbacks that were

attributed to black gill disease that same year.[53] Not unlike infections linked to *Hematodinium*, black gill is caused by a parasite, in this case a ciliate, and the dark discoloration of the gills is the shrimp's immune response to the parasite. While the appearance of a shrimp with black gill may be disheartening, the shrimp remain edible. Researchers at the SkIO indicate that the information to date shows a connection to decreases in landings but cannot determine an exact cause.[54]

From their beginnings as humble native food and through the succession of peoples living on the coast through time, oysters, crab, and shrimp have held their unique position in Georgia cuisine.[55] Culturally, they have been symbolic of self-sufficiency for Georgians for centuries. The prominence of shellfish in our palate has been consistent as the protein of the peasants and the privileged. For the professional fisherman or the recreational angler, pulling food from our waters imparts a connection that is tangible. For those who consume them, the slurp of a tender oyster, bite of a firm shrimp, and backfin of a perfectly seasoned crab give a satisfaction that is truly vibrational.[56]

NOTES

1. D. C. Rhoads, "Organism-Sediment Relations on the Muddy Sea Floor," *Oceanography and Marine Biology* 12 (1974): 263–300.

2. Ronal T. Kneib, "Bioenergetic and Landscape Considerations for Scaling Expectations of Nekton Production from Intertidal Marshes," *Marine Ecology Progress Series* 264 (2003): 279–296.

3. Elizabeth J. Reitz, Barnet Pavao-Zuckerman, Daniel C. Weinand, Gwyneth A. Duncan, and David H. Thomas, "Pre-Hispanic Subsistence Patterns in the Southern Atlantic Bight," in *Mission and Pueblo of Santa Catalina de Guale, St. Catherines Island, Georgia: A Comparative Zooarchaeological Analysis,* Anthropological Papers of the American Museum of Natural History, 0065–9452, no. 91 (New York: American Museum of Natural History, 2010), 45–76.

4. Elizabeth J. Reitz and Elizabeth S. Wing, "Control of Animals through Domestication," in *Zooarchaeology*, 2nd ed., (Cambridge: Cambridge University Press, 2008), 287–315, doi:10.1017

/CBO9780511841354.010; B. Meehan, "Shell Bed or Shell Midden," *Australian Archaeology* 34 (1982): 3–21.

5. David Hurst Thomas, *Native American Landscapes of St. Catherines Island, Georgia, 3 vols.*, Anthropological Papers of the American Museum of Natural History, no. 88 (New York: American Museum of Natural History, 2008).

6. Morgan Raymond Crook, *Archaeological Investigations at the North End Site (9Gn107), Little St. Simons Island*, Antonio J. Waring Jr. Archaeological Laboratory Report of Investigations (Carrollton: University of West Georgia, 2005), 1–15.

7. Victor D. Thompson and Fred T. Andrus, "Using Oxygen Isotope Sclerochronology to Evaluate the Role of Small Islands among the Guale (AD 1325 to 1700) of the Georgia Coast," *USA Journal of Island and Coastal Archaeology* 8 (2013): 190–209.

8. Reitz et al., "Pre-Hispanic Subsistence Patterns."

9. Robert Preston Brooks, *History of Georgia* (Atlanta: Atkinson, Mentzer & Company, 1913).

10. George Brown Tindall and David E. Shi, *America: A Narrative History* (New York: W. W. Norton, 1997).

11. Kenneth Coleman, *A History of Georgia* (Athens: University of Georgia Press, 1991).

12. "An Early Description of Georgia from *The Gentleman's Magazine*, January, 1756, Volume 26," *Georgia Historical Quarterly* 2, no. 1 (March 1918): 37–42, https://www.jstor.org/stable/40575575.

13. Julie Anne Sweet, "Will the Real Tomochichi Please Come Forward?" *American Indian Quarterly* 32, no. 2 (Spring 2008): 141–177.

14. Coleman, *History of Georgia*, 39.

15. David Lee Russell, *Oglethorpe and Colonial Georgia: A History 1733–1783* (Jefferson, N.C.: McFarland and Company, 2006).

16. Russell, *Oglethorpe and Colonial Georgia*, 46.

17. Charles MacKay, *Life and Liberty in America* (London: Smith, Elder and Co., 1859).

18. Tyson Gibbs, Kathleen Cargill, Leslie Sue Lieberman, and Elizabeth Reitz, "Nutrition in a Slave Population: An Anthropological Examination," *Medical Anthropology* 4, no. 2 (1980), 175–262, DOI: 10.1080/01459740.1980.9965868.

19. Timothy J. Lockley, "Trading Encounters between Non-elite Whites and African Americans in Savannah, 1790–1860," *Journal of Southern History* 66, no. 1 (2000): 25–48; quotes from Betty Wood, Women's Work, Men's Word: The Informal Slave Economies of Lowcountry Georgia (Athens: University of Georgia Press, 1995), 84.

20. Gullah Geechee Cultural Heritage Corridor Commission, *Gullah Geechee Cultural Heritage Corridor Management Plan* (Denver Service Center: National Park Service, 2012).

21. Karen Bell, "Rice, Resistance, and Forced Transatlantic Communities: (Re)envisioning the African Diaspora in Low Country Georgia," *Journal of African American History* 95, no. 2 (2010): 157–182.

22. Charles W. Smiley, "Statistics of the Shad-Hatching Operations Conducted by the United States Fish Commission in 1882," in part 10 of *The Report of the Commissioner of Fisheries to the Secretary of Commerce and Labor*, ed. Spencer A. Beard (Washington, D.C., 1882), 903–914.

23. Ben G. Blount, "Coastal Refugees: Marginalization of African Americans in Marine Fisheries of Georgia," *Urban Anthropology* 29, no. 3 (2000): 285–313.

24. David S. Shields, *Southern Provisions: The Creation and Revival of a Cuisine* (Chicago: University of Chicago Press, 2015).

25. David Starr Jordan and Carl H. Eigenmann, "Notes on a Collection of Fishes Sent by Mr. Charles C. Leslie from Charleston, South Carolina," *Proceedings of the United States National Museum* 10, no. 627 (1887): 269–270, https://doi.org/10.5479/si.00963801.10-627.269.

26. *Bulletin of the United States Fish Commission* 4, no. 17 (Washington, D.C.: GPO, July 30, 1884).

27. Arnold E. Sholes, *Sholes' Directory of the City of Savannah* (Savannah, Ga.: Morning News Steam Printing House, 1880), vol. 2.

28. Arnold E. Sholes, *Sholes' Directory of the City of Savannah* (Savannah, Ga.: Morning News Steam Printing House, 1882), vol. 4.

29. Arnold E. Sholes, *Sholes' Directory of the City of Savannah* (Savannah, Ga.: Morning News Steam Printing House, 1884), vol. 6.

30. Alexander Harrison MacDonnell, *The Code of the City of Savannah* (Savannah, Ga.: Savannah Times Publishing Company, 1888), 121.

31. Luciana M. Spracher, *A History of Thunderbolt, Georgia* (Thunderbolt, Ga.: Thunderbolt Museum Society, 2003); Arnold E. Sholes, *Sholes' Directory of the City of Savannah* (Savannah, Ga.: Morning News Steam Printing House, 1896), vol. 17.

32. J. H. Matthews, "Fisheries of the South Atlantic and Gulf States," *Economic Geography* 4 (1928): 324–348.

33. Spracher, *History of Thunderbolt*, 94.

34. Spracher, 92; Rebecca Bowen, "African American Fishing in Pin Point, Georgia," interview by Dionne Hoskins, Pin Point, Ga., June 11, 2015.

35. Spracher, *History of Thunderbolt*, 103.

36. Spracher, 92.

37. "A History of the American Shrimping Industry," Wild American Shrimp, https://www.americanshrimp.com/about-our-shrimp/history/.

38. Herman Hanif Haynes, "Georgia Black Fishermen," interview by Dionne Hoskins, *Voices from the Fisheries*, Pin Point, Ga., December 18, 2012; "Shall We Gather at the River," *Savannah Magazine*, March 15, 2017, http://www.savannahmagazine.com/shall-we-gather-at-the-river/.

39. Matthews, "Fisheries of the South Atlantic," 326.

40. NOAA Office of Science and Technology, Fisheries Statistics Division, 2018.

41. Spracher, *History of Thunderbolt*, 96; Ambos, https://www.ambosseafoods.com/legacy.

42. Melissa Fay Greene, *Praying for Sheetrock: A Work of Nonfiction* (New York: Fawcett Columbine, 1992).

43. See, for example, ads of the time in the *Savannah Tribune*.

44. Knights of Columbus, Brunswick, Georgia, eighty-sixth annual oyster roast, March 2, 2019, http://www.kocbrunswick.com/photos.html.

45. Saddler Taylor, "Beaufort Stew/Frogmore Stew," in *New Encyclopedia of Southern Culture*, vol. 7: *Foodways*, ed. John T. Edge (2007), 121–122.

46. Randal Walker, "The Collapse of the Twentieth-Century Georgia Oyster Fishery," in *Coastal Nature, Coastal Culture*, ed. Paul S. Sutter and Paul M. Pressler (Athens: University of Georgia Press, 2018), 282–283.

47. Georgia Department of Natural Resources, *Living Shorelines along the Georgia Coast: A Summary Report of the First Living Shoreline Projects in Georgia* (Brunswick, Ga.: Coastal Resources Division, 2013).

48. André Gallant, "The Spat King," *Atlanta Journal-Constitution*, September 5, 2015, https://personaljourneys.ajc.com/oysterman/; André Gallant, "Hope on the Half Shell," *Garden and Gun,* December 2018–January 2019, https://gardenandgun.com/feature/hope-half-shell/.

49. NOAA Office of Science and Technology, Fisheries Statistics Division, 2018.

50. Richard F. Lee and Marc E. Frischer, "The Decline of the Blue Crab: Changing Weather Patterns and a Suffocating Parasite May Have Reduced the Numbers of This Species along the Eastern Seaboard," *American Scientist* 92, no. 6 (2004): 548–53, http://www.jstor.org/stable/27858483.

51. Georgia Shrimp Association, https://wildgeorgiashrimp.org/the-georgia-shrimp-association.

52. Mary Landers, "Coastal Georgia Shrimpers Turn to Jellyfish to Make Money," *Savannah Now*, May 15, 2011, https://www.savannahnow.com/story/news/2011/05/16/coastal-georgia-shrimpers-turn-jellyfish-make-money/13430548007/.

53. Mary Landers, "Black Gill Disease Shows Up Early in Georgia Shrimp," *Savannah Now*, June 27, 2016, https://www.jacksonville.com/news/georgia/2016-06-27/story/black-gill-disease-shows-early-georgia-shrimp.

54. Marc E. Frischer, Richard F. Lee, Ashleigh R. Price, Tina L. Walters, Molly A. Bassette, Rufat Verdiyev, Michael C. Torris, Karrie Bulaski, Patrick J. Geer, Shirley A. Powell, Anna N. Walker, and Stephen C. Landers, "Causes, Diagnostics, and Distribution of an Ongoing Penaeid Shrimp Black Gill Epidemic in the U.S. South Atlantic Bight," *Journal of Shellfish Research* 36, no. 2 (2017): 487–500.

55. Victor Thompson and John Worth, "Dwellers by the Sea: Native American Coastal Adaptations along the Southern Coasts of Eastern North America," *Journal of Archaeological Research* 19, no. 1 (March 2011): 51–101.

56. Vertamae Smart-Grosvenor, *Vibration Cooking, or, the Travel Notes of a Geechee Girl* (Athens: University of Georgia Press, 2011).

CHAPTER 17

Killing Privilege

J. DREW LANHAM, professor of wildlife ecology, Clemson University

Lanham contemplates how spending time in nature strengthens our relationship with the land and with wildlife. A deepening appreciation for and understanding of nature moved us from onlookers to caretakers and toward responsible stewardship. He explores the difference between taking personal responsibility through hunting as a way to provide food for the table and the prevailing practice of buying plastic-wrapped animal pieces from industrial slaughter. Lanham considers how this choice affects our personal connections with the larger environment through our relationship with the natural world. ✿

Sitting, as I often do, watching the broom sedge on an old field glisten and bow to a new day's sun rising, or listening for the shuffling of sharp hooves crackling fallen autumn leaves in an evening-dimmed bottomland hardwood forest, I'm not thinking too deeply about what it means for me to be here, but my decision to hunt is one rife with contradictions. I'm a Black southern man taking to the woods to seek and kill when I don't have to. I could be treading ground where trees were once considered more as lynching posts than as platforms for climbing. Up in a tree stand I am away from most of the discrimination that would plague me on the ground, amid less wild places where I'm prone to the judgments of people. It is a major reason I continue to hunt. It's an escape from a crowded and persistent sociological reality into the depths of an often lonelier but kinder wild one. It's a killing privilege I take.

I'm a birder and naturalist. I'm solidly middle class and well compensated for my job as a college wildlife ecology professor. Many in my circle of friends and professional peers see hunting as passé and killing as cruel or simply an unnecessary and unethical "stress" on a natural system already under enough intense pressure without my intrusion. Some don't buy into my food-gathering rationale, and they're right. My family doesn't need the food for survival—but I demand it as essential for my well-being.

I have no doubt that hunting has been what's kept me in touch with much of who I am beyond labels of identity and perception. An often-bitter past in woods once filled with hate and fear from terrorist racists would tell me to stay out. There's something good beyond remembering all the bad that makes me go in. The characterizations of who I should be based on my appearance, profession, or avocation make me want to go the opposite way. Convention has always been a strict deterrent. My preference for killing what I eat with a single shot instead of having it done for me by industrial slaughter brings me closer to what I see as my true being. I see it as a direct connection to being whole and to wholesomeness. It's a killing privilege I take.

My ancestors didn't have the privilege or choices that I do. My father wasn't an avid hunter, as we raised our own beef and pork, supplemented with creek-caught fish in the summer, and an occasional yard bird (chicken) thrown in for variety. There were nights that a rabbit, shot out of the vegetable garden, ended up on our dinner table. Daddy would sling out the guts and skin it. Mama braised and smothered it in a cast-iron skillet with onions and gravy. Wild rabbit with onions and gravy over rice with kale, in an upscale French restaurant, is *lapin sauvage aux oignons et sauce sur riz au chou frisé*. For the six of us sitting around the table back at my rural homeplace, it was the pennies-on-the-dollar cost of a .410 shotgun shell and the incalculable price of Mama's time and caring. In the restaurant, I would imagine much more for just a single plate with no second helpings and not much care beyond the production line of an arrogant chef. Cottontail rabbits were the occasional preferred wild table fare in my family. There was minimal investment of time in seeking or preparation, from garden's edge to family gullet. Time is a privilege many people don't have, and it has historically been that way for folks without the luxury of disposable hours to sit and wait and ponder the pursuit of game. Long before we enjoyed an occasional rabbit swimming in its own greasy juices, my rural ancestors likely spent bits and pieces of their time in the wild, pursuing easier quarry as table fare—small game such as possum, 'coon, fish, and occasional gamebirds such as bobwhite quail and marsh hens. These were active pursuits, often assisted by dogs, and reliably productive, because food was the requisite—not recreation. Whether it was enslaved great- and great-great-grandfathers taking time at night to kill hound-treed coons or slow-moving possums as supplements to the foods given to human chattel, coming home empty-handed meant meatless meals—or perhaps no meal at all. Hunting, then, was not a privilege but necessary for survival.

According to almost anyone's definition of survival, it's not necessary for me now. I would continue to live and grow fatter without hunting. My choice to sit and wait for white-tailed deer is an evolved privilege paid for by the efforts of those who went before me. But then too, it is born of my desire, again, to be as close as possible to some base of my existence. Pushing a shopping cart through the orderly aisles of canned and boxed goods, to choose from the blood-drained cutlets of animals once standing knee-deep in their own shit and now corralled piecemeal in Styrofoam and cellophane, is several degrees of separation from who I want to be. It's not that I will become an extremist in my carnivory—but when given the choice, I would rather know that there were some choices, too, in the life led by the flesh I eat. The white-tailed deer I shoot less than 10 percent of the time I hunt ate fallen acorns,

ran free, rutted, bleated, fought, nursed fawns, pissed on pawed-up ground, and mated before I set my crosshairs on it to kill it.

Beyond that killing is the work done that brings me closer to the omnivory that makes me human. I can't call such a thing "sport" though, and I will not sanitize my killing acts as "sporting." It is hunting. Hunting for me has its genesis in natural history and in understanding the creature you seek. There is a critical middle act of killing, followed necessarily by the final act of eating flesh sacrament. The process to the nonhunter is hard to understand. For me, context is gained most rapidly in the closest moments.

I've had my hands heart deep inside a white-tailed buck. It was the last act of intimacy with an animal that I admired, then killed. I knelt beside a little two-and-a-half-year-old, eight-point buck for almost an hour—my hand feeling its dying muscles quiver in the cold that it couldn't feel. As I'd done maybe a dozen times before, I killed another being. In doing so I took full measure of myself in ways that only hunting seems to bring. Just a few moments before I had again sat high, watching over maybe three hundred acres of rolling pasture and old field, broken by fingers of pine-hardwood forest. It was late November, past the peak of deer season, I thought. In that thinking, I was still intent on the possibilities and had imagined the draw at the base of the broom sedge– and frostweed-choked slope would be a natural magnet for does traveling between forest fragments. The does would be the magnets for bucks. When that simple math of supply and demand came together, I would be there. For most of the season, only bits and pieces of the equation had come together. The does were there, and I could've taken one, but they were always with their yearlings, and I chose not to. But on this day, after I'd passed on more deer, this buck lying beside me in death shivers had been very much alive. I watched it as it came up from the draw—maybe one hundred yards away toward a scent trail I'd laid down. Nose to ground, tail wagging high and white in the wind, it was intent on finding sex. I couldn't take my

bare eyes off it at first. It was beautiful, almost like the pictures I've seen in magazines of rutted-up bucks with swollen necks and white-walled eyes, single-mindedly on the trail of does in heat. As it pushed closer, I remembered my intent. Death. I covered my eye with the rifle scope and found a spot where the buck's neck joined its shoulder. I grunted. The buck stopped and looked straight at me. I shot the quarter-sized spot that filled my eye and the deer fell. Dead.

Less than an hour before, it had been a bundle of bunched nerves all coiled up into itself and wanting another thing so badly that it couldn't see that its own undoing perched above it. Nose to ground, it had walked blindly into its own end. I climbed down from my stand, trembling as I always do after a killing, and less than fifty paces from where I laid crosshairs on its shoulder, I looked down on what I'd done. I knelt to touch it. I'd never felt death like that: flesh quivering as if a thousand lives struggled to escape the dead thing suddenly entrapping them. I removed the glove from my still-shaking hand and in the cold air that blew between my living and the buck's death laid brown hand on brown hide to feel skin on skin. The buck's one eye facing the sky was still bright, but fixed. It reflected things the deer would never again see—clouds, the tall brown grass, the hillside where desire had done it in. The intercourse was brief but seemed endlessly long. I disconnected briefly enough to call my friend Ralph. We found a hillside in the woods closer to my truck where we could field dress the carcass. We tied off the four legs so that it lay on its back—legs splayed with head uphill and tail down. I cut carefully around the anus and pulled out the short tube of duodenum to tie off any fecal spillage that might taint the meat. Then, starting at his testicles and using the fingers of one hand to guide the blade away from the organs, I used my other hand to slice open the white belly to the brisket, feeling the hide and a layer of fascia underneath it zipper apart at the edge of the sharpened blade. Even in the freezing cold, fleas scurried like flecks of black pepper scattering through the coarse white hairs. Were they confused

or somehow despondent in some sort of unknowable parasitic way because the living, breathing ship upon which they had sailed was sinking? The life I'd taken so cleanly opened to reveal a glistening mass of muted color: a visceral palette of moss green, yellowing white, rust red, and mud brown. The past tense of metabolism steamed upward, and the odor of everything the deer had ever been poured out. The smell was pungent—the same scent I remember from every animal's evisceration I've ever been a part of. There is an expected stench of death that should be breathed in and possessed. Maybe in the inhalation, a bit of was becomes is: recent past recycled to sudden present. I needed to release the mass of viscera from the body, and the major tether still holding it in was hidden. I pushed my hands inside the rib cage and below the sternum to sever the windpipe from the throat. Blindly, I felt past the heart, which was intact and almost double the size of my own. It had been the bounding, leaping, fast-running engine that made the buck the miraculous creature it was. I could feel the spongy lungs too; they gassed the heart's blood with the cold air I'd watched streaming, first from the living buck's nostrils and then from its corpse lying open. My hands were now bathed in blood from the messier blind work as I found the windpipe, a tougher-than-expected tube ribbed with cartilage. I severed it, tore unknown fleshy things from the moorings of their owner. We untied a hindleg and a foreleg, then rolled the buck on his side, and the inner workings all rolled out onto the leaf litter: a hot, glistening pile of life essence.

There it all was. Everything that had been inside—was out. The buck's body was now a shell of muscle. From that empty corpse the meat would come. Loin and tenderloins lying along the spine and ribcage would become chops and cutlets. The neck would be lean roasts. Most of the remainder would be rendered into ground meat—burgers and spiced sausage. All of it would be neatly packaged by a local processor and acceptably confined to vacuum-sealed packages that gave no clue of a bipedal life and the drama of the sudden death I'd rendered. In the work of dismantling, I was no longer cold. I was sweating and removed my jacket. I'd spent all this intense time preparing the deer for my own consumption and needed to see what I would be eating. I sliced open its stomach and found it full of bits and pieces of acorns. They seemed this deer's choice. The fragments of orange, brown, and yellow acorns were mixed in with masticated clots of green—some of it likely the clover and turnip greens planted in food plots to attract the deer to this very end.

In this messy work—a rough kind of grocery shopping—I feel as close to wildness and my own purpose as I ever do. The dismantling was a way of reassembling me. The search and speculation on what might be out there are the joy in it all. The killing is the hardest task. There's always a pause in my trigger pull because I'm never 100 percent sure that I want to kill. It is the animal's sacrifice and another cog in the cycle of recycling. The retrieval and field dressing are penance. Sitting over a medallion of tenderloin seared to medium rare or joining family and friends in a hearty meal of pasta and marinara thickened with ground venison is prayer and supplication.

Intimate connections. Understanding how precious and precarious life is comes in moments like this for me. Each chew I take comes only because of thousands the deer took. That I connect to life by killing sometimes seems an odd thing, I know. The venison will feed many beyond me for more than a year. It will sustain life. Perhaps all of us taking stock of what life truly means and jamming our hands heart deep into the mass of it can mean something going forward. There is so much to be learned in the death of another. The connections were clear to me as I was elbow deep in what was left of a once-living thing. The gut pile left in the leaf litter was a lesson. Each morsel of meat I eat will remind me of life and death and the fine line between the two.

It seems a complex and maybe contradictory thing: killing to connect to life. There are other choices, yes. Grocery

stores are the options most take, as they buy manufactured death from fully stocked shelves. The litany of things few can pronounce preserves and protects the industrial farm fare. It is easy hunting. But to obtain healthy whole foods connected closely to some patch of ground we would consider green worthy—that is more difficult. Walk through one of the markets where naturally fresh, organically grown, free-range, gluten-free, non-GMO, cruelty-free food is sold, and one thing becomes immediately apparent—eating what's alleged to be healthiest for you and sustainably sourced from Mother Earth costs more than a small fortune. Whatever the name of the place—fresh or whole—one might need a thicker wallet, deeper purse, or precious metal credit-card limit to simply buy dinner. Without even building significantly onto whatever the current government-sanctioned food pyramid looks like, a single reusable, recyclable brown paper bag half-full of groceries may cost as much as a full tank of gas for the hybrid car. Admittedly, there's a huge selection to be had in such places. It's a United Nations–like selection of good and wholesome foods, but most of it is meant for folks who can't afford to go green. Such places are the habitats of the well-to-do and mostly upper or middle crusters who have the income, information, and disposition to spend excess time and money doing good for themselves and the environment. The killing privilege is likely to ring hollow to most of those urbane enough to find themselves lost in the middle of so much whole, sustainable, green-worthy stuff. Hunter numbers are declining rapidly in the United States. These declines not only mean a loss of tradition, which when practiced ethically works to manage and conserve huntable game species as well as nongame and even endangered species (for example, the Migratory Bird Hunting and Conservation Stamp Act, also known as the Duck Stamp Act, provides funding for wetland habitats that benefit waterfowl species and critically endangered whooping cranes on national wildlife refuges); they also mean a loss of connection to the primal base of gathering.

What happens when we lose the connections to what we eat, whether it be wheat or whitetails? What may seem primal and passé to some is prerequisite for others. There is sustenance, and then there are the things that sustain us. While I, too, am privileged enough, along with the fresh/whole folks, to wander and choose without the tension of survival in the moment, I know there are others who've hunted and fished, past and present, with little thought other than bringing home the next meal. Some of us have the luxury of thinking about the quality of our food, but it isn't nearly universal in the land of plenty. Ironically, as some shop for wholesomeness at the upper end, and others settle for whatever is on sale or questionably labeled in the middle, there are food deserts surrounding islands and fragments of abundance. There are no expanses of desolate sand, excruciating heat, or even cacti to define such spaces. They exist in most states and are mapped by what's not there instead of what is. A lack of whole and green foods—minimally processed and in a condition as close as possible to that of the plant that grew out of the ground or the animal that walked around while it was living—determines where the deserts are. Food maps are also marked by high rates of poverty and are more likely to be in areas where people of color live. Even in rural areas, where deer and other game probably thrive, food deserts persist. It is a failure of our landscape and conservation ethics that we choose to go without when the opportunity to do better exists. Hunters with an excess of game often donate meat to food banks approved to distribute wild game. Annually, tons of meat are processed and offered at little or no cost to tens of thousands in need. And yet, the gap between those who have options and those who do not widens. Whole-and-fresh shoppers see themselves as earth savers, while whatever-we-can-get foragers work to save themselves. What is the result for conservation of land and considerations for sustainable agriculture and natural resources management when something as essential as food separates us?

Disparities tell the story in so many cases where human well-being is at stake. Differences in the distribution and availability of goods and services along a continuum of factors such as race, ethnicity, gender, and socioeconomic status mean that stakeholder investment suffers, since those on the "have-not" end of the spectrum possess little or no rationale for investing in a whole from which they receive little. If the disparities also result from resources being misallocated, stolen, and then retrofitted in a way to serve the "haves," there may be little hope for convergence. The food we *should* buy versus the food we *can* buy—or how we view where our food comes from and the degrees of separation between it and us—may define a large gap in the ways we think about nature, land, and ideas such as wildness. Food connects us to everything. If we're disconnected from it, then, like dominoes, our capacity to care for everything else falls as well. The gentrification of conservation and consumption looms large in stymieing an inclusive, sustainable wholesale land ethic. Eco-prophet Aldo Leopold opined that "there are two spiritual dangers in not owning a farm. One is the danger of supposing that breakfast comes from the grocery, and the other that heat comes from the furnace."[1] That disconnect still persists. Leopold's admonition that conservation is "a state of harmony between [people] and land" yet stands as a comforting and convincing mantra for how we might think about our relationships to nature.[2]

It's a deeply personal decision to hunt. It's a moral one to kill. It may even be a matter of my own life and death. Sitting in my doctor's office not so long ago, I learned that my blood pressure had risen significantly from the year before, and my weight had ballooned along with it. The electrocardiogram indicated a glitch in my heart rhythm—enough for my physician to ask for blood work and a stress test. In a frank conversation, we discussed the factors that might have caused the changes in my health. Family genetics deserved some of the blame—my father died at fifty-two, and here I was just two years beyond that. But I also had to consider diet and increased stress. My genes aren't malleable, but my food choices and my methods for handling the worry in my life are. Talking about it aloud to someone else was like a confessional. I self-diagnosed. It turns out that over the past couple of years I'd let hunting slip in priority to everything else. The lack of time in the deer woods unquestionably pushed my stress levels higher. I exchanged the outlet of watching wildness for too much travel and idling time in tameness. That deer stand deficit also led to poorer diet choices; I chose the easy route and filled my gut and arteries with fat-saturated fast foods and grain-fed, hormonally enhanced beef instead of free-range, acorn-finished venison. I've been creating my own self-care disparities. My blood pressure and waistline are the rising barometers of things going south. My heart has dams of cholesterol building that will spell an early end for me if I don't regather the good that comes from wiser, wilder living. I know that hunting is one way to set things right. I've vowed to make it more than just a pastime in my life. It should be a priority. For all the thinking I do about what hunting means to me and perhaps for many others, maybe it isn't a privilege I've taken for granted, after all. Maybe it's a greater necessity for me than I ever knew.

NOTES

1. Aldo Leopold, *A Sand County Almanac* (1949; reprint, New York: Oxford University Press, 1987), 6.
2. Leopold, 196.

PART IV

Recipes from Celebrated Lowcountry-Inspired Chefs

CHAPTER 18

Practical and Unpretentious

Working-Class Cookery in the Lowcountry, 1734–1744, Reinvented for the Twenty-First Century

SARAH V. ROSS

Indigenous provisions and introduced heirloom crops are featured in these recipes, which were developed by nationally recognized Gullah Geechee and other award-winning chefs, renowned Lowcountry cooks, and professional foragers. Each entry features primary ingredients originating from the noted continent and social cookery traditions, as well as from meals routinely consumed by geographically and culturally linked groups. The recipes are not intended to replicate historical formulas or procedures. In contrast, they acknowledge our current access to a bountiful array of ingredients, adopted techniques, modern equipment, and extraordinary options to source foodstuffs and learn new cooking skills.

Developed exclusively for this book, these recipes consider alternatives recognized by cultural groups to modify traditional foodways after being transported, wholly unprepared, to a radically different environment.

While the basic character of traditional foodways of the Lowcountry remains, these recipes push historic boundaries to enhance or overcome earlier cultural and ecosystem limitations to expand culinary options. Various and sundry ingredients today are distributed worldwide, flowing through indefinite boundaries. Likewise, cooking methods now include shared multicultural practices, adopted techniques, and globally sourced cooking equipment. Culinary options have never been more available and there is no shortage of recipes. For these recipes to matter, we focus on the connection between the local environment's provisions

and the many social traditions that transform various pieces of nature into a meal. Furthermore, dishes such as potted swan and roasted passenger pigeon were excluded; accordingly the surviving recipes align with common consumption preferences and cookery practices. Decades of researching food history guide the reinvention and contemporary alignment of meals from three distinct cuisines. The recipes represent a range of local experience and economic status in the Lowcountry from 1734 to 1744, including Indigenous Americans, working middle-class colonists, and enslaved and indentured workers. Not represented are extravagant meals prepared and served by indentured or enslaved domestics for affluent landholders.

This is not a cookbook; there are numerous sources for quick, simple meals, and this is not one of them. Packaged concoctions and trendy convenience ingredients are not called for. The recipes have been crafted and thoroughly tested for present-day menus, and tasters report they are truly delicious. Be that as it may, the recipes do not need to be prepared and consumed to be useful. Simply reading through the chapter will reveal cultural parallels and customary foodways of the period. Notably, domesticated livestock and dairy products are not included in sections featuring Indigenous American or African American recipes, as neither group domesticated animals for human consumption until they were introduced to the Americas and Africa by Europeans.

These recipes do not require expertise in historically correct cookery methods, colonial frontier implements, or skills usually necessary to prepare food in the mid-1700s, such as hunting, dismembering, and butchering; foraging and harvesting crops; felling trees and chopping wood; and managing fire during the cooking process. Nonetheless, all of these procedures were routinely practiced throughout the recipe development process to demonstrate fidelity to outcomes while using current cooking procedures. While middle-class colonial wives may have managed to prepare a family dinner with only a large iron stewpot, iron skillet, a few wooden bowls, a few long-handled utensils, and a sharp knife, the convenience of electric lighting, refrigerators, cooktops, ovens, and blenders cannot be overstated.

Foodways Are Relational While Industrial Agriculture Is Transactional

When Europeans landed in the Lowcountry they found a landscape with plentiful hunting, abundant shellfish, year-round plant foraging, and crops cultivated by Indigenous Americans, including high-yielding corn. However, as city dwellers they knew how to obtain food with coins but lacked experience procuring their own food from the earth with weapons and hoes. Consequently, the colonists would have starved (similar to the Jamestown colonists' experience during the "starving time" in 1609) if not for liberal supplies from their homeland, as well as ongoing tutoring and provisions from Indigenous Americans.

Discovering a new food can be thrilling, but deeply embedded food customs are tough to abandon. While Indigenous Americans acquired new culinary options from Europeans and Africans, it was not an equitable exchange. Old World groups faced the loss of beloved traditions and customs as they were forced to adapt to foreign environmental limitations and unfamiliar cultural practices. Reworking a cuisine may appear as simple as the adoption of the European iron pot by Indigenous Americans (drastically changing their foodways), the substitution of Indian meal for wheat flour breads by the colonists, or the replacement by Africans of amaranth leaves with collard greens. However, reimagining foodways, the fundamental essence of a culture, is not a modest change. Foodways are an infinitely complex web connecting each and every strand that keeps us alive and culturally nourished. Foodways are inseparable from religious practices and beliefs, as well as from secular traditions, technological innovations, creativity, social status, and national pride. Reimagining and reinventing everything that a foodway

encompasses mark a profound change that reverberates throughout society. Foodways—emerging from an environment's assets and forged by social groups—reinforce community connections and nourish all levels of society. Everyone, from an individual to whole cultures, benefits from lifelines to healthy, reliable food sources and the all-encompassing foodways connection to the cultural community.

Local Larder, the Lowcountry Landscape on Our Plate

Tidal rivers and creeks link seemingly endless marsh islands and support a robust and variable community of estuarine and marine fauna. Marine resources such as fish and shellfish were dominant foods for Indigenous Americans for thousands of years before European contact. In the Coastal Plain, subtropical forests of maritime oak (*Quercus* spp.) and pine (*Pinus spp.*) provided the earliest inhabitants with plentiful deer (*Odocoileus virginianus*) and other game, as well as terrestrial flora including acorns (primarily from live oaks) and several types of walnut (*Juglans* spp.), hickory and pecan nuts (*Carya* spp.), persimmon (*Diospyros virginiana*), mulberries (*Morus rubra, M. alba*), a native groundnut (*Apios americana*), and plants such as goosefoot (*Chenopodium album*), greenbrier root and growing tip (*Smilax* spp.), muscadine grapes (*Vitis rotundifolia*), tuberous roots of the sunchoke, also called Jerusalem artichoke (*Helianthus tuberosus*), and prickly pear cactus (*Opuntia* spp.).

Indigenous American, colonial, and African American cooking in the eighteenth and early nineteenth centuries continuously adjusted to fluctuating ecological conditions in the region. Hurricanes, droughts, and predation were just a few of the factors that periodically damaged or destroyed crops and wild harvesting opportunities. Colonists and African Americans, in particular, faced with an unfamiliar frontier, blended culinary traditions and adapted New World ingredients into customary eating habits out of necessity. These ingredients included corn, beans, and squash. Indigenous Americans adopted Old World foods that thrived in the Lowcountry, such as hogs, field peas, and okra. Cooking from a regionally harvested larder is evident in Lowcountry stews, a method of preparing food common to all three cultures. One-pot stews comprising a starch, vegetables, and usually some protein are the foundation for hoppin' John, limpin' Susan, perleau (pilau, perlo, etc.), gumbo, Lowcountry boil, and Frogmore stew. These related culinary traditions still inspire chefs to seek the best components seasonally available while respecting regional preferences. Adaptability is an attribute of the practical, unpretentious, multicultural cookery in the Lowcountry.

Cornbread: The Warp and Weft of Daily Fare

Often taken for granted or belittled, cornbread has been a major keystone of southern cookery for almost three centuries. The longevity and heritage of this uniquely American food are remarkable. Throughout these many decades, cornbread routinely, and sometimes singularly, kept bodies alive. Cornbread is the offspring of traditions and ingenuity from multiple cultures cohabitating in a compatible growing environment for corn. The birth of this culinary creation occurred when colonists arrived in flocks from Europe eager to eat their staff of life—bread. But European grains, such as wheat, rye, and barley, struggled to survive in the heat, humidity, and poor soils along the coast. Additionally, the grain crops were frequently ravaged by pathogens and periodically destroyed by drought. Even in auspicious years, Old World grains yielded diminished harvests compared to the New World's indigenous corn. Today, corn produces more food energy, or calories, per acre than other cultivated grains.

The Rise of Baking Powder from the Ashes

European grains, such as hard winter wheat, were finely ground into flour, leavened with yeast, and baked in wood-fired ovens. Gluten in the wheat forms an elastic structural matrix that allows the carbon dioxide off-gassed by the yeasts to expand the volume of the loaves, creating more tender, lighter, softer tooth textures than the less desirable, unleavened hardtack. However, growing conditions in the Lowcountry, a world away from the European landscape, did not produce adequate wheat crops. When English colonists arrived in Charleston in the earliest decades of the 1700s and Savannah in the mid-1700s, many of the farmers began planting wheat and other European grains for their traditional baked breads, which did not acclimate to growing conditions in the Lowcountry environment. After numerous failed grain crops, colonists grudgingly adopted the grain introduced to them by Indigenous Americans, and corn largely replaced their beloved wheat.

In addition, grinding wheat required precisely milled stones, commonly powered by falling water. There were no adequate stones from parent material intrinsic to the Lowcountry environment. Furthermore, sufficient falling waters existed along the geological feature called the fall line, which demarcated the upper edge of the Coastal Plain in the interior of the territory. The solution to this conundrum was devised by the Salzburgers who settled the community of Ebenezer, near Savannah. When they immigrated from Germany (from parts of present-day Austria), they brought an exceptional variety of wheat that tolerated conditions in the Lowcountry environment; sadly, this valuable heirloom landrace of wheat is long lost. They also constructed a flour mill powered by moving water from the Savannah River.

While the lack of their familiar flour forced colonists to rely on Native American maize for baking breads, they also had to contend with a new method to make this novel grain concoction rise. Unlike wheat, corn does not contain gluten, and therefore the dough cannot support the slowly released gases long enough to bake as a risen loaf. Notably, in addition to introducing Europeans to corn cultivation, Indigenous Americans derived a natural soda, also known as potash or pearl ash, from wood ashes and employed it to leaven mixtures of ground corn and water. When alkaline pearl ash is mixed with an acid and a liquid it creates bubbles of carbon dioxide gas that expand, allowing cake, muffin, and pancake batters and quick bread doughs to rise.

Potash was used in the Netherlands to leaven quick breads, including gingerbread, as early as the 1300s CE. Amelia Simmons, the first American to publish a cookbook, *American Cookery*, in 1796, used pearl ash as leavening for quick breads, including those based on cornmeal. While Simmons invented the cupcake, it was *American Cookery* and her documentation of pearl ash that inspired all kinds of uniquely American cakes. Pearl ash also inspired an English chemist, Alfred Byrd, in the 1840s and a Harvard chemist, Eben Horsford, in the 1850s to improve and refine chemical leaveners, formulating the baking powder we use today.

Cooking Pot or Baking Oven

Before contact with Europeans, both Indigenous Americans and Africans predominantly relied on a single cooking pot for meal preparation. While Europeans regularly used cooking pots, their diet was also invested in grain production and baking bread. Beehive-shaped ovens, constructed above ground and heated by hardwood, baked not only breads but often the entire menu. Baked breads were among the first hand-held, "to-go" food items. While cooking pots tied eaters to the hearth, bread severed this restraint and facilitated individual or group travel far from home cooking fires. Traveling with lunch made tracking and moving livestock practical, as well as cultivating more distant and larger acreage of grains.

Indigenous Americans shared heirloom maize seeds with colonists and taught them how to cultivate the crop and harvest, dry, grind, and store the grain. The British generic term for all of their grains was corn, which included maize. Colonists also referred to dried ground corn as Indian meal. While Anglo-Europeans brought the expertise of constructing aboveground masonry ovens, the magic happened when the colonists mixed Indian meal with their scant wheat flour supply, a chicken egg, and sour milk to create the world's first cornbread. The uniquely American formula and procedure for cornbread may not have happened without distinctive multicultural contributions.

From Local Constraints to Cosmopolitan Options

The Columbian Exchange, launched just over five centuries ago when Christopher Columbus made his voyage to the Americas, accelerated the ancient and ongoing interchange of ideas and commodities, mixing up foodways around the globe. This dramatic opening up of the exchange of cultures would have a remarkable effect on the entire world. Widespread adoption of exotic edible plants and animals is as ubiquitous as it is historic. Humans are conspicuously opportunistic. How long before an exotic food item is considered not just fully integrated into but inseparable from the cultural foodways of its adopters? Consider barbecue, a long-revered core American dietary staple, which is based on slowly roasting relatives of the enormous hogs (*Sus scrofa*, with an adult weight of three to seven hundred pounds) that the Spanish conquistadors brought to the Lowcountry in the mid-1500s. How long did it take before barbecued pork as we know it was accepted as an "American" dish? Is the main ingredient in our barbecue American or Spanish? Or must we go back ten thousand years to the Fertile Crescent where pigs (and other livestock) were first domesticated to attribute proper credit

for the edible animal, as well as for the technique of roasting it over a fire? Remarkably, not only did Spanish sailors offload hogs; they also captured the diminutive guinea pigs (with an adult weight of two pounds) native to the Andes region of South America and carried them to Europe, where they were considered enchanting pets. Surprisingly, before 1500 CE, the largest mammal domesticated for food in the Americas was the guinea pig. American culinary fidelity complicates the question: Should we raise guinea pigs for pets or for dinner?

Biological and cultural transfers have provoked disorder when it comes to the provenance of many of our beloved foodstuffs. Although agricultural activities started around ten thousand years ago, we often identify cuisines through the lens of the relatively recent Columbian Exchange of the fifteenth and sixteenth centuries CE. The global diffusion of plants and livestock generated major transformations in ecosystems, agriculture, and distinctive cuisines. Edible plants and animals were traded, transported, domesticated, and selectively bred long before recorded history. In the Lowcountry, dietary options expanded from the earliest gathering and hunting to the inclusion of agricultural crops and then to an explosion of imported goods from worldwide sources. The transatlantic voyage landing in the New World in 1492 triggered unprecedented global exchange and consequential mixing of food traditions. Port cities along the southern coast such as Charleston, Savannah, and Darien reveled in exporting regional resources in exchange for exotic imports. The influence of exotic foods arriving at Lowcountry ports is still reflected in Lowcountry cookery. Culinary traditions worldwide and throughout time have been notably flexible and fluid, routinely including and discarding ingredients, techniques, and tools as improved options emerged.

Transitory Food Security of Industrial Agricultural Practices

An implicit message throughout this book is that the environment is the underpinning on which foodways develop. The food system is fundamentally dependent on a fully functioning environment, with ongoing interactions among climate, geography, geology, hydrology, and soils (edaphology), as well as ample biodiversity of living components (see, for example, chapter 6). These interconnected elements are the fundamental source from which originates every morsel of food, whether that food provides mere subsistence or a bountiful cuisine. However, we are witnessing increasingly frequent upheavals in the ubiquitous industrial food systems, disruptions that were exacerbated by a proliferation of international threats, such as a global pandemic, lingering war in regions of vital grain production, and an escalation of weather-related disasters fueled by climate change. Many links in the industrial food supply chain, including those between producers and the global transportation system, triggered countless, and often unexpected, problems that restricted food access and security. No country is exempt, as empty grocery shelves and starving families contribute to the probability of violence, civil wars, and political mayhem.

Our twenty-first-century industrial agricultural practices are not well suited for our unrelenting attachment to thinking of the environment as an unlimited resource. Agriculture that is dependent on fossil fuels, fertilizers, insecticides, and herbicides remains unrelenting as it plows full steam ahead, extracting finite resources from farmlands without provision for their renewal. Massive fields of monocrops, measured not in acres but in hundreds of square miles, as well as livestock in confined feeding operations, discharge greenhouse gases into the atmosphere, exacerbating climate change. Meanwhile industrial agriculture's outpouring of pollutants threatens the health and sustainability of our soils, drinking water, streams, rivers, and oceans. The illusion that productivity in agriculture should be the leading measure of success is approaching a collision with reality. Pending environmental consequences resulting from unconstrained resource withdrawal may be temporarily masked by remnants of unexploited abundance. Nonetheless, ultimately there is nowhere to hide from nature—our lives are inseparable from and thoroughly ruled by biology, chemistry, and physics. At our peril we ignore the adage coined by Rob Watson: "Mother Nature bats last and she always bats a thousand."

Modification of Plants through Time

The earliest humans were largely limited in their selection of foodstuffs by the menu of plants and animals afforded by their local environment, coupled with their capacity to acquire the items and render them edible. Over time, humans figured out how to save seeds from particular plants exhibiting desirable characteristics. Planting choice seeds year after year allowed the expression of anticipated traits to dominate. For example, Indigenous Americans domesticated corn (maize) from a close relative, the wild plant teosinte. Choosing desirable traits in annual maize harvests, they transformed the cobs of the diminutive wild teosinte, which were only two to three inches long with five to twelve kernels each, into twelve-inch cobs with five hundred or more kernels. Indigenous Americans also preferentially selected genes to soften the unbreakable coating encasing teosinte into a thin, film-like coating. Over the six to ten thousand years of domestication, Indigenous Americans targeted approximately 1,200 genes to transform wild teosinte into modern corn.

Lowcountry ecosystem conditions elicit significant challenges to agricultural crops: nutrient-poor soils that are remarkably low in nitrogen; negligible humus in soils, amplifying droughts; a hot, humid, semitropical climate that continues through a ten-month growing season, which also supports robust populations of herbivores including

insects, mammals, and birds. In addition, latitudes in the Lowcountry permit intense sunlight on most summer days, routinely desiccating crops. Winters in the Lowcountry are short and moderately cold with reduced sunlight, as solar rays in southern latitudes are cast at an angle subject to the earth's tilt on its axis. Food plants that not only survive these growing conditions but thrive through the long, harsh Lowcountry summers include corn, beans, squash, sweet potatoes, and peanuts native to Mesoamerica. Rice, field peas, okra, and watermelon native to West Africa also do well in this environment, as do collards, turnips, carrots, beets, and kale, which arrived from England (via the Fertile Crescent and Roman territory) and flourish in the Lowcountry in the mild winter season. These crops enjoy similar conditions in early spring and late autumn as they would in much of Europe.

The Power of Hope and the Reality of Adversity

Lowcountry residents have been routinely harvesting oysters for thousands of years. The endurance of this living resource is truly remarkable, but it's an anomaly. Much terrestrial wildlife that had been commonly consumed for thousands of years was decimated by hunters in the nineteenth century, including deer, turkey, bear, alligator, and several species of waterfowl. In recent decades, federal and state repatriation projects, wildlife research, laws regulating hunting, and ongoing game management made it possible to reinstate the opportunity to hunt these animals.

It can be shocking to consider that the only native foodstuffs remaining as part of a common diet for Lowcountry residents consist primarily of aquatic animals—bivalves, crustaceans, and fish from ocean salt water, brackish tidal creeks, and freshwater rivers and lakes. All of the other ingredients on Lowcountry menus are native to other countries. From corn to tomatoes, collard greens to hogs, and rice to watermelons, our culinary mainstays are essentially "foreign." Yet these interlopers became a unique strength of Lowcountry foodways. Seeds and livestock, meticulously selected, represented not just calories but a vision for creating afresh the best each culture could imagine in a strange new world.

Lowcountry foodways are the culmination of three centuries of unwelcome conflicts. The stage is the ever-present, evolving environment, in all of its unique living and nonliving glory. The earliest influences came primarily from three cultures. Indigenous Americans, through trial and error, perfected the art of mitigating environmental constraints while acquiring skills for advantageous use of inherent opportunities. City-dwelling colonists arrived from England lacking basic essential skills to subsist in a new landscape. Trade and tutelage from the Indigenous Americans were essential, enabling them to adapt to the utterly foreign environment. Africans taken from their homeland by force arrived with skills and knowledge that transferred remarkably well to the Georgia and Carolina Lowcountry, as they were accustomed to working in the environment and maintained many fundamental abilities, including farming, harvesting, gathering, and cooking.

In addition to environmental challenges, cultural collisions sparked unwelcome losses as well as fortuitous gains, leading to forced acceptance or glad embrace of new foods, customs, obligations, and expectations. Bite by bite, each meal for three hundred years in the Lowcountry nurtured the resurrection of hope from the cauldron of adversity. As we dine along the coast, we are eating tangible portions of the relationship between the environment and countless multicultural generations that cultivated a life in the Lowcountry.

Recipes are organized chronologically by arrival of the cultural group in the Lowcountry.

Native American
Anglo-European, Lowcountry 1734–1744
West African and African American

Social Roots Exclusive Recipes

MASHAMA BAILEY, cookbook author, co-owner and executive chef, the Grey, Savannah, Georgia; **ROOSEVELT BROWNLEE,** private chef, Savannah, Georgia; **BRANDON CARTER,** co-owner and executive chef, FARM, Bluffton, South Carolina, and Common Thread, Savannah, Georgia; **GRIFF DAY,** co-owner of Back in the Day Bakery, Savannah, Georgia, named "Best Bakery in the South" by *Southern Living* magazine; **B. J. DENNIS,** executive chef and caterer, Bluffton, South Carolina; **SALLIE ANN ROBINSON,** cookbook author and chef, Daufuskie Island, South Carolina; **SARAH V. ROSS,** coastal ecology researcher, chef, farmer, and hunter, Savannah, Georgia; and **DR. WILLIAM (DOC BILL) THOMAS,** physician, cookbook author, specialty crops grower, and chef, Sapelo Island, Georgia

Native American

Across the globe, humans have foraged wild plants for millennia. Foragers who could positively identify, process, and prepare wild plants lived to teach these skills to others. They passed on to the next generation not only their genes but their knowledge of exactly which plants were safe to eat and what part of the plant was safe; critical preparation techniques to purge toxins; and information about look-alikes that might be poisonous. Many plants we routinely consume, such as potatoes, have both edible and poisonous parts; we eat the tubers but never their toxic leaves.

Most residents in the Lowcountry today did not grow up learning about edible wild plants. Do not touch, pick, or taste any wild plant without a positive identification from more than one reliable source. There are excellent resources available written by experts who focus on native plant identification, which is entirely beyond the scope of this book. Recipes offered here are intended to highlight the types of plants that are native in the Lowcountry.

Spending time in nature, studying native plants in their ecosystems, and rethinking local food options will help build relationships with the landscapes that support us. Cultivating even a few food plants, buying from farmers markets, and cooking with local ingredients are a joyful way to reconnect with the landscape and indigenous foodways.

Authors of individual recipes are noted by initials at the end of the recipe.

❧ Pecan (*Carya illinoinensis*) and Pumpkin Seed (*Cucurbita* spp.) Spread

This delicious spread is quick and easy to make and remarkably multipurpose: use as a topping for plain rice, add to pasta as pesto, spread on toast for breakfast, add to tomato or cheese sandwiches, or spread on crostini for a quick appetizer.

⅓ cup extra-virgin olive oil, or sunflower oil
1½ cups unsalted hulled pumpkin seeds (pepitas)
¾ cup pecans
4 garlic cloves, chopped
½ cup dry white wine
1½ cups coarsely chopped fresh cilantro
4 scallions, chopped
2 tablespoons nutritional yeast
4 tablespoons fresh lime juice
Salt
Ground black pepper

In a large heavy skillet over low to moderate heat roast pumpkin seeds and pecans in about 1 tablespoon of the oil. Add salt and pepper to taste, stirring constantly until seeds are just starting to lightly brown. Add garlic and cook over low heat, stirring, 1 minute. Transfer to a cookie sheet and allow mixture to cool completely.

Pulse seed mixture in the food processor with wine, cilantro, scallions, nutritional yeast, lime juice, and remaining oil until mixture just comes together but is still coarse. Add salt and pepper to taste.

Approximately 2 cups SVR

❧ Roasted Squash Seeds

Cut squash in half lengthwise and scoop seeds from center. Rinse seeds clean from bits of squash. Dry seeds with a cloth. Sprinkle seeds with ⅛ teaspoon salt. Place on a baking sheet. Bake at 350°F for 10 to 12 minutes or until golden brown. SVR

❧ Sautéed Greenbrier Tips

PER SERVING:

4 or 5 greenbrier tips, approximately 4 inches in length
1 tablespoon butter or sunflower oil
6 pecans, chopped
Salt
Ground black pepper

Melt butter in a cast-iron frying pan, add greenbrier tips, and gently sauté until barely tender. Add chopped pecans and continue cooking a few minutes until nuts are lightly browned. Sprinkle with salt and pepper to taste. Serve warm. SVR

❧ Sunchokes

Indigenous people cultivated sunchokes for untold centuries in North America. Native to the central plains of the Midwest, sunchokes are easy to grow and thrive in a wide range of soil types.

Sunchokes can be cooked any way you would cook a potato: boiling, baking, roasting, stir-frying, steaming, or sautéing. Although sunchokes can be eaten raw, I suggest cooking, as raw consumption can cause gas in some individuals.

SUNCHOKE CHIPS

A simple method to prepare sunchokes is to wash them well (but there is no need to peel the tubers), slice thinly, and sauté in sunflower or other high-heat oil. Sprinkle with salt and enjoy delicious sunchoke chips.

Wash tubers well, dry them (but there is no need for peeling), slice thinly, toss in sunflower oil, and sprinkle with salt and pepper. Roast in a 400°F oven for 35 minutes. SVR

☀ Sunchoke and Wild Mushroom Soup

4 tablespoons sunflower oil, divided
1 large onion, chopped
1 pound mixed fresh mushrooms (chicken of the woods, lion's mane, morels, chanterelles, shiitake, oyster, button, or cremini)
4 garlic cloves, peeled and smashed
1 tablespoon fresh thyme leaves
7 cups chicken or vegetable stock
½ pound sunchokes, scrubbed and sliced
½ pound Yukon Gold potatoes, scrubbed and cubed
¾ teaspoon salt
¼ teaspoon ground black pepper
1 tablespoon fish sauce
1 tablespoon freshly squeezed lemon juice
¼ cup chopped fresh chives
12 fresh whole sage leaves, fried in sunflower oil

In a Dutch oven, heat 2 tablespoons of oil over medium heat. Add onion and gently fry until translucent, then remove from pot and reserve. Heat remaining 2 tablespoons oil over medium heat and add mushrooms. Without stirring, gently cook mushrooms until lightly browned on one side. Add garlic and thyme and sauté 1 to 2 minutes. Return onions to pot and add stock, sunchokes, potatoes, salt, pepper, and fish sauce. Gently simmer for 25 minutes.

When potatoes are fork tender, remove pot from heat. Using an immersion blender (or regular blender), blend until smooth. Stir in lemon juice and chives. Taste and adjust seasonings as needed. Ladle into bowls and place fried sage leaves on top. Serve hot.

Serves 6 SVR

☀ Pumpkin (*Cucurbita* spp.) Soup with Roasted Sunflower Seeds (*Helianthus annuus*)

4 tablespoons (½ stick) butter
2 leeks, thoroughly washed and sliced crosswise
2½ cups fresh or canned pumpkin puree
1 teaspoon salt
1 teaspoon sugar
½ teaspoon freshly grated nutmeg
½ teaspoon freshly ground black pepper
½ teaspoon fresh minced thyme
1 quart chicken stock, preferably homemade
⅓ cup pecan butter
½ cup shelled sunflower seeds, roasted at 300°F for 11 minutes
2 tablespoons minced fresh parsley

Melt butter in a large saucepan and sauté leeks over gentle heat for 10 minutes. Add next eight ingredients and simmer for 15 minutes. Ladle into bowls and sprinkle the sunflower seeds and parsley on top.

Serves 6 SVR

❧ Wild Turkey Sauce

4 slices hickory smoked bacon, diced
1 large onion, chopped
1 red bell pepper, chopped
3 garlic cloves, finely sliced
1 teaspoon smoked mild paprika
2 pounds ground turkey
2 cups chopped fresh tomatoes or 1 (28-ounce) can whole
 tomatoes, chopped
2 teaspoons sumac powder
1 teaspoon salt
1 teaspoon ground black pepper
¼ cup fresh parsley, roughly chopped
¼ cup fresh basil, roughly chopped
¼ cup invasive wild garlic mustard (*Alliaria petiolata*),
 diced (optional)
¼ cup fresh chives, roughly chopped

In a Dutch oven, cook bacon over medium heat. Remove bacon and reserve, leaving the fat in the pot. Add onion and bell pepper, and sauté over medium heat for 10 minutes, stirring as needed. Add garlic and paprika, and cook 3 to 4 minutes. Remove vegetables from pot and reserve. Cook turkey on medium-high heat until completely browned, about 8 minutes, adding a tablespoon of oil if the meat is sticking. Return vegetable mixture and bacon to the pot; add tomatoes, sumac powder, salt, black pepper, parsley, basil, and wild garlic mustard, if using. Simmer 10 minutes. Serve hot on corn and bean tortillas and sprinkle chives on top.

Serves 6 SVR

❧ Corn and Bean Tortillas

2½ cups white corn flour or finely ground cornmeal
¾ cup cooked beans (pinto, kidney, navy, or lima),
 mashed
½ teaspoon salt
2 cups boiling water

In a large bowl combine flour, beans, and salt. Stir in boiling water. Dough will be hot, so dip hands in iced water and then form the dough into balls the size of ping-pong balls. Flatten each ball into a 4-inch circle by hand or using a tortilla press. Cook the tortillas in a large pot of simmering water for 30 minutes. Drain in a colander. Serve hot topped with tomato and wild turkey sauce.

Serves 6 SVR

❧ Fried Squash Blossoms (*Cucurbita* spp.)

6 to 8 squash blossoms
¾ cup whole wheat pastry flour, sifted
¼ teaspoon baking powder
¼ teaspoon salt
½ cup nut milk (almond, cashew, macadamia)
¾ cup yellow corn flour
1 cup sunflower or peanut oil

Harvest male squash blossoms early in the morning. Rinse in cold water. Combine flour, baking powder, salt, and nut milk. Dip blossoms into flour mixture and then into corn flour. Heat oil in a cast-iron pan to 350°F and fry the blossoms, turning once, until both sides are golden brown and crisp. Serve immediately. SVR

❧ Elder (*Sambucus canadensis*) Flower Fritters

Elderberry is one of the most commonly used medicinal plants in the world. The uncooked berries, leaves, bark, and roots of the plant contain the chemicals lectin and cyanide, which can cause nausea, vomiting, and diarrhea. Cooking the berries and seeds will remove the cyanide.

2 egg whites, whipped to very soft peaks
⅔ cup all-purpose flour, sifted
¼ teaspoon salt
½ cup ginger ale
½ teaspoon Cajun seasoning
Peanut oil
16 clusters of elder flowers

Gently combine beaten egg whites, flour, salt, and ginger ale. Add Cajun seasoning and mix well.

Pour peanut oil into frying pan to a depth of two inches. Hold the flower clusters by the stem and dip in batter, shaking gently to release excess batter. Lower into the hot oil, and allow the flowers to spread out in the pan. Cook until golden brown, carefully remove with tongs, and drain on a wire rack (not paper towels!). Before serving, lightly sprinkle warm flower clusters with a bit more Cajun seasoning. *The elderflower stems should not be consumed.*

To make as a dessert rather than as an appetizer, leave out the Cajun seasoning and substitute 1 teaspoon sugarcane syrup, sorghum, or maple syrup and ½ teaspoon vanilla extract, then cook as directed.

Serves 6 to 8 SVR

❧ Grape Leaves (*Vitis* spp.) or Collard Greens (*Brassica oleracea* var. *acephala*) Stuffed with Pearl Millet (*Pennisetum* spp.) and Smoked Quail (or Chicken)

1 tablespoon peanut oil
½ cup finely chopped onion
2 jalapeño peppers, seeded and minced
2 garlic cloves, minced
½ teaspoon ground cumin
1 teaspoon sumac powder
3 ½ cups quail or chicken stock, preferably homemade, divided
1 cup pearl, teff, or fonio millet
¾ teaspoon salt (if there is no salt in the stock)
1 teaspoon grated lemon rind
¼ cup dried peaches or apricots, minced
¾ cup smoked quail or cooked chicken, finely chopped
½ cup pecans, lightly toasted in a dry skillet, then minced
24 grape leaves, freshly harvested or from a jar (if using canned, rinse to remove brine), or 12 tender young collard leaves, preferably an heirloom variety from your own garden
½ cup dry white wine
Juice from 1 lemon
3 tablespoons olive oil

Heat peanut oil in a large sauté pan, add onion and jalapeño peppers, and cook over medium heat 3 to 5 minutes. Add garlic, cumin, and sumac, and cook another minute. Add 3 cups stock, millet, salt (if needed), lemon rind, and dried peaches. Cover and simmer for 15-minutes. Remove from heat, and stir in chopped quail and pecans.

While millet mixture is cooking, remove center rib from leaves. Simmer for 4 minutes (for wild grape or heirloom young collard leaves) or parboil for 10 minutes (for commercially available collard leaves). Drain and submerge

leaves in chilled water to stop cooking. If using collards, trim to approximately 3- to 4-inch-square sections; if using grape leaves, leave them whole.

Lay leaves shiny side down (vane side up) on counter and place 2 tablespoons of filling on the center of each leaf. Fold in both sides and top and bottom of each leaf and roll. Arrange in a shallow baking pan so each roll supports the others. Combine remaining ½ cup stock, wine, lemon juice, and olive oil and pour on top of stuffed rolled leaves. Bake at 325°F for 45 minutes.

Serves 6 to 8 SVR

🎋 Yaupon Holly Tea (*Ilex vomitoria*)

Native Americans in the southeastern Coastal Plain discovered the only naturally occurring source of caffeine in their environment in a native holly (*Ilex vomitoria*), commonly called yaupon. They developed a simple method of extracting caffeine for consumption by roasting the leaves and stems and then boiling them, analogous to methods of preparing tea or coffee today. According to anthropologist John Reed Swanton, "Around 1595 Fray Andres de San Miguel described the use of cassina by the Guale Indians living near the present location of St Simons Island, Georgia. After parching the cassina leaves in an earthenware pot, the Guale added water and brought the decoction to a boil, while it was still boiling they drew some of it off and drank it hot" (as noted in Charles M. Hudson, *Black Drink: A Native American Tea* [Athens: University of Georgia Press, 1979], 52). While this native American tea, referred to as black drink, was consumed by high-ranking men in religious ceremonies, it was also enjoyed as a social beverage and as a psychological or physiological stimulant.

With such an unappealing Latin name, it is a wonder any European ever tasted this remarkable tea. There are at least two theories about how the plant received the name *Ilex vomitoria:* that Europeans incorrectly believed the plants reliably caused vomiting, or that the moniker was fabricated as a marketing tool to encourage the purchase of imported British teas. (It is possible that yaupon could have caused vomiting if it was brewed strongly and then consumed in vast quantities while one was fasting. There are also suggestions that Native Americans intermittently used sea water to brew the tea and may have added other herbs with known emetic elements.) *Ilex vomitoria* and, to a much lesser extent, *I. cassine*, are the only two plants native to North America that contain caffeine. Now widely accepted as an exceptionally healthy beverage, yaupon tea has about the same amount of caffeine as green tea and noteworthy amounts of antioxidants and flavonoids.

Harvest yaupon leaves from either female or male trees, but if there are red berries on the female plants be sure to remove and discard them. Lightly roast the leaves in a 325°F oven for about 25 minutes, until they are light to medium brown. Let the leaves cool, at which point they will be easy to separate from the stems. Store the dried leaves in a glass jar. To make tea, crush 2 teaspoons of whole leaves for each cup. Place crushed leaves in a teapot, add 6 ounces of boiling water per cup, and let steep for 5 or more minutes.

If you can't find fresh yaupon leaves, ASI, a company in Savannah, produces and distributes yaupon tea in packages ready to brew at home. SVR

☸ Prickly Pear Cactus (*Opuntia* spp.) Fruit Syrup

For use in cocktails or desserts or over pancakes

12 large or 24 small freshly harvested prickly pear cactus fruits
½ cup ginger ale
2 cups sugar
Juice of 1 lemon

Harvest cactus fruits with tongs while wearing protective gloves. (Be careful: the fruits as well as the pads [leaves] harbor tiny, hard-to-see spines as well as the more obvious long spines.) Place fruits in a large saucepan, crush with a potato masher, and add ginger ale. Simmer for 15 to 20 minutes. Cool and strain through four layers of cheesecloth lining a metal strainer or colander; don't press pulp, but instead let it slowly drain overnight. Pour strained liquid into a clean saucepan and add sugar and lemon juice. Gently simmer 5 minutes while skimming off surface scum.

3 cups SVR

☸ Other Simple Succulent Food Uses

SPIDERWORT (*TRADESCANTIA VIRGINIANA*) FLOWERS

Fresh in salads or as plate garnishes, spiderwort flowers are absolutely beautiful and are indigenous to the Lowcountry.

PRESERVED SPIDERWORT FLOWERS

Harvest newly opened flowers early in the morning. Let flowers dry inside. Froth 2 egg whites and dip flowers into whites. Dust confectioner's sugar through a strainer onto egg-white covered flowers. Place each blossom on a baking tray and leave in refrigerator overnight. The next day, remove tray and leave at room temperature to cure. When completely dry, store in glass jar up to two months.

YUCCA (*YUCCA ALOIFOLIA*) FLOWERS

Like spiderwort flowers, yucca blossoms are delicious raw in salads or garnishing almost any dish.

GLASSWORT (*SALICORNIA* SPP.) AND SALTWORT (*BATIS MARITIMA*)

Boil in unsalted water for one minute, then drain and toss with butter. SVR

☸ Sautéed Glasswort or Saltwort

2 cups glasswort or saltwort
1 tablespoon peanut oil or butter
2 garlic cloves, thinly sliced
2 tablespoons benne (sesame) seeds

Soak glasswort or saltwort in fresh water for 20 minutes and drain. Sauté in peanut oil with thinly sliced garlic and benne seeds for a few minutes.

Serves 6 to 8 SVR

☸ Three Sisters Smoked Venison Meatloaf

5 strips of bacon, diced
1¼ cup chopped onion
2 jalapeño peppers, seeded and minced
¾ cup fresh corn grated from the cob
2 garlic cloves, minced
½ cup beef or chicken stock
1 cup diced dried tomatoes, divided
2 pounds ground venison or beef
2 eggs, lightly beaten
1½ teaspoons salt, divided

½ teaspoon freshly ground black pepper

½ cup cooked winter squash (butternut, acorn, etc.), pureed

½ cup cooked pinto beans, pureed

½ cup crumbled leftover cornbread

2 teaspoons fish sauce

⅓ cup sorghum or sugarcane syrup

3 tablespoons apple cider vinegar

Sauté bacon in a large heavy pot for a few minutes over medium heat. Stir and add ¾ cup onion. Lower heat and cook, stirring occasionally, for about 15 minutes. Add jalapeños and corn and cook another 10 minutes, stirring as needed to prevent sticking. Add garlic and cook a minute or two. Meanwhile simmer stock and ½ cup dried tomatoes for 10 minutes. Remove bacon mixture from heat and pour in stock and tomato broth. Add venison, eggs, 1 teaspoon salt, pepper, winter squash, pinto beans, cornbread, fish sauce, and sorghum and mix well.

Grease a cast-iron loaf pan, add venison mixture, cover with aluminum foil, and place in smoker. Cook at 225°F for 2 hours.

Meanwhile, to prepare the topping, combine remaining ½ cup sundried tomatoes, remaining ½ cup onion, sorghum, vinegar, and remaining ½ teaspoon salt. Mix well, simmer for 20 minutes, and puree.

After the venison mixture has cooked for 2 hours, remove foil, cover with topping, raise heat to 375°F, and cook an additional 30 minutes.

Serves 6 to 8 SVR

✺ Smoked Quail

Wrap each quail in one slice of bacon, place in smoker heated to 225°F, and cook for 40 minutes.

✺ Smoked Mullet

Freshly caught mullet are key. In the Lowcountry the saying goes, "You've gotta cook mullet on the tide in which they were caught"—in other words, as soon as you get back home with your catch. Clean the fish, cutting the length of the belly to open the fish flat. A bit of salt is all that is needed, but you can sprinkle the fish with your favorite seasoning. Place in a smoker heated to 185°F and slow cook for 90 minutes. You may want to preemptively invite the neighbors, as they will smell the mullet smoking and come over to see what you are having for dinner. SVR

✺ Succotash

This recipe is scaled for a family, but you can simply multiply the quantities to feed a crowd.

2 slices bacon, chopped

¾ cup diced red bell pepper (*Capsicum annuum*)

2 cups lima beans (*Phaseolus lunatus*), preferably heirloom varieties such as Christmas, Florida, Speckled, Baby Fordhook, fresh or frozen

Corn cut from 6 fresh cobs (*Zea mays*)

½ teaspoon salt

Freshly ground black pepper

Sauté bacon over medium heat for 5 minutes in a medium-large Dutch oven, reduce heat, add red pepper, and gently fry until tender. Add the beans, cover with water, and simmer until tender—15 minutes for frozen beans, about 30 minutes for fresh. Add the corn and salt. Cook gently for 3 minutes. Reduce the heat to low and cook, without stirring, until the liquid is reduced, 5 to 10 minutes. Season with black pepper and serve immediately.

Serves 6 to 8 SVR

⚘ Squash (*Cucurbita* spp.), Black Bean (*Phaseolus vulgaris*), and Corn (*Zea mays*) Soup

3 tablespoons peanut oil
3 cups peeled and diced butternut or candy roaster squash
1½ cups fresh corn kernels
1 medium red onion, chopped
¾ cup chopped red bell pepper
½ teaspoon ground cumin
2 garlic cloves, minced
2 cups chicken stock
1 (14½-ounce) can diced tomatoes, undrained
2 tablespoons minced fresh sage leaves
1 chipotle pepper in adobo sauce, chopped
1 (15-ounce) can black beans, rinsed and drained
2 cups harvested edible wild greens or fresh spinach

In a large Dutch oven, heat oil over medium heat and sauté squash, corn, onion, bell pepper, and cumin for 10 to 15 minutes. Reduce heat and add garlic to the pot, cooking for another 1 to 2 minutes. Add stock, tomatoes, sage, chipotle pepper in adobo sauce, and beans. Simmer 15 minutes or until squash is tender. Add greens and cook 2 more minutes. Serve hot.

Serves 6 to 8 SVR

⚘ Pecan (*Carya illinoinensis*) and Indian Meal (*Zea mays*) Cake

4 large eggs, divided
1 cup peanut oil
1 cup sugar or ⅔ cup light molasses
Juice and zest from 1 lemon
1 tablespoon minced fresh thyme leaves
½ teaspoons ground cardamon
1½ cups finely ground cornmeal or corn flour
½ cup pecans, or hazelnuts, ground in a food processor into meal
1 teaspoon baking powder
½ teaspoon salt
½ cup hickory nuts, chopped

Preheat oven to 350°F. Butter a 9-inch round cake pan and line bottom with parchment paper. Butter and flour parchment paper.

Beat egg whites to medium-stiff peaks and set aside. In a large bowl, beat oil and sugar. Beat in egg yolks, lemon juice, zest, thyme, and cardamon.

In a separate bowl, whisk cornmeal, pecan meal, baking powder, and salt. Add to the creamed mixture and beat on low until just combined.

Gently fold in beaten egg whites.

Pour into prepared pan, top with hickory nuts, and bake for about 40 minutes, or until the top is golden brown and a cake tester inserted into the middle comes out clean. Cool on a rack 10 minutes, then invert cake onto a rack and turn right side up.

Serves 10 to 12 SVR

☙ Cattail (*Typha latifolia, T. angustifolia*) Pollen Skillet Cornbread

3 tablespoons butter
1 large egg
2¼ cup whole buttermilk
1¾ cups cornmeal
1 teaspoon salt
1 teaspoon baking powder
3 tablespoons cattail pollen
2 teaspoons sumac powder

Place butter in a 9-inch cast-iron skillet and melt in a 425°F oven. In a medium-sized mixing bowl, whisk egg, then add buttermilk. Stir in remaining ingredients. Remove hot skillet from the oven and pour the melted butter into the batter. Stir the batter, then pour it into the hot skillet. Bake for 20 to 25 minutes, until browned and edges are pulling away from sides of the skillet. Serve with the best butter you can find and sugarcane syrup or sorghum.

Serves 6 SVR

Anglo-European, Lowcountry 1734–1744

While colonists emigrated to the Lowcountry from numerous countries, French Huguenots made up 21 percent of the population in Charleston, South Carolina, in 1723. In 1734, Germanic Salzburgers settled twenty-five miles north of Savannah and established themselves among the most successful colonists in the region, thanks to their advanced agricultural and technological competence. With respect to the many nationalities in the Lowcountry from 1734 to 1744, space limitations guide the focus of these recipes on Anglo-European traditions.

Brandon Carter is executive chef and partner at Farm in Bluffton, South Carolina, and co-executive chef in his sister restaurant, Common Thread, in Savannah, Georgia.

Chef Carter was raised in Georgia and graduated from the Culinary Institute of America in Hyde Park, New York. He perfected his cooking skills at some of the top restaurants in the Southeast before moving to Bluffton to become the head of culinary operations for Palmetto Bluff.

☙ May River Blue Crab Rice

PEPPER PASTE

3 tablespoons olive oil
4 garlic cloves, sliced
1 red bell pepper, julienned
1 Vidalia onion, julienned
2 habanero chilis, halved, seeded, and julienned
Kosher salt

Heat olive oil in a skillet over medium-high heat. Toast garlic lightly. Add pepper, onion, and chilis and lightly caramelize. Season with salt to taste. Puree in a blender and reserve.

SOFRITO

¼ cup olive oil
4 garlic cloves, sliced
1 Vidalia onion, small diced
1 red bell pepper, small diced
Kosher salt

Heat half of the olive oil in a skillet over medium-high heat. Toast garlic lightly, add pepper, and cook until the temperature of the pan returns to medium-high heat. Remove garlic and peppers from the skillet and reserve. Heat the remaining half of the olive oil in the skillet and cook the onions until translucent. Season with salt to taste and reserve.

4 cups canola oil
4 shallots, sliced ⅛ inch thick on mandolin
Kosher salt

Heat oil in a 4-quart pot to 300°F. Add shallots and fry, stirring occasionally, just until they start to brown. Strain shallots and reserve the oil for second fry. Return the oil to the pot and heat to 350°F. Return shallots to the oil and fry until golden brown. This will happen very quickly, so be sure to keep your eye them. Remove the shallots, once again reserving the oil. Drain the crispy shallots on paper towels and season with salt to taste. Set shallots and oil aside.

TO FINISH

¼ cup shallot oil
1 pound crabmeat, picked
3 cups cooked Carolina Gold rice
1 cups sofrito (from above)
1 cup pepper paste (from above)
1 tablespoon Old Bay Seasoning
Juice of 2 lemons
Kosher salt to taste
¼ cup roasted peanuts, chopped
¼ cup crispy shallots (from above)
¼ cup sliced green onions

Heat shallot oil in a large nonstick or well-seasoned cast-iron skillet over medium-high heat. In a mixing bowl combine crabmeat, rice, sofrito, pepper paste, Old Bay Seasoning, and lemon juice. Season with salt, and mix to combine. Add to the pan once it is hot. Allow the rice to brown and get crispy, then stir and repeat. Once the rice is hot and it has a good amount of crispy bits, divide between four bowls and garnish the tops with peanuts, shallots, and green onion.

Serves 6 to 8 BC

⚑ May River Oyster Sausage

2 tablespoons olive oil
2 large garlic cloves, sliced
½ cup small-diced Vidalia onion
½ cup small-diced red peppers
¼ cup small-diced celery
⅔ cup oyster liquor (liquid saved from shucking the oysters)
½ cup Carolina Gold rice
9-ounce pork shoulder
9 large shrimp, peeled and deveined
1 tablespoon kosher salt
⅓ cup heavy cream
2 egg whites from medium-sized eggs
6 ounces shucked oysters
¼ teaspoon ground cayenne
½ teaspoon toasted and ground coriander seed
2 teaspoons lemon zest
1 tablespoon sliced fresh chives
2 teaspoons chopped fresh thyme
3 feet hog casings

Prepare the meat grinder (stand mixer with meat grinder attachment) by placing the metal parts in the freezer for at least one hour.

Heat olive oil in a skillet and sweat the garlic, onions, pepper, and celery until they are translucent. Transfer the vegetables to a baking sheet and chill in the refrigerator.

Heat the oyster liquor in a small saucepot over high heat until it comes to a boil. Stir in the rice, cover, and reduce heat to low. Cook for 5 minutes, remove from the heat, and let sit covered for 15 minutes. Spread the rice on a baking sheet and chill in the refrigerator.

Cut the pork and shrimp into pieces that will fit into your grinder. Combine and mix with the salt. Spread in a single layer on a baking sheet and place in the freezer until the meat gets a little crunchy on the outside. Grind through a medium-sized die.

In a metal mixing bowl, whisk together the heavy cream and egg whites. In another bowl combine the pork, shrimp, cooked rice, oysters, sweated vegetables, cayenne, coriander seed, and lemon zest. Put both bowls in the refrigerator and chill for at least 1 hour.

Working in three batches, process the meat mixture in a food processor. When the mixture starts to become smooth, slowly add liquid ingredients while the processor is still running. Transfer the mixture to a bowl, add the chives and thyme, and mix by hand to combine.

Rinse the hog casings under cold water and soak for 20 minutes.

Using a sausage stuffer attachment, shoot the sausage mixture into the casings.

Twist the sausages into 3-inch lengths. Using butcher's twine, tie off the sausages. Poach the sausages in 180°F water to an internal temperature of 155°F.

Chill sausages in cold running water.

Store in the refrigerator until you're ready to eat. To finish, cook the sausages in brown butter or on the grill.

Serves 6 to 8 BC

🎯 Salsa Macha, Fried Onions, and Refried Speckled Mayo Peas

SALSA MACHA

¾ cup olive oil
5 garlic cloves
½ cinnamon stick
3 allspice berries
1 teaspoon dried cumin seed
½ ounce pequin chilis
½ ounce guajillo chilis, stemmed and seeded
2 teaspoons kosher salt
3 tablespoons brown sugar
⅓ cup apple cider vinegar

Heat olive oil over medium heat until it starts to shimmer. Add garlic and fry until golden brown. Add the spices and chilis and toast until fragrant, about 1 minute. Remove from heat and add the remaining ingredients. Allow to cool for about 15 to 20 minutes; remove cinnamon stick and discard. Process remaining ingredients in a blender until smooth.

FRIED ONIONS

1 quart canola oil
½ Vidalia onion, sliced crosswise to ⅛ inch thick
Kosher salt
⅓ cup cornstarch

Heat oil in a 5-quart pot to 300°F. Season onions with salt and then toss with just enough cornstarch to coat. If the onions start to clump together, add more cornstarch and toss to coat again. Add the onions to the oil and fry, stirring occasionally, until golden brown. Remove onions from oil, drain on paper towels, and season with salt to taste.

REFRIED SPECKLED MAYO PEAS

3 tablespoons olive oil
2 garlic cloves, sliced
1 shallot, peeled and sliced
4 cups speckled mayo peas, cooked until creamy
Juice and zest of 1 lemon
½ to ¾ cup vegetable stock, as needed
Kosher salt
Ground black pepper
2 ounces farmer cheese or feta (¼ cup), crumbled

Heat the olive oil in a sauté pan. Add the garlic and shallot; cook until translucent. Add the peas, lemon juice, and lemon zest and cook until warm. Transfer the contents of the pan to a food processor and process until smooth. Adjust consistency with vegetable stock, as needed, until the peas have a smooth texture. Season to taste with salt and pepper. Serve with crumbled cheese, salsa macha, and fried onions.

Serves 6 to 8 BC

🦐 Wormsloe's Potted Shrimp

¼ pound (1 stick) butter (clarified, if possible)
1 pound locally netted shrimp, peeled and deveined
½ cup sliced shallots
2 tablespoons fresh thyme leaves
1 tablespoon freshly grated ginger
½ teaspoon freshly grated and sifted nutmeg
¼ cup gin
⅓ cup dry sherry
¼ teaspoon salt
¼ teaspoon freshly ground pepper
2 teaspoons hot sauce
2 tablespoons lemon juice
Butter, softened

Melt 2 tablespoons of the butter in a cast-iron skillet over medium heat. Add shrimp, shallots, thyme, ginger, and nutmeg. Stir to combine ingredients. Cook 3 minutes, then remove shrimp and reserve. Add gin and sherry to the shallot-herb mixture in skillet. Allow to gently simmer until liquid is reduced by half. Remove from heat and add salt, pepper, hot sauce, and lemon juice. Combine with shrimp in a food processor and pulse until shrimp are reduced to ¼-inch chunks.

To store, transfer mixture to a wide-mouth jar and spread butter over the shrimp mixture to a depth of ½ inch. Refrigerate up to three days.

Serves 8 as an appetizer SVR

🦐 Jones's Creek Pickled Shrimp

2 pounds large locally netted shrimp
1 tablespoon mustard seeds
1 teaspoon celery seeds
1 teaspoon crushed dried red pepper
1 teaspoon salt
2 teaspoons sugar
1 cup apple cider vinegar
¼ cup gin
Juice and zest of 3 lemons
1 lemon, thinly sliced
1 cup Georgia olive oil
½ teaspoon freshly ground black pepper
5 garlic cloves, minced
½ Vidalia onion, thinly sliced into crescents
3 tablespoons chopped fresh dill
3 tablespoons chopped fresh parsley

Bring a large pot of water to a boil. Add the shrimp and simmer 1 to 2 minutes, just until flesh becomes opaque. Do not overcook. Drain in a colander, rinse with cold water, then submerge in a large bowl of iced water until thoroughly chilled. Peel and devein shrimp.

Place mustard and celery seeds, dried red pepper, salt, and sugar in a mortar; grind with the pestle. Place in a large bowl, add shrimp and remaining ingredients, and mix well. Cover and refrigerate 1 to 3 days. Serve chilled.

Serves 8 as an appetizer BC

❧ Chicken Liver Pâté with Neighborhood Pears and Sage

Kieffer pears are especially hardy, flood and drought resistant, and heat tolerant. They are the most widely planted pears in the South and thrive in backyards throughout the Lowcountry. These are not the best pears to eat raw, as the skin is rough and the flesh very firm even when ripe, but they are ideal for preserves, pear honey, canning, or baking. They are ripe when the skin color turns from green to yellow.

3 strips bacon, cut into 1-inch pieces
1 large Vidalia onion, chopped
6 shiitake mushrooms, chopped
⅜ pound (1½ sticks plus 1 tablespoon) butter, divided
1 ripe Kieffer pear (or underripe commercial variety), peeled, cored, and chopped
1 tablespoon minced fresh thyme leaves or 1 teaspoon dried
1 tablespoon minced fresh sage leaves or 1 teaspoon dried
1 pound chicken livers, membranes removed, rinsed well
½ cup brandy, Madeira, dry white wine, or apple juice
¼ teaspoon freshly grated nutmeg
1 teaspoon freshly ground black pepper
½ teaspoon salt
⅓ cup heavy cream

Cook bacon and onion in a large cast-iron skillet over low heat. Remove bacon and onion and place into the bowl of a food processor.

Add mushrooms and 4 tablespoons (½ stick) butter to the skillet along with any remaining bacon fat and gently sauté over medium heat 5 minutes. Add 4 more tablespoons (½ stick) butter, pear, thyme, and sage, and cook 10 minutes. Scrape mixture into the food processor with the bacon. Process until smooth.

Add chicken livers, brandy, nutmeg, pepper, and salt to the skillet and gently simmer until livers are half-cooked and still pink in the middle. Add liver mixture and cream to food processor and process until smooth, then add 4 tablespoons (½ stick) butter and blend again. Warm the remaining tablespoon of butter and spread on top of pâté. Refrigerate an hour or until thoroughly chilled. Serve with a rustic, crusty bread.

Serves 6 as an appetizer SVR

❧ Glasswort or Samphire (*Salicornia* spp.)

1 pound freshly harvested glasswort or samphire
2 tablespoons olive oil
2 garlic cloves, minced
1 tablespoon lemon juice
Freshly ground black pepper

Fill a large saucepan half full of water and bring to a boil. Add glasswort and simmer 2 to 3 minutes. Remove with a slotted spoon and transfer to a large bowl of very cold water. When glasswort is cool, drain and remove any fibrous parts. Place cold glasswort in a medium bowl and toss with oil, garlic, and lemon juice. Season with pepper to taste.

Serves 6 to 8 SVR

🦀 Jones's Creek She-Crab Soup

The English colonists encountered Atlantic blue crabs in great abundance and therefore considered their populations to be limitless. But after more than a century of overharvesting, pollution, and habitat destruction, crab populations have plummeted. Ecological efforts today to preserve crabs discourage harvesting females, and it is illegal in many coastal states to harvest female crabs with roe on their undersides ("sponge crabs"). Be sure to check regulations regarding size as well as gender, which vary by state. Mature male blue crabs, or "Jimmies," have a strongly tapered apron on their undersides that resemble the Washington Monument. Mature female blue crabs, or "Sooks," have a broad, rounded apron resembling the U.S. Capitol dome. Crabbing is best in the summer months, when the adult crabs migrate to shallow waters to spawn.

To capture the velvety texture of the original version of this Lowcountry soup, the following recipe replaces crab roe with egg yolks.

3 tablespoons butter
½ Vidalia onion, minced
2 stalks celery, finely minced
1 garlic clove, finely minced
½ teaspoon ground mace
½ teaspoon paprika
1 teaspoon tomato paste
⅓ cup sherry
3 cups seafood (or chicken) stock
2 raw egg yolks, beaten lightly
2 hard-boiled egg yolks, pressed through a sieve
2½ cups heavy cream

1 pound jumbo lump crab meat
1 teaspoon salt
1 teaspoon Worcestershire sauce
2 tablespoons chopped fresh chives

Melt butter in a large Dutch oven over low-medium heat. Add onion and celery and cook gently until softened; do not allow vegetables to brown. Add garlic, and cook until softened. Stir in mace, paprika, and tomato paste and cook for 30 seconds over low heat. Add the sherry and gently simmer 5 minutes. Puree in a countertop blender or with an immersion blender.

Add stock and bring to a low simmer. Remove one cup of warm stock, let cool to 180°F, and slowly whisk into the beaten egg yolks. When thoroughly blended, add the stock–egg yolk mixture to the Dutch oven and whisk until the hot stock thickens. Add all remaining ingredients except for the chives and gently heat to just below a simmer. Top with chives.

Serves 6 SVR

🦀 Wormsloe Oyster Soup (*Crassostrea virginica*)

6 tablespoons (¾ stick) butter, divided
½ cup finely chopped celery
1 leek, thoroughly washed, sliced crosswise
¼ cup vermouth
¼ cup gin
3 tablespoons flour
4 cups chicken stock, preferably homemade
1 quart fresh oysters, drained, with liquid reserved
½ cup cream
¼ cup chopped chives, cut into ½-inch pieces

Add 3 tablespoons butter to a skillet. Cook celery and leek over medium heat until soft, but do not brown. Add

vermouth and gin, and simmer until liquids are reduced by half. Puree mixture in a countertop blender or with an immersion blender.

Melt remaining 3 tablespoons butter in a large saucepan, and stir in flour. Slowly whisk in chicken stock until smooth. Stir in oyster liquid and cream. Add celery and leek mixture and heat through. Add drained oysters and heat to barely a simmer. Cook just until edges of the oysters start to curl. Sprinkle chives on top and serve immediately.

Serves 6 SVR

Leek and Stilton Soup

6 tablespoons unsalted butter
6 medium leeks, trimmed, washed, and finely chopped
2 stalks celery, roughly chopped
2 large baking potatoes, peeled and diced
7 cups chicken stock
2 tablespoons minced fresh thyme leaves
Salt
Freshly ground black pepper
½ cup cream
10 ounces (½ cup) Stilton cheese, crumbled
2 tablespoons thinly sliced fresh chives

Melt butter in a Dutch oven over medium-low heat. Add leeks and celery and cook until soft, about 8 minutes. Add potatoes, stock, thyme, salt, and pepper and gently simmer for 30 minutes. Remove soup from the heat and allow to cool for 10 to 20 minutes. Puree soup with an immersion blender until smooth. Add cream and Stilton and blend again. Sprinkle chives on top of soup before serving either warm or chilled.

Serves 6 to 8 SVR

Quarters Field Vegetable Soup

6 cups chicken or vegetable stock
4 medium potatoes, peeled and diced
2 cups coarsely chopped green cabbage
2 leeks, diced
1 large onion, chopped
⅓ cup chopped parsley
1 teaspoon salt
¾ teaspoon freshly ground black pepper
½ teaspoon ground mace
¾ teaspoon caraway seeds
2 bay leaves
½ pound bacon (optional)
¾ cup sour cream (optional)

Simmer all ingredients, except bacon and sour cream, in a large Dutch oven for 45 minutes or until potatoes are tender.

Meanwhile, cook bacon, drain, and crumble.

Remove one cup of the soup liquid. In a small bowl, stir together with sour cream and then stir back into the pot. Serve warm, topped with crumbled bacon.

Serves 8 SVR

✦ English Peas with Baby Red Potatoes

1 pound baby (or new) red potatoes (4 to 5 medium
 potatoes) cut into bite-sized pieces
½ cup fresh or frozen peas
¾ cup sour cream
3 egg yolks
½ cup buttermilk
Salt
Freshly ground black pepper
3 tablespoons chopped fresh chives

Bring a large pot of water to a boil over high heat. Add potatoes and boil for 20 minutes or until tender. In a large, heavy-bodied saucepan, bring 1 cup of water to a boil and simmer peas for 5 minutes, drain, and set aside. In a small bowl, stir together the sour cream and the egg yolks. In the same saucepan used to cook the peas, heat the buttermilk over low-medium heat, stirring often. When the milk begins to simmer, whisk in the sour cream–egg yolk mixture and stir constantly until thickened. Add salt and pepper to taste. Add potatoes and peas and warm over medium heat, stirring often. Sprinkle chives on top and serve immediately.

Serves 6 SVR

✦ Roasted Root Vegetables with Herbs

Spanish sailors planted citrus and olive trees along the coast of Georgia in the mid-1500s, and subsequent plantings still thrive in the Lowcountry.

1 pound parsnips
1 pound carrots
1 large onion, cut into 8 wedges
3 tablespoons Georgia olive oil
Salt
Ground black pepper
3 garlic cloves, thinly sliced
½ cup halved walnuts
2 tablespoons mix of fresh minced herbs such as summer
 savory, marjoram, thyme, or parsley
¼ cup chopped chives, cut into 1-inch pieces
Juice and zest of 1 lemon

Wash and peel parsnips and carrots, cut lengthwise into quarters, and place in a medium saucepan. Cover with water and bring to a boil. Simmer 5 minutes, then drain. In a large bowl, toss the boiled parsnips, carrots, and raw onion with olive oil, salt, and pepper to taste, and sliced garlic. Place vegetable mixture in a single layer on a rimmed baking sheet. Reserve any olive oil remaining in the bowl to toss with vegetables again after roasting.

Roast at 400°F for 35 minutes. Add walnuts during last 5 minutes of roasting. Remove vegetables from the oven and return to the large bowl. Toss with chives, lemon juice, and zest. Adjust salt and pepper to taste. Serve warm or chilled.

Serves 6 to 8 SVR

❧ Venison (or Beef or Lamb) Forcemeat Loaf

A forcemeat loaf is the English version of a terrine or pâté. This recipe may appear complicated, but it comes together quickly and is certainly worthy of the effort.

¼ cup fresh bread crumbs
4 tablespoons finely chopped fresh parsley
3 tablespoons minced fresh thyme leaves
1½ teaspoons ground mace
2 tablespoons Dijon mustard
1 pound mild sausage meat
3 garlic cloves, minced
3 eggs
½ cup port
¼ teaspoon salt
1 teaspoon freshly ground black pepper
2 tablespoons peanut oil
1½ pounds venison, cut into chunks (beef or lamb
 may be substituted)
Cornichons (optional)

Cut a piece of cardboard to fit inside the top of a terrine dish or 5-by-9-inch bread pan and wrap it in aluminum foil.

Preheat the oven to 325°F.

In a large bowl combine bread crumbs, parsley, thyme, mace, mustard, sausage meat, garlic, eggs, port, salt, and pepper. Mix well. Heat the oil in a large frying pan and sauté the venison pieces 3 to 5 minutes to brown lightly. Divide the sausage mixture equally into three portions. Place one layer in the bottom of the terrine dish. Add half of the game pieces. Repeat, finishing with a layer of the sausage mixture. Cover with a lid or double layer of aluminum foil.

Half-fill a roasting tin with boiling water, place the terrine dish inside, and bake for 1½ hours. Terrine is fully cooked when internal temperature reaches 185°F.

Remove terrine from oven and place foil-wrapped cardboard on top (remove lid but leave foil cover in place). Distribute heavy items such as canned goods or full water bottles on top of covered terrine to evenly weigh it down while it cools. Let it rest for about an hour and then chill, with weights still in place, in refrigerator overnight.

Thickly slice the terrine and serve cold with toasted rustic or sourdough bread. Garnish with cornichons, if using. Terrine will keep 4 days in the refrigerator.

Serves 8 SVR

Venison (or Lamb, Beef, or Beans) Hand Pies

6 slices bacon, chopped, or 2 tablespoons peanut oil

1 pound venison, lamb, or beef, ground, or 1½ cups
 black beans, cooked, rinsed, and roughly squashed

1 carrot, cut into ¼-inch cubes

2 medium onions, chopped

6 shiitake mushrooms, sliced thin

3 garlic cloves, minced

1 tablespoon butter

2 tablespoons tomato paste

½ teaspoon smoked paprika

½ cup Madeira wine or beef stock

¾ cup pitted and sliced green olives

12 prunes, chopped

2 tablespoons Worcestershire sauce

½ teaspoon salt

½ teaspoon ground black pepper

½ teaspoon ground mace

1 teaspoon dried thyme

4 cups pastry flour or other low-protein flour

1 cup freshly rendered lard or ½ pound (2 sticks) butter

2 teaspoon salt

1 cup very cold water, divided

1 egg, beaten with 2 teaspoons water

In a large, heavy skillet, slowly cook bacon over medium heat to render the fat (or place the oil in the skillet). Add ground meat and carrot and cook thoroughly (if making without meat, just cook carrot). Remove and reserve. Add onions and mushrooms to pan and sauté over medium heat. Reduce heat to low, add garlic, and cook one minute. Move ingredients in pan to one side and add 1 tablespoon butter to the empty area. Top with tomato paste and paprika, and cook one minute. Add beans (if using), wine, and next seven ingredients (through thyme). Simmer until wine is reduced by half.

Preheat oven to 375°F. Place flour, lard, and salt in a large bowl. Cut in the lard with a pastry blender or your fingers until the mixture resembles coarse crumbs. Add ¾ cup of the cold water and mix with a fork, adding more water as needed, 1 Tablespoon at a time, until the mixture holds together. Gather dough into a ball, wrap in waxed paper, and refrigerate for at least 30 minutes.

Transfer the dough to a floured work surface. Roll the dough out to ⅛ inch thick and cut into rounds 8 inches in diameter. In each round place ¼ cup venison mixture. Moisten edges of pastry with cold water, fold in half, and press edges with a fork to seal. Repeat with the remaining pastry and filling. Place on a cookie sheet lined with parchment paper and brush tops with egg-water mixture. Bake 20 to 25 minutes or until pastry is golden brown.

Serves 8 as an appetizer or 4 as a main course SVR

Rabbit (or Chicken) Braise

1 cup flour

Salt

Ground black pepper

1 three-pound rabbit or chicken, cut into 6 pieces

¼ cup lard or peanut oil

1 large onion, chopped

5 medium shiitake mushrooms, stems discarded, thinly
 sliced

2 tablespoons flour

1½ cups dry white wine

2 cups chicken stock

2 teaspoons Worcestershire sauce

3 tablespoons Dijon mustard

1 tablespoon dried marjoram

1 tablespoon dried sage

1 tablespoon dried thyme leaves

¾ cup sour cream

3 tablespoons roughly chopped chives

Preheat oven to 350°F. Mix 1 cup flour, ¼ teaspoon salt, and ½ teaspoon pepper in a shallow bowl. Dredge rabbit in flour mixture. Heat lard in a large Dutch oven over medium-high heat. Fry rabbit until browned. Remove from pan and set aside. Add onion to the Dutch oven and sauté until translucent. Add mushrooms and cook until lightly browned. Season with salt and pepper to taste. Add 2 tablespoons flour, stir, and cook until flour is very lightly browned. Whisk in wine, stock, Worcestershire sauce, and mustard. Stir until thickened, and adjust seasonings. Stir in the marjoram, sage, and thyme.

Return rabbit to the Dutch oven, cover, and bake for 1 hour. Remove rabbit pieces from sauce and set aside. Place Dutch oven over medium heat and stir in sour cream. Simmer gently over low heat until thoroughly warmed. Sprinkle chives on top and serve.

Serves 4 SVR

To see how and why perfectly good recipes from the eighteenth century have been simplified in this collection, consider the recipe below from Hannah Glass (1708–1770) from her book *The Art of Cooking Made Plain and Easy*, first printed in London in 1747.

TO MAKE A CHICKEN-PYE

Make a puff paste crust, take two chickens, cut them to pieces, seasoned them with pepper and salt, a little beaten mace, lay a force-meat made thus round the side of the dish: take half a pound of veal, half a pound of suet, beat them quite fine in a marble mortar, with as many crumbs of bread; seasoned it with a very little pepper and salt, an anchovy with the liquor, cut the anchovy to pieces, a little lemon peel cut very fine and shred small, a very little thyme; mix all together with the yolk of an egg; make some into round balls, about twelve, the rest lay round the dish. Lay in one chicken over the bottom of the dish; take two sweetbreads, cut them into five or six pieces, lay them all over, season them with pepper and salt, strew over them half an ounce of truffles and morels else, two or three artichoke bottoms cut to pieces, a few cocks combs, if you have them, a palate boiled tender, and cut to pieces; then lay on the other part of the chickens, put half a pint of water in, and cover the pye; bake it well, and when it comes out of the oven, fill it with good gravy, lay it on the crust, and send it to table.

✿ Chicken Potted Pye

3 slices bacon or 1 tablespoon peanut oil

1 medium onion, chopped

2 garlic cloves, minced

2 tablespoons butter, divided

4 ounces shiitake, oyster, or button mushrooms, sliced

⅓ cup flour

1 teaspoon dried thyme

1 teaspoon dried tarragon

½ teaspoon paprika

½ teaspoon salt

½ teaspoon ground black pepper

2 pounds chicken thighs, skin and bones removed, cut into 2-inch cubes, or extra-firm tofu, drained well and cut into 1-inch cubes

¾ cup dry white wine

2 cups chicken or vegetable stock

1 medium carrot, chopped

1 stalk celery, chopped

1 small apple, peeled, cored, and chopped

¼ cup raisins

Zest from 1 lemon

½ cup fresh or frozen peas

⅓ cup Madeira

Pastry for single-crust pie, frozen or made fresh from recipe below

1 egg, beaten with 2 teaspoons water

Preheat oven to 400°F.

Slowly fry bacon in a Dutch oven over medium-low heat, remove from pan, and roughly chop. Add onion to pan and cook over medium-low heat until soft. Add garlic and cook another minute, then remove from pan. Increase heat to medium-high and add 1 tablespoon of butter and the mushrooms. Cook mushrooms on one side undisturbed until lightly browned, then remove from pan. Add remaining tablespoon of butter to pan.

Mix flour, thyme, tarragon, paprika, salt, and pepper in a large bowl. Add chicken pieces and mix well. Sauté chicken pieces on each side until browned. Add any flour-herb mixture remaining in the bowl and stir well. Add wine and scrape the bottom of the pan to loosen browned bits. Add stock, carrot, celery, apple, raisins, and lemon zest. Simmer for 15 minutes. Add peas, cooked bacon, onion-mushroom mixture, and Madeira. Simmer 10 minutes.

Cover top of chicken mixture with pie pastry cut to fit Dutch oven, with a layer of crust folded over 1 inch around edge of pot. Brush top with egg-water mixture. Bake for 25 minutes or until crust is browned. Serve hot.

PASTRY FOR SINGLE-CRUST PIE

2 cups pastry flour or other low-protein flour

½ cup freshly rendered lard or ¼ pound (1 stick) butter

1 teaspoon salt

½ cup very cold water

Place flour, lard, and salt in a large bowl. Cut in the shortening with a pastry blender or your fingers until the mixture resembles coarse crumbs. Add ¼ cup of the cold water and mix with a fork, adding more water as needed, 1 tablespoon at a time, until mixture holds together. Gather the dough into a ball, wrap in waxed paper, and refrigerate for at least 30 minutes.

Transfer the dough to a floured work surface. Roll the dough out to ⅛ inch thick and cut into a round 2 inches larger than your Dutch oven.

Serves 6 SVR

⚸ Pork Pie with Persimmons (*Diospyros virginiana*) and Mulberries (*Morus rubra*)

4 slices hickory smoked bacon
2 ounces dried persimmons
½ cup fresh or dried mulberries
¾ cup apple juice
½ cup dry white wine
2 teaspoons cornstarch
1 tablespoon fresh lemon juice
⅓ cup dark brown sugar
2 tablespoons finely grated ginger
1 teaspoon ground cardamom
½ teaspoon freshly grated nutmeg
1 teaspoon salt
1 teaspoon ground black pepper
2 pounds pork tenderloin, placed in freezer for 20
 minutes before using
pastry for double-crust pie (use the recipe above for
 single-crust pie and double the ingredients)
1 tablespoon heavy cream

Preheat oven to 425°F.

Simmer persimmons (and mulberries, if using dried) in apple juice and wine for 15 minutes or until soft. Drain fruit, reserving liquid. Return fruit liquid to pan. Combine cornstarch and lemon juice and stir into pan. Simmer over medium heat until thickened.

In a small bowl, combine brown sugar, ginger, cardamom, nutmeg, salt, and pepper.

Slice barely frozen pork into very thin slices.

Make the pie crust, using the recipe above and doubling the ingredients. Divide the dough in half and roll each half into circles ⅛ inch thick. Lay bottom crust into a pie plate and prick with a fork. Cover with foil and pie weights or ½ cup of dried beans. Bake in hot oven for 10 minutes.

Remove from oven, remove foil with pie weights, and place on cooling rack.

Alternate layers of persimmons, mulberries, and pork slices on top of the partially baked crust. Sprinkle each layer with part of the spice mixture.

Spoon thickened persimmon liquid mixture over pie filling.

Top with upper crust, crimp edges, and cut a few slits in crust to allow steam to escape. Brush top crust with cream.

Bake for 15 minutes at 425°F, then reduce heat to 350°F and bake another 35 minutes.

Serves 6 to 8 SVR

⚸ Elderberry (*Sambucus canadensis*) Apple Cake

3 cups pastry flour, sifted
2 cups light brown sugar
1 teaspoon salt
1 teaspoon baking soda
1¼ cups peanut oil
3 eggs, lightly mixed in a small bowl
2 teaspoons vanilla
Juice and zest of 1 lemon
2 teaspoons sumac powder
3 cups diced apples
½ cup fully ripe elderberries, stems removed
1 cup chopped pecans

Combine flour, brown sugar, salt, and baking soda in a large mixing bowl. Stir in oil, eggs, vanilla, lemon juice, lemon zest, and sumac powder, mixing well. Fold in apples, elderberries, and pecans. Pour into a generously buttered and floured angel food pan. Bake in a 350°F oven for about one hour. Cake is done when a toothpick inserted into the baked batter comes out clean.

Serves 12 SVR

🎋 Mulberry (*Morus rubra*) and Peach Cobbler

6 ounces (3/4 stick) unsalted butter
1 cup mulberries
1¼ cups sugar
1 cup pastry flour, sifted
1 teaspoon salt
1 teaspoon baking soda
¾ cup whole buttermilk
Juice and zest of 1 lemon
¼ cup elderflower liqueur
3 cups peeled and sliced peaches

Put butter in a 9-by-9-inch baking pan, place in the oven, then heat oven to 350°F.

In a small bowl combine mulberries with ¼ cup of the sugar and lightly crush.

In a large mixing bowl mix sugar, flour, salt, and baking soda. Stir in buttermilk, lemon juice and zest, and elderflower liqueur. Remove pan from the oven when the butter is melted and pour the batter into the pan.

Spoon the peach slices across the batter, followed by the elderberries.

Bake in the 350°F oven for about one hour. Cobbler is done when a toothpick inserted into the baked batter comes out clean.

Serves 6 SVR

🎋 Blackberry-Lavender Baked Pudding

2 teaspoons butter
2 cups fresh or frozen blackberries
1 cup buttermilk
3 eggs

1 teaspoon vanilla extract
⅓ cup sugar
¾ cup all-purpose flour, sifted
¼ teaspoon baking powder
Pinch salt
½ teaspoon finely chopped dried lavender
½ teaspoon finely chopped fresh lemon thyme

Butter a baking dish and add blackberries. Combine buttermilk, eggs, and vanilla in a medium-large mixing bowl. Whisk in remaining ingredients. Pour over blackberries. Bake at 325°F for 35 minutes or until set.

Optional: Sprinkle additional fresh lemon thyme leaves and lavender flowers on top.

Serves 6 SVR

🎋 Ogeechee River Persimmon (*Diospyros virginiana*) Torte

8 ounces dried persimmons
1½ cups apple juice
Juice and zest of 1 lemon
2 sprigs fresh thyme
4 Earl Grey tea bags
¼ cup Calvados
2 teaspoons cornstarch
1½ cup pecans
4 eggs, separated
1 cup sugar
½ cup flour
¼ teaspoon salt
2 cups heavy cream
1 tablespoon Calvados
½ teaspoon vanilla extract
2 tablespoons sifted confectioners' sugar

Preheat oven to 350°F. Butter a 9-inch springform pan. Line bottom with parchment paper. Butter and flour the parchment.

Place persimmons, apple juice, lemon zest, lemon juice, thyme, and tea bags in a medium saucepan. Simmer 3 minutes. Remove tea bags. Simmer an additional 20 minutes. Remove sprigs of thyme and discard. Pour the ¼ cup of Calvados into a small bowl, add the cornstarch, and stir until the cornstarch is dissolved. Stir into the persimmon mixture. Simmer until thickened, about 5 minutes. Let cool to room temperature.

Finely chop by hand or grind pecans in a food processor. Beat egg whites in a medium bowl until stiff peaks form. In a separate medium bowl beat egg yolks until doubled in volume, 8 to 10 minutes. Slowly add sugar and beat another 5 minutes. Stir in chopped pecans, flour, and salt. Stir in persimmon mixture. Gently fold in beaten egg whites.

Bake at 350°F for 30 to 35 minutes or until the sides are starting to pull away from the pan. Cool on a rack. Whip cream with the tablespoon of Calvados, vanilla, and confectioners' sugar. Slice the torte, and serve topped with whipped cream.

Serves 8 SVR

⚘ Old World Gingerbread with Crème Anglaise

½ cup rye flour

1½ cups white whole-wheat flour

1 teaspoon baking soda

½ teaspoon salt

1 teaspoon ground cinnamon

½ teaspoon ground cardamon

½ teaspoon ground mace

3 tablespoons fresh ginger, finely grated

½ cup butter, melted

1 cup light-flavored molasses

2 medium eggs

1¼ cups buttermilk

½ cup diced crystallized ginger

¼ cup Scotch, brewed Earl Grey tea, or water

Preheat oven to 350°F. Butter and flour a deep 9-inch cake pan. In a large mixing bowl combine all dry ingredients. Combine fresh ginger, melted butter, and molasses, and add to dry ingredients. Whisk together eggs and buttermilk and add to batter. Stir in crystallized ginger and Scotch. Pour batter into cake pan and bake 35 minutes or until an inserted toothpick comes out clean. Let cake thoroughly cool in the pan before cutting. Serve with whipped cream or crème anglaise.

CRÈME ANGLAISE

¾ cup cream

1¼ cup whole milk

1 vanilla bean, split lengthwise and scraped

6 egg yolks

½ cup sugar

Combine cream, milk, and vanilla bean with scrapings in a heavy saucepan and slowly bring to a simmer. Remove from heat. In a medium bowl, whisk together egg yolks and sugar. While whisking, slowly add 1 cup of the hot custard mixture to the egg yolk mixture. Repeat with remaining custard mixture. Pour combined egg and custard mixture into the saucepan, return to a low heat, and stir continuously until thickened. Do not allow to boil. If custard is not perfectly smooth, strain through a sieve.

Serves 6 to 8 SVR

West African and African American

Dr. William Thomas (also known as Doc Bill) is a co-owner and founder of Georgia Coastal Gourmet Farms in South Georgia and one of the founding members of the Sapelo Island Purple Ribbon Sugarcane Project, Sapelo Red Pea Project, and Sapelo Sour Orange Project. He is a contributing author of the cookbook *Foods of the Georgia Barrier Islands*. Doc Bill is a full-time physician in Georgia. The following recipe is his.

Fried Soft-Shell Crab Topped with Crab Geechee Gravy

CRAB GEECHEE GRAVY

6 fresh blue crabs (cooked and cleaned, with meat
 separated from shells)
Salt
2 tablespoons vegetable oil
1 cup chopped onion
1 tablespoon minced garlic
3 tablespoons all-purpose flour
1 to 2 dashes hot sauce
2 fresh bay leaves
Ground black pepper

In a large pot place crab shells with enough water to cover. Boil until a rich crab stock is obtained. Season with salt to taste.

Heat the vegetable oil in a medium skillet, add chopped onion and garlic, and cook for 5 minutes. Stir in the flour and cook until the roux is browned. Add 3 cups of the prepared crab stock and hot sauce to the roux and simmer until a rich gravy is achieved. Add bay leaves and season with salt and pepper to taste. Keep gravy warm and set aside.

FRIED SOFT-SHELL CRAB

6 fresh (or frozen) soft-shell crabs
Salt
Ground black pepper
1 egg
⅓ cup water
1 cup all-purpose flour
⅓ cup clarified butter

Clean the soft-shell crabs and season with salt and pepper. Combine egg and water in a medium bowl and beat well to make a light wash. Place crabs in the egg wash and then roll each in flour.

In a 10-inch cast-iron skillet over medium heat, add the clarified butter. Add the crabs and cook on both sides until golden brown and cooked through.

SERVING/ASSEMBLING THE DISH

Place soft-shell crabs on a plate and pour a big spoonful of the hot Geechee gravy in the middle of each crab, leaving the legs and claws crispy. This dish is best served with Carolina Gold rice, but grits are also an option.

Serves 3 WT

B. J. Dennis, a Charleston native, trained at Johnson and Wales University in his home city. After stints in famous Charleston restaurants he honed his craft as a private chef and caterer. He is featured in *Bon Appetit*, the *New York Times,* and numerous other publications. Chef Dennis starred in part two of the Netflix series *High on the Hog,* where—with his celebrated colleague and heirloom meat producer Marvin Ross—he demonstrated the traditional overnight process of slow roasting a hog over embers. The following three recipes are his.

⚸ Baked Ogeechee River Shad

1 medium shad
Salt
Ground black pepper
1 medium shallot, chopped
2 garlic cloves, minced
1 tablespoon minced ginger
2 tablespoons rice wine vinegar, lemon juice, or lime juice

Heat oven to 325°ғ. Place shad in a shallow baking pan and season with salt and pepper. Sprinkle all ingredients over the fish and cover the pan with parchment paper, alumnum foil, or a banana leaf. Bake for 7 to 10 minutes.　　BJD

⚸ Cornmeal and Okra Mush

2 cups chopped okra
1 teaspoon salt
¼ teaspoon ground black pepper
¼ cup coconut oil or bacon drippings
2 cups cornmeal

Place okra, salt, pepper, and coconut oil in a large saucepan and cover with water. Simmer for 15 minutes or until okra is tender. Add 2 cups of water, bring to a boil, and vigorously stir in the cornmeal. Serve with Baked Ogeechee River Shad.

Serves 4　　　　　　　　　　　　　　　　　　　BJD

⚸ Radish Greens with Ossabaw Pork

1 medium onion, chopped
2 cups radish greens, washed and chopped
½ cup cooked and shredded Ossabaw pork or smoked
　pork or chopped bacon
Salt
Ground black pepper

Sauté onion until tender, about 3 minutes. Add radish greens and shredded pork, season with salt and pepper to taste, and cook 5 minutes or until radish greens are tender.

Serves 4　　　　　　　　　　　　　　　　　　　BJD

⚸ Peanut-Benne Dressing

2 cups peanuts, roasted
2 cups benne seeds
1 small onion, minced
1 cup brown sugar
Juice from 2 limes
1 teaspoon salt
½ cup peanut oil or benne seed oil

Blend all ingredients in a food processor or blender. Serve on cooked fish, chicken, or pork.

4 ½ cups　　　　　　　　　　　　　　　　　　　BJD

Sallie Ann Robinson is a sixth-generation Gullah, born and raised on Daufuskie Island, South Carolina. She is an African American foodways historian, celebrated Gullah chef, author of three Gullah cookbooks, and coauthor of *Daufuskie Island*. Sallie Robinson stars in part two of the Netflix series *High on the Hog*, part of which was filmed at her home on Daufuskie. The following recipes are hers.

⚜ Corned Fish

This method of preserving fish uses salt in much the same way it is used to prepare corned beef.

Cod, historically abundant in the North Atlantic Ocean, was a vital commodity in the early trade routes linking Europe with the New World. Preserving with salt and air drying stabilized the fish for an especially long shelf life. For centuries, North Atlantic cod was a revered component of cuisines across Europe as well as a critical source of protein for enslaved Africans throughout the Caribbean. Cod are cold-water fish limited to a range beginning at Cape Hatteras, North Carolina, and extending northward. But the technique of salting to preserve fish and meat is widespread. In addition, Native Americans frequently smoked fish and meat to extend storage time. In the Lowcountry, locally caught species such as mullet are often preserved by salting or smoking. Mullet run in dense schools through the tidal creeks and near-shore waters and can be easily caught with a cast net. They were traditionally prepared right away—on the same tide as they were caught—smoked over a low fire or preserved as corned fish. SAR

⚜ Saltfish

1 or more large mullet
Salt, preferably coarse sea salt or rock salt

Descale and fillet fish. Lay fish flat and coat generously with salt. Place in a wooden box or similarly protected container and leave for 1 to 2 nights. Using wire, hang the fish outdoors and allow to dry in the sun. SAR

⚜ Saltfish Two Ways

1 pound salted fish
¾ cup finely chopped onion
½ cup finely chopped red bell pepper
1 teaspoon minced Scotch bonnet pepper (gloves are recommended for handling)
¾ cup chopped tomato
2 tablespoons peanut oil (or coconut oil if you cook the vegetables)

Soak fish overnight in water. Place soaked fish in a large saucepan and cover with cold water. Heat water to boiling, then discard water. Taste fish to determine saltiness. Repeat the steps of covering the fish with cold water, bringing water to the boiling point, and discarding the water, as many times as necessary until the salty taste is removed. Break fish flesh into small pieces, and remove and discard skin and bones.

At this point you can simply add the remaining ingredients to the fish, mix, and serve at room temperature or chilled. Or you can gently panfry the remaining ingredients in coconut oil until tender, then stir in the fish, and serve warm.

Serves 4 SAR

Roosevelt Brownlee, born and raised in Savannah, has cooking experiences like no other. After serving in the military in Vietnam as a cook, he moved to Stockholm, Sweden, to be the chef at the Best of Harlem restaurant, where his talents were swiftly recognized. He was quickly summoned to cook at the Montreux Jazz Festival in Switzerland for musicians including Muddy Waters, Dizzy Gillespie, Nina Simone, Josephine Baker, Stan Getz, and Thad Jones. Back in Savannah again, Chef Brownlee is writing a cookbook and tending his heirloom garden. The following recipes are his.

� Rice-and-Coconut Lentils

½ cup black lentils
¼ cup diced onion
1 tablespoon extra-virgin olive oil
½ teaspoon salt
½ teaspoon ground black pepper
¼ teaspoon dried thyme
1½ cups water
2 cups rice
¼ cup chopped onions (pieces should be approximately the size of the lentils)
¼ cup chopped carrots (pieces should be approximately the size of the lentils)
⅔ cup coconut milk
⅔ cup water

Combine lentils, ¼ cup onion, olive oil, salt, pepper, thyme, and 1½ cups water in a 1-quart saucepan. Bring to a boil, then cover and lower to medium heat. Let cook for 18 to 20 minutes.

 Uncover and add rice, ¼ cup chopped onions, carrots, coconut milk, and ⅔ cup water to the half-cooked lentils. Stir until combined. Bring back to a boil, then cover and lower heat. Cook for 25 minutes, keeping an eye on it to make sure the coconut milk doesn't burn.

Serves 4 RB

✦ Fried Cabbage or Collards

¼ cup vegetable oil
1 medium onion, thinly sliced
1 medium carrot, thinly sliced in 2-inch-wide sections
2 stalks celery, thinly sliced in 2-inch-wide sections
1 medium-sized cabbage or collards, thinly sliced (4 cups)
1 medium green bell pepper, thinly sliced
½ teaspoon dried thyme
¼ cup water
Salt
Ground black pepper

Heat oil in a sauté pan. Sauté onion, carrot, and celery on medium heat for 2 minutes or until translucent. Add cabbage, bell pepper, and thyme, stirring frequently to avoid burning. Once the mixture decreases by half, add salt and black pepper to taste. Add water and cover. Let simmer for about 15 minutes.

Serves 4 RB

✦ Asparagus Mushroom Benne

1 tablespoon extra-virgin olive oil
1 cup thinly sliced mushrooms (button or shiitake)
1 bunch asparagus, ends removed
2 tablespoons tamari or soy sauce
¼ lemon
1 teaspoon benne (sesame seeds)

Heat oil in a sauté pan. Add mushrooms and sauté for 2 minutes. Add asparagus and stir to combine. Let cook for 1 to 2 minutes before adding the tamari. Cover and cook over low heat for 2 minutes. Remove from heat and place on a serving dish or plates. Squeeze lemon juice onto the vegetables and sprinkle with benne seeds.

Serves 4 to 6 RB

Mashama Bailey is the executive chef and co-owner of the Grey and the Grey Market restaurants in Savannah, Georgia, as well as the Diner Bar and a second Grey Market in the Thompson Austin Hotel in Austin, Texas. In 2019 she won a James Beard Award as best chef in the Southeast and three years later received the James Beard Outstanding Chef Award. Chef Bailey spent summers during her childhood in Savannah, and her focus as a chef is on southern Port Cities. The following recipes are hers.

Venison and Oyster Sausage

Natural casings
2 pounds venison
1 pound 10.5 ounces pork fat (fatback)
2 rounded tablespoons salt
½ teaspoon Instacure No. 1
2 tablespoons garlic powder
2 teaspoons ground allspice
½ teaspoon ground cinnamon
1 teaspoon ground black pepper
1 pound 4 ounces oysters
¼ cup minced fresh parsley

EQUIPMENT

Stand mixer with meat grinder, paddle, and sausage
 stuffer attachments

Soak the casings overnight to remove salt.

After soaking, rinse under cold running water for 10 minutes, opening the casing to allow the water to run through the inside as well.

Cut venison and pork fat into 1-inch cubes or pieces that are small enough to fit into your grinder.

Mix together the salt and the next 5 ingredients and toss with the meat, working lightly to keep the meat cold. Grind the meat and set aside. Drain the oysters from their liquor and grind. Fold the ground oysters into the ground meat and add minced parsley.

Place the sausage mix in the base of the mixer and, with the paddle attachment on low, mix until well combined, being careful not to overmix or heat.

The sausage can now be formed into patties or stuffed into casings.

USING CASINGS

Remove the grinder attachment from the mixer and replace with the sausage attachment. Place a sheet pan below the sausage stuffer to catch the sausage. Feed a piece of casing into the sausage stuffer, leaving only an inch or 2 of the casing hanging off the end of the stuffer. Tie a knot at the end of the casing. With the mixer on the slowest speed, take small amounts of the sausage mixture and feed them into the "hopper." Air will come through first, filling up the casing like a balloon, so hold the casing in place until the meat fills the casing, then slowly guide the filled casing off the stuffer as it's filled. This might require two people, one person to add meat into the insert and one to hold the sausage as it comes off the stuffer. If you see air bubbles, make sure you force the air out of the casing. Leave about 3 inches of empty casing on the end.

FORMING THE SAUSAGES

Starting with the knotted end of the sausage, measure off the desired length of sausage and squeeze between your thumb and forefinger to mark the end of the first sausage. Measure a second sausage, squeeze again, then twist between the first and second sausages about three times. Continue measuring, squeezing and twisting, alternating the directions in which you twist. At the end of the chain of sausages, tie a knot after the last sausage. If the tail isn't long enough to tie a knot, squeeze out the last sausage from the casing and add it back to the ground meat mixture to use in the second batch of sausages.

Coil the sausages on a sheet pan and puncture any visible air bubbles so they won't split during cooking. For best results, refrigerate the sausages, uncovered on a rack, overnight before cooking to dry out the casing and maximize caramelization while cooking.

4 pounds of sausage MB

Green Gumbo

¾ cup peanut oil

1 cup all-purpose flour

3 large onions, chopped

1 large green bell pepper, chopped

4 ribs celery, chopped

6 garlic cloves, thinly sliced

¾ teaspoon black pepper

¾ teaspoon cayenne pepper

2 teaspoons salt

2 teaspoons dried thyme

2 teaspoons dried oregano

2 teaspoons sumac powder

9 cups chicken stock

3 fresh native red bay (*Persea borbonia*) leaves

2 tablespoons sassafras (*Sassafras albidum*) leaves, dried and ground to a powder, or purchased file powder

4 cups mixed garden greens such as collards, kale, or turnip or mustard greens

4 cups mixed wild-harvested greens such as red pigweed (*Amaranth spp.*), curly dock (*Rumex crispus*), or goosefoot or lamb's quarters (*Chenopodium album*) (can substitute 4 cups of mixed garden greens)

1 pound smoked sausage, cut into bite-sized pieces

Heat oil in a large, heavy-bottomed stewpot. Stir in flour, and cook on medium heat until it turns a dark caramel color. Add onions, bell pepper, and celery. Sauté about 8 to 10 minutes or until the vegetables are limp. Add garlic and cook 2 minutes more. Add black and cayenne peppers, salt, thyme, oregano, sumac, chicken stock, red bay leaves, and sassafras or file, stir until well blended, then add greens. Simmer 20 minutes, then add sausage and cook 35 more minutes. Serve with Carolina Gold rice and cattail pollen cornbread.

Serves 6 to 8 SVR

Heritage Okra (*Abelmoschus esculentus*) Salad

When harvested young and small, heritage okra is delicious raw. In the Wormsloe gardens, we eat the pods while we are harvesting. Recommended heritage varieties are Aunt Hettie's Red, Green velvet, Stewart's Zeebest, Clemson spineless, or Cajun Jewel.

¼ teaspoon salt

¼ teaspoon ground black pepper

½ cup peanut oil

4 tablespoons rice wine vinegar

1 teaspoon sugarcane syrup

1 teaspoon hot sauce

2 cups thinly sliced, 3- to 4-inch okra pods

1 small onion, thinly sliced

2 medium tomatoes, cut into chunks

¼ cup thinly sliced sweet red pepper

Combine the first six ingredients, and stir well. Combine all ingredients and let rest a few hours at room temperature or overnight in the refrigerator.

Serves 4 to 6 SVR

✺ Pickled Heritage Okra Pods (*Abelmoschus esculentus*)

For best texture and flavor, allow okra pods to pickle for two weeks before eating. Okra pickles will keep for 2 to 3 months in a refrigerator. Recommended heritage varieties are Aunt Hettie's Red, Green Velvet, Stewart's Zeebest, Clemson Spineless, and Cajun Jewel.

1 pound 3- to 4-inch heritage okra pods
1 teaspoon dried mustard seeds
2 hot peppers, split lengthwise
1 teaspoon finely grated fresh turmeric
1 teaspoon finely grated fresh gingerroot
2 garlic cloves, peeled
6 fresh dill sprigs
1 cup rice wine vinegar
1 cup bottled spring water
½ teaspoon white peppercorns
2 tablespoons pickling or kosher salt
2 pint-sized glass canning jars with new lids, all parts sterilized by running through the hottest cycle in the dishwasher just before use

Wash okra in cool tap water. Trim okra stems to ½ inch. Place ½ teaspoon mustard seeds, 1 pepper, ½ teaspoon turmeric, ½ teaspoon ginger, 1 garlic clove, and 3 sprigs dill into each of the sterilized jars. Combine vinegar, water, peppercorns, and salt in a large saucepan, bring to a boil, and pour over okra, leaving ½ inch between top of liquid and the lid.

Screw metal bands on tightly. Process 10 minutes in a boiling water bath.

2 pints SVR

Griff Day is one of the South's most respected bakers and has been nominated for the James Beard Award for outstanding baker. He is co-owner of Savannah's acclaimed Back in the Day Bakery, which was named "Best Bakery in the South" by *Southern Living* magazine. The following recipe is his.

✺ Harvest Day Garden Pizza

Pizza made at home is a great way to celebrate every season and let nature's bounty fill you with surprise. Load it up with all your favorite fresh herbs and vegetables, and top it off with edible flowers.

4½ cups unbleached all-purpose flour, plus more for sprinkling on work surface
2 teaspoons kosher salt
½ teaspoon instant yeast
1¾ cups water
2 tablespoons olive oil
1 cup sour cream
1 cup mayonnaise
2 tablespoons olive oil
¼ cup fresh finely chopped dill fronds
½ teaspoon smoked paprika
Cornmeal
¼ teaspoon cayenne pepper (optional)
4 cups shredded mozzarella cheese, divided
2 cups thinly sliced pickled okra (homemade or store-bought), divided
2 cups cherry tomatoes, cut in half lengthwise
2 cups pickled red onion (homemade or store-bought)
2 cups finely grated Parmigiano Reggiano cheese
4 cups baby arugula
Olive oil
Balsamic vinegar
Sea salt
Ground black pepper

In the bowl of a stand mixer fitted with a dough hook, combine the flour, salt, and yeast. Turn the mixer on low speed, add water, and mix until the dough comes together. Turn the speed up to medium and mix for 3 to 5 minutes, until a smooth, elastic dough forms. Transfer the dough to an oiled bowl, turning to coat the dough with oil. Cover the bowl with plastic wrap and refrigerate for 24 hours.

(To save the dough for future use, divide it into 4 equal pieces and shape each one into a ball. Wrap in plastic wrap and then aluminum foil and freeze for up to a month. Before use, thaw in the refrigerator for 24 to 48 hours.)

Remove the bowl of dough from the refrigerator and divide into 4 equal pieces. Shape each piece into a tight ball, pinching the bottom seams closed, and arrange on a baking sheet. Put it back into the refrigerator to rest for 4 hours.

Meanwhile, at least 1 hour before you are ready to bake, position a rack in the middle of the oven and put a baking stone on the rack. (If you don't have a stone, substitute a pizza pan or baking sheet.) Preheat the oven to 450°F.

To make the sauce, combine the sour cream, mayonnaise, olive oil, dill, and smoked paprika in a small bowl. Stir to combine thoroughly, and set aside.

Remove the dough from the refrigerator and allow it to rest for about 30 minutes. Coat each ball of dough with flour and, working on a lightly floured work surface, press and stretch with your fingers, working from the center out to the edges, to form into a 12-inch round. Place the dough on a peel lightly dusted with cornmeal. Reshape into a 12-inch round if needed.

Evenly spread ½ cup of the sauce to the edges of the pizza dough. Top each pizza with 1 cup mozzarella and ½ cup each of the pickled okra, cherry tomatoes, pickled red onion, and Parmigiano Reggiano cheese. Add fresh cracked pepper, and drizzle pizzas with a quality olive oil.

Bake on the baking stone for 12 to 15 minutes. Meanwhile, place the baby arugula in a medium-sized bowl and toss with a drizzle of olive oil, balsamic vinegar, sea salt, and pepper to taste.

Remove pizzas from the oven, cut into slices, top with baby arugula, and serve.

Makes four 12-inch round pizzas GD

Afterword

"Where Does Our Food Come From?"

PAUL S. SUTTER, Department Chair and Professor of History, University of Colorado, Boulder

Imagine a meal. Begin with raw oysters from the surrounding marshes, which pulse with productivity. There are fresh shrimp as well, boiled with corn, potatoes, and pork sausage or served over creamy grits. There are red field peas, cooked in a thick gravy and served over Carolina Gold rice, or perhaps hoppin' John with black-eyed peas, rice, fatty pork, onions, and peppers. There are collard greens swimming in a pot likker flavored with a ham hock, and an okra gumbo with tomatoes and peppers. Maybe there is venison from the surrounding woods, or quail—or, if it is truly a special occasion, a whole hog roasted over wood coals, with coal-roasted sweet potatoes on the side. There are boiled peanuts and hot cornbread, with butter and a drizzle of local cane syrup or molasses. For me, a nonnative, these are the flavors of the Lowcountry South, and I cannot imagine this meal without visualizing the environments from which it came. Indeed, one spot that comes immediately to mind is a cabin at Wormsloe, overlooking the marsh, where Sarah Ross has cooked many of these dishes for me, with produce fresh from her garden.

Where does our food come from? For many of us, this is a question with which to critique our modern food system, with its industrial scale, its cruelties, and its obfuscating complexity. Too often, the answer is that we don't know, and we take that answer as a troubling symptom of our disconnection from the natural world. Or perhaps it's the sickness itself. Eating is an act of environmental connection, of other lives feeding ours, and one premise of the many overlapping food movements

today—organic, slow, locavore—is that our frequent failures to know where our food comes from is both a form of illiteracy and an ethical failing. Aldo Leopold famously wrote that "we can only be ethical in relation to something we can see, understand, feel, love, or otherwise have faith in."[1] That is not the case for the food most of us eat, or the systems that produce it. So much of our food has become denatured, and that is a source—one of many—of the myriad environmental and health crises we face today.

One of the foundational premises of *Social Roots* is, as the subtitle suggests, to reconnect "Lowcountry foodways with the landscape." There are good environmental reasons for doing so, not the least of which is the sustainability of our food systems. Most of our food springs from the soil, perhaps our most taken-for-granted natural resource. We are degrading soils at a startling rate worldwide, and unhealthy soils in turn breed unhealthy habits, such as heavy reliance on synthetic fertilizers and chemicals. Our foods are, in some senses, artifacts of climate and weather, and yet the fruits and vegetables on our tables often defy those limitations through long travel. Produce from California or Florida, or Mexico or Chile, allows us to eat like it's summer in the depths of winter. Indeed, in the late nineteenth and early twentieth centuries, the truck gardens of the Lowcountry were critical to delivering early-season produce to northern cities.[2] Our foods connect us to an insect world against which we have been indiscriminately at war, and they connect us to common environments whose generous beneficence we have relentlessly diminished. Our foodways also connect us to particular spaces in the landscape, to geographies and topographies of production—to marshes, piney woods, inland swamps, even the precise locations in estuaries where tidal salt water pushes plugs of fresh water into rice canals and fields. To know where our food comes from is to know these places and, let us hope, to care for these resources. It is to celebrate and protect natural abundance, and the working lives of those who are its stewards.

Where does our food come from? In the Lowcountry South, this question has another dimension beyond environmental connection, for Lowcountry cuisine has a complicated historical geography that we also must learn to read. The diasporic complexities of my imagined meal are staggering. Some of the ingredients—the shrimp, the oysters, and the other pluff mud proteins—are native to the Lowcountry in a deep historical sense. We know from the shell middens that they left behind, for instance, that Indigenous peoples consumed large quantities of gathered fish and shellfish well before Old World peoples came on the scene. In a region to which pre-Columbian agriculture came fairly late, however, little else might be considered fully of the place. My imagined meal, like so much of the cuisine of the rest of the world, is filled with plants of American origin: corn, potatoes, sweet potatoes, peppers, tomatoes, and peanuts. But the Columbian Exchange logic that considers these foods to be native because of their American provenance flattens the journeys they made to the Lowcountry. Tomatoes, peanuts, and potatoes of various sorts had to travel from the Andean cultures of South America, sometimes through Europe and Africa, while corn and peppers had Mesoamerican origins and their own itineraries. Then there are the Eurasian and African additions—the pork, onions, collards, sugar, rice, okra, and field peas. Thinking about points of origin for some of these ingredients can be as confusing as it is revealing. Okra and field peas, for instance, are of African origin, crops that came with enslaved peoples. But what of rice, the archetypal Lowcountry export staple and foodstuff? Rice as a crop has origins in both Asia and Africa, but there is a rich debate about whether, and how much, people of European and African ancestry deserve credit for its transfer to the Lowcountry—though there is little doubt that a substantial amount of what the geographer Judith Carney called rice's "agrarian genealogy" is West African.[3] Sugar and collard greens have similarly tangled stories of

diffusion that defy easy generalizations about points of origin. From all of this emerges another great truism of *Social Roots*—Lowcountry cooking is a creole art, its ingredients global in their origins and its techniques deeply syncretic. The Lowcountry is a cosmopolitan meeting point of cultures, and its cuisine and ingredients reflect that reality.

My imaginary meal came to mind as a celebration of the abundance and cultural diversity of a region, but the question "Where does our food come from?" can also be heard as a pressing one, synonymous with concern about the origins of one's *next* meal. Lowcountry foodways are, in many ways, a richness born of poverty, scarcity, food insecurity, and oppression. From the first native adoption of agriculture in the region through the failures of early European settlers to support themselves and their agrarian dreams to the system of slavery that came to dominate and the system of tenancy that followed, food has been linked with power in the South. These have been the conditions for Lowcountry and southern culinary innovation, and recognizing that requires that we understand the inequities that have historically undergirded my imagined meal. These are the most troubling ways in which Lowcountry cuisine connects us with the landscape.

Take the humble collard green, a member of the *Brassica* family and a crop that several of this volume's chapters dwell on. Likely of Asian origin—many of the references I have seen cite Greece as the hearth region for *Brassica* of various sorts, but recent genetic sequencing and environmental modeling suggest Central Asia as a likely point of origin—collards came to the American South with Europeans, where they then were adopted by and became a staple of African American cooking.[4] For me, collards invoke both economic marginality and a kind of food security. They grow easily in all kinds of soils; during most of the year in the Lowcountry, they are rich in vitamins and other nutrients; and they are relatively resistant to pests. These qualities have made them an ideal complement to tenuous lives and constrained diets. Prepared with a small

piece of pork from low on the hog and served with some cornbread, collards saw many poor southerners through hard times. Their cultivation and preparation often were expressions not only of one's southernness but also of one's place in the economic order of the South.[5]

Or take corn and pork, celebrated staples of southern cuisine today that, historically, dominated the southern diet in problematic ways. Corn came to the Lowcountry and established itself among the Guale and Timucua as a tribute crop, a sign of their growing political dependence on the Mississippian cultures to the west in the centuries prior to colonization by Old World peoples. Just as important—and contrary to the common assumption that agriculture was a boon to hunting-and-gathering people—there is a growing consensus that reliance on corn by Lowcountry native peoples marked an unhealthy turn in their lives.[6] Pigs arrived with the Spanish and became both a vital food source and feral pests, key creatures in the "ecological imperialism" that undermined native lifeways. More than that, the southern reliance on pork grew from the regional economy's monomaniacal focus on cash crops and the failure to practice careful animal husbandry—and thus to care for their soils. The abilities of pigs to fend for themselves on the edges of plantation production was their greatest selling point. By the middle of the nineteenth century, the plantation South had a major "food problem," as its reliance on staple crops and enslaved labor meant that the region struggled to feed itself adequately. It was in this context that corn and to a lesser extent pork became the dietary mainstays, particularly for those who could not afford other food or did not have the power to control their own agricultural production.

Ironically, during the antebellum period, enslaved peoples and other marginal southerners may have had a greater capacity to supplement their poor diets with fresh foods that they raised or gathered. This was particularly true of the Lowcountry, where rice culture and the task system gave enslaved peoples the time and space to supplement

(or sometimes wholly supply) their sustenance with gardening, hunting, and gathering. After the Civil War, however, the South's reliance on "hog meat and hoecake," to invoke the title of Sam Bowers Hilliard's classic historical geography of the food supply of the Old South, became a pathology. The region's increasing reliance on cotton, the growing reach of the market economy, and the spiraling indebtedness of its small farmers meant that landowners and lenders could dictate the planting of more and more cotton at the expense of any provisioning gardens. One result was the emergence of pellagra, a disease of niacin deficiency and a particularly southern malady rooted in a diet overly reliant on what were called the three Ms: meal (cornmeal), meat (mostly low-quality pork such as fatback), and molasses. Pellagra killed tens of thousands of poor southern tenants, sharecroppers, and mill workers and afflicted many more until Dr. Joseph Goldberger helped to identify and correct the problem in the years around World War I. There is no small irony that my imagined meal includes foods that a century ago made so many southerners sick.[7]

As a few of this volume's authors intimate, field peas connect foodways and the southern landscape in similarly complex ways. As African crops that came over with the slave trade (and, along with rice, likely provisioned it), field peas were certainly cultivated in the gardens of enslaved and freed people, gardens that were critical, when and where they could be grown, to correcting for diets otherwise heavy on corn, light on pork, and devoid of much else. As such, they ought to be celebrated as an African contribution to southern foodways. But at a certain point, southern white planters also took to field pea cultivation for a variety of their own reasons. Heavy reliance on cotton and corn across much of the plantation South resulted not only in a food crisis and the marginalization of animal agriculture but also in widespread soil exhaustion and erosion, another distinctively southern malady. Field peas, or cowpeas, came to planters' fields as a cure-all. A legume easily intercropped with corn, cowpeas restored nitrogen

to the soil, held it in place, and retained soil moisture, helping to correct for exhaustion and erosion (problems to which corn could be as big a contributor as cotton). As their name suggests, cowpeas also proved ideal as a livestock fodder in a region largely devoid of improved pasture—either harvested as peavine hay or left in the field for after-harvest grazing by pigs and cattle. And, in a region wanting for food, field peas fed people as well—particularly enslaved agricultural laborers struggling on meager provisions. These multipurpose qualities of cowpeas might have been, under other circumstances, entirely positive. But in the late antebellum South, the humble cowpea, the "clover of the South," may well have propped up the Cotton Kingdom, ameliorating critical environmental problems in an unjust and exploitative system of production.[8]

As a final example, let's move more solidly back to the Lowcountry and think about rice. There is, of course, a deep irony—yet another one—to the revival of Carolina Gold, a key ingredient in my imagined meal and a restored "heirloom" celebrated by Lowcountry chefs for its remarkable flavor. Carolina Gold, whose seed supposedly arrived in Charleston from Madagascar in 1685, soon came to be a rice variety grown in large quantities on tens of thousands of acres of Lowcountry tidal swamp during the colonial and antebellum periods. It was mostly enjoyed by a white elite or exported to great acclaim, with its profits reinvested in the complex agro-engineering of tidal flow rice culture that enslaved Africans made possible. It was the staple crop, along with Sea Island cotton, of Lowcountry capitalism.

So, what does it mean to restore this specific land-race as part of a Lowcountry culinary heritage that celebrates local and place-based agriculture? In the recently aired documentary series *High on the Hog: How African Cuisine Transformed America* (based on Jessica B. Harris's book *High on the Hog: A Culinary Journey from Africa to America*), one of the most poignant and important moments comes during a conversation between host Stephen

Satterfield and Glenn Roberts, the founder of Anson Mills and one of the people most responsible for the revival of Carolina Gold. Satterfield asks Roberts where Carolina Gold had disappeared to, and Roberts notes that it disappeared with the end of slavery and the African labor and expertise that had made its cultivation possible. Then Satterfield asks, more pointedly, whether Roberts has "complicated feelings as a white man being involved in this trade." Roberts admits that he does, though he also notes that he gives away the seed free of charge as a kind of "reparations pathway." Still, Satterfield persists, observing that it is Roberts's very commercial success through the monetization of Carolina Gold that allows such a giveaway. "Do you think that this Carolina Gold rice is the legacy of slavery?" Satterfield asks by way of conclusion. Roberts responds by saying, simply, that Carolina Gold represents "the horrors of slavery." With Carolina Gold rice, there is a fine line between terroir and terror; here landraces necessarily intersect with racial memory.[9]

My point in offering these brief and necessarily incomplete discursions on the foods in my imagined meal is to suggest that they connect us to the Lowcountry landscape not merely in environmental and geographical ways. They also connect us to complex and contested histories that can be ethically and socially challenging, and that can complicate the arguments of those who advocate for local agriculture and place-based or heritage cuisine. These histories are precisely what make Lowcountry foodways and the landscapes and peoples that support them so rich and complex, and we must honestly reckon with them in the fullness of the Lowcountry community. The foods and ingredients of my imagined meal, and the reconnections that they promise, are only as good as the company and conversation around the table. *Social Roots* is a perfect conversation starter. Dig in.

NOTES

1. Aldo Leopold, *A Sand County Almanac, and Sketches Here and There* (New York: Oxford University Press, 1949), 214.

2. On Savannah truck gardening and its historic role, see Willard Range, *A Century of Georgia Agriculture, 1850–1950* (Athens: University of Georgia Press, 1954), 112–113.

3. Judith Carney, *Black Rice: The African Origins of Rice Cultivation in the Americas* (Cambridge, Mass.: Harvard University Press, 2002), 2.

4. See Alex C. McAlvay, Aaron P. Ragsdale, Makenzie E. Mabry, Xinshuai Qi, Kevin A. Bird, Pablo Velasco, Hong An, J. Chris Pires, and Eve Emshwiller, "*Brassica rapa* Domestication: Untangling Wild and Feral Forms and Convergence of Crop Morphotypes," *Molecular Biology and Evolution* 38, no. 8 (2021): 3358–3372, https://doi.org/10.1093/molbev/msab108.

5. *The New Encyclopedia of Southern Culture*, vol. 7: *Foodways*, ed. John T. Edge (Chapel Hill: University of North Carolina Press, 2007), 170–174.

6. David Hurst Thomas, "Deep History of the Georgia Coast: A View from St. Catherine's Island," in *Coastal Nature, Coastal Culture: Environmental Histories of the Georgia Coast*, ed. Paul S. Sutter and Paul M. Pressly (Athens: University of Georgia Press, 2018), 61–68.

7. Sam Bowers Hilliard, *Hog Meat and Hoecake: Food Supply in the Old South, 1840–1860* (Carbondale: Southern Illinois University Press, 1972); Alan M. Kraut, *Goldberger's War: The Life and Work of a Public Health Crusader* (New York: Hill and Wang, 2003).

8. I tell this cowpea story in more detail in *Let Us Now Praise Famous Gullies: Providence Canyon and the Soils of the South* (Athens: University of Georgia Press, 2015): 148–149. John Hebron Moore discusses this story of the deployment of the cowpea on Mississippi plantations in *Agriculture in Antebellum Mississippi* (1958; reprint, Columbia: University of South Carolina Press, 2010).

9. See Jessica Harris, *High on the Hog: A Culinary Journey from Africa to America* (New York: Bloomsbury, 2011); *High on the Hog: How African Cuisine Transformed America*, episode 2, "The Rice Kingdom," Netflix Studios, 2021. See also David Shields, *Southern Provisions: The Creation and Revival of a Cuisine* (Chicago: University of Chicago Press, 2015).

NOTES ON CONTRIBUTORS

Nydia Blas

MASHAMA BAILEY is the executive chef of the Grey in Savannah, Georgia, and coauthor of *Black, White, and the Grey: The Story of an Unexpected Friendship and a Landmark Restaurant*. Mashama has earned several accolades, including James Beard Foundation's Best Chef Southeast award in 2019. She also serves as vice chair on the board of the Edna Lewis Foundation, working to preserve and celebrate Edna's legacy, which heavily influenced her menu at the Grey.

SAM BALLING was born on a small farm in upstate New York in 1979 but settled in the South more than fifteen years ago with his Georgia-native wife. They currently split time between Athens, Georgia, and the Georgia coast. His most recent work has been driven by a strong sense of place—dictated by the land, its people, and their shared history.

APRIL BISNER is a project manager in the biology department at the College of Charleston in South Carolina.

ROOSEVELT BROWNLEE served in the Vietnam War, after which he spent several years as a cook to touring musicians on the jazz festival circuit in Europe and Montreal. He now works as a private chef and sells food at festivals near his hometown of Savannah, Georgia.

David Kaminsky

BETSY CAIN is a multimedia painter living in Savannah, Georgia. Cain's work includes paintings, cutouts, and paper works influenced by the salt marshes, tides, and barrier islands surrounding her hometown of Savannah. Her works have been shown in artists' installations, curated invitational exhibitions, galleries, and museums, including the Roswell Museum and Art Center in Roswell, New Mexico; the Museum of Contemporary Art of Georgia in Atlanta; the Telfair Museum's Jepson Center for the Arts in Savannah; and the High Museum of Art in Atlanta.

Kristen Morales

JULIA HOLLY CAMPBELL is a public service assistant at the Warnell School of Forestry and Natural Resources at the University of Georgia. Her outreach work focuses on wildland fire, community forestry, and arboriculture education in Georgia and the southern region of the United States. One of her current outreach projects is the development and delivery of a project funded by the National Institute of Food and Agriculture on firescaping, or fire-resistant landscaping. She is also involved in the development and delivery of community forestry trainings, webinars, and publications.

C. RONALD CARROLL is a professor emeritus at the Odum School of Ecology at the University of Georgia. Carroll's research interests include conservation biology, sustainable development, and forest regeneration. He is the coauthor of *Principles of Conservation Biology*.

Eastwoods Media

BRANDON CARTER is the executive chef and partner of FARM in Bluffton, South Carolina, and was named a 2019 South Carolina Chef Ambassador. He has previously worked as executive chef at the Inn at Palmetto Bluff, the Ritz-Carlton Naples in South Florida, and the Mumbo Jumbo Bar and Grill in Atlanta.

Katherine Arntzen

CHRISTOPHER M. CURTIS is head of the Department of History at Armstrong State University. Curtis is the author of *Jefferson's Freeholders and the Politics of Ownership in the Old Dominion*.

DORINDA G. DALLMEYER is a faculty member of the Environmental Ethics Certificate Program at the University of Georgia and is also the associate director of the University of Georgia's Dean Rusk Center of International, Comparative, and Graduate Legal Studies. She is the editor of five books, including *Values at Sea*.

GRIFF DAY is the co-owner of Back in the Day Bakery in Savannah, Georgia, which was named "Best Bakery in the South" by *Southern Living* magazine.

Clay Williams

B. J. DENNIS is a personal chef and caterer. He infuses the flavors of the Lowcountry and West African cultures into his Gullah-Geechee cuisine, bringing a new taste to the ever-expanding culinary palate of the South.

EDWARD G. FARNWORTH is an adjunct professor of entomology at Clemson University's Coastal Research and Education Center in Charleston, South Carolina. He received a PhD in entomology and ecology and a master of science degree in entomology and zoology from the University of Florida, as well as a bachelor's degree in biology from Stony Brook University. He lives in McClellanville, South Carolina, and is a coastal South Carolina master naturalist.

Courtesy Savannah State University

DIONNE HOSKINS-BROWN is an associate graduate professor in marine science at Savannah State University. Hoskins-Brown is chair of the Gullah-Geechee Cultural Heritage Corridor Commission and a member of the Savannah–Chatham County Public School System Board of Education.

TOMMY JORDAN is associate director emeritus of UGA Center for Geospatial Research.

PHILIP JURAS is a painter whose art expresses his desires to both explore and understand the patterns of the natural world. Philip's art examines the rich aesthetics of a wide range of ecologically intact natural environments. His ongoing projects include Georgia's barrier islands, fire adapted landscapes of the Southeast, tall grass prairie restoration in Illinois, and the paramo and cloud forests of the Colombian Andes.

DAVID KAMINSKY is an artist and photographer living in Savannah, Georgia.

JOHN A. KNOX is a professor of geography at the University of Georgia and the undergraduate advisor for atmospheric sciences. His research interests include the dynamics of weather and climate, geoscience education, atmospheric hazards, satellite remote sensing applications, and meteorological applications of social media data.

PAM KNOX is an agricultural climatologist for the University of Georgia in the Department of Crop and Soil Sciences. Knox is a certified consulting meteorologist in the areas of forensic meteorology and climatology and director of the UGA Weather Network. She is also a regional coordinator for the volunteer Community Cooperative Rain Hail and Snow Network in Georgia. Knox serves on the advisory board for the Georgia Weather Network.

J. DREW LANHAM is Alumni Distinguished Professor of Wildlife Ecology in the Department of Forestry and Environmental Conservation at Clemson University. Lanham is also a master teacher and certified wildlife biologist whose research interests include the relationship between ethnicity and conservation issues, such as wildlife.

MARGUERITE MADDEN is a professor in the Department of Geography at the University of Georgia. Madden is also director of the UGA Center for Geospatial Research and a science advisor for the NASA DEVELOP national program. Her research interests include GIScience and landscape ecology, geovisualization, and geographic object–based image analysis as applied to landscape-scale biological/physical processes and human impacts on the environment.

LAWRENCE A. MORRIS is a professor emeritus of the Warnell School of Forestry at the University of Georgia. His research interests focus on the impacts of forest management on soil properties, long-term site productivity, and the utilization of forests and trees in waste recycling and site remediation.

EMILY PAULINE is a climate risk analyst for the Climate Service in Morrisville, North Carolina, where she develops models to quantify the financial impacts of climate change. She has a master's degree in geography from the University of Georgia and a bachelor of science degree in meteorology from Valparaiso University.

ROGER PINCKNEY is the author of *Dead Low Water*, *Crying in the Wilderness*, *The Mullet Manifesto*, *The Right Side of the River*, *Reefer Moon*, and other books. Pinckney is also the senior editor of *Sporting Classics Magazine*, as well as a regular contributor.

JANISSE RAY is a writer, naturalist, and activist. She is the author of five books of literary nonfiction in addition to a collection of nature poetry. Her recent works include *Wild Card Quilt*, *Pinhook*, *The Seed Underground: A Growing Revolution to Save Food*, and *Drifting Into Darien: A Personal and Natural History of the Altamaha River*. Ray has also been a contributor to *Audubon*, *Orion*, and other magazines, as well as a commentator for NPR's *Living on Earth*. As an environmental activist, she has campaigned on behalf of the Altamaha River and the Moody Swamp.

SALLIE ANN ROBINSON is a cookbook author, chef, and cultural historian. A native of Daufuskie Island, South Carolina, Robinson often incorporates the history and traditions of her Gullah ancestry into her recipes and books.

SARAH V. ROSS is executive director of the University of Georgia Center for Research and Education at Wormsloe in Savannah, Georgia, as well as president of the Wormsloe Foundation and executive director of the Wormsloe Institute for Environmental History. Both organizations conduct and coordinate agricultural and environmental research focused on Georgia's coastal landscapes. After growing organic vegetables in the Coastal Plain for forty-five years, Ross now cultivates more than four hundred heirloom

Andrea Pesotto

varieties of vegetables organically in experimental research plots in Savannah and in Allegheny County, North Carolina. Her focus is to classify flavor profiles, document growth rates, measure drought and flood tolerance, and identify pest and disease resistance of diverse varieties.

CHARLES SCARBOROUGH is an air quality data scientist at Sonoma Technology in Petaluma, California. Scarborough grew up in southeast Georgia and attended the University of Georgia as an undergraduate and the University of Delaware as a graduate student in geography.

B. MERLE SHEPARD is a professor emeritus of entomology at Clemson University, head of the Entomology Department at the International Rice Research Institute, vice president of the Carolina Gold Rice Foundation, and chair of the Agriculture Committee for the Agricultural Society of South Carolina. Shepard's interests include biological control of insects, integrated pest management, and insect pollinators.

DAVID S. SHIELDS is known throughout the South as "The Flavor Saver." As chair of the Carolina Gold Rice Foundation and as Carolina Distinguished Professor at the University of South Carolina he has researched and restored dozens of classic culinary ingredients to southern farms and tables that had gone extinct. Author of thirteen books, he is the Southern Foodways Alliance's "Keeper of the Flame," Slow Food USA "Snailblazer for Biodiversity," and a James Beard Book Award finalist. His most recent publication is *The Ark of Taste: Delicious and Distinctive Foods That Define the United States.*

HAYDEN R. SMITH is a visiting assistant professor of history at the College of Charleston, South Carolina. His teaching and research interests examine the intersection of environment, technology, and culture, with a particular focus in the South Carolina Lowcountry and broader American South. He is also a contributor to the Lowcountry

Digital History Initiative and an affiliate faculty member in the Center for Historical Landscapes and the Program in Southern Studies. Smith earned his PhD from the University of Georgia and is the author of *Carolina's Golden Fields: Inland Rice Cultivation in the South Carolina Lowcountry, 1670–1860.*

HALEY STUCKEY is a meteorologist for the National Weather Service in Kentucky. She holds bachelor of science degrees in both atmospheric science and geography from the University of Georgia.

PAUL S. SUTTER is a professor and department chair of history at the University of Colorado Boulder. He is the author of *Driven Wild: How the Fight against Automobiles Launched the Modern Wilderness Movement* and *Let Us Now Praise Famous Gullies: Providence Canyon and the Soils of the South.* He is also the coauthor of *The Art of Managing Longleaf: A Personal History of the Stoddard Neel Approach,* the coeditor (with Christopher Manganiello) of *Environmental History and the American South: A Reader,* and the coeditor (with Paul Pressly) of *Coastal Nature, Coastal Culture: Environmental Histories of the Georgia Coast.*

DREW SWANSON is a professor of history at Wright State University, and his research examines the intersections of nature and culture in the American South. He is the author of several journal articles and book chapters, as well as three books: *Beyond the Mountains: Commodifying Appalachian Environments, A Golden Weed: Tobacco and Environment in the Piedmont South,* and *Remaking Wormsloe Plantation: The Environmental History of a Lowcountry Landscape.*

JOHN MARTIN TAYLOR is a cookbook author and culinary historian. He has owned and operated his culinary bookstore, Hoppin' Johns, for thirty-three years and is the author of four cookbooks: *Hoppin' John's Lowcountry Cooking; The New Southern Cook; Hoppin'*

John's Charleston, Beaufort & Savannah: Dining at Home in the Lowcountry; and *The Fearless Frying Cookbook*. His work has appeared in publications including the *New York Times, Food & Wine, Gourmet, Fine Cooking, Journal of Gastronomy, Gastronomica, Bon Appétit, Country Home, Cooking Light*, and the *Washington Post*.

DR. WILLIAM THOMAS (also known as Doc Bill) is a co-owner and founder of Georgia Coastal Gourmet Farms in South Georgia and one of the founding members of the Sapelo Island Purple Ribbon Sugarcane Project, Sapelo Red Pea Project, and Sapelo Sour Orange Project. He is a contributing author of the cookbook *Foods of the Georgia Barrier Islands*. Doc Bill is a full-time physician in Georgia.

MARK UZMANN is an artist and photographer. Uzmann earned his MFA while teaching psychology and photography at the Savannah College of Art and Design. He has received awards for his work including Best of Show at Arts on the River in Savannah, Georgia, and a Special Merit Award the following year in the same overall competition. In 2007, two of Mark's photographs were accepted into the permanent collection of the Telfair Museums of Art in Savannah. Traditionally, Uzmann has been most concerned with developing a visual conservation of the South as a region.

DWIGHT WILLIAMS is the owner of Bottle Tree Gardening in Charleston, South Carolina. He holds a PhD from Louisiana State University, along with a bachelor of science and master of science from the University of Arkansas.

INDEX

American, 226–235; Ogeechee River persimmon torte, 248–249; Ogeechee River shad, 251; okra salad, 255; peanut-benne dressing, 251; pecan and Indian meal cake, 234; pecan and pumpkin seed spread, 227; pickled okra pods, 256; pizza, 256–257; pork pie with persimmons and mulberries, 247; prickly pear cactus fruit syrup, 232; pumpkin soup, 228; Quarters Field vegetable soup, 241; rabbit braise, 244; radish greens with Ossabaw pork, 251; rice-and-coconut lentils, 252; roasted root vegetables, 242; roasted squash seeds, 227; salsa macha, 237; saltfish, 252; sautéed glasswort, 232; sautéed greenbrier tips, 227; smoked mullet, 233; smoked quail, 233; squash, bean, and corn soup, 234; succotash, 233; sunchokes, 227–228; terrapin stew, 140; venison and oyster sausage, 254–255; venison forcemeat loaf, 243; venison hand pies, 244; venison meatloaf, 232–233; wild turkey sauce, 229; Wormsloe oyster soup, 240–241; Wormsloe potted shrimp, 238; yaupon holly tea, 231

Redcliffe Plantation (S.C.), 177
refried speckled mayo peas (recipe), 237
Reynolds, Stephen J., 41
rice cultivation, 47–49, 48, 171–172, 259; Carolina Gold variety of, 190, 192, 258, 261–262; cattle and, 24, 191–192; climatic factors in, 225; environmental factors of, 179–186; hurricanes and, 31; soils for, 74–75

rice cycle, 184–185
rice plantations, 4, 101, 126, 132–133; cuisine of, 188; slaves for, 14, 49, 122
rice-and-coconut lentils (recipe), 253
Rising Sun Hurricane (1700), 31
Roberts, Glenn, 262
Robinson, Sallie Ann, 155–159, 252
Rosomoff, Richard, 192
Ross, Sarah V., 1–5, 168–169; on ecosystems, 9–24; on working-class cookery, 219–225
rotation of crops, 12, 19, 84, 175, 191
Ruffin, Edmund, 19–20, 141, 183
rule of law, 120
rum, 123, 143
rutabagas, 175, 176
Rutledge, Sarah, 24n17, 187, 190, 194
rye, 173, 221

salad, okra (recipe), 255
Salatin, Joel, 168
salsa macha (recipe), 237
salt grass, 47
salt marsh ecosystems, 12
saltfish (recipe), 252
saltwort (recipe), 232
Salzburg settlers, 129, 163, 235; silk culture of, 171; wheat crops of, 173, 222
samphire (glasswort), 47; recipes with, 232, 239
"sandlappers," 190
sand-sharing system, 56, 56–57
Satterfield, Stephen, 262
Sauer, Carl, 16
Savannah, Ga., 129; climate of, 29, 35–38; earthquake of 1886 and, 62n2; Oglethorpe and, 123, 127; during Revolutionary

War, 140; satellite view of, 27; thunderstorms of, 33–34, 36; winter storms of, 30–31
Savannah Coastal Refuges, 64n20
scarabs, 93
Scarborough, Charles, 26–38
Schulze, Dick, 190
Scottish settlers, 129, 168
scuppernongs, 153
sea oats, 56, 63n8
sea-level changes, 36–37, 57, 57–59, 58, 59
sesame, 4, 15, 173
settlers, 3–4; charity, 127–129; cookery of, 16; environmental influences on, 9; land tenure of, 14; Salzburg, 129
Sewee people, 174
shad (recipe), 251
sheep, 175
Shepard, B. Merle, 86–97, 195n27
Shields, David S., 170–178
Sholes, Arnold, 201
Shore Protection Act (1979), 62
shrimp, 197–207, 259; black gill disease in, 206–207; cast nets for, 157, 158–159; pickled (recipe), 238; potted (recipe), 238
silk cultivation, 123, 132, 171
Silver Bluff Terrace, 59
Simmons, Amelia, 222
Simms, William Gilmore, 183
Simons, Charlie, 159
Skidaway Institute of Oceanography, 207
Skidaway Island, 58, 61
skippers, 93–94, 95
slave societies, 142, 149n12
slavery, 4, 15, 121–123, 130–133; Carolina Gold rice and, 261–262. See also enslaved workers
Smart-Grosvenor, Vertamae, 5

Smith, Hayden R., 179–186
soil horizons, 67–70, 69, 70, 73, 75
soil mapping, 71, 72
soiling crops, 171
soils, 18–20, 42, 66–78, 69, 224; anthropogenic, 76–78, 77, 78; drainage of, 70, 72; ecosystems of, 67, 68; of forests, 74–76, 76; imaging of, 77; for rice cultivation, 180–183; taxonomy of, 69
sorghum, 177–178, 191
soup (recipes): crab, 240; leek, 241; oyster, 240–241; vegetable, 241
South Carolina, 14, 122, 127; slavery in, 15; Stono Rebellion in, 131–132
soybeans, 164, 190
Spalding, Thomas, 142
Speer, Harriet A. J., 30
spiders, 83
spiderwort flowers, 232
spinach, 141, 164, 176, 177
Spotswood, Alexander, 127
squash, 12, 162, 168, 176, 221; climatic influences on, 225
squash, bean, and corn soup (recipe), 234
squash blossoms (recipe), 229
squash seeds (recipes), 227
St. Catherines Island, 62; soil of, 72
St. Simon's Island, 199, 231
Stafford, Thomas, 157
Stephens, William, 129–130, 131
Stewart, Mart, 183
Stokes, Anthony, 33, 35
Stone Mountain, 63n3
Stono Rebellion (1739), 131–132
Stuckey, Haley, 26–38
succotash (recipe), 233
sugarcane, 141, 177, 259–260
Sullivan, Buddy, 47, 49